Drama-Based Pedagogy
Activating Learning Across the Curriculum

Drama-Based Pedagogy
Activating Learning Across the Curriculum

Kathryn Dawson and Bridget Kiger Lee

intellect Bristol, UK / Chicago, USA

First published in paperback in the UK in 2018 by
Intellect, The Mill, Parnall Road, Fishponds, Bristol, BS16 3JG, UK

First published in paperback in the USA in 2018 by
Intellect, The University of Chicago Press, 1427 E. 60th Street,
Chicago, IL 60637, USA

A catalogue record for this book is available from the
British Library.

Copy-editor: MPS Technologies
Cover designers: Intellect Books
Production manager: Faith Newcombe
Typesetting: Contentra Technologies

Print ISBN: 978-1-78320-739-8
ePDF ISBN: 978-1-78320-740-4
ePUB ISBN: 978-1-78320-741-1

Printed and bound by Hobbs the Printers Ltd.

Contents

Acknowledgments

First, we want to acknowledge Dr. Sharon Grady's leadership of the *Drama for Schools* (DFS) program, where the earliest drafts of this book were created. DFS was developed in response to the transmission-focused teaching approaches of Texas public school educators during the United States' *No Child Left Behind* era; its goal was to improve the learning culture of the classroom. Grady was a key teacher and mentor to both authors of this book. Her tremendous intellect, skill and experience continue to be at the foundation of our practice in Drama-Based Pedagogy (DBP).

We acknowledge the significance of our shared undergraduate training in theatre and education at Northwestern University and graduate education at the University of Texas at Austin, as well as Bridget's additional doctorate degree in Educational Psychology. Our training shaped our understanding of the theories and practices of drama and education.

Katie appreciates the crucial early career faculty support she received from Theatre and Dance Chairs, Richard Issakes, Bob Schmidt and Holly Williams. Current Theatre and Dance Chair, Dr. Brant Pope, continues to offer unfailing support of Drama for Schools and Drama-Based Pedagogy much of the credit for DBP's international reputation is based on his generous support and efforts. The Dean of the College of Fine Arts, Dr. Douglas Dempster, has also provided tremendous support for the development of Drama-Based Pedagogy, and related work on arts integration, through research funds and operational support for DFS, as has Associate Dean for Arts Education, Dr. Hunter March. The work of former and current faculty within the Drama and Theatre for Youth and Communities program at UT—Dr. Coleman Jennings, Joan Lazarus, Dr. Suzan Zeder, Lynn Hoare, Dr. Megan Alrutz, Roxanne Schroeder-Arce, and Lara Dossett—has shaped our thinking on DBP. Katie particularly acknowledges Megan for her ongoing commitment to DFS as one of many anchor programs in the Drama and Theatre for Youth and Communities MFA degree program.

As a teacher and researcher at The Ohio State University, Bridget acknowledges essential support from Dr. Caroline Clark, who stepped out

on a rather shaky limb multiple times to make sure that dramatic inquiry has an ongoing home at OSU. Under Clark's leadership, OSU faculty members created the first PhD in Education with a specialization in Dramatic and Arts-Based Teaching, which will provide important ongoing research in Drama-Based Pedagogy and its related fields. At OSU, Dr. Patricia Enciso and Dr. Brian Edmiston have both given time, support, and generous feedback throughout the development process of this book. They introduced us to the ways that DBP can be used with Shakespeare's plays through their work with the Royal Shakespeare Company. They also offered essential mentorship in literacy and sociocultural theories, to help us better understand how drama-based pedagogy can be used to teach complex texts.

Drama-based pedagogy was primarily developed through our partnerships with public school teachers from rural, urban, suburban, and borderland schools across the US and Australia. We acknowledge the many communities, school districts and schools that have engaged in multi-year research projects on the impact of Drama-Based Pedagogy in their schools with one or both of us. We want to thank the educators of Galena City School District in Alaska; Tyler ISD, Victoria ISD, McAllen ISD, Austin Discovery School, and Austin ISD in Texas; the Heartland Fine Arts Leadership Academy in Wisconsin; the Columbus City Schools in Ohio; and the public schools of Adelaide, South Australia. The application suggestions in our strategy descriptions, the featured examples of practice, and model learning experiences in this book are based on collaborations with these amazing innovators.

We offer appreciation to Dr. Brent Hasty of MINDPOP, our partner in Austin's Creative Learning Initiative, who provided wise counsel and collaboration at crucial points in our development of DBP. Our work with our colleagues in South Australia also helped to refine our thinking; we acknowledge the insights and support of Margot Foster and the Department of Education and Child Development; our colleagues at the University of South Australia including Jeff Meiners, Dr. Robyne Garrett, Prof. Lester-Irabinna Rigney, Prof. Stephen Dobson, Joss Rankin, Dr. Kathy Paige, Leni Brown; and our phenomenal team of Carclew (teaching) artists including Kerrin Rowlands, Eliza Lovell, Jo Naumann Curren, Carol Wellman Kelly, and James Parker, along with the entire Carclew staff. Additionally, national colleague Daniel Kelin offered important feedback on the book's structure.

We acknowledge the essential research funding that has contributed to our efforts to understand how Drama-Based Pedagogy impacts students, teachers, and teaching artists. We thank the Hewitt Foundation, Victoria ISD, the Department of Education, Austin ISD and the Creative Learning Initiative, MINDPOP, the Carolyn Bartlett Rice Family Foundation, the Heartland Fine Arts Leadership Academy, the UT Longhorn Innovation Fund for Technology,

South Australia's Department of Education and Child Development, the US State Department, Arts South Australia, Creative Classroom Fund, the Rea Charitable Trust, an LRNG grant, the National Endowment for the Arts, and the University of South Australia.

Most importantly, this book would not have been possible without the efforts of the UT graduate students who worked with Drama for Schools over the past fourteen years. Their knowledge and discoveries were crucial in the evolution of the DFS program over time. We want to particularly recognize the contributions of Joshua Streeter, Briana Bower, Lauren Smith, and Stephanie Kent who offered additional editing and indexing of this book. We also thank the tireless editors of Intellect who answered many long and complicated questions with patience and warmth.

Our deepest thanks are reserved to three women whose intellectual and practical "heavy lifting" made the largest impact on the development of Drama-Based Pedagogy: DFS Director of Research, Dr. Stephanie Cawthon; former DFS Professional Learning Coordinator, Sarah Coleman; and, current DFS Professional Learning Coordinator, Lara Dossett. Friends, this book has your heart, wisdom and integrity in each of its pages.

Our final acknowledgment goes to our families.

Katie thanks Bob, and our children Ruby and Lilah. I thank you for the time away to write and work and think. Your willingness to travel across the world to support my learning adventures and your forever support gives me the strength to fail and try and wonder. I'm so glad we are on this life journey together. I'm also thankful for my parents, brothers, and extended family that continually model for me how to listen, love and become an agent for good in our collective world.

Bridget thanks Joshua, who completed his PhD during this book project and still found time to coach soccer, lead cub scouts, and care for our children. To Tivon and Kaia Pax, thank you for your curiosity, imagination, and willingness to play. I love that it's still "cool" to have mom teach drama to your classmates and friends. I look forward to reading your ideas that you capture in future books, performances, films, or wherever life takes you. Finally, I'm thankful for my mom Judy, a teacher for 39 years, who allowed me to try out my ideas over 20 years ago in her rural small school and has supported me every step of the way.

Foreword

When I first became an English teacher, I knew why I wanted to use drama. Drama was like no other pedagogy. Texts were resurrected as they came to life in voices and moving bodies, students kept asking when they could get out of their seats again, and I had known—occasionally—what flow felt like.

If this book had been on my desk, I would have felt the support I yearned for. If only I had known theoretical reasons why drama can be educational, I would have been able to explain to the principal why the young people wanted—and needed—to move and speak like Grendel, not just read lines from Beowulf sitting down. If only an array of strategies had been documented from practice, I wouldn't have been stuck with my adaptations of realistic role-play relying on my one book of theatre games. If only there had been plans to guide me, tested in the classroom, and that made sense because I understood the thinking behind them, I wouldn't have had to flounder so often not knowing how begin, how to sequence activities or when to stop.

Even after a year studying with Dorothy Heathcote, what I still needed was the guidance that Katie Dawson and Bridget Lee have synthesized in this invaluable book.

Drama-Based Pedagogy is unique. It's like three books in one that are synergistically interwoven. There are too many books out there with a serious imbalance between theory and practice, and very few strategy handbooks with a rationale for how, why and when we might choose to use particular strategies. There are too few books like this one that show how teaching must be reflective as well as active, cyclical rather than linear, and never finished but always in process. As Dawson and Lee put it succinctly, teaching is an "ongoing reiterative process of pedagogical reflexivity."

Open this book anywhere and you'll find something you might use tomorrow. Read it cover to cover as you apply ideas in your classroom—but reflect on what happened—and you'll feel like you've just completed a college course that you treasure. Read the tips and stories when you only have a few minutes to spare. Copy key pages like the planning guide or the list of strategies and you'll have invaluable daily references.

They close, as I do, with a quote from bell hooks: "the function of art is to do more than to tell it like it is—it is to imagine what is possible."

Let the imagining begin.

Brian Edmiston, Ph.D.
Professor of Drama in Education
The Ohio State University

Introduction

I was afraid of drama. What about their behavior? They didn't understand basic stuff so how is this going to help? As I was testing the waters of [drama-based pedagogy], got some more experiences, I started to think, "Ok, I can do this." Then you see something work that you did. Then you creep in a little more. The more you do it, then the more you personally love it. Then the kids are more comfortable with it. This changes you as a teacher. And maybe a few years from now, they will remember something from my history class when they are voting or teaching their kids a life lesson. They are interested in the human condition. They love stories and they love stories about people.

—Middle School History Teacher, Ohio

What makes an effective learning environment? What can teachers do to improve student engagement, increase student collaboration and participation, and support the development of critical thinking and creativity in every student? Many studies have lauded the benefits of using the arts, specifically drama, as a cross-curricular approach to improve both social-emotional and academic learning for K-12 students in a wide range of subject areas (Lee, Patall, Cawthon, & Steingut, 2015; Lee, Cawthon, & Dawson, 2013; Podlozny, 2000; Walker, Tabone & Weltsek, 2011). Part of the effectiveness of integrating the arts into other subject areas is that the arts enable learners to express their opinion, make meaning, and reflect in a variety of ways. From a mysterious paper bag used to inspire inquiry and engagement before reading, to a geometric investigation situated inside a knight's quest, to a multi-layered role-play about the ethics of nuclear energy, Drama-Based Pedagogy (DBP) offers teachers a dynamic way to help every student become more engaged in learning.

Who is this book for?

This book is for educators who work, think, train, and learn in schools and/or artistic settings and contexts. Specifically, this book supports the generalist[1] classroom teacher's understanding of DBP and its use across all areas of the curriculum. This book also supports drama/theatre[2] teachers' and teaching

artists' use of teaching and learning theory and practices to guide the design of learning experiences in DBP. This book offers language for all educators to advocate for the use of teaching and learning through the arts in a range of educational contexts. Working across the boundaries and intersections of education and drama, this book offers context examples and content-specific language from each field. To this end, the theory described in this book offers a translational space for educators and artists to better facilitate the creativity, communication, critical thinking, and collaborations that are a part of the process of doing DBP.

> *This approach allows teachers to find their practice, what brought them to this work, which is being in front of children and doing good teaching.*
>
> —Arts Education Trainer and Consultant, Washington, DC

How is this book organized?

This book is divided into three parts: (1) Why: An introduction to DBP through a brief background review of related drama and education theory and introduction to Drama-Based Pedagogy learning design; (2) What: An overview of the DBP strategy categories and detailed explanations of each strategy; and (3) How: A collection of expanded examples of DBP in practice, featuring a range of learning experiences and investigations developed by educators and artists across all years and areas of K-12 curriculum in a range of school contexts.

Throughout each section, we use education and drama/theatre theory to explain key ideas and offer practical examples from educators working in a range of educational environments. By blending education and drama theory and practice, we invite the reader to discover, remember, and ratify their own beliefs about the potential of the arts as a pedagogical tool.

How should this book be read?

This book offers and describes a wide range of drama-based pedagogical practice; as a result, readers are encouraged to engage with the content of the book based on their needs. A university student or classroom teacher new to the use of drama across all content areas might choose to read the book from beginning to end to understand the full scope of why, what, and how drama can be used for learning. A classroom teacher or teaching artist with a background in DBP might choose to read Parts I and III of the book first, and refer to Part II as a source for key strategies and ways of working in and through drama that support effective

> *The beauty of drama-based [pedagogy] is that it offers a range of possibilities.*
>
> —Teaching Artist, Texas

practice. Many of the strategies shared in Part II have origins in a range of foundational drama, improvisation, and educational texts. Our adaptations of familiar and new drama-based strategies were curated and codified over ten years of work in a range of classroom contexts; the strategies represent what has been done, as a way to inspire *what can be done* in the future.

Above all, we hope this book serves as a catalyst to incorporate creative learning across the curriculum. Educational theorist Paulo Freire reminds us that "Knowledge emerges only through invention and re-invention, through the restless, impatient, continuing, hopeful inquiry human beings pursue in the world, with the world, and with each other" (2007, p.72). In the end, we, the authors, hope this book invites our colleagues in the arts and education fields to continue to explore and design possibilities for drama to transform teaching and learning for every educator and student in every classroom.

Notes

1 We use the term "generalist" to refer to the teacher who does not teach drama/ theatre explicitly, but instead teaches any other subject or a combination of subjects.
2 We use the hybrid term drama/theatre teacher to describe a certified educator in the area of drama and theatre education. The use of the word drama rather than theatre to describe the key area of practice discussed in this book is further explored in Part I.

Part I

Why Use DBP?

Why Use DBP?

To begin, the teacher invites the kindergarten students to sit in a circle on the classroom rug. A child nudges her friend, another whispers in the ear of the person to his right. The teacher stands silently and places a large, plain paper bag in the center of the circle. The students are momentarily still.

"Can someone please describe one thing you see about the object in the center of our circle?" Many hands are raised. "It's a bag," suggests a student. "What do you see that makes you think it's a bag?" asks the teacher. "It's brown," suggests a student. "It's paper," says another. "It can hold stuff," offers a third. The teacher continues to take students' observations about the object; eventually he asks, "Based on our observations, what sort of person or character might own this bag?" The room bursts into conversation as students make connections between their understanding of bags and how different people use bags for different jobs and tasks. The teacher works to bring out as many ideas as possible.

Next, the teacher walks back to the center of the circle, picks up the bag, and holds it sideways. The teacher discovers, along with the students, a large circular whole cut through the bottom of the bag. He peers through the bottom of the bag at the students. An audible gasp is heard in the room. "Hmm…now, what if I tell you that someone cut a hole in this bag to help them solve a problem. What sort of problem can be solved by using a bag with a hole in the bottom?" Many predictions are made about who owns the bag and how it was used. Now the teacher writes on the board, "How can we overcome great challenges?"

Eventually, the teacher brings out a copy of *The Paper Bag Princess* by Robert Munch. He shares the cover of the book with his class, which features a young girl with a crown, wearing a paper bag and facing a large dragon. "What challenges might the Princess in this picture be facing? What might she do to overcome this challenge?" After the students make observations about the bag and the dragon, the teacher asks, "Show us with your body how you would feel if you

were standing in front of a large dragon only wearing a paper bag." The students freeze their bodies showing fear, bravery, and cunning. The teacher makes observations of the students' work: "I see big eyes and open mouths. I see strong arms and legs. I see hands over faces as if you are trying to hide. Okay, you can relax. So, how do we think this young girl on the cover of our book is feeling right now?" The teacher takes answers from students and invites them to build upon each other's ideas. "Thank you for your creative thinking. In our drama work today, we will explore how a young person can overcome great challenges. Let's meet the princess..."

The teacher in this example uses a simple Drama-Based Pedagogy (DBP) strategy, called *Artifact,* to introduce his students to the world of the story. He uses a scaffolded meaning-making routine to help students make connections between observation and interpretation, to extend and elaborate, and to "hook" students' interest in the topic. He also engages students into a larger collective, inquiry through imagination and story. He asks, "What sort of problem can be solved by using a bag with a hole in the bottom?" Then he asks students to embody their understanding and consider a character's point of view through a simple strategy called *Show Us*: "Show us with your body how you would feel if you were standing in front of a large dragon only wearing a paper bag." Throughout this process, the teacher facilitates the students' active meaning-making to prepare them to engage in a larger inquiry based on a children's storybook.

> *[DBP] meets the needs of the standards, but it also meets the needs of the kids in a variety of ways. I like that a lot.*
> —University Professor, Utah

Part I of this book begins with a brief overview of the foundational drama/theatre education pedagogies and practices on which DBP is based. Next, we use drama/theatre and education theory to explore how drama-based strategies support teaching for effective learning in all areas of the curriculum. We share our definition of DBP and explore three of its main characteristics of practice through the use of (1) active and dramatic approaches; (2) aesthetic, academic, and affective learning; and (3) dialogic meaning-making, focusing on the Describe–Analyze–Relate reflection process. We conclude with an introduction to DBP learning design.

Chapter 1

Origins of *Drama for Schools*' Drama-Based Pedagogy

In our practice, the term "Drama-Based Pedagogy" has emerged as a productive way to describe a specific approach that uses drama techniques to teach across the curriculum in the United States public schools. Generally, practitioners and researchers refer to theatre as work that is oriented toward a performative[1] product, whereas drama is work that is oriented toward a non-performative process or "process oriented" (see Figure 1). The intention of drama is often characterized as exploratory and reflective; it is work that springs from inquiry. Theatre's intention is often focused on the creation and reception of a product for an audience. This is not to suggest that there is a fixed dichotomy between theatre and drama. Certainly, drama-based work can move toward a production, and theatre-based work can engage in reflective practice in preparation for a performance. For this book, Drama-Based Pedagogy privileges the *process* of drama over the *product* or performance of theatre. However, the practice of theatre remains a central and necessary underpinning of the work.

Drama's process-oriented use in the classroom and across the curriculum has been described and theorized by scholars and researchers across multiple fields since the middle of the twentieth century. Recent scholarship that influences our work includes writing from areas as diverse as education, literacy, social studies, and social justice/equity (Anderson, 2012; Boal, 2002; Bolton & Heathcote, 1995; Edmiston, 2014; Edmiston & Enciso, 2002; Grady, 2000; Miller & Saxton, 2004; Neelands & Goode, 2000; Nicholson, 2011;

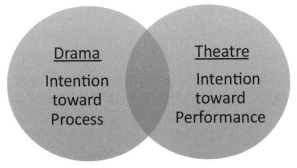

Figure 1: Relationship between drama and theatre.

Taylor, 1998; Thompson, 1999; O'Neill, 1995; Pendergrast & Saxton, 2013; van de Water, McAvoy & Hunt, 2015; Wagner, 1998). Drama and theatre work in educational contexts goes by many names including drama in education, theatre in education, applied drama, applied theatre, educational drama, dramatic inquiry, role-play, creative drama, improvisation, and Theatre of the Oppressed techniques. The strategies and methods described in this book have their roots in various lines of drama and theatre, but primarily come from the key drama teaching practices that teachers and teaching artists have developed and used in classrooms. For ten years, we have worked in partnership with teachers across the United States to pilot and structure this wide range of drama practices into a flexible, methodological toolkit that supports generalist classroom educators in their efforts to teach for effective learning across all disciplines. Our adaptation of these approaches focuses on "the integration and blurring of the boundaries between personal and social learning and academic learning; learning between subjects as much as within them" (Neelands, 2009, p. 177).

Note

1 We use the term "performative" to suggest both a "relationship to artistic performance" as well as a reference to the performance "of a social or cultural role" (http://www.oxforddictionaries.com/us/definition/american_english/performative).

Chapter 2

What Is Drama-Based Pedagogy?

What is Drama-Based Pedagogy?

> Drama-Based Pedagogy (DBP) uses *active* and *dramatic* approaches to engage students in *academic, affective* and *aesthetic* learning through *dialogic meaning-making* in all areas of the curriculum.

As discussed in the previous section, we use the term "drama-based" to describe this practice because the collection and codification of strategies presented in this book are adapted primarily from the field of drama. We use the term pedagogy in this book to focus on the theoretical or philosophical understanding of *teaching and learning* (Watkins & Mortimore, 1999). DBP offers educators tools and a structure to activate their pedagogical beliefs that align with sociocultural (Vygotsky, 1978) and critical theories of learning (Freire, 2007; hooks, 1994) in the classroom, where participants co-construct their understanding and personal identities as part of the classroom culture.

This chapter explores the theories behind three foundational concepts that are named in our DBP definition: (1) active and dramatic approaches; (2) academic, affective, and aesthetic outcomes; and (3) dialogic meaning-making. When relevant, each concept is discussed through an educational and a drama lens. By discussing both perspectives, teachers may better understand the foundational work of drama and artists may better understand the foundational work in education that informs Drama-Based Pedagogy. Key questions and sections from the example of practice at the beginning of Part I are also included as ways to illuminate and navigate the terrain.

Why does Drama-Based Pedagogy use "active and dramatic approaches"?

Drama-Based Pedagogy uses strategies that bring together the body and the mind through the art of drama/theatre. As others have noted (Edmiston, 2014), both active and dramatic approaches are necessary to fully realize the

potential of drama-based inquiry. In DBP participants actively work as an ensemble to imagine new possibilities and to embody and make meaning as a way to situate understanding within the larger narrative/story of the human condition. For example, in the DBP example of practice that began Part I, students were given the opportunity to work as an ensemble, to imagine and embody a possible story about a brown paper bag with a hole on the bottom, a princess, and a dragon. In the next section, we explore how DBP engages in *ensemble, imagination, embodiment,* and *narrative/story* as a central aspect of its active and dramatic approach to learning.

> To begin, the teacher invites the kindergarten students to sit in a circle on the classroom rug.

Ensemble: DBP offers a way to engage students as a community of learners or an ensemble. As suggested by US theatre scholar and practitioner Michael Rohd, ensemble is "at its simplest, a group of people that work together regularly. At its best, a group of people who work well together, trust one another, and depend upon each other" (2002, p. 28). Drama in education practitioner and researcher Jonathon Neelands furthers this argument when he writes that students in an ensemble "have the opportunity to struggle with the demands of becoming a self-managing, self-governing, self-regulating social group who co-create artistically and socially" (2009, p. 10). Building trust, finding the way through struggle, and learning how to co-create as a community of learners are key artistic skills in DBP that enable students to comfortably use their imagination and body within narrative/story.

There's a sense of play, now, on our whole campus.

—Fourth Grade Teacher, Texas

In educational contexts, ensemble is often described as a sense of belonging, community or relatedness among peers (Anderman, 2003; Ryan & Deci, 2000; Osterman, 2010). Educational theorist, John Dewey argued that the quality of education could be marked by "the degree in which individuals form a group," (1938, p. 65) and characterizing the group as one that acts "not on the will or desire of any one person [...] but the moving spirit of the whole group" (1938, p. 54). These theoretical concepts suggest that people have a psychological need to feel accepted and to identify with others in social situations. However, research on students' need for belonging in the school context suggests that many schools unknowingly neglect or

undermine fostering and facilitating this feeling of community (Osterman, 2009). DBP offers a way to build upon and incorporate a sense of belonging or ensemble among teachers and learners in the classroom that is vital to student success.

> The teacher peers through the bottom of the bag at the students. An audible gasp is heard in the room. "Hmm…now, what if I tell you that someone cut a hole in this bag to help them solve a problem. What sort of problem can be solved by using a bag with a hole in the bottom?"

Imagination: During DBP, students are often invited to make new meaning based on what they know about and see within a situation. Although often associated with arts, the importance of imagination was widely championed by Russian psychologist and educational scholar Lev Vygotsky, who wrote about the relationship between student culture and context within education. Vygotsky suggests that when young people use their imaginations, they live beyond themselves (Vygotsky, 2004). It is the enactment of imagination in learning—as the young person engages with a character, a story, or a concept—that builds an understanding of alternative perspectives and ideas. Using the imagination is rigorous intellectual work, which occurs when two or more ideas are combined to form new images or actions that are not already in the young person's consciousness (Vygotsky, 2004). Imagination is not simply about conjuring something out of nothing, or accessing creativity from within, but rather involves young people making sense of what is in front of them (Lee, Enciso, & Austin Theatre Alliance, 2017).

> *It gives the teacher real, tangible activities that they can do to move students to move toward higher order thinking, to get the rigor in the classroom.*
>
> —Fine Arts Director, Texas

When people imagine, they fill in the gap between what they know and what they think is possible. Rather than just working in the "as is" world within the classroom, in DBP, participants have the opportunity to bring the "as is" world into the "as if" (Heathcote & Bolton, 1995) creating and recreating and imagining and reimagining the world of the classroom and the world of the story (Edmiston, 2014). Many drama practitioners refer to imagination as a "suspension of disbelief," suggesting that we can transform a chair into a throne or a desk into a mighty ship by agreeing to imagine together in and through the story. Galvin Bolton and Dorothy Heathcote, experts in drama and education, describe imagination as "'raising the curtain' inviting the class to take a peep at

the metaphorical stage where fiction can take place" (1995, p. 27). In this fictional space in DBP, students "harness the power they have […] to direct, decide, and function," (p. 18) thus becoming more responsible and agentic in what they learn.

> The students freeze their bodies showing fear, bravery, and cunning.

Embodiment: In DBP, students often demonstrate their real or imagined viewpoints through their body. Drama is inherently an embodied practice, a production of cultural experiences and social interactions (Nicholson, 2005) that are placed and enacted in and by the body. In other words, people perform their own cultural and social identity as means to express who they are becoming. Additionally, embodiment in drama is also a way of showing what is known about concepts or ideas that may be better described through a physical representation. As drama and educational scholars Perry and Medina suggest, "The experiential body is both a representation of self (a 'text') as well as a mode of creation in progress (a 'tool')" (2011, p. 63).

Reflecting on twentieth century US classrooms, John Dewey wrote, "The limitation that was put upon outward action by the fixed arrangements of the typical traditional schoolroom, with its fixed rows of desks and […] pupils who were permitted to move only at certain fixed signals, put a great restriction upon intellectual and moral freedom," (1938, p. 61). The idea of "fixed" education is still, at times, present in the United States—desks in rows oriented toward the teacher and bells indicating a passage in time. Social activist and educational practitioner Paulo Freire suggests that without activity and social interactions, it may be easy for teachers to see students as "empty vessels" to be filled with knowledge (1970). This perpetuates the idea of a mind/body dualism and

Drama allows those boys a chance to use muscles and learn in a manner that is friendly to males and expressive in action, not just words. Look at Athabascan dancing, in which boys tell stories through kinesthetic movement. [DBP] helps connect schools to boys in a way that is expressive of their culture by allowing and praising movement to tell a story.

—Elementary Teacher, Alaska

disconnection where teachers are expected to solely address the needs of a child's mind. However, as Vygotsky notes, every child in school "always has a previous history" (1978, p. 84), including cultural experiences that can be incorporated into teaching and learning in the classroom. Through the use of embodiment, DBP opens up an opportunity for students and teachers to show who they are and demonstrate their understanding.

"So, how do we think this young girl on the cover of our book is feeling right now?" The teacher takes answers from students and invites them to build upon each other's ideas. "Thank you for your creative thinking. In our drama work today, we will explore how a young person can overcome great challenges. Let's meet the princess, now, and begin."

Narrative/Story: In DBP, the teacher supports students to work together, using their imagination and bodies to take action within a story. The skill for creating narratives has been assumed to be a natural act and to come with ease for students. In actuality, "it requires work on our part—reading it, making it, analyzing it, understanding its craft, sensing its uses, discussing it" (Bruner, 1996, p. 41). Therefore, part of what DBP offers students is a way to learn how to consider, build, analyze, pull apart, and synthesize narrative and story.

In drama, the educator often uses a *story or narrative* to structure the imaginative act for and with participants. Brian Edmiston, drama in education scholar and practitioner, reminds us that "Listening to a monologue about abstractions is not an event [or story]" (2014, p. 135). He argues instead for the importance of multiple perspectives and the immediacy of action in the exploration of narrative or story in drama. In the retelling and authoring of narratives through drama, participants can also investigate whose stories have been told and accepted as truth and then attempt to counter these stories in more inclusive ways (Nicholson, 2005). Through DBP, students and teachers have the opportunity to embody, explore, investigate, and rewrite narratives through their collective imagination.

How does Drama-Based Pedagogy support 'academic, affective and aesthetic learning'?

"Can someone please describe one thing you see about the object in the center of our circle?"

When describing the work of education, many people first think of the academic curriculum or what is taught and tested. This, however, may be overlooking the full picture of what is happening in classrooms. Our

consciousness is composed of two dimensions: intellect and affect (Vygotsky, 1978). Intellect can be thought of as the rational, logical, "academic" curriculum in the classroom. When students are asked to "describe one thing you see" in the example of practice above, they engage in the cognitive, critical thinking task of making visual observations about the object. Then students are asked to engage in a transfer between symbol systems; they analyze or make semiotic meaning of what the characteristics or "signs" found in the object mean. During this process, students are encouraged to make multiple interpretations and to synthesize how their differing meaning relates to individual or shared experience. In the example of practice, the teacher chooses to complicate students' initial meaning-making, by revealing new information that poses a new problem.

> The teacher discovers, along with the students, a large circular whole cut through the bottom of the bag. He peers through the bottom of the bag at the students. An audible gasp is heard in the room.

This moment of shared discovery and surprise between the teacher and the students demonstrates one of the many ways that the social, cultural, or *affective* curriculum is brought into the learning experience during DBP. Affective learning is often referred to as the "hidden" curriculum. Teachers are astutely aware of how cultural/social/emotional learning impacts every aspect of their daily teaching. Yet, most US public schools pay limited attention to affective learning—positioning it as a separate, brief "SEL" time, if it is even addressed at all. When teaching attempts to separate "the intellectual side of our consciousness from its affective, volitional side," the result is separation "from all the fullness of real life, from living motives, interests, and attractions of the thinking human" (Vygotsky, 1934a, p. 14). Vygotsky argues that affect and intellect/academic are mutually dependent; moreover, he suggests that *aesthetic* experiences are necessary for students to encompass and engage both the intellect (the mind) and affect (the emotions).

When you look at what do the arts bring to a campus your looking at something beyond paper/pencil, you're looking at a different way, not only to deliver instruction but also to have kids show you what they know.

—Elementary Principal, Texas

The students freeze their bodies showing fear, bravery, and cunning. The teacher makes observations of the students' work: "I see big eyes and open mouths. I see strong arms and legs. I see hands over faces as if you are trying to hide. Okay, you can relax. So, how do we think this young girl on the cover of our book is feeling right now?"

The teacher in this example invites students to make an embodied, aesthetic choice based on their observation and interpretation of the inner life of the character. He uses rich description to describe and further support their aesthetic exploration. Then he invites students to make a more complex inference about the character based on their individual and collective embodied, imaginative exploration. Within aesthetic experiences, Vygotsky incorporates three pedagogical purposes: (1) the technical understanding of how to "do" the art form, (2) the cultural understanding to make meaning and interpret the art, and (3) the ability to create that which does not exist. In other words, aesthetics incorporates the skills of art-making, meaning-making, and creating.

Contemporary philosopher and educator Maxine Greene expands upon this idea and suggests that "Aesthetics is the study of the arts: the nature of art objects, the making of art, the art experience, the relation between art and culture, the role of the perceiver, the sensual and imaginative aspects of art" (2007, p. 1). Greene aligns with Vygotsky when she argues for the centrality of learning in and through the art form—the creation of art through imagination, the interpretation of art through the senses, and the influence of culture on an individual's perception of art. In line with this, DBP teaching and learning facilitates *rigorous* aesthetic experiences, moments when intellect and affect come together to support the skills of creating, interpreting, and transferring between symbol systems of meaning.

It is important to note that although we have broken apart academic, affective, and aesthetic learning as a way to understand the types of individual skills and tasks that the US educational curriculum often defines through specific standards or proficiencies, we agree with Vygotsky and his contemporaries that working in and through aesthetics (the arts) offers a way to bring together the academic and the affect (the mind and the body/emotion). The unique power of DBP lies in its capacity to weave together all three aspects of learning throughout a sequential learning experience. The chief way this occurs is through DBP's focus on individual and collective meaning-making.

Why does Drama-Based Pedagogy focus on 'dialogic meaning-making'?

"Based on our observations, what sort of person or character might own this bag?" The room bursts into conversation as students make connections between their understanding of bags and how different people use bags for different jobs and tasks. The teacher works to bring out as many ideas as possible.

A key characteristic of Drama-Based Pedagogy is its use of *dialogic meaning-making* (Edmiston, 2014). Meaning-making describes the process by which ideas or concepts feel more finalized and steady (Aukerman, 2013). Although people are always trying to make meaning of interactions internally and individually, in DBP the facilitator strives to make dialogic meaning-making an intentional, explicit, and shared process. Dialogic meaning-making supposes that there is not one right path to the one right answer; the focus is on the process to arrive at the answer. This has been described as "sense-making," or the ideas or concepts in process that people struggle to understand or are unable to use words to describe (Aukerman, 2013).

A focus on dialogic meaning-making in DBP is based on research that suggests that the quality of interactions between and among people and their environment impact their learning. DBP works to move beyond a single question-answer verbal exchange between teacher and student, toward an interactive exchange that includes all members of the learning community listening, responding, and building upon each other's offers and ideas. Educational theory suggests that students develop language and grow through dialogue with their teachers, their peers, and their environment (Vygotsky, 1978); more interactions result in more growth (Wertsch, 1985). However, the quality of the interaction matters. If students disregard others' ideas as they express their own opinion, then the students' growth and understanding will be less substantive and nuanced than if they are listening to and building upon another's ideas as part of their own expression (Chi, 2009).

It's about using your body and about using your voice. It's about communicating; it's about working with people; it's about demonstrating knowledge and assessing knowledge through art.

—Second Grade Teacher, Texas

Additionally, recent research on language development (Kress, 2003; Leander & Bolt, 2013; New London Group, 1996) argues that people communicate in a variety of ways. Multimodal meaning-making acknowledges that individuals communicate through the spoken and written word as well as through the interactions with the environment, including drawings or visual images, gestures, facial expressions, and bodies. Including multimodal meaning-making in learning increases the opportunities for students to engage with one another and the curriculum. It encourages students to express, listen, and engage with ideas presented in multiple ways.

Through DBP, educators (who may or may not have more expertise with a concept then their participants) facilitate dialogue meaning-making in response to students' authentic questions, to deepen *everyone's* understanding and to support students individual and collective struggle for meaning through dialogue (Edmiston, 2014). In this way, educators share information or offer their expertise as a way to facilitate further discovery, rather than as a way to assert authority of knowing over their students. In DBP, multimodal, sense-making and meaning-making dialogue enables participants to co-construct a more solid, nuanced, and complex understanding of a concept or idea.

Dialogic meaning-making through DAR

Vygotsky (1978) offers the terms *zone of actual development* (ZAD), what a student can already do on his/her own, and *zone of proximal development* (ZPD), what a student can do with the assistance of or in collaboration with a teacher or a more capable peer, as a way to explain how students grow and mature. He suggests that "What a child can do with assistance today she will be able to do by herself tomorrow" (1978, p. 87) when taught through a collaborative, scaffolded approach to learning. These processes that the student can complete with help are the ones that are maturing or "becoming" in the student.

D—*Describe*
A—*Analyze*
R—*Relate*

To support participants working in their ZPD, we use the Describe, Analyze, Relate (DAR) meaning-making routine within each strategy and/or throughout a unit of inquiry. This supports critical thinking and reflection. Drama scholars Morgan and Saxton (2006) argue that "better questions" and reflection time must be embedded in and throughout each discussion for improved learning. Research suggests that teachers often ask many questions, but the questions themselves can lack depth and can be haphazard (Walsh & Sattes, 2005). Through DAR, the facilitator pays attention to how each question they offer scaffolds, or builds upon, prior ideas to support individual and collective meaning-making and understanding.

"Who can raise their hand and describe one thing you see about the object in the center of our circle?" Many hands are raised. "It's a bag," suggests a student. "What do you see that makes you think it's a bag?" asks the teacher. "It's brown," suggests a student. "It's paper," says another. "It can hold stuff," offers a third.

In DAR, participants are first invited to fully perceive and *D—Describe* what they see. This is the basis for participant inferences and predictions for the next two types of reflection.

"Based on our observations, what sort of person or character might own this bag?"

Next, participants are invited to *A—Analyze* and infer based on their observations or prior knowledge, linking their observations to interpretations. In the *Analyze* stage of DAR, it is important to explore how and why multiple interpretations might be made based on the same observation. Throughout this process, the focus is generally on participant engagement in dialogic sense-making as discussed above; the focus is on the facilitator asking questions like "What is another interpretation?" rather than posing statements Like "Yes, that's it."

"What sort of problem can be solved by using a bag with a hole in the bottom?" Many predictions are made about who owns the bag and how it was used. Now the teacher writes on the board, "How can we overcome great challenges?"

Finally, participants are invited to synthesize through collective meaning-making, to move from making "sense" to making "meaning" or understanding, as they *R—Relate* and connect their sense-making and textual/visual evidence to a larger concept, another text, and/or the human experience. Sometimes when asked to make an observation of an object or performance, participants will offer an interpretation instead. When this happens,

Describe—make observations
Analyze—make interpretations
Relate—make connections

facilitators can ask, "What do you see that makes you say that?" or simply "What makes you say that?" to encourage participants to both differentiate and make a connection between an observation and an interpretation. As participants get more comfortable with DAR and the relationship between observation and interpretation, many facilitators find it productive to toggle back and forth between *D—Describe* and *A—Analyze* during a specific line of inquiry ending with questions to *R—Relate* back to the larger goal.

In DAR, the facilitator scaffolds critical thinking skills, particularly for younger participants, to support more complex and nuanced meaning-making (Kuhn, 1999). The questions in DAR are sequenced to support a process of "data-driven decision-making" (Beasley-Rodgers-Combs, 2014). This also scaffolds learning for participants who may have varying levels of prior knowledge or understanding of a concept or skill and provides a way to make meaning together. When DAR is internalized by the participants as the way they reflect in order to make meaning together, it can be a rigorous and thoughtful questioning and reflection routine used across all areas of the curriculum.

This discussion of the three underlying concepts of DBP—*active and dramatic approaches; academic, affective, and aesthetic learning; and, dialogic meaning-making* through DAR—will guide the reader throughout this book. In the third and final chapter of Part I, we introduce a step-by-step process for creating a new DBP learning experience. This approach builds upon and extends key ideas introduced in the definition of DBP as it explains how to put the theory and pedagogy of DBP into practice.

Note

1 DAR is adapted from a popular visual art analysis approach used in aesthetic education that asks participants to Describe, Analyze, Interpret, and Reflect (Toth, 1996).

Chapter 3

Introduction to DBP Learning Design

Teaching is a means to an end. Having a clear goal helps us educators to focus our planning and guide purposeful action toward the intended results.
(Wiggins & McTighe, 2006, p. 12)

This book is based on a belief that a teacher is a knowledgeable learning designer who is best situated to determine the needs of their individual context. US educators Grant Wiggins and Jay McTighe (2006) further this argument in their popular constructivist curriculum and lesson planning approach called "backwards design." This approach invites educators to reflect on "what students need to know" and "big idea" teaching goals as they construct an "essential question" to drive the larger inquiry. It also encourages teachers to use key indicators and evidence that students are "getting it"—making progress towards the identified learning goals—within their teaching and learning design. In DBP planning, we build upon Wiggins and McTighe's structure and offer important adaptations based on the unique characteristics of the arts.

Define it!
***Backwards Design** is a curriculum planning method that starts with the destination first and then focuses on the how to get there—or the road map.*

—Wiggins and McTighe, 2006

We begin by situating Drama-Based Pedagogy in the US educational context. Specifically, as shown in Figure 2, we acknowledge how the school, the teacher, and the individual and collective learners each bring an interrelated set of assets, needs, and intentions that can help determine the most valuable and relevant content for students.

The school: In the United States, individual schools are shaped by outside factors including the school district, the state and national government, and the textbook and standardized testing companies; each factor provides information to teachers about what students need to know. The school is an extension of the larger school system context, which is located within a city, and is regulated by and held accountable to explicit state and federal laws that mandate what is taught to students, often expressed as state or national curriculum standards[1].

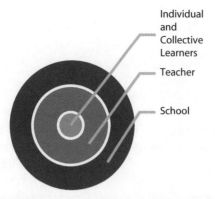

Figure 2: Stakeholders in the US educational system.

The teacher: Each teacher and/or teaching artist working in a school has a unique set of personal characteristics—identity markers, educational training, and life experiences—that informs why and how they teach. Either implicitly or explicitly, these personal characteristics inform teaching and learning design decisions.

The individual and collective learners: Each classroom is made up of individual students whose unique identities, life experiences, and interests collectively shape and inform how, what, and why they learn. The social life and systems of the classroom significantly influence student learning (Moll, 1990); therefore, it is productive to view student and classroom experiences and culture as *part* of the process of learning rather than as a *separate* act.

To acknowledge and engage with the needs of this interrelated group of stakeholders, we have structured a flexible, multi-step planning process to use as a guide in the construction and design of a DBP learning experience. We start our planning process with reflective questions that move between each of the stated stakeholder intentions (including *the individual and collective learner* and *the teacher*) in an effort to offer equal emphasis to the needs of the school, teacher, and students.

DBP Learning Design: Step One
CONSIDER STAKEHOLDER INTENTION

In DBP learning design, *the teacher* considers *the school's* intentions (the given curriculum) through the complex identities and needs of students *(individual*

and collective learners) as well as his/her own interests. The teacher asks the following:

Who are the students?
This invites the teacher to consider the number of participants and how their individual and collective backgrounds might inform specific teaching choices. The teacher also considers the level of trust and familiarity there is between the participants and the facilitator, because elements of DBP require a level of physical and emotional risk-taking.

What is the main curricular topic for this learning experience?
This invites the teacher to consider the central content area and/or goal for learning. This topic may be determined by general skills (collaboration and critical thinking) and/or the given curriculum (persuasive writing, ecosystems, or integers).

What excites me the most about exploring this topic with DBP?
This invites the teacher to consider their personal values and self-efficacy with the topic and/or DBP. The teacher is an active agent in the teaching/learning process; what do they also want to try, to discover, or to learn?

DBP Learning Design: Step Two
IDENTIFY WHAT STUDENTS NEED TO KNOW

Once all stakeholder intentions are identified, the teacher narrows her focus to specific goals or standards to explore, use, and/or master through the larger DBP plan. During this process, it is productive to keep in mind what types of knowledge all stakeholders feel is worth being familiar with in the given and emergent[2] academic and social curricula related to the topic (Edmiston, 2014; Strike & Posner, 1992 Wiggins & McTighe, 2006). The teacher asks the following:

Define it!
A Big Idea, according to Wiggins and McTighe, "is a concept, theme, or issue that gives meaning and connection to discrete facts and skills."

—Wiggins and McTighe, 2006, p. 5

What are the big idea learning areas or content standards that relate to this topic?

What are the facts and concepts students should know, and the strategies, processes, and skills they should understand how to use based on the task requirements?

33

This might include aesthetic, academic, and affective skills or standards such as inferencing, non-linguistic representation, steps in the water cycle, the causes of World War II, how to solve for equivalent fractions, collaboration, or perspective-taking.

Once the standards and learning areas have been identified, the teacher considers where individual and collective learners are in relationship to their understanding and mastery of the selected content. A key way constructivist educators think about the learning cycles comes from the 5(E) instructional model (Bybee, et. al, 2006), which adapt here for our learning design approach.

Where are the learners in the instructional cycle? Within each teaching and learning cycle, teachers scaffold students' learning in response to their current understanding of a concept or skill (Dewey, 1938; Bruner, 1996; Vygotsky, 1978). It is important, then, to determine *where* the learners are in this learning cycle as part of effective DBP design:
Do participants have a limited understanding of, or experience with the concept, skill, or procedure? Then, the goal is to "introduce."
Do participants have an interest in or need to have more information or depth about the concept, skill, or procedure? Then, the goal is to "teach."
Has the concept, skill, or procedure been taught before or multiple times, and thus participants need to practice applying the information or to demonstrate their understanding? Then, the goal is to "extend" or to "assess."
Do participants need to review the concept, skill, or procedure for a summative formal assessment (quiz or test)? Then, the goal is to "review."

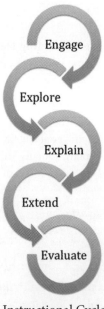

In any given classroom, a teacher may need to differentiate learning for students such that they are pursuing multiple goals through a learning experience. Of important note, when the goal of learning falls further from the beginning of the instructional cycle, for example, the goal of extending learning, participants may need a quick re-introduction of the topic before the facilitator is able to begin an investigation focused on extending learning. Although the various points within the instructional cycle (e.g., "introduce" or "review") are

Instructional Cycle
Figure 3: 5(E) DBP Learning Cycle.

articulated individually above, each step is one part of a larger cycle of learning for participants as illustrated in Figure 3.

DBP Learning Design: Step Three
DEFINE RELEVANT STUDENT CONNECTIONS

Facilitators identify the *big ideas* (see Step Two) and the essential questions (EQ) that anchor DBP learning with students. This anchor guides students to "enduring understandings" that they remember—perhaps long after they have forgotten the explicit details within the arc of the exploration (Wiggins & McTighe, 2006). In direct relationship to the *big idea* for the DBP plan, teachers develop essential questions that will be relevant for students, encourage dialogue among students, and provide a touchstone to enter the inquiry from multiple contexts.

What is the essential question for this plan?

Define it!
*An **Essential Question** is an important question that recurs throughout one's life. They are questions that help us learn about learning.*

—Wiggins and McTighe, 2006

To create an effective essential question for drama-based teaching and learning, teachers craft questions that are accessible, open-ended, and applicable. The following considerations can guide that process:

- *Accessible:* What are the events, theme, conflict, or people in the curricular content that are most relevant, familiar, and accessible to participants?
- *Open-ended:* How can the question be phrased to encourage multiple viewpoints and avoid a single "right" answer?
- *Applicable:* How can the question be crafted to address other relevant contexts in the curriculum, participants' lives, or the human condition?

For example, a teaching artist working in a third grade classroom explores the story of Rumpelstiltskin during a folktale unit. He identifies grade-appropriate reading standards and selects an *accessible big idea* from the story—power—as a developmentally relevant topic for third graders who often focus on the negotiation of their peer relationships and their world. He drafts an EQ based on how characters in the story use power to influence each other: "Who holds the power: Rumpelstiltskin or the Queen?" He chooses this question because it

can be answered differently depending on the timeline of the narrative; it also poses the opportunity for students to examine the story from different characters' perspectives and engages them in a critical thinking about what is power. Next, he considers the applicability of his question. The teaching artist wants to use an EQ as part of a larger thematic unit across the nine-week term that looks at different ways to effectively communicate ideas. The teaching artist decides to broaden his question for the unit to allow for connections across the curriculum, to participants' lives, and to the human condition. "How do words hold power over people?" This final EQ is accessible, open-ended, and applicable—to give all students an entry and anchor into the DBP work.

Once the EQ has been constructed, the teaching artist considers where or how individuals struggle with decisions related to the question. As discussed in Part I, drama involves conflict. Identifying a tension or problem within an event or events creates a reason or need to explore the *big idea* and is an important step of the DBP learning design process. The EQ guides the facilitator in making decisions about how to pursue the teaching and learning in the unit.

What are the key events related to the EQ that will promote dialogue?

If there is a given story from a literary or informational text, the teacher *chooses key events from the story* that support exploration of the EQ. Generally, story events follow a basic structure: someone has a problem, they face obstacles, and they explore possible solutions until they find a resolution. For example, in *Rumplestiltskin,* key events that connect to the question of "how do words hold power over others" could include the following:

- Problem: The Miller tells the King his daughter can spin straw into gold. The daughter is thrown in a room with straw and told she will be killed overnight if she can't spin the straw into gold.
- Obstacle: Rumplestiltskin helps the daughter but makes her promise to give him her first-born child in exchange for the help.
- Possible Solution: Later, Rumplestiltskin returns to get the now Queen's child. The Queen can save her child if she finds out his name.
- Resolution: The Queen finds out the name and saves her child. Rumplestiltskin leaves angrily.

If there are standards and/or content but no story, *key events need to be imagined and constructed* that engage with the EQ. Generally, imagined events follow the same basic story structure: problem, obstacles, possible solution, and resolution. For example, a teacher is about to begin a unit with the EQ: "How can our school be made accessible to everyone?" In math, she wants

to facilitate a unit on the area of regular 2-D polygons, circles, and composite figures with a focus on the Pythagorean Theorem. Based on the EQ, she imagines a scenario about accessibility and math related to ramps versus stairs at their school. Next, she lists key events that could propel students to "need to know" how to calculate areas of triangles using the Pythagorean theorem:

- An old building next door to a school has just been donated to house a new recording studio for students. However, the building can only be accessed through two different staircases. Individuals with physical disabilities may have difficulty entering the building. (problem)
- The school has only a small amount of money to remedy the situation and will have to return the donated building if it is not made accessible to every person. (obstacle)
- Students, thinking like civil engineers, need to use the Pythagorean Theorem to design ramps to fit over the staircases. They select materials to make the ramps and figure out total costs for purchasing the materials from a local hardware store. (possible solutions)
- Students present designs to each other and engage in a larger dialogue about the American Disability Act. (resolution)

DBP Planning Process: Step Four
CHOOSE STRATEGIES AND PERFORMANCE-BASED ASSESSMENT

Once the topic, the key learning areas/standards, the *big idea* and EQ, and the key events are identified, the facilitator needs to select specific strategies which could be used to structure and scaffold participant learning throughout the DBP plan. At this point, teachers need to consider how students will demonstrate what they know and understand at each point in the teaching and learning process, as well as identify which of the strategies can be used as an informal, performance-based assessment and which might be used as a summative (or final) assessment of student knowledge, skill, or understanding.

Which strategies might productively explore and rehearse key learning areas?

It is often useful to focus on the main DBP strategy or primary learning first and then identify which key strategy might productively explore and rehearse that idea. For example, a tenth grade biology teacher wants to address the *big idea* of biodiversity in rainforests. She has an ongoing unit focusing on the

EQ: How do our current needs, wants, and actions affect our future needs, wants, and actions? The teacher selects a Public Service Announcement (**PSA**) dramatic dilemma as a main DBP strategy to extend students' understanding of biodiversity and sustainable logging. Next, she lists which strategies could come before this main strategy to prepare participants to successfully participate. First, she chooses *Poster Dialogue* to assess students' collective current conceptions of biodiversity in a rainforest habitat. Next, she wants to prepare students to speak from a specific perspective in-role, so she decides to use *Guided Imagery* and to share a first-hand account from the sustainable logging industry as well as a biologist's report of biodiversity health in areas of sustainable logging. She realizes that students might need to work collectively to make meaning of the biologist's report. The teacher decides to use a *Role on the Wall* strategy after the *Guided Imagery*, so the group can map out the larger arguments being presented in the informational text.

At this point, she feels that students are ready to take the arguments presented and to create and share PSAs that present arguments from multiple perspectives of sustainable logging in rainforests. Finally, to assess individual meaning-making and understanding at the end of the learning experience, the teacher decides to invite students to pick a character who wants to respond to the arguments presented in the PSAs. This final, individual performance-based assessment will use *Writing in Role* and will ask students to write an individual op-ed piece for an imaginary paper from one of three viewpoints: (1) a biologist, (2) a corporate head within the logging industry, or (3) a community member living near the rainforest. See Figure 4 below to consider the relationship between DBP strategies and assessment.

Which strategies might be used as a performance-based assessment of student knowledge, skill, or understanding?

In the biodiversity example, the teacher uses *Poster Dialogue* sheets to assess students' prior meaning-making. She can also create a rubric to assess media literacy including language and rhetoric, as well the technical aspects of the students' work on the PSA. In addition, the teacher can assess perspective-taking, persuasive writing, and use of textual evidence in the students' individual *Writing in Role* op-ed assignments.

Throughout DBP teaching and learning, facilitators can heighten moments of informal assessment as needed. Each individual strategy often begins with a

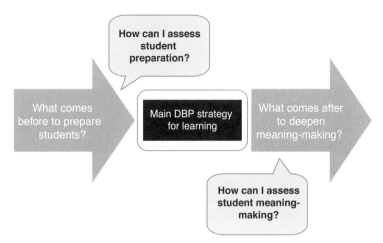

Figure 4: Assessing through DBP.

simple moment of meaning-making and ends with extended time spent on individual and the collective meaning-making. Then, each full DBP plan—with multiple strategies linked together—also begins and ends with extended meaning-making that can include formative and summative assessment of both individual and collective understanding.

DBP's unique characteristics provide educators nuanced and authentic assessment tasks to measure students' understanding and learning progress. Where typical non-arts-based assessment methods might include a written essay, short-answer quiz, lab project, or an oral presentation of material, drama-based approaches enable educators to access a wide range of informal, dialogic, performance-based, and individual self-assessments (Edmiston, 2014).

All of these assessment choices are an extension of what the teacher values and expects of his or her students' enduring understandings (Edmiston, 2014). If a teacher values dialogue, then she needs to assess students' abilities to engage in dialogue. If a teacher values applying the understanding of a topic, then they need to assess students' ability to apply understanding. In most US schools, mandated state-wide assessments document students' academic learning and ignore students' twenty-first century skills like collaboration and creativity. Drama-based pedagogies allow opportunities to assess learning in multiple areas through strategies that make individual and collective meaning-making visible.

DBP Planning Process: Step Five
CONSTRUCT A DESIGN THAT ENGAGES, EXPLORES, AND REFLECTS

Once the intended strategies to assess individual and collective learning have been identified, backwards design invites the facilitator to structure the full facilitation plan in detail. Many approaches to using drama in the classroom have been articulated by a number of excellent books (Bowell and Heap, 2013; Edminston, 2014; Miller & Saxton, 2004; Neelands & Goode, 2000; and O'Neill, 1995, among many others); all of which have shaped our approach. However, the lesson planning structure used in this book is primarily based on the work of Sharon Grady (2000), an early mentor to both authors and the original program architect of the Drama for Schools' professional learning model on which DBP is based. Grady's approach to the design of a "structured learning opportunity that unfolds over time" divides the body of the lesson into multiple key components, which we have adapted for this book:

DAR

Engage—This anticipatory strategy is used *to hook* students into the *big idea*; *to connect* their lived experience to the larger question or story; *to build ensemble and prepare* students for drama work; and/or *to assess* their current understanding. This may include an on-your-feet DBP strategy or a seated dialogue focused on the *big idea* or *EQ*, or a simple sharing of a relevant story/source material or a moment of pre-reflection or pre-flection on previous work and understanding.

> **Define it!**
> *Pre-flection* is the act *of forming and sharing thoughts to set intention or to gather and assess prior knowledge from participants at the beginning of a learning experience.*

Meat of lesson

Explore—This main section of the DBP plan uses multimodal approaches *to identify and develop* the story, source material, concepts, or skills through *practice and application* within an authentic task or situation. Often, a variety of strategies are linked together, through moments of individual and collective meaning-making, *to scaffold* the complexity of participant thinking and skills. This usually includes a combination of various DBP strategies that build upon the *big idea* and deepen the meaning-making and complexities in response to the *EQ*.

2 strategies

Reflect—This essential thinking routine occurs throughout the structured inquiry as participants are invited to *pre-flect* on the work they are going to do

and *reflect-in* each action taken. However, the most substantive and essential reflection happens at the end of the inquiry when participants *reflect-on* the full scope of individual and collective action and meaning-making in relationship to the *big idea* and *EQ*. This usually includes DBP strategies specifically designed to concretize meaning-making and some form of final, facilitator-lead meaning-making dialogue with the group. (Grady, 2000, pp. 157–158)

Our visual depiction of Grady's approach (Figure 5) uses shaded directional arrows to connote *Engage, Explore, Reflect* sections; unique shapes for each DBP strategy category; bold outlines to identify key strategies; and dotted outlines to indicate assessment strategies. Categories of strategies have also been placed in the design structure to suggest where a category of strategy is often found in the sequence of strategies within an inquiry (e.g., *Activating Dialogue* as the engagement strategy).

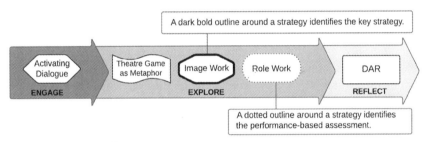

Figure 5: DBP learning design structure.

However, there is no fixed placement within a learning design plan for where a certain type of strategy *must* go. In general, *Activating Dialogue* and *Theatre Game as Metaphor* are used early in the learning process, and *Image Work* and *Role Work* are used later, but not always.

Final thoughts

When a facilitator designs a new DBP plan for the classroom, they must balance and consider a tremendous amount of information: *What is the topic's big idea? Which essential question will incite a larger, enduring understanding for participants? Which strategies will support participants' academic affective, and aesthetic learning within the inquiry? Which strategies will give participants practice using new knowledge to gain the concepts and skills they need and want to learn?* These questions and this process can feel overwhelming at best.

However, a teacher using DBP is not designing individual discrete moments of learning, but rather designing ways of working in their classroom that can be transferred across subjects, across settings, across problems, and across tasks. Wiggins & McTighe remind us the following:

> The ability to transfer our knowledge and skill effectively involves the capacity to take what we know and use it creatively, flexibly, fluently, in different settings or problems, on our own. Transferability is not mere plugging in of previously learned knowledge and skill. Understanding is about 'going beyond the information given.' We can create new knowledge and arrive at further understandings if we have learned with understanding some key ideas and strategies.
>
> (2006, p. 40)

To develop this classroom culture and way of working, the facilitator must create opportunities for participants to make their thinking and learning visible in every step of a lesson. One way to do this in a multiple strategy structure is to remember that each discrete strategy functions—in a limited way—within its own individual arc of engage, explore, and reflect. Although only indicated at the end of Figure 5, DAR can be used at various points within each drama-based strategy or unit of inquiry. At the beginning, DAR can be used to ask a group to reflect on what they see when they look at an object or image, or what they think of when they read/see a word or phrase, to introduce a key theme or concept or inquiry. DAR can also be used during an activity when a facilitator asks a group to reflect on their choices and actions in order to make recommendations for collective improvement. Finally, DAR is essential at the end of each strategy as a means to reflect on what happened within the activity, to consider why it happened, and how what happened relates to larger questions or actions that can be taken in the future or to other areas of the curriculum.

When educators teach curriculum in disconnected silos, they make it more challenging for students to make connections to other areas of the curriculum and to their lives, when, in fact, many aspects of learning (e.g., inferencing, analysis, synthesis, categorization, model making) are used within multiple areas of the curriculum. Similarly, the DBP strategies, which are introduced in detail in Part II of this book, can be used within multiple areas of the curriculum. Research has also shown that students have a richer, deeper understanding when concepts are interrelated to one another and to their experiences (Webb & Mastergeorge, 2003; Yager & Akcay, 2008). The beginning labor of designing an inquiry through DBP can be extensive; however, this groundwork for the processes and culture of using DBP in the

classroom provides the foundation for and transfers to every future DBP learning experience.

Our experience aligns with the research that suggests that teachers do not have a single prescriptive approach or formula for how and when they link strategies together to teach and explore a topic with students (Posner, 1995). However, we have found that certain sequences or linking together of strategies tend to better support teachers' abilities to successfully facilitate the academic/cognitive, aesthetic, and affective tasks required. This is particularly true when using DBP. Much of this has to do with the drama form and the way that each explicit strategy supports a different type of critical thinking, rigor, and understanding. Detailed examples of effective DBP strategy sequences from a variety of contexts and content areas are further explored in Part III.

Part I of this book has positioned DBP as an intentional pedagogical approach that applies elements of drama and theatre practice—drama in education, creative drama, and Theatre of Oppressed techniques—to teaching and learning in all subject areas. We have argued that DBP is effective in all areas of the curriculum, in part, because it uses and supports (1) active and dramatic approaches to teaching and learning; (2) academic, affective, and aesthetic learning; and (3) dialogic meaning-making. Part I also introduced DBP learning design, a five-step approach to building a drama-based plan for the classroom context. Part II will introduce the DBP strategies through an organizational framework; detailed introduction, direction, and examples of curricular application for each strategy; and tips for effective facilitation.

Notes

1 In the United States, federal, state, or local mandates often require that students pass benchmark tests in certain grades in order to move forward.

2 "Given" refers to the state or national standards in arts and non-arts curricular; "emergent" refers to the topics that emerge within an inquiry based on students' questions, concerns, and interests.

Part II

What Is DBP?

Image 1: DBP board.

After exploring Drama-Based Pedagogy (DBP) strategies in her classroom for a month, a teacher asked her students to help her create a DBP reflection board for their classroom. Together, they posted strategies that they used in class and brief reflections about their experience with DBP. Over the next few months, she used the wall as a resource tool; students were invited to select a strategy from the wall to use as part of their daily learning and inquiry.

The teacher in this example asked her students to participate in both the reflection on and application of drama as a learning tool in the classroom. She understood that when students understand the how, why, and when of their learning process, they become active and responsible agents for their own learning rather than simple "receivers" of information. As argued in Part I of this book, learning is not a passive endeavor. Learning is the result of active individual and collective thinking; it is based on a sense- and meaning-making process. Part II of this book offers strategies that promote dialogue as a means of learning and make connections to students' life worlds; they improve student engagement, disposition, and academic achievement in all areas of the curriculum, including the arts. We begin with an introduction to the larger categories of DBP and the organizational structure of the strategy sections.

The categories of DBP

As discussed in Part I of this book, our use of DBP in the US educational system has evolved in name and approach. Over time, we developed four main categories to describe how teachers most often apply Drama-Based Pedagogy and practice in a variety of educational settings. In practice, these strategies are generally linked together as part of a larger inquiry as detailed in the learning design section of Part I. However, we found it productive to introduce individual DBP strategies first as a way to better understand how each type of strategy can function within a learning experience. The DBP strategy categories include (1) *Activating Dialogue*, (2) *Theatre Game as Metaphor*, (3) *Image Work*, and (4) *Role Work*. The category titles describe drama/theatre practices (image, role, and games) as well as educational goals (dialogue and metaphor). The strategies are often taught and applied in the same hierarchical sequence that they are listed in Figure 6. This does not suggest a hierarchical value to the strategies, but rather acknowledges the benefit of building the DBP knowledge and skills of the facilitator and participants in implementation. Effective *Role Work* often uses a combination of the skills and meaning-making processes found in the *Activating Dialogue*, *Theatre Game as Metaphor*, and *Image Work* strategies; in other words, a facilitator might begin with strategies that explore how to safely use dialogue as means of learning before leading a complicated role-play scenario.

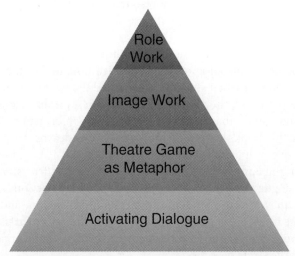

Figure 6: DBP categories.

	Strategies	What is it?	Why use it?	When is it used?
ACTIVATING DIALOGUE	*Embodied Dialogue* *Text/Visual Dialogue* *Rituals to Open and Close*	Strategies that use verbal, written, and/or embodied dialogue to connect participants' prior knowledge and lived experience to a larger inquiry	To make thinking visible, to engage with multiple perspectives about a topic, and to assess and understand how and why we author meaning	Used to generate interest, to set intention, to synthesize a new understanding, and to offer closure through ritual
THEATRE GAME AS METAPHOR	*Ensemble, Energy, and Focus* *Setting, Story, and Character* *Power and Problem-Solving*	Strategies that use group games to develop mind/body awareness, rehearse pro-social skills, and explore elements of story, e.g., character, setting, and conflict	To develop ensemble; to create concrete representations of an abstract idea, process, or relationship; and to rehearse key drama skills	Used to rehearse ways to work toward a collective goal; can also be used to represent and explore a relationship, story, or conflict, or to practice problem-solving
IMAGE WORK	*Object as Image* *Body as Image* *Images in Action*	Strategies that use an object or the body to represent an idea, feeling, character, relationship, force, setting, or situation	To develop multi-modal skills in expression, inferencing and meaning-making; to explore multiple perspectives; and to create a complex understanding of a relationship	Used to explore the difference between observation and interpretation of an aesthetic form, and to physically express an opinion or understanding of an idea, character, or concept
ROLE WORK	*Creating Context and Subtext* *Performing Character* *Performing Conflict & Story*	Strategies that invite participants to think, dialogue, problem-solve, and act either as themselves or as someone else in response to a set of imagined circumstances	To engage in story and rehearse inferential and dramaturgical skills, to explore character choice and motivation, and to embody and apply new knowledge and understanding	Used to explore conflict, theme, character, and the human condition within a real or imagined story or moment in time

Table 1: Categories of DBP strategies.

To support facilitators' ability to understand and use all levels of DBP strategies, we offer broad conceptual and theorized definitions for each category as detailed in Table 1. The subheadings next to each main category serve to group the larger collection of strategies into tasks that emphasize pedagogical goals in both drama and general education. Next, we offer a broad definition of each strategy category based on the participant/ learner's experience in the "What is it?" column. The "Why use it?" column describes the value of the learning opportunities associated with the strategies. Finally, the "When is it used?" column notes when teachers and teaching artists most frequently apply strategies within the instructional cycle.

The organization of part II

Part II of this book includes a detailed exploration of each of the four large categories, divided into their sub-categories and individual strategies. For example, Activating Dialogue is divided into *Rituals to Begin and End*, *Text-Based/Visual Dialogue* and *Embodied Dialogue*. These sub-categories also include a brief introduction to the guiding questions "What is it?," "Why use it?," and "When and where is it used?" The sub-sections also include a "How do you use it?" section, which includes additional questions and tips for the facilitators to consider as they design their DBP inquiry. These sections are called *participants' knowledge and skills* and *facilitator context*. Our goal in these sections is to highlight key choices and questions successful facilitators ask when designing a DBP lesson inquiry, with an emphasis on factors such as *group size, space*, and *time*. Each group of sub-categories also has one *Spotlight on...* section. This is an example of practice by a teacher, which details the teacher's work to adapt and use a strategy within a specific context. All *Spotlight on...* sections are based on amalgamations of actual teachers who have participated in the Drama for Schools program.

Also located in the sub-category is the complete collection of individual strategy descriptions, as shown below in Figure 7.

Source: Name of individual(s) who published or often associated with the strategy

Number of players: Minimum number of players needed

Space: Amount of space generally needed

What is it and why use it? A brief explanation of the strategy

Directions: Clear step-by-step instructions about how to facilitate the strategy

Reflection: Example questions to use to reflect on thinking and learning

Possible side-coaching: Example statements and questions commonly used within the strategy to improve participation

Possible variations/applications: Examples of how teachers often adapt or apply strategy within their context

Figure 7: Strategy page outline.

Each individual strategy description includes information on the *Source* of the material. The origins of many of the DBP strategies can be cited to a wide-range of texts and practitioners. Our version of each strategy was developed specifically with teachers, teaching artists, and students in a range of learning contexts. When relevant, we list a scholar and/or practitioner who informed our initial understanding of the strategy. We also include generalized thoughts on *Numbers of Players* and the *Space* requirements needed for each strategy. We also offer succinct *Directions* for how to facilitate the strategy, with specific language to support student success within the facilitation. Language for reflective practice is explicitly noted throughout and specifically detailed at the end of the strategy description in a separate *Reflection* section. Information regarding *Possible Variations/Applications* of the strategy by teachers and teaching artists into their specific subject areas—math, science, social studies, writing, reading, foreign language—is also listed at the bottom of each page.

Final thoughts

In our ten-year journey to develop DBP through our professional learning model, we have found that teachers and teaching artists need to experience DBP as a participant—individually, in their own bodies, and as a member of a group—to understand how to facilitate the work. During our trainings, after each strategy, we make meaning of our experience as participants first, so we can more effectively transfer, apply, and/or adapt the strategy to meet our individual instructional needs. First, we ask the following:

- *What did you notice about yourself and the group in this strategy?*
- *What did you discover?*

- *How might this process relate to a larger question about our world or the human condition?*

Then, we ask the following:

- *What did we do in this strategy?*
- *Why did we do this strategy?*
- *Where in our curriculum might we want to engage in this type of learning?*

This same idea applies to the use of DBP by the teachers and teaching artists when they return to their classrooms and their students. Effective DBP facilitators invite participants to reflect on their experiences before, during, and after a strategy to heighten the awareness of self, the community, and the curriculum. Reflective questions also support transfer and application of the embodied experience to the teaching and learning objective/s for learners. Like the example of students who created a reflective bulletin board about how and why they use DBP in their learning, we have found that DBP is most effective when individual and collective reflection is connected to specific action and choices. John Dewey reminds us that "[t]here is no such thing as genuine knowledge and fruitful understanding except as offspring of doing" (1916, p. 321). This curation of drama-based pedagogical strategies was developed through an ongoing iterative process of reflection in a range of contexts. It is our hope that DBP will continue to evolve, improve, and grow as educators and artists around the globe engage in the larger act of "doing" drama, across all areas of the curriculum.

DBP Strategies

4. **Activating Dialogue**
 A. RITUALS TO BEGIN AND END
 i. Check-in
 ii. Cover the Space
 iii. It Made Me Think
 iv. Perspective Web
 v. Recipe for Me
 vi. Thumbs
 vii. Touchstones
 viii. Words of Wisdom
 B. TEXT-BASED/VISUAL DIALOGUE
 i. Alphabet Relay
 ii. Group Mural
 iii. Identity Iceberg
 iv. Poster Dialogue
 v. Punctuation to Punctuation (P2P)
 vi. Snowball
 vii. Visual Mapping
 C. EMBODIED DIALOGUE
 i. Constellations
 ii. Cross the Room/Stand Up if
 iii. Exploding Atom
 iv. Four Corners
 v. Vote with Your Feet
 vi. Vote from Your Seat

5. **Theatre Game as Metaphor**
 D. ENSEMBLE, ENERGY, AND FOCUS
 i. Buzz
 ii. Circle Dash
 iii. Crumbling
 iv. Data Processing
 v. Fruit Bowl
 vi. Group Counting
 vii. Group String Shapes
 viii. Heads Up
 ix. Heartbeat Ball
 x. Invisible Balls
 xi. Islands
 xii. Jump
 xiii. People Shelter Storm
 xiv. People to People
 xv. Round of Applause
 xvi. Stop and Go and Jump
 xvii. Telephone
 xviii. Truth about Me
 xix. Three Ball Toss
 xx. Two by Three by Bradford
 xxi. Zip, Zap, Zop
 E. SETTING, STORY, AND CHARACTER
 i. Everybody Do
 ii. Gift Giving
 iii. Give and Take
 iv. In the Manner of the Adverb
 v. New York, New York
 vi. One-Word Storytelling
 vii. This is a/is Not a
 viii. Story of my Name
 F. CONFLICT, POWER, AND PROBLEM-SOLVING
 i. Columbian Hypnosis
 ii. Defender
 iii. Keeper of the Keys
 iv. Knots
 v. Mirrors
 vi. Obstacle Course
 vii. Three Changes
 viii. Trust Walk
 ix. Who Started the Motion?

6. **Image Work**

G. OBJECT AS IMAGE
 i. 3-D Models
 ii. Artifacts
 iii. Object of Metaphor
 iv. The Great Game of Power

H. BODY AS IMAGE
 i. Frozen Picture
 ii. Sculptor/Clay
 iii. Show Us
 iv. Statues
 v. This Setting Needs

I. IMAGES IN ACTION
 i. Bippety, Bippety, Bop
 ii. Complete the Image
 iii. Connecting Images
 iv. Machine
 v. Mapping Geographies of Home
 vi. Real and Ideal Images
 vii. What's the Story?

7. **Role Work**

J. CREATING CONTEXT AND SUBTEXT
 i. Guided Imagery
 ii. Objects of Character
 iii. Role on the Wall
 iv. Soundscapes
 v. Time Travel Machine
 vi. Tour of a Space
 vii. Visual Dramaturgy

K. PERFORMING CHARACTER
 i. Conscience Alley
 ii. Hot Seating
 iii. Narrative Pantomime
 iv. Paired/Group Improvisation
 v. Voices in the Head
 vi. Writing in Role

L. PERFORMING WITHIN A DRAMATIC DILEMMA
 i. Advertising/Design Pitch
 ii. Exploration/Adventure
 iii. Public Service Announcement
 iv. Talk Show/Press Conference
 v. Town Hall Meeting
 vi. Trial/Courtroom

Chapter 4

Activating Dialogue

Teacher: *To conclude our investigation of the impact of weathering and erosion on Stony Peak Mountain, we will build a* Perspective Web. *Let's hear from each character one solution for the issues faced by Stony Peak Village. When you get the string, please share your character's opinion, then hold on to one end of the string and throw the string to another person; then, they will then share their opinion. Afterwards, be ready to discuss any connections and differences you hear in our arguments.*

Image 2: A group makes a Perspective Web

What is it? Activating Dialogue strategies use verbal, written, and/or physical or embodied dialogue to connect students' prior knowledge and lived experience to a larger inquiry in the curriculum.

Why use it? Activating Dialogue strategies encourage students to make visible a range of perspectives so that we are able to author "understanding about what we *value* in one another, ourselves, our communities, and our world" (Edmiston, 2014, p. 306). In these strategies, students

- Make thinking visible: These strategies create an opportunity to use and practice multimodal (verbal, visual, textual, and embodied) ways of knowing and expressing meaning.
- Engage with multiple perspectives: These strategies enable students to engage with multiple responses to a prompt to deepen, complicate, and ground student understanding.
- Author meaning: These strategies offer teachers a way to assess sense-making and meaning-making among students at various points in the instructional cycle.

When and where is it used? Activating Dialogue strategies are often used to generate interest in a topic at the beginning of a learning experience or to synthesize a new understanding at the end of an instructional cycle. The choice about when and where to use Activating Dialogue strategies depends upon what will best support student engagement and learning. If the goal is to set a collective intention, synthesize understanding, or provide closure for a curricular unit, then *Rituals to Open and Close* provide a range of useful approaches. These strategies can also be repeated each day so that students feel comfortable with the procedure. If written expression offers students a better entry point, then a teacher can choose *Text-Based/Visual Dialogue* strategies to involve every student in the meaning-making process. Other times within the learning process, students benefit from a connection between their interior lives and their exterior actions, or they need to compare and consider multiple interpretations of a single topic or question. In these instances, an *Embodied Dialogue* strategy offers a way to engage kinesthetically and verbally in individual and collective meaning-making.

Final thoughts

The strategies in this section are organized into three main categories: *Rituals to Begin and End, Text-Based/Visual Dialogue* and *Embodied Dialogue*. These strategies support a learning culture of individual and shared meaning-making, which values students' diverse backgrounds and viewpoints on a wide variety of topics. This can be a significant change from the transactional nature of US public education, which often requires students to provide one "right" answer to a teacher's question. For this reason, we often recommend that teachers use an ACTIVATING DIALOGUE strategy early in their exploration of DBP with a group. Students need time to develop their critical thinking skills and to make connections between past knowledge/experience and new knowledge/experience through verbal, physical, and written expression.

Activating Dialogue Strategies

A) Rituals to Begin and End	
4.a.i. Check-in	4.a.v. Recipe for Me
4.a.ii. Cover the Space	4.a.vi. Thumbs
4.a.iii. It Made Me Think	4.a.vii. Touchstones
4.a.iv. Perspective Web	4.a.viii. Words of Wisdom

B) Text-Based/Visual Dialogue

4.b.i. Alphabet Relay
4.b.ii. Group Mural
4.b.iii. Identity Iceberg
4.b.iv. Poster Dialogue

4.b.v. Punctuation to
 Punctuation (P2P)
4.b.vi. Snowball
4.b.vii. Visual Mapping

C) Embodied Dialogue/Sociometrics

4.c.i. Constellations
4.c.ii. Cross the Room/Stand
 Up if
4.c.iii. Exploding Atom

4.c.iv. Four Corners
4.c.v. Vote with Your Feet
4.c.vi. Vote from Your Seat

A) RITUALS TO BEGIN AND END

What is it? *Rituals to Begin and End* are strategies that use a multimodal (verbal, written, and embodied) routine as a way to set intention, synthesize understanding, or provide closure for a learning unit or project.

Why use it? *Rituals to Begin and End* ask students to use language, text, or movement to share their intention or new understanding as a form of "performance-based assessment" (Edmiston, 2014, p. 265). In these strategies, students consider and express how they are feeling and set an intention for learning. Or, they consider and express what they learned about themselves or the human condition through the dramatic work. Making student thinking visible enables teachers to put similar or conflicting ideas and beliefs in dialogue with one another and to locate students' "off-track" thinking or areas of confusion.

When and where is it used? *Rituals to Begin and End* are often used at the beginning of an investigation to establish a learning environment that values multiple interpretations and multimodal expression. Some strategies recognize and make visible how recent lived experiences impact a readiness to learn (Check-In), while others engage students through movement or an embodied metaphor to introduce how individual and collaborative meaning-making occurs in Drama-Based Pedagogy (Cover the Space, Thumbs). *Rituals to Begin and End* are also used at the end of learning to bring closure to the class session through a shared embodied or verbal experience. These strategies can require limited physical activity (It Made Me Think) or offer choice about the level of participation (Touchstones). They can be used in the curriculum when students might benefit from a physicalized way to make visible connections between abstract beliefs or ideas (Perspective Web), or when a teacher needs a quick (Words of Wisdom) or more complex (Recipe for Me) performance-based assessment to end a lesson or unit of study. All of these strategies can be used as assessment tools when the teacher needs to know more about the affective and academic goals and needs of the group.

How do you use it? *Rituals to Begin and End* can be adapted for a variety of ages in a variety of subject areas. When using these strategies, teachers might consider the following:

Student knowledge and skills

Academic: What type of information do students need to successfully set an intention or goal at the beginning of a day or a unit of work? Students will be able to make more rigorous connections to their past knowledge and

experience when they have an understanding of what new information they need to consider and why they are being asked to make a connection to curricular content or to past experience.

Affective: What level of trust and respect is required for students to openly share their emotions and to empathetically consider the emotional state of others? Students need to access social skills like effective communication, collaboration, and mutual respect in many of the DBP strategies; *Activating Dialogue* strategies build a community of learners who respect and support individual difference and experience.

Aesthetic: What support do students need to understand how intention is connected to choice and outcome? Students need practice in identifying how personal experience shapes response and interpretation. They need to understand how to use specific aesthetic vocabulary like line, color, shape, and balance to describe what they see. These strategies build students' capacity as artists to think, talk about, and assess specific aspects of their work or their working process with one another.

Context needs

Group Size: Does every member of a large group need to share their thinking with the full group? With very large groups, it can be useful for students to work in pairs or small groups to share opinions first and then invite a few volunteers to share their discussion in order to maintain engagement and decrease wait time.

Space: What space does the activity require? Is the task done best at desks, in a seated circle, or while standing? Do students need to see the student leader or the teacher leader when they are talking to maintain a higher level of focus? Some of the strategies require space to walk and make small groups; consider whether there is a larger space to use in your building or outside.

Time: What pre-thinking or pre-flection time do students need before they share their thoughts out loud with a partner or the full group? It is important to set aside time for individuals to make personal connections before they are asked to speak to others.

4.a.i. Check-in

Source: Unknown
Number of Players: 3+
Space: Any, best in a circle or U-shape
Materials: None

What is it and why use it?

At the beginning of a work session, the teacher invites students to offer a brief, individual response about how they are feeling (physically/emotionally) or what they are looking forward to regarding their work together. This strategy recognizes that affect (body and emotion) and intention shape how an individual participates in the learning environment, particularly when the exploration involves physical or emotional risk-taking by the students.

Directions

Begin by establishing expectations for the activity: *Each person in the circle will have an opportunity to share some information about themselves at the beginning of our work.* Give an open-ended prompt (e.g., *Today I'm feeling…because…* or *Today I'm excited about…because…*) and clear instructions on how much time students can take to verbally share their answer (unlimited to 30 s, potentially shown on a visible timer). Next, give a small amount of think time for students to consider their responses. The teacher may also share whether students can "pass" completely or if they can just opt to say very little (which makes this an "all play" activity). Begin with a student who volunteers to go first. When the student is finished, they say "Checked-In" to complete their turn. Encourage students to listen intently to their colleagues' words. In general, there is very limited (or no) commentary offered from the teacher or other students after each individual Check-In. The teacher may choose to offer a simple acknowledgment. For example, *Thank you* or *That's good to know, I'll keep that in mind today.*

Reflection

- *What types of things did we hear? How is our group, generally, feeling today?* or *What are we most excited about?*
- *What larger things around us are shaping how we feel?*
- *How might this information inform how we work together today/on this investigation?*

Possible side-coaching

- *Before we begin, take a minute to think about what you want to share with the group. I'll know you are ready to share when your eyes are back on me.*
- *This is an all-play activity. But you can choose what you want to share.*
- *Please remember our classroom commitments to respect and listen actively during this activity. If we are having challenges, we will stop and discuss how to move forward in a more positive manner.*

Possible variations/applications

- Allow students to check in using a physical gesture instead of words (e.g., thumbs up, thumbs side, and thumbs down).
- Provide a prompt that engages with a theme (e.g., *What are the Roses and Thorns in my day?*) or addresses a specific issue (e.g., *What is one goal you have for our in-class presentations today?*).

4.a.ii. Cover the Space

Source: Various
Number of Players: 5+
Space: Open area, room to walk around with ease
Materials: None

What is it and why use it?

This strategy encourages participants to be aware of space and present in their bodies, as they move safely through a defined area. It is often used at the beginning of a series of activities as a warm up. Cover the Space develops students' skills in following side-coaching from the teacher. It can be expanded to become a group categorization activity that uses analysis and synthesis skills.

Directions

Begin by designating a playing space with a very clear perimeter. Next, ask the group to walk around the space without talking or making contact with any of the other participants. During the silent walk, participants can be asked to stretch their arms, reach for the ceiling, and/or shake out as they walk the space. Invite them to notice their walking pace and to consider the pathways they are making on the floor; encourage students to vary their pattern and

their pace (while remaining respectful of other bodies in space). Next, invite students to make eye contact with one another as they pass. A verbal or physical greeting can be added to eye contact, if desired. Return to silent and individual walking or prepare for a transition to a variation listed below.

Reflection

- *What did you notice about yourself in this exercise? What did you notice about the group?*
- *How did you communicate with one another during tasks that required you to work silently?*
- *Why might it be important to take time to settle yourself into a space and group at the beginning of our work together?*

Possible side-coaching

- *What do you notice in your body as you walk around the space?*
- *Remember to stay within the perimeter of our space.*

Possible variations/applications

- Sort Based on Observation: Invite students to silently form groups based on an observable characteristic. *Make a group based on what you are wearing on your feet.* Once groups are formed, ask each group to come up with a name for their group and have groups share their names. Dialogue about what types of properties were used to make groups (color, size, use, etc.).
- Sort Based on Experience: Invite students to form groups based on an experience; they can talk. *Make a group based on what you like to eat for breakfast.* Once groups are formed, ask each group to come up with a name for their group and have groups share their names. Dialogue about what the categories tell us about each group? Why?
- Sort Based on Opinion: Invite students to think of their response to a prompt. *To be successful as a class, we should…* Invite students to cover the space sharing their answers to the prompt with each other as they pass in space. Next, invite students to make groups based on their words/ phrases. Once groups are formed, ask each group to come up with a name for their group and have groups share their names. Dialogue about what the categories tell us about each group. Why?
- Groups can also be asked to make a physical gesture/movement, based on the title of their group, which they perform as they share their title. Have the rest of the group make meaning from each gesture and title as

it is shared. Explore how physical gesture gives further meaning to the verbal title being offered.

4.a.iii. It Made Me Think

Source: Megan Alrutz
Number of Players: 5+
Space: Any, best in circle
Materials: None

What is it and why use it?

It Made Me Think is often facilitated at the end of a session, using the repetition of a single phrase to encourage students to reflect on themes explored during the class session. This activity is often used as a quick way to check for understanding and provides an elegant, ritualized closure for the final moments of a learning experience, class, or workshop.

Directions

Ask each student to reflect on the day's work and think of one word or very short phrase that captures their opinion and completes the phrase "it made me think." The phrase can describe something that intrigued or inspired them during class or something that was thought provoking or memorable. After they have had a moment to choose, students go around the circle and say their word or words, followed by the phrase "It made me think." Some examples related to a range of content inquiries are as follows:

> *The interconnectedness of ecosystems, it made me think.*
> *Tomatoes are fruits! It made me think.*
> *Working together, it made me think.*
> *The author's intent, it made me think.*

Reflection

- *What did you notice about this activity?*
- *What ideas did you hear more than once in our reflection? Why do you think this is?*
- *Why is it important to think about and name our own thinking?*

Possible side-coaching

- *Your phrase should be between one and five words.*
- *Your phrase/word doesn't have to be the most important or profound thought; it could be anything that made you think. However, please do stay on the topic of today's class.*
- *It's okay if you make the same connection as someone else; don't worry if someone before you says what you want to say. It's useful to know if many of us are thinking the same thing.*

Possible variations/applications

- Invite students to "popcorn" responses, meaning the students share their responses one at a time in no particular order.
- In a large class, this can serve as the "exit ticket" with students writing their name and "…it made me think" as a final ticket for attendance.
- Invite students to use a gesture to go with their words, or to just offer a gesture without words as their response.
- Other prompts to consider: *A discovery I made today is…A question I still have about this topic is…A goal I have based on my/our work today is…An appreciation I have for the group is…*

4.a.iv. Perspective Web

Source: Unknown
Number of Players: 5+
Space: Room for a circle
Materials: Ball of yarn

Image 3: *Perspective Web*

What is it and why use it?

Perspective Web can be used as a metaphor for the idea of connectedness or community. This closing ritual offers a simple, visual way to share responses to one or two reflective prompts to synthesize individual and collective understanding.

Directions

Invite the group to form a large seated or standing circle. Offer an opening reflective prompt to the group. For example, *One thing I learned in our process was…,* or *Something I appreciated about our work together was….* Give a

minute for students to consider how they would complete the statement. *I'll know you are ready with a response when your eyes are back on me.* Repeat the statement and answer it as a model. Then, unravel a few feet of yarn, keeping hold of the end, make eye contact with someone else in the circle, and gently toss or roll the yarn ball to another player across the circle. Be sure to hold on to one point on the yarn to keep the prior connection. The new player answers the prompt and, then, gently tosses the yarn to another player who is ready to receive it while holding on to the yarn end. Continue passing the ball until everyone has received the yarn and shared a reflection point. The yarn then returns to the teacher. Result? A web! End the activity with a final statement about the community and connections made through the activity and/or the larger experience that is being referenced through the reflection; the newly constructed web often provides a dynamic visual metaphor to support larger meaning-making and discovery.

Reflection

- *What did you notice about yourself or the group in this activity?*
- *What kinds of things did our group learn/appreciate the most?*
- *If we had to title our perspective web based on all of our responses, what would you call it?*

Possible side-coaching

- *It's fine if you share the same thing someone else said. It's interesting for us to note where our feelings are similar and different.*
- *Make sure you have enough slack on the yarn to throw it. Keep ahold of your end as well.*
- *Raise your hand if you still need the yarn to come to you because you haven't had it yet.*

Possible variations/applications

- Reverse the process with another question prompt—*Something I'm still wondering about is....* Then, wind the ball of yarn back up as students throw it back to the person who threw it to them.
- Invite students to cut and keep a piece of the web as a symbol of their experience and to remind them of what they learned, a connection they made, or a hope for the future.

4.a.v. Recipe for Me

Source: Albany Park Theatre Project
Number of Players: 5+
Space: Any
Materials: Paper, pencil/pen/marker

What is it and why use it?

Recipe for Me is a writing exercise (with a possible performance extension) where participants reflect on personal or collective identity through the language and structure of a recipe (i.e., ingredients, preparation and cooking directions, etc.). Students are invited to use metaphorical language and cultural food references to name, describe, and share multiple aspects of their background and identity markers with a group.

Directions

Invite students to take 5 min to create a list of words that describe who they are; this might include words that describe specific identity markers, things they like to do, or personality traits. Next, ask students to describe the elements, structure, and language in a recipe. If a group has not seen a written recipe, it might be important to share an example and make observations. Introduce the task. *Turn your list of words that describe who you are into a Recipe for Me, using the structure and format of a recipe to share your information.* Each Recipe for Me should include a list of ingredients and measurements, cooking directions, and serving directions, along with a title for the recipe. Provide examples as needed, emphasize ways to use cooking as a metaphor to describe who you are. Students will need 10–30 min to complete the task, depending on age, skill, and desired complexity of writing. When completed, choose a way to share the work:

- Pairs to Full Group Share: Students pair up and share their recipe with a partner. Then, each individual in the pair introduces the partner, shares the favorite line from the partner's recipe, and explains why the line was chosen.
- Individual to Full Group Performance: Each student reads over their recipe and selects one line of text to share with the group. Then the full group gathers in a circle and says, together, "A recipe for us…". Then, each individual shares a line going around the circle, one at a time; this can also be shared as an improvised choral poem with no assigned speaking

order. The recipe ends when the teacher cues the group to say together "And that is a recipe for us."

Reflection

- *What was the writing process like for you? What did you notice about our recipes?*
- *What recipe might you write in 5 or 10 years? How might your recipe change over time?*
- *What parts of your recipe do you think will always be the same throughout your life? Why?*

Possible side-coaching

- *Consider a recipe that you have made before. What were the ingredients? In what order were the directions presented?*
- *What terminology was used in the preparation?*
- *How can you use a recipe as a metaphor to show who you are and what you believe?*

Possible variations/applications

- Have small or full groups create a performance using elements from their recipes to share with others. This may include physical gestures to illuminate the meaning behind the text.
- Invite students to individually or collectively create recipes for different things. For example, students might create a "Recipe for a Successful Classroom" or a "Recipe for Problem Solving."

4.a.vi. Thumbs

Source: Megan Alrutz
Number of Players: 5+
Space: Open area, room for a circle
Materials: None

Image 4: Thumbs.

What is it and why use it?

The purpose of this strategy is to help students consider how they juggle multiple objectives at the same time. This allows the students to tackle and

make visible the challenges of problem solving through a simple activity. It also serves to energize and focus a group at the beginning of a lesson.

Directions

Invite the group to sit or stand in a circle, then ask students to create the "thumbs down" sign with their right hand and hold their left palm open, facing upwards, slightly in front of the person to their left. Next, students shift their right thumbs facing down over the palm of the person standing to their right. The right thumb should just graze the open left-hand palm of the other person. Explain that the goal of activity is to try and grab the person's right thumb that is over your left hand, while moving your right thumb away from the person who is trying to grab your thumb. Both actions happen at the exact same time on the count of 3-2-1-GO. Ask for questions. Then, play a few rounds. After each round ask how it went. Next, switch hands so that the left thumb is down and the right hand is up, so the whole process is reversed. Try the process a few times with the new configuration.

Reflection

- *How did it go? What did you notice about yourself in this activity?*
- *What strategies did you use to be successful?*
- *What does this activity have to do with our preparation for our work together today?*

Make a connection!
Use this strategy to explore cognitive demands on the brain, multi-tasking, or strategic thinking.

Possible side-coaching

- *Focus on your objectives.*
- *How does it feel to work for two different objectives at the same time?*
- *How can you improve your skills at playing the game?*

Possible variations/applications

- Have one of the students count for the group: 3-2-1-GO.
- Play with anticipation by counting extremely slowly, or pausing after counting to two, and observe how many students go early.

4.a.vii. Touchstones

Source: Eve Tulbert
Number of Players: 3+
Space: Room for a circle
Materials: 3–8 pieces of large paper, marker

What is it and why use it?

Touchstones is a reflection activity that is used to assess student opinion and understanding at the beginning, middle, or end of a unit of inquiry. Touchstones provides a structure for asking questions and responding to topics through an active, student-driven process. Since students are able to choose which prompt to explore and to speak when they are ready, they have more agency and autonomy within the structured dialogue.

Directions

Prior to the activity, write an open-ended statement on large piece of paper; create 3–5 statements that relate to a similar topic or content area of shared experience. For example, *My favorite moment in the story was…If I could talk to one character in the story, I would like to speak to…This story makes me think about…*Everyone gathers in a circle. Read each paper and put them on the ground in the center of the group. Invite a volunteer to pick up one piece of paper, read it, respond to the statement, and then crush the paper into a ball and throw it to someone else who indicates that they want to answer the prompt. The new student catches the paper and responds to the statement. This is repeated until all students who want to speak have spoken; then the group allows the paper to hit the floor, ending that prompt. Next, another volunteer chooses another paper, reads, responds, crushes the paper into a ball, and throws it to the next speaker and the process repeats. Students choose how often and when they participate and whether all statements are used.

Example statements to use at the beginning of an inquiry:

- A question I have about this topic is…
- One way to explore this topic could be…
- Something I know about this topic is…

Example statements to use at the end of an inquiry:

- I am proud of…
- I learned or discovered…
- Now, I wonder…

Reflection

- *What did you notice about yourself in this activity?*
- *Which statements/comments got the most speakers? Why?*
- *Are there specific words/phrases that we heard multiple times? Why do you think this happened?*

Possible side-coaching

- *You don't have to talk for every piece of paper, but I would like you to speak to at least one prompt.*
- *Raise your hand if you want the paper/prompt to be thrown in your direction.*

Possible variations

- Create prompts related to specific content. For example, *One thing I learned about the Industrial Revolution…* or *One fact about right triangles…*
- Create prompts related to a specific moment in a book or text. For example, *If I were in the book's main character's shoes, I would…*
- See "Snowball" for a similar strategy.

4.a.viii. Words of Wisdom

Source: Shana Merlin
Number of Players: 3+
Space: Room for a circle, can also be played at desks
Materials: None

What is it and why use it?

Words of Wisdom is a group activity used to set intention before or reflect after an activity by building a statement collectively. This strategy honors individual ideas in order to create a cohesive whole. The "Yes" part of the activity allows students to work together verbally and kinesthetically to acknowledge the idea/thought created by the entire group.

Directions

Students stand in a circle. The group is given a prompt that sets a challenge for the day or reflects on what happened. For example, *To end our work, we will offer a group Words of Wisdom that explains how we felt about the day. Each person will offer a word as we make up sentence together. Our goal is to*

build on the word and idea that is offered before. One person volunteers to begin. Each person offers one word each, to collectively build a short sentence or phrase. *Today-was-fun-because-we-got-to-play-and-think-together.* After the group feels a complete phrase/sentence been spoken, everyone energetically says "yes" and shimmies into the circle, then steps back into the circle for the next phrase to begin. The next person in the circle then says the first word of the next *Words of Wisdom* statement. The teacher can do multiple statements, moving around the circle or through a row or group of seated students. The tone and style of these short sayings, or words of wisdom, can vary. They can be inspirational, like Zen quotations, or silly, like fortune cookies, or can follow a more serious reflective approach.

- Example statements created by students to set goals for a science inquiry: *I-wonder-what-we-will-find-in-our-experiment? Yes! We-will-try-to-take-turns-talking-in-our-group. Yes! We-will-be-awesome! Yes!*
- Example statements during a literacy learning experience: *I-wonder-what-will-happen-next-to-the character? Yes! What-does-ameliorate-mean? Yes!*
- Example statements after a mathematics learning experience: *We-need-to-review-our-multiplication-facts. Yes!*

Reflection

- *What types of wisdom did we offer to one another?*
- *What skills do we need to be successful in this strategy?*
- *What ideas or action items for future work or next steps came out in phrases?*

Possible side-coaching

- *Try not to think about it too hard; just say the first word that comes to mind, that follows the sentence.*
- *Work together to feel when to say "yes."*

Possible variations/applications

- Small groups answer the statements, rotating through members to create answers.
- Pose an open-ended question related to a larger inquiry. For example, *What does it mean to be free?* or *What might happen if we don't conserve our resources?*

✳B) TEXT-BASED/VISUAL DIALOGUE

What is it? *Text/Image-Based Dialogue* strategies ask students to use written and visual text to express personal opinion in response to a prompt.

Why use it? *Text/Image-Based Dialogue* strategies invite students to engage in written and visual literacy through an active, structured activity. These strategies focus on metacognition by helping students to think about their thinking. *Text-Based/Visual Dialogue* creates structured opportunities for polyphonic dialogue (Bakhtin, 1986), where multiple perspectives mix and mingle with one another to generate a new, shared understanding. In this way, students are able to hear and see what others are thinking in relation to their own ideas.

When and where is it used? *Text/Image-Based Dialogue* strategies are often used at the beginning of a lesson as a way for students to make connections between their lives and the larger topic or inquiry. They can also be used as a tool to gather and synthesize student understanding at the middle or end of a lesson as a type of authentic formative assessment. For example, to begin an elementary unit on geometric principals in math, a teacher asks students to work in groups to create a collective list of words or images that represent where triangles appear in their everyday world in an adapted Alphabet Relay activity. During an English/language arts lesson, focused on the reading of complex informational texts, students use a Snowball exercise to generate key facts from the text, which are written onto single small pieces of paper. Next, they collectively, physically map and group the textual evidence into larger themes and arguments in a Visual Mapping activity.

How do you use it? *Text/Image-Based Dialogue* strategies can be adapted for a variety of ages and spaces in a variety of subject areas. When using these strategies, teachers might consider the following:

Student knowledge and skills

Academic: What background knowledge do students need to be active and successful participants? For example, if students are expected to pull textual evidence from an informational text, do they need an example of how to identify textual evidence in a written passage? Do all students feel comfortable writing and reading in front of others?

Affective: How ready are the participants to share their knowledge with others? If students are new to the content or to the group, or both, they could

Handwritten margin notes: "Beg. Lesson →"; "lives → topic"; "1st grade loves sharing ☺"

benefit by working anonymously at their individual comfortable level in a Poster Dialogue or Snowball activity. Or, if they have a level of comfort with the content, or respond well to playful competition as a way to build investment (*Which group can finish first?*), then an Alphabet Relay strategy could be useful. Does the group have a high level of trust and ability to negotiate decisions with limited teacher input? Then, a Visual Mapping activity might offer a rigorous way to access their strong communication and interpersonal skills.

Aesthetic: What design skills and visual vocabulary (shape, color, line, texture, and form) do participants need to successfully engage in some of these strategies? How can students use an aesthetic vocabulary to consider the arrangement of words or image in space as an additional layer of meaning-making in the activity?

Context needs

Group Size: How do participants need to be grouped for maximum success? How many students can use one set of materials at the same time? For example, with a large group, multiple copies of the same prompt in Poster Dialogue or Alphabet Relay or Group Mural will keep everyone engaged. Or, if the ideas generated from Snowball are divided into groups to be processed collectively in the Visual Mapping strategy, students can better tackle the verbal and physical negotiation of mapping answers with a smaller number of students.

Space: Where do the materials need to be placed so that all participants can access them? In a silent activity, it can be useful to group prompts together on the floor, tables, or wall. If students are talking or negotiating ideas verbally, it helps to provide space between work areas, as conversation can be loud, even when it is on task. To process and reflect on pages collectively at the end of the strategy—to synthesize a larger, collective understanding—move the paper or the people so that everyone can see. It is hard to participate when students cannot see the visual information.

Time: How can time limits be used to build engagement and excitement? Let students know how much time they will have (*You will have 10 minutes to complete your page*) and then adjust accordingly. Are they dropping out of the action? Then, shorten the time (*You have one minute left, how many more answers can you write?*). Are they engaged but struggling to complete the task? Then, stretch the time to meet the need and avoid frustration. (*I can see you working hard to complete the activity. I'm going to give you an extra five minutes.*)

4.b.i. Alphabet Relay

Source: Unknown
Number of Players: 8+
Space: Open area
Materials: Large posters
with A-Z written on them,
markers

use w/ teacher writing? (2 groups)

Image 5: Alphabet Relay.

What is it and why use it?

Alphabet Relay requires participants to work as a team to generate words and ideas in response to a prompt or question. Reflecting on the posters as one big group helps students see the range of ideas the class has about a particular prompt or idea, as well as the common themes that might emerge.

Directions

Start with multiple posters, each lettered A–Z down the side, with room to write after each letter. Place the posters side by side where students of all sizes can easily reach and write on them (taped to a wall, on a large table, etc.) Divide students into groups (5–10 members per group) equal to the number of posters and offer a prompt related to the current content inquiry. For example, *What do we know about the Civil Rights Movement in the United States?* Explain that each team needs to come up with one-word answers to a prompt from A to Z. Working from a single-file line, the first person in the line will run to the poster and write a word that starts with the next available letter on the list—starting with A, then B, and so on. The goal is to complete every word on the poster A–Z as quickly as possible. Once groups have finished their list, they are encouraged to cheer on the other groups to finish. After all teams have completed their poster, the class gathers where everyone can see the posters to reflect on the activity and the ideas they generated.

Reflection

- *What strategies did your team use to successfully complete the activity?*
- *What words do you see on more than one alphabet poster?* (Circle words that are similar or repeated.)
- *What words are circled? What do these words tell us about thinking?*

Possible side-coaching

- *Go with your first instinct—don't overthink your answer.*
- *Look ahead and start thinking of an answer for your next letter!*
- *If you get stuck, ask your team for help. Support each other by helping to brainstorm responses together.*

Possible variations/applications

- Consider playing without the relay and invite students to work in small groups to create an A–Z poster with images and text.
- Encourage the teams to collectively brainstorm responses before or during the game to add fun and alleviate pressure on individuals.
- Play at the beginning and end of a unit as a performance-based assessment.
- Math or Science: Have students generate words connected to mathematical thinking or to animal characteristics or ecosystems.
- Reading/Writing or Social Studies: Have students generate themes from a book; arguments on a topic to prepare for persuasive writing; or vocabulary connected to a historic event, cultural group, or geographic region.

4.b.ii. Group Mural

Source: Various

Number of Players: 3+

Space: Walls, tables, or floor for blank poster paper

Materials: Large pieces of blank paper, markers

Image 6: Group Mural.

What is it and why use it?

This strategy encourages participants to work collaboratively in groups to brainstorm visual and text-based responses to a prompt. Students are encouraged to consider how line, shape, texture, and color draw attention to ideas and communicate additional meaning to the viewer.

Directions

Begin with a discussion about the function of a mural. Consider how visual art is used to communicate opinions about an idea or group identity

or moment in time. Consider how color, shape, and line function in a wall mural. Explain that today the group will respond to an open-ended prompt using words and images to share their thoughts to collaboratively create a mural that communicates their opinion. Invite the group to sit or stand around one very large piece of blank paper on a table or floor, or taped to a wall surface, and provide a large set of marker or crayons for writing. Or, divide the large group into smaller groups, each with their own piece of large, blank paper and set of markers/crayons. Ask students to work silently to use words and images to respond to the prompt. Play music while students work. After 10–15 minutes, gather around the page(s) to reflect. Or invite to students to place a word or image as a respectful response to something made by another student in a final, silent round or to add further color or detail to an image/word already on the paper.

Reflection

- *What images/words stand out to you the most?*
- *Are there specific words/phrases that appear on multiple pages? What connections can we make across the pages?*
- *Why did this group offer these responses?*

Possible side-coaching

- *This is a mural; how might you use space, color, line, and shape express your ideas and tell a story?*
- *If you finished one piece, find another open white space and add another.*

Possible variations/applications

- Use more than one set of prompts. For example, with two groups, one group answers "One thing I know about this topic is…" while another answers "One thing I wonder about this topic is…"
- Reading/Writing: Explore character and motivation—*At this point in the story the character is feeling…*, while the other half explores *A prediction I have for the story is…*
- Social Studies: Explore a society over time—*The United States in the 1950s…*, while the other half explores *The United States in the 2000s…*
- Science: Explore different ecosystems—*The tundra… The rainforest…*

- Invite students to silently look at the work, then ask each person to make a personal "tag" on a sticky note and place it on the image/word that most represents an idea of interest.

4.b.iii. Identity Iceberg

Source: Bridget Lee, AmeriCorps Training
Number of Players: 4+
Space: Any
Materials: Small pieces of sticky paper, writing utensils, large writing surface

What is it and why use it?

Iceberg of Identity invites participants to consider how identity markers influence and shape our perspective of others and ourselves. This strategy invites students to interrogate a multifaceted construction of identity and its relationship to privilege.

Directions

Invite students to brainstorm a broad range of identity communities based on a range of markers (e.g., religious communities, race/ethnicity groups, socioeconomic status, familial relationships, and/or hobby/vocation). Based on these identity communities, ask each student to compile an individual, written list of "identity markers," which the society may use to describe them (e.g. *female, black, liberal, daughter, girlfriend, young adult*). Each student chooses five markers from their list—that they feel comfortable sharing—and writes one marker each, on five different post-its or individual pieces of paper. Draw a picture of a large iceberg outline in the water on a chalk/white board. It is important that the drawing includes parts of the iceberg formation above and below the water level. Invite students to select and place 3–5 of their individual "markers" onto the iceberg image based on whether they believe their identity marker is seen by (placed above the water) or hidden from (placed below water level) others. Afterward, ask students to observe where identity markers are placed. Engage in dialogue about what markers are placed where and why. To close the strategy, invite students to reflect on the ways individual and group identities are seen and not seen in this learning community and how this could impact an individual's learning experience.

Reflection

- *How did it feel to write down ideas about your identity? What categories of identity markers did we choose to include/exclude?*
- *What identity markers are similarly/differently placed? Why do you think that happened?*
- *How might identify inform our work together in this learning community?*

Possible side-coaching

- *Consider what identity markers are most important to who you are.*
- *You only need to share those things that you are comfortable sharing with our group.*
- *We may have different ideas about where the same identity marker is placed.*

Possible variations/applications

- Reading/Writing or Social Studies: Have students move through this strategy thinking from a specific individual's perspective from literature or a moment in history.

4.b.iv. Poster Dialogue *Seasons* *4 tables*

Source: Unknown
Number of Players: 3+
Space: Large area
Materials: Large space to write (paper or board), markers for students, music (if desired)

What is it and why use it?

Poster Dialogue asks participants to use words and images/symbols to respond individually and reflect collectively to a series of open-ended prompts. The prompts invite students to make personal connections between the topics to be explored and their lived experience. The teacher uses this strategy to assess student knowledge and opinion.

Directions

Prior to the activity, write open-ended statements/questions at the top of a poster-sized piece of paper or spread out on a whiteboard/chalk board one statement/question per page or area of the board. For example,

triangles are…, squares are…, and circles are… To begin, invite students to use a marker to silently respond to each question/statement, in any order they prefer. If students finish early, ask them to read and respond to what other students have written. Once the task is complete, assemble the pages in the same space in front of the full group. Facilitate the groups' meaning-making process to synthesize meaning on individual posters. For large groups, read the words—or most of the words—aloud from each page as way to build interest and support those who cannot read what is written from a distance. Conclude by making meaning between and across posters that look at the same idea from different points of view as described below.

Reflection

Individual pages:

- ✓ *Which words/responses got the most check marks on the page or did you hear the most as I read what was written?*
- *What does this group value or think is most important in relationship to this topic?*

Comparing pages:

- *Are there specific words/phrases that appear on multiple pages? What is the relationship between visible/invisible identity, power and privilege?*
- *What do these ideas have to do with each other or our larger inquiry?*

Possible side-coaching

- *If someone has written exactly what you wanted to say, you are welcome to put a check mark by that statement.*

Possible variations/applications

- ↪ Use images instead of words for students where constructing individual text is challenging. Images can be drawn by the student or supplied for students to place as their response.
- Use the same set of prompts multiple times across a unit of inquiry so that the teacher and students can document and assess shifts in knowledge and understanding over time.

- Groups of 5–10 can start with one poster prompt to work on as a group; then, posters can be passed simultaneously until each group has added their comments to the prompt.
- Reading/Writing or Social Studies: Have students reflect on key themes before or after reading. Students can share their understanding of a culture, geographic region, or event.

4.b.v. Punctuation to Punctuation (P2P)

Source: Cecily Berry and Rachel Gartside,
Royal Shakespeare Company
Number of Players: 3+
Space: Varies
Materials: Text on paper/tablet
for students to use

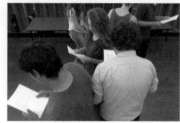

Image 7: P2P.

What is it and why use it?

Punctuation to Punctuation provides a low-risk way for participants to read and re-read, question, and respond to a complex text. Students and the teacher share in constructing their understanding of individual words, patterns in the text, and possible meanings of the full passage.

Directions

Gather the group in a seated circle and provide a copy of the complex text being used for each student. Explain that the group will read and respond to the text over multiple rounds. (Round 1) A designated student will begin to read the text aloud; (s)he will stop when (s)he arrives at a punctuation mark (— : ; , . ! ?). Then, the next student in the circle will read until (s)he reaches a punctuation mark. This may mean that a person reads only one word, e.g., "car," or an entire sentence. Keep reading around the circle, punctuation to punctuation, until everyone gets an opportunity to read and the text has ended. Restart the text from the beginning, if necessary. (Round 2) Next, the text is re-read from the beginning, changing readers at each punctuation, but this time students also say "Stop!" if there is a word that is confusing or not understood. When stopped, the group works together to make meaning of the confusing word or phrase; this continues until the full text has been read and all "Stops" are answered. (Round 3) All

> **Define it!**
> *A **Complex Text** uses more complex levels of meaning, structure, language, conventionality and clarity, and prior knowledge.*

82

students stand and begin to walk as they read the text out loud together from the beginning. At each punctuation mark, students change the direction of their walking until the text is finished.

Reflection

- *What did you notice about the text and yourself during this activity?*
- *In Round 3, at what points in the text were you turning and at what points were you walking straight? How might that inform our understanding of this text?*
- *How does our understanding of this text shape or shift our larger inquiry?*

Possible side-coaching

- *In Round 3, walk slowly and be aware of others as you shift directions; we need to be respectful of other bodies in space.*

Possible variations/applications

- When re-reading the passage, allow students to paraphrase and interpret their P2P section.
- Reading: Before walking the text, invite all students to read the text aloud together. At predetermined points, offer interpolated questions and comments (Example from *Midsummer Night's Dream*: Teacher: *What shall I do?* Students (reading): *Therefore, fair Hermia, question your desires.* Teacher: *What else?* Students (reading): *Know of your youth, examine well your blood.*)
- When walking the text, ask students to change directions based upon the type of punctuation mark [(-- : ; ,) = 90° turn] and the full stop [(. ! ?) = 180° turn].

4.b.vi. Snowball

Source: Imagination Stage
Number of Players: 3+
Space: Any
Materials: Strips of paper and writing utensils

What is it and why use it?

Snowball creates an opportunity for participants to share their personal opinions in an anonymous, low-risk way. In addition to individual expression,

this strategy also gives students a chance to discover others' viewpoints and to consider shared or differing opinions.

Directions

Give students a strip of paper and ask them to write, as clearly as possible, a brief response to a question/statement that is read aloud. For example, *What facts did you find most persuasive in the video on global warming?* or, *What questions remain about the characters in our drama work?* Next, students crumple their paper response into a ball and throw it into the middle of a circle. Each student picks up a different balled paper. The group reads their anonymous response one at a time. Each response can lead to further dialogue (for example, if the statement is a question for the group) or it can just be read alongside other opinions with processing occurring at the end of all statements being read.

Reflection

- *What were some of our common responses—meaning where did we offer similar answers to the prompt? Why do you think this might be? Where were our areas of difference? Why might this be?*
- *How many of you found you agreed with someone else's opinion in the group when the statements were being read aloud? Can anyone share an example?*
- *What do these responses have to do with our larger inquiry?*

Possible side-coaching

- *This is anonymous so use this opportunity to express a respectful opinion, concern, or question.*
- *This is about your opinion. I'm not looking for a single "right" answer.*
- *It's not a problem if you pick up your own snowball; no one will know unless you choose to share the information.*

Possible variations/applications

- Students can answer multiple prompts and answers can be tracked on different colored paper.
- Once the activity is understood, a student or group can design the prompts.
- One the snowball answers have been read, ask students to "map" them, grouping like ideas on a paper together on the floor or wall. For

further information on this approach, see the Visual Mapping strategy description.

- Reading/Writing or Social Studies: Invite students to take on a role of a character or historical figure and respond to various prompts as that person.
- Math: Have each student pick a number within a range, write it in standard form on a slip of paper, crumple it up, and throw it into the middle. When students pick a piece of paper from the middle, they each take a moment to write the number in a different type of numerical notation (fractions, equations, etc.) on the slip of paper. Once they finish, they throw the slip back into the middle. This process repeats for several rounds.

4.b.vii. Visual Mapping

Source: Drama for Schools
Number of Players: Any
Space: Any, access to walls, large table or open floor area
Materials: Post-it notes or 1/3 sheets of paper, markers

What is it and why use it?

Visual Mapping invites participants to synthesize ideas and generate responses to prompts that are verbal and visible to the whole group. It also allows students to see where their ideas and responses intersect or overlap with those of other students. Working collaboratively to organize the group's collection of responses, students make new connections between ideas as they discover ways to visually represent how ideas intersect.

Directions

Give 3–5 small pieces of paper or large post-it notes and a marker to each student and ask them to write multiple responses to a single, open-ended prompt. For example, *A key argument or fact from last night's reading was…*, or, *A goal I have for myself in math is…*, or, *Equity means…* One response is put on each piece of paper. All papers are collected and spread out on the floor or a large desk surface or wall (if paper/tape or sticky-backed paper is used). Invite students to read responses and then organize or "map" out responses in related groups. Once grouped, students can provide a name for each category of group of responses if desired, or consider how some responses might bridge or connect between categories. If working with a large group

85

(more than 15), split the group in two and let each group make their own visual map of their responses. Then share the two maps together to compare ideas and groupings.

Reflection

- *What do you notice about yourself or the group during this process?*
- *What categories emerged? How did you decide on each category group? Why?*
- *What new insights or information does this map give you?*
- *Where was the "heat" or our interest most focused for our group? Why do you think this is?*

Possible side-coaching

- *Take some time first to read and look at all the responses.*
- *Be sure you are sharing the process of moving and mapping the ideas.*

Possible variations/applications

- Ask multiple questions and students can color-code their answer (*Please put all answers to prompt one in blue and all answers to prompt two in green*, etc.). Or if there is a need to track responses for specific groups in a diverse class, groups can be assigned marker colors (*all female identifying students use blue*; or, *all students in row 1 use red*; or, *undergraduates use green*; or, *students from Ms. Johnson's class use orange*).
- After mapping is completed, ask individuals to "tag" (create a small marker with their name or a symbol of their name) and mark a location on the map. For example, *Place a marker on the word/s that you are most interested in talking further about*; or, *Place a marker on the topic or skill you feel you understand best*; or, *Place a marker on the topic or skill where you are still learning.*
- Reading/Writing or Social Studies: Have students map key themes from a text, or settings, or map events and then group them in order.
- Science or Math: Have students name animals and then group them into categories using scientific properties or attributes. Students pick up random objects outside, then group the objects found based on properties using scientific and mathematical language.
- See *Identity Iceberg* for a related activity procedure.

C) EMBODIED DIALOGUE

What is it? *Embodied Dialogue* strategies ask participants to express their personal opinions by placing their bodies on a continuum in response to a question or statement.

Why use it? *Embodied Dialogue* invites students to first share their individual meaning-making through their body rather than words. The strategies support research in the area of literacy, which recommends a multimodal approach to how we acquire, struggle with, and make meaning (New London Group, 1996; Kress, 2003; Aukerman, 2013). After making their physical choice, students can dialogue—in pairs, small groups, or all together—about their decision.

When and where is it used? *Embodied Dialogue* strategies are often used at the beginning of a lesson as a way for students to make connections between their lives and the larger topic or inquiry. For example, as part of a first grade science unit, a teacher might use Cross the Room if/Stand Up if… to make connections for students between activities they like to do on the playground and two forces of motion: push and pull (e.g., *Stand up if you've ever pushed someone else or been pushed by someone else on the swings.).* In a fifth grade classroom, students could pick which character from their reading they would most like to question about an event during a Four Corners activity. Once in their "character corner," students generate a list of questions to ask the character based on textual evidence from the reading. In a secondary government classroom, a teacher might use Vote from Your Seat to make connections between the Bill of Rights and Students' beliefs about personal freedom.

How do you use it? *Embodied Dialogue* strategies can be adapted for a variety of ages and spaces in a variety of subject areas. To prepare to use these strategies, a teacher might consider the following:

Student knowledge and skills

Academic: How can statements be structured so that students easily understand the question or topic? Avoid statements that are double-barreled, meaning they ask more than one question, or questions that produce a double negative if the answer is no. For example, *I don't think 18 year olds should vote or be able to drink.* can be confusing to answer (I agree/I disagree). *I think 18 year olds should vote.*, and then, *I think 18 year olds*

should be able to drink. as two separate questions, written in the positive, is easier to answer.

Affective: How can statements create a safe space for students to represent diverse identity markers (race, ethnicity, class, sexual orientation, ability, and gender) in their responses? Very often, the statements are created so students will want to challenge generalized assumptions about "all people" or "everyone." Students can also be invited to move after other opinions have been shared, if their opinion has changed. This builds students' skills in persuasion and critical thinking, and improves their ability to engage in challenging dialogues.

Aesthetic: How does this strategy invite students to make connections between their experience and the ways they make meaning? A significant aspect of working and thinking as an artist is the ability to understand the relationship between artistic expression and ideas, feelings, and personal meaning. When appropriate, incorporate reflective moments within the strategy facilitation to make larger connections to artistic thinking.

Teacher context

Group Size: How can a large group participate verbally as well as physically in *Embodied Dialogue*? After making a physical vote response, a large group can be invited to *Think* for 30 s about how and why they voted, then they can *Pair* with a colleague to discuss their response. Finally, the teacher can call on a few groups to *Share* out to the larger collective.

> **Think** – on your own
> **Pair** – to build upon our ideas
> **Share** – our ideas with the group

Space: How much space is available to do the activity? Vote from Your Seat and Stand up If… can be done in seats when space is limited. Vote with your Feet and Four Corners can be facilitated down a single row between desks/tables, at the front of the room in front of desks/tables, or on the outer four corner areas of an instructional space. Exploding Atom and Cross the Room require an open space to move and group.

Time: How much time is available for conversation and reflection between questions or statements in the activity? If all students need to share their thoughts, it is best to have fewer questions/statements. Sometimes it is productive to mix up which questions/statements within a strategy use

physical and verbal responses and which just use physical responses. For example, in response to their first question, students are asked to *vote* and then *notice the room*, while the next question asks students *to vote, notice the room, and then to offer a verbal response as to why they voted the way they did*. Variation between physical only and physical and verbal responses can keep students more engaged and improve the pacing and flow of the activity.

Spotlight on sociometrics

Four of the strategies in the next section are variations of a sociometric. A sociometric in Drama-Based Pedagogy is a quick, physical way to measure and compare student opinions regarding a series of related questions based on a larger topic or inquiry. This Spotlight on first offers a table that names and compares the four different sociometric strategy approaches offered in this section of the text. Next, we offer an example of practice to explore the construction and facilitation of statements/questions within an effective sociometric facilitation.

How to pick the best sociometric for your group and need

To select the right sociometric for the group and task, it is useful to consider three key factors: level of student risk, level of cognitive complexity, and amount of space required. Each of the four sociometric strategies (Vote from Your Seat, Cross the Room/Stand up If…, Exploding Atom, and Vote with Your Feet) involves a similar structure—a series of open-ended statements or questions—but shifts how student responses are made as documented in Table 2.

STRATEGY NAME	Level of Student Risk	Level of Cognitive Complexity	Amount of Space Required
Vote from Your Seat	Low	Medium	Low
Cross the Room/ Stand up If…	Medium	Low	High
Exploding Atom	Medium	High	High
Vote with Your Feet	High	Medium	Medium

Table 2: Comparison of sociometric strategies.

How to Facilitate an Effective Sociometric

Create appropriate statements

Consider the objectives of the task. What type of knowledge can be accessed through this strategy? For her high school health class, Suzan wants to engage her students in dialogue about why teenagers drink alcohol. Since she has a large, open classroom space, she decides to use Exploding Atom to allow her students to get up and move after sitting for the first part of class. To prepare for the strategy, she writes a first draft of statements that ask students to consider broad generalizations about drinking.

1. *Drinking is fun.*
2. *Drinking makes me more comfortable in social situations.*
3. *I like to drink.*

Consider whether it is better to write statements from a first or third person point of view. Suzan looks at her statements and decides they might feel too risky for some students. She decides she might be able to get more honest and diverse viewpoints and participation if she revises her questions to use the third person. She also adds language that suggests a strong viewpoint (words like "all") so that students might push against the generalization to dig deeper into the issue. She revises the statements to read:

1. *Drinking is fun.*
2. *Teenagers drink to feel more comfortable in social situations.*
3. *All teenagers like to drink.*

Consider the order of statements; how can student thinking scaffold from the personal to the larger questions that shape the issue or the larger impact of a choice. Suzan decides to reorder and expand her sequence to add statements that push students to reflect on some of the conflicting arguments about drinking from media and society. She revises the statements a final time to read:

1. *All teenagers like to drink.*
2. *Drinking is fun.*
3. *Teenagers drink to feel more comfortable in social situations.*
4. *Alcohol is safe because adults drink it all the time.*
5. *Alcohol is safe as long as you don't binge drink or become an alcoholic.*

Use reflection to support student risk-taking

Consider how and when Students will be asked to offer verbal support of their physical opinions. Suzan finalizes her facilitation plan by adding in some directions for herself about how she might process each statement. She adds in notes for a number of different approaches to verbal reflection: reflect collectively on the full group position; reflect in pairs about personal position and then pairs can volunteer to share; two or three students self-select from any part of the continuum to reflect on personal position to whole group; and, two or more students, each from different ends of the spectrum, are invited to reflect on their personal position to the whole group. She makes choices about where she thinks each reflection structure might work. She also makes a mental note to watch group behavior to be ready to change her reflection option based on the vote spread and level of engagement.

1. *All teenagers like to drink.*
 a. Reflect on full group: *Take a minute to notice how the group voted overall. In general, does our group agree or disagree with this statement?* (after response) *Why might this be?*
2. *Drinking is fun.*
 a. Reflect in pairs: *Please turn to someone near you and discuss your vote, then we will hear from a few groups about their discussion.*
3. *Teenagers drink to feel more comfortable in social situations.*
 a. Volunteer reflects on self (random location): *Would someone please share why they are standing where they are standing?* (after response) *Let's hear from someone else, why are you standing where you are?*
4. *Alcohol is safe because adults drink it all the time.*
 a. Volunteer to reflect on self (random location): *Would someone whom we haven't heard from yet, please share why they are standing where they are standing?* (after response) *How about someone else?*
5. *Alcohol is safe as long as you don't binge drink or become an alcoholic*
 a. Volunteer to reflect on self (directed location): *Who will share their thoughts from this group standing on this far side of the continuum?* (Take answers.) *Then who will share their opinion on the other side of the continuum?* (Take answers.)

Consider ways to bring out multiple viewpoints, to deepen understanding, and to keep the entire group engaged in rigorous meaning-making. Suzan makes a mental note to never single out a response as "right" or correct. She also reminds herself to ask the questions:

- *Can we think of another reason why this might be true?*
- *Why might someone feel differently about this issue?*

Conclude the sociometric exploration by synthesizing key ideas and making connections back to the larger inquiry and topic. Suzan ends her planning for Exploding Atom by including some short verbal and written reflection questions for students after they returned to their seats:

- *What did you notice about yourself during our Exploding Atom activity?*
- *When did our group have the most agreement? Why do you think that is?*
- *When did we have the most difference of opinion? Why do you think that is?*
- *Reflect back on the ideas and arguments brought up by your colleagues in this activity. On your desk you will find an index card. Please write one idea that came up in the Exploding Atom that you think we should revisit in our upcoming drug and alcohol unit.*

4.c.i. Constellations

Source: *Playing Boal: Theater, Therapy, Activism* (Mady Shutzman and Jan Cohen-Cruz, ed.)
Number of Players: 5+
Space: Room to move through space
Materials: None

What is it and why use it?

Constellations invites participants to consider and physically demonstrate connections among a group in response to statements. This strategy allows students to develop a sense of community, identity, and belonging by making interpersonal connections visible.

Directions

Define the parameters of the space that is going to be used. Next, explain that a series of prompts will be read, which require each student to place their hand on the shoulder of someone who meets the criteria of the statement. For example, *Place your hand on the shoulder of a person in the room whom you've known the longest.* Encourage students to respond to each statement as quickly as possible; there is no right or wrong answer, and everyone will have multiple ways to respond to each statement. Next, ask the group to move slowly through the room or cover the space; students are encouraged to explore a variety of pathways and to try and keep their bodies equidistant from each other. Offer a prompt and ask students to quickly form a constellation by connecting to each other's shoulders. Once grouped, invite students to notice the room. It can be helpful to offer additional meaning-making (*Take a minute to notice the room; part of our work together is about building on strong foundation with each other and the friendships we've made over time.*) The teacher may also choose to ask each constellation to engage in a brief moment of reflection (*Turn to someone in your constellation and discuss your favorite moment from our work together today.*) and share out their dialogues (*Let's hear from one or two groups about their reflection.*). After each prompt is finished, ask students to drop their arms and return to walking through space without touching or talking to prepare for the next prompt.

Example prompts for groups

- *Place your hand on the shoulder of a person you've known a short amount of time.*

- *Place your hand on the shoulder of a person who has a skill you'd like to learn.*
- *Place your hand on the shoulder of a person you'd like to get to know better.*

Reflection

- *What did you notice about yourself doing this activity? What did you notice about the group?*
- *What, if anything, took you by surprise?*
- *Why might it be important for us to consider the types of connections we share?*

Possible side-coaching

- *Don't overthink it. Just find the first person that could be an answer to the prompt for you.*
- *Take a quick look at how we are connected. What do we notice about the room?*

Possible variations/applications

- Invite or assign students to play as someone/something else, as it might pertain to the lesson.
- Math: Assign students to play as numbers—*Place your hand on a number that is a factor of you.*
- Reading: Students are assigned to play as characters—*Place your hand on another character whom you help in the story.*

4.c.ii. Cross the Room/Stand Up if

Source: Various
Number of Players: 4+
Space: Room to make two standing lines with at least 5 feet of distance between; or room to stand at seat
Materials: None

> **For further help!**
> *check out **Spotlight on Sociometrics** in the introduction to this section (p. 89).*

What is it and why use it?

Cross the Room/Stand Up if is an out-of-your-seat strategy in which participants either stand up at their seat or cross the room in order to express

their opinion about a given statement. This strategy allows students to focus on: *YES, I agree.* It is particularly useful for concrete thinkers who might struggle to place themselves on a spectrum of opinion.

Directions

Before the activity, create a series of statements on a topic that will evoke an opinion from students. For example, *Cross the room if you think you would like to visit Narnia.* For *Cross the Room,* ask students to create two lines facing each other. There should be some distance between the two lines and roughly an equal number of students on each side. The teacher will read a statement out loud. If the statement is true for the participants they will cross the room and join the other line. If the statement is not true for the participants, they will remain standing in the line. The activity is repeated with each new prompt. When desired, stop and unpack or process the students' responses to the statements. *Someone who said YES, please share why.* Then, *Someone who said NO, please share why.* For *Stand up if,* students stand up if their response is "yes." After each statement, the full group (standing or sitting) resets to sitting in their seats. When desired, after any statement, lead a dialogue with the group to reflect on individual or the full group response.

Reflection

- *What did you notice about the groups' responses to the questions? When did we move the most? When did we move the least?*
- *What did we learn about the group from this activity?*
- *How might these statements make us think differently or understand more about our larger inquiry?*

Possible side-coaching

- *Don't worry what anyone else thinks; this is about your opinion/ experience.*
- *Move if the statement is true for you.*
- *If the statement is not true for you, do not move.*

Possible variations/applications

- Discuss with students the quality of movement they use to show the level of agreement as they cross the room. Very active movement or dance can signal strong agreement; slow, careful movements can signal a lower level of agreement.

- Invite or assign students to play someone or something else.
- Math: Students can play as shapes—*Cross the room if you have four sides.*
- Reading/Writing: Students can play as vocabulary—*Cross the room if you are in the first person/an adjective/if you describe something.*
- See related sociometric variations.

4.c.iii. Exploding Atom

Source: Jonathon Sullivan
Number of Players: 3+
Space: Large, open area where
the group can stand and spread out
in multiple directions
Materials: None

What is it and why use it?

Exploding Atom is an out-of-your-seat strategy in which participants express their opinion on their own continuum spoke that starts at the center and moves to the outermost point of the standing circle space. Like Vote with Your Feet, this strategy allows students to see the range of opinions in their class while embodying their own opinion.

Directions

Before the activity, create a series of statements on a topic that will evoke a range of opinions from students. For example, *Everyone is equal in America.* The full group stands in a large, open space in a circle. Explain that a statement will be read. If the student agrees with the statement the student should come as close to the center of the circle as possible. (It can be helpful to model this action.) If the student disagrees with the statement the student should stand as far away from the center as possible within a set boundary. (It can be helpful to model this action.) Show how each student is on an individual continuum between "agree" and "disagree" in response to each statement. Take any questions. Read the first statement and ask students to vote with their bodies by moving to the place that best expresses their response between "Yes, I agree" and "No, I disagree." When desired, stop and unpack or process the students' responses to the statements. *Someone who is standing closer to "I agree," please share why.* Then, *Someone who is standing closer to "I disagree," please share why.* Or, *Please turn to the person next to you and share why you*

are standing where you are standing. Re-set the group to a neutral circle between statements to prepare for the next prompt.

Reflection

- *What did you notice about the responses in the room?*
- *What did we learn about the group from this activity? Where we most in agreement? Why?*
- *How might these statements make us think differently or understand more about our larger inquiry?*

Possible side-coaching

- *Remember, this is about your opinion. There is no right or wrong response to the statements.*
- *Remember to be respectful of each other's opinions and positions.*
- *Let's hear from the where the largest group is standing first, would anyone like to share why they are standing where they are?* (Always make sure that the smallest group has the last word.)
- *No one has to speak. People can say "pass" or "it's been said."*

Possible variations/applications

- Place a water bottle (or other object) in the middle of the circle for the students to see where "agree" is or make connections between the title of the game (Exploding Atom) and the strong pull of electrons in the nucleus "agree" and the weak pull of electrons on the edge of the atom "disagree."
- After each discussion allow students to reassess their placement and move if they choose.
- See related sociometric variations.

4.c.iv. Four Corners

Important reminder!
Avoid using this strategy as a multiple-choice quiz, where there is one right answer. Choose four answers that offer different, possible, viewpoints on a topic.

Source: Unknown
Number of Players: 8+
Space: Open area with four separate spaces
Materials: None

What is it and why use it?

Four Corners is an out-of-your-seat strategy in which participants choose between four different answers and

move to the designated "corner" to register their "Yes/I agree" vote. This strategy asks students to physically make a choice and is especially useful for concrete thinkers who benefit from specific choices.

Directions

Before the activity, create a series of statements on a topic, each of which has four predetermined choices as answers. For example, *I am most focused in the...early morning/midday/afternoon/evening.* Begin by designating each of the four corners of the room to represent a particular answer. Then, call out the prompt, to which students respond by moving to one of the four corners of the room. Once students have divided themselves into four corners, invite the groups to dialogue about why they made their choice. *Talk with your group about why you picked this time of the day as your most focused time.* Groups can synthesize their responses to share with the entire group. This process can be repeated with a new statement and set of response categories. Ideally, the group will shift and rearrange into a variety of different subgroups so that students have a chance to dialogue with many different people throughout the activity.

Reflection

- *What did you learn about yourself? About someone else?*
- *What did we learn about the group as whole? How do our discoveries impact what we want to do?*
- *What does this activity have to do with our larger inquiry?*

Possible side-coaching

- *Introduce yourself to people you don't know before beginning discussion.*
- *Talk with people in your corner about why they are standing where they are. Come up with a sentence to share with the group that synthesizes your dialogue.*
- *What did you learn about some of the people you talked with in your group?*

Possible variations/applications

- Designate the four corners of the room as "Strongly Agree," "Agree," "Disagree," and "Strongly Disagree."
- Reading: Designate each corner as a character/setting/event from a book. Students pick their favorite corner and then answer a question about the person, place, or event.

- Math or Science: Designate each corner as a shape, a number, a species, or an element from the periodic table. Groups must then name a favorite property or a fact using mathematic or scientific language.
- Social Studies: Designate each corner as a geographic area, a famous leader from history, or a time period and have students discuss what they know, generate facts, or construct a question for the rest of the group to answer about their corner topic.
- Expand or contract the number of the choices, this could be Three Corners or Five Corners.

4.c.v. Vote with Your Feet

For further help!
*check out **Spotlight on Sociometrics** in the introduction to this section (p. 89).*

Source: Various
Number of Players: 3+
Space: Enough room to create a straight line from one side of the room to the other (everyone should be able to fit on the line)
Materials: None

What is it and why use it?

Vote with Your Feet is an out-of-your-seat strategy in which participants express their opinions by standing in different areas of a single-line continuum. This strategy allows students to embody and compare their personal opinion to the opinion of others in a group and to explore the various reasons behind different viewpoints. In comparison to Exploding Atom, in this strategy individual choices are very visible, as all students stand on a single continuum together.

Directions

Before the activity, create a series of statements on a topic that will evoke an opinion from students. For example, *I am loyal to my family*. Explain where the imaginary continuum, or line, is in the room. Point out the ends of the continuum as "strongly disagree" and "strongly agree." Explain that students can choose to stand anywhere on the line in between these two points. Students will silently move in order to place themselves on the continuum in response to each prompt. It is useful to read the prompt once so students have time to consider their response, and then have them move once the response is read a second time. Once the group has voted, use follow-up prompts to invite individual, paired, and/or full group reflection on individual and collective positions responses.

Reflection

- *What did you notice about the responses in the room?*
- *What did we learn about the group from this activity?*
- *How might these statements make us think differently or understand more about our larger inquiry?*

Possible side-coaching

- *Remember, this is about your opinion only. There is no right or wrong to this activity.*
- *Remember to be respectful of each other's opinions.*
- *No one has to speak. People can say "pass" or "it's been said."*
- *Any time during our discussion if your opinion changes, you may move.*
- *Turn to someone who is standing near you and discuss why you are standing on this point in the continuum.*

Possible variations/applications

- After each discussion allow students to reassess their placement and move if they choose.
- Reading/Writing: Explore a theme from literature or play "in-role" as characters from the story. Use as a preparation for a persuasive writing assignment or drama activity.
- Science: Explore an ethical dilemma in science like cloning or energy resource use.
- Social Studies: Consider how privilege and access function in society in relationship to race, ability, class, or other identity markers.
- See related sociometric variations.

4.c.vi. Vote from Your Seat

Source: Unknown
Number of Players: Any
Space: Can be done in chairs or
seated at desks
Materials Needed: None

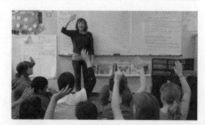

Image 8: Vote from Your Seat

 ## What is it and why use it?

Vote from Your Seat is a strategy in which seated participants use their arms to show their answer (up = I agree; down = I disagree) to a prompt or question. This limited-movement strategy ensures that students feel safe to contribute to the activity, while providing a quick snapshot of student opinion to generate further dialogue.

Directions

Before the activity, create a series of statements on a topic that will evoke an opinion from students. For example, *Learning is easy*. Explain that in this activity the group will be asked to listen to a statement and decide whether they agree or disagree with what is being said. If students agree, they should raise an arm/hand high into the air. (It can be useful to model this action.) If students disagree, they should put their hand/arm down to their side. (It can be useful to model this action.) Explain that students can choose to vote anywhere between "strongly agree" arms up and "strongly disagree" arms down. (Model a middle or "sometimes" vote.) Explain that each statement will be read twice and then the vote will happen. Ask if there are any questions. Read the first prompt twice, the second time, ask students to vote from their seat. Once the group has voted, ask students to keep their hands still and to scan the room to see other responses; then ask everyone to put their hands down. When desired, after any statement, the teacher can lead a dialogue with the group to reflect on the full group response; reflect in pairs on individual responses; or reflect from different ends of the response continuum on the ideas being explored (an "agree" and a "disagree").

For further help!
*Check out **Spotlight on Sociometrics** in the introduction to this section (p. 98).*

Reflection

- *In general, what did you notice about the responses in the room? When did we most agree? When did we disagree?*
- *What did we learn about the group from this activity?*
- *How might these statements make us think differently or understand more about our larger inquiry?*

Possible side-coaching

- *When you vote, please be sure that your hands clearly display your opinion.*
- *Remember, this is about your opinion only. There is no right or wrong to this activity.*
- *This activity is about listening and understanding a new point of view.*
- *Turn to a neighbor and discuss why you voted the way you did.*

Possible variations/applications

- After each discussion, allow students to reassess their placement and "re-vote."
- Students can stand or sit to show their opinion.
- See related sociometric variations.

Chapter 5

Theatre Game as Metaphor

Teaching Artist: *This is not a triangle…this is my sharp, dangerous shark fin. Dnah, dnah, dnah, dnah…*

Teaching Artist puts triangle on head and pantomimes that he is a shark swimming in the ocean.

Teaching Artist: *What did I do that let you know what this triangle had been turned into?*

Students describe the way he used his voice, body, the shape of the triangle, and music to create a fin on the back of a dangerous shark.

Image 9: Students play This is a/is Not a.

What is it? Theatre Game as Metaphor strategies use group games to develop mind/body awareness, rehearse pro-social skills, and explore elements of story such as character, setting, and conflict.

Why use it? Theatre Game as Metaphor strategies can be used to help students create a concrete representation of an abstract idea, process, or relationship to support student meaning-making and collaboration. In these strategies, students do the following:

- Build Ensemble: In particular, theatre games offer opportunities to develop and practice pro-social culture and to form a community of learners through a group challenge.

- Represent Concrete Ideas: Theatre games can provide ways to explore complex ideas like power and conflict and/or deepen students' understanding of dynamic characters or settings.
- Practice Drama/Theatre Skills: Theatre games provide space to rehearse the tools of drama/theatre in order to prepare students to participate in complex role-play strategies and lessons.

When and where is it used? Theatre Game as Metaphor strategies are often used at the beginning of drama work. The *Exploring Ensemble, Energy, and Focus* strategies in this section particularly support students' abilities to work toward a collective goal within specific parameters. These strategies can be used as a warm-up or "icebreaker" to begin any drama work. They are particularly useful for new groups, such as at the beginning of a school year, or for groups who need to re-set focus after a transition (i.e., during a 90-minute block period or after lunch). The *Exploring Setting, Story, and Character* strategies use simple drama/theatre skills to prepare students to step into a larger dramatic approach within a lesson. They work best when the instructional task is focused on how to explore elements of character and story, and are particularly useful in social studies, history, and English/ language arts. *Exploring Relationships, Power, and Problem-Solving* strategies invite students to work individually or collectively to solve and reflect upon a real or imagined problem as a way to bring a dilemma to life. They can be particularly useful in mathematics and science investigations. They also invite students to look more closely at the dramatic elements of plot and conflict. Once the procedure is understood, many of these strategies can also be used as a simple dramatic "in-role" structure in which students play "as if" they are someone/something else.

Final thoughts

The strategies in this section are organized into three main categories, and each collection of strategies focuses on specific instructional tasks and goals. Students often need to begin DBP work through an exploration of theatre games that support the culture and skills of *Ensemble, Energy, and Focus*. After developing a sense of trust and collaboration, the teacher might focus the work on basic theatre skills through a *Setting, Character, and Story strategy*, which activates content through the use of imagination, voice, and body. *Conflict, Power, and Problem-Solving* strategies prove helpful in encouraging students to think critically about how systems of power shape individuals' lives, providing hands-on experience in navigating conflict in relationships and problem-solving solutions to issues or challenges. These strategies often

become group favorites. Teachers often find that they can reuse and return to these strategies to explore multiple areas of the curriculum and the drama/theatre art form or as a way to provide a quick focus activity or warm-up at the beginning of a classroom session.

Theatre Game as Metaphor Strategies

D) Ensemble, Energy, and Focus

5.d.i.	Buzz	5.d.xii.	Jump
5.d.ii.	Circle Dash	5.d.xiii.	People Shelter Storm
5.d.iii.	Crumbling	5.d.xiv.	People to People
5.d.iv.	Data Processing	5.d.xv.	Round of Applause
5.d.v.	Fruit Bowl	5.d.xvi.	Stop and Go and Jump
5.d.vi.	Group Counting	5.d.xvii.	Telephone
5.d.vii.	Group String Shapes	5.d.xviii.	Truth About Me
5.d.viii.	Heads Up	5.d.xix.	Three Ball Toss
5.d.ix.	Heartbeat Ball	5.d.xx.	Two by Three by
5.d.x.	Invisible Balls		Bradford
5.d.xi.	Islands	5.d.xxi.	Zip, Zap, Zop

E) Setting, Story, and Character

5.e.i.	Everybody Do	5.e.v.	New York, New York
5.e.ii.	Gift Giving	5.e.vi.	One-Word Storytelling
5.e.iii.	Give and Take	5.e.vii.	This is a/is Not a
5.e.iv.	In the Manner of the Adverb	5.e.viii.	Story of my Name

F) Conflict, Power, and Problem-Solving

5.f.i.	Columbian Hypnosis	5.f.vi.	Obstacle Course
5.f.ii.	Defender	5.f.vii.	Three Changes
5.f.iii.	Keeper of the Keys	5.f.viii.	Trust Walk
5.f.iv.	Knots	5.f.ix.	Who Started the Motion?
5.f.v.	Mirrors		

D) ENSEMBLE, ENERGY, AND FOCUS

What is it? *Ensemble, Energy, and Focus* strategies rehearse pro-social behavior, collaboration, and focus through energized group challenges. Some of these strategies can also be played "in-role" from an imagined character's perspective.

Why use it? *Ensemble, Energy, and Focus* strategies focus on creating an ensemble through physical activity and group play. These strategies can create "moments where participation is impossible to resist" (Rohd, 1998). Many of these strategies position the teacher as a group member and model to support an all-play ethos. Most importantly, they create opportunities for groups to articulate and practice a shared social contract for how to positively interact with one another as an ensemble. This encourages deeper, more meaningful commitment to the group's goals, inviting teachers and students to "become jointly responsible for a process in which all grow" (Freire, 1970, p. 80).

When and where is it used? *Ensemble, Energy, and Focus* strategies can often be found in social-emotional learning curriculums and in the theatre classroom and rehearsal rooms. In DBP, teachers often use these strategies at the beginning of a lesson to establish and rehearse a culture of pro-social learning. For example, an elementary school teacher who wants to build a positive classroom community during the first week of school might play the Truth About Me, Circle Dash, and Fruit Bowl. Later in the semester, they might return to the Truth about Me or Fruit Bowl to explore classification in a science unit or use Zip Zap Zop or Three Ball Toss to review multiplication tables through skip counting. In a secondary classroom, Circle Dash or Heads Up can invite students to focus on eye contact, trust, listening, and collaboration during the first few weeks of classes, with the teacher actively modeling pro-social behavior alongside her students. Later in the semester, strategies like Heartbeat Ball can be used to discuss multitasking and goal setting for a group project.

How is it used? *Ensemble, Energy, and Focus* strategies can be used on a daily basis any time a group needs to focus, re-set, and connect. When using these strategies, teachers should consider the following:

Participant knowledge and skills

Academic: What is the learning objective? These strategies are often played two ways: (1) using the objectives of the original game, which involve focus,

collaboration, listening, and/or sequencing; or (2) using similar rules paired with curricular content to review and extend learning. Either way, it is most important that the group understands the strategy procedure first so that students are already versed in the strategy's rules when the teacher applies academic content to it. Many of these strategies also involve students' abilities to listen, observe, and make quick decisions about whether or not they should take action to meet a goal. These activities require students to multitask, to categorize and group by like characteristics, or to remember a sequence over time.

Affective: Are students able to listen, focus, share eye contact, build personal and group awareness, and use persistence within this strategy? If not, give time to learn how to work collaboratively. The group may need support in understanding how to handle challenging situations encountered in the game through a constructive and supportive manner. With time and repetition, students develop personal and social capabilities within each strategy and task.

Aesthetic: Are students able to use physical actions and their bodies with ease and confidence? The teacher can help students connect the ensemble activity to creative thinking and problem-solving skills, which are key to the artistic process. Consider ways to make connections between the persistence and skill building the activity requires and the way artists show initiative, confidence, resilience, and adaptability within their work.

Context needs

Group Size: For a large group, the teacher may need to select a game that will keep all students engaged in the action. Some strategies work particularly well with smaller groups playing simultaneously (Data Processing, Group/String Shapes). Other games are particularly suited to larger groups (Fruit Bowl, The Truth about Me, Stop and Go and Jump). Certain games work best with smaller numbers in a single group (Group Counting and Telephone). Be aware there are a few activities that involve students in specific sized groupings: groups of two (Two-by-Three-by-Bradford and People to People) and groups of three (People/Shelter/Storm).

Space: What space is needed to successfully move in this activity? Consider the importance of finding a space without distractions where the group can comfortably make a circle to play the game, and where everyone can hear and see the teacher for directions and classroom management.

Time: What time is needed to teach the strategy and play through it multiple times? Many of these strategies are purposefully constructed for the group to learn to solve a physical and cognitive task together; however, they need time to negotiate how to do it. Make sure to leave time at the end of the lesson to reflect and connect the task of the activity to the larger themes or questions of the class.

Spotlight on Facilitation

When planning a science lesson in his third grade class, Carlos wanted to use a Theatre Game as Metaphor strategy to help students make connections between animal characteristics and adaptations in specific habitats. Carlos's students often got off-task and became distracted when they were out of their seats during transitions. There were also some issues with negative social behavior between groups of girls in the room, which caused challenges both on the playground and in class. He decided to use The Truth About Me… to help build community in his class and engage with the classroom content. He began by using the strategy as a warm-up to work on collaboration and pro-social connections. He then taught content about animal characteristics. Finally, he played the activity again as a conceptual metaphor, so students could practice science vocabulary and apply their knowledge about animal characteristics and habitats.

Offer clear instructions and expectations

Consider how to give thorough information and check for understanding so every student can meet the expectations of the activity. Be prepared to offer simple, clear directions for each part of the activity.

To begin the activity, Carlos faced his seated students and explained:

> CARLOS: *Today, we are going to explore a new activity called The Truth about Me… To play this activity, we need enough space to make a large circle in the front of the class. Can someone raise their hand and offer a suggestion of how you think we might create enough space to make a standing circle in the front of the room?*

After suggestions were offered from the group, the class planned to move desks carefully and silently. Carlos clarified the group challenge: to move desks and create a standing circle without talking in 15 seconds. Then Carlos said GO and gave the group a slow count of 15 to successfully accomplish the task. The group moved the desks and stood in a circle. Carlos joined them as a member of the circle.

CARLOS: *Thanks for that great teamwork; this is a terrific circle. Your ability to move so quickly and quietly really lets me know that you are ready to explore this game. I have in my hand small pieces of blue tape that I've prepared. Please place your tape, on the floor, in front of your feet. This will mark a place in the circle. You might notice that I don't have a space. In this activity one player will always not have a space; they are the caller. The caller stands in the center and makes a statement that is true about them. After listening to the statement, if what the caller says is also true about you, you have to move to another space in the circle. At the same time the caller is also trying to get an open space. The last one to find a space becomes the new caller.*

He then demonstrates the game by stating his name and explaining the cognitive tasks required by the activity:

CARLOS: *So, in this game I might say, "My name is Mr. Carlos and the truth about me is that I am wearing shoes." This would be a smart choice because everyone would move—you all are wearing shoes. Or my statement might be about something that is true that you can't necessarily see…"My name is Mr. Carlos and the truth about me is that I was born in Texas." Or "the truth about me is that I like pizza." Remember, as active, successful students in this game, your job is to listen to the statement from the caller in the center and decide if the statement is also true about you. If it is true, your job is to find another space in the circle.*

Invite students to co-construct success

Consider ways to build guidelines of success through dialogue with the group for better ownership and understanding.

After explaining the general structure of the game Carlos asks the group:

CARLOS: *Because one of the goals of the game is to find an open place in the circle and not end up in the center of the circle, what suggestions do you have for how we might play this game successfully as a group?*

The students brainstorm ideas; he thanks each student for her or his answer and translates any negative statements to a positive action when necessary.

STUDENT: *No pushing people out of the way.*
CARLOS: **Thanks. Yes, can we agree to keep our bodies to ourselves at all times?**
STUDENT: *We want to walk fast but no running.*
CARLOS: **Thank you. Yes, can we agree to only walk fast in this activity?**

After taking a number of suggestions, he reviews the guidelines they have developed. He states that if they have difficulty following the directions, he will stop the game to discuss what is happening. Then they will work together to find a solution to the issue. He reviews the full directions of the game one more time. He could brainstorm possible "characteristics" and write them on the board (What is the participant wearing, what do they like, where have they been, what do they like to do?) as a visual prompt. Then Carlos steps into the center to begin the activity with a statement that he hopes will give a lot of students an opportunity to move.

CARLOS: **My name is Mr. Carlos. The truth about me is…I enjoy riding a bike.**

Focus on group challenges

Use task-related discipline to focus students on the game and group rather than their individual need for attention.

After playing a number of rounds, students understand the instructions and they begin to engage more energetically in the game. Two students clearly enjoy being in the center of the circle and begin to walk slowly so they can have multiple turns in the center. Carlos pauses the game and offers some side-coaching:

CARLOS: **I want to remind you of the rules of this game. Your job is to try and find a space in the circle. If you end up in the center a second time, no problem; I will choose someone else who hasn't been in the center to take your place.**

After this rule is added students stop trying to end up in the center. Also, once students understand that they will not get "stuck" in the center, they begin to engage even more fully.

Make thinking visible within and after the strategy

Direct participant attention toward strategic choices within the game. Model how to use critical thinking to be more successful, e.g., to get more people to move as the caller.

When a student offers a statement, *The truth about me is that I'm a student at Cooper Elementary*, everyone moves and Carlos pauses the game.

> CARLOS: *I want to point out that I just saw every single person move on the last statement made by Jinny. Why did we all move?*

Carlos works with the students to make meaning about the types of statements that can be used to get more or less people to move. He invites students to think strategically about how they might get a lot of students to move when they are in the center. After the game has played out and almost everyone has had a turn in the center, Carlos makes sure that he is the person left in the center so he can pause and end the game.

> CARLOS: *Terrific work. I am going to rejoin the circle for a minute. Let's talk about what we just did in The Truth about Me…*

(The following is reflection dialogue that might occur between teacher and students after the strategy is complete.)

> CARLOS: *What did you notice about yourself in this activity?*
>
> STUDENT: *I had to think fast.*
>
> STUDENT: *I couldn't think of anything about myself.*
>
> STUDENT: *I'm the only one who has three brothers.*
>
> CARLOS: *I hear you making observations about how you played the game and what you discovered about yourself in relation to the group. What did you notice about the group?*
>
> STUDENT: *We all love summer.*
>
> CARLOS: *What makes you say that?*
>
> STUDENT: *Everyone moved. But I didn't move. I like winter because that's when my birthday is.*
>
> CARLOS: *So not everyone moved on "we all love summer" but a lot of us did; why was that?*
>
> STUDENT: *Because we don't have school.*

STUDENT: *And we also get to swim and watch more TV. (Nods of agreement)*

CARLOS: **So was there any TRUTH that made us all move?**

STUDENT: *We all have hair. (They laugh)*

STUDENT: *We like pizza. (Nods of agreement)*

CARLOS: **How did you use strategies to be successful in this activity?**

STUDENT: *I chose something that everyone would like.*

STUDENT: *I moved really fast.*

CARLOS: **I hear you making connections to both how you used your mind and your body to be successful in this game. Thank you.**

Play the strategy for the procedure first, then add curriculum content

Make time for students to understand the rules of the activity before they play as something or someone else. Use the strategy as an anticipatory set for learning and review around characteristics.

Carlos has the students move their desks into cooperative learning groups, which they often use in class. Each group gets an image of an animal in a unique habitat. They complete a worksheet in which they make observations of the habitat using geographic vocabulary (e.g., tundra, desert, and rainforest) and the animal within it. They observe characteristics of the animal (ear size, skin/fur, claws, and size of mouth/teeth) and make connections between animal characteristics and its location. Eventually, each group is given a picture of their animal attached to a piece of string to wear around their neck. Each member of the group has an image of the same animal. Carlos invites students to re-set the circle for The Truth about Me… This time, however, students will play the game as their animal. They review the types of truths they might name (kinds of claw, body/fur covering, color, size, etc.). Then, Carlos stands in the center wearing his picture of the polar bear on a string.

CARLOS: *I am a polar bear. The truth about me is the color of my animal fur camouflages me when I am in my habitat…*

Carlos continues to play this strategy to assess student understanding of content knowledge and academic vocabulary.

5.d.i. Buzz

Source: Unknown
Number of Players: 5+
Space: Room for a standing circle
Materials: None

What is it and why use it?

Buzz invites students to physically, verbally, and cognitively demonstrate knowledge through an energizing group challenge. This strategy allows students to verbally and physically represent a pattern, usually related to math or numeracy.

Directions

Invite students to stand in a circle. Introduce the activity: *In my hands is an imaginary bolt of energy; the goal is to pass this energy around the circle as the groups counts numerically from 1 to 30.* (The end number can be adapted as needed so that everyone gets to pass a number 2 or 3 times.) Encourage students to work quickly to maintain engagement and develop ensemble skills. *How fast can we pass 1–50 around our circle?* Once this is mastered, add the next level. Depending on the math content, state that certain numbers (multiples of 2, prime numbers, etc.) will no longer be used in the game; instead, the person will say "buzz." For example, if the group is working on multiples of "5" then the game would sound like "1, 2, 3, 4, Buzz, 6…" Students should work through the process slowly. Everyone listens to make sure that no mistakes are made and corrects the math when necessary. Once all students are clear on the sequence, the teacher might repeat the same math pattern multiple times to improve speed and fluency. Start each sequence in a different part of the circle to vary who says which numbers. If there is a mistake, encourage students to simply start again without discussion.

Reflection

- *What did you notice about yourself in the activity? What did you notice about the group?*
- *What strategies did you use to be successful?*
- *What sort of pattern did you notice as we played multiple rounds with different numbers?*

Possible side-coaching

- *Work to stay focused. Let's see if we can get the bolt of energy to never hit the ground.*
- *Don't worry if we make a mistake. Fix it and let's keep going.*

Possible variations/applications

- Have students play in smaller table groups of 4–6 in which they practice speed and fluency of sequence (everyone works on multiples of 3, or some groups work on 3s while other's do 4s); groups can share for each other when they feel they are ready.
- Reading/Writing: Ask the group to list the alphabet (a, b, c…); every time a vowel comes up, the students say "buzz."

5.d.ii. Circle Dash

Source: Michael Rohd
Number of Players: 6+
Space: Room for a standing circle
Materials: None

Image 10: Circle Dash.

What is it and why use it?

Circle Dash invites pairs of students to successfully, silently switch places in a circle before a center person can take their open space. This strategy encourages the development of non-verbal communication, risk-taking, making and accepting offers, and observation skills. It can also be used as a metaphor for other spaces in class or in life in which non-verbal communication, risk-taking, and strategizing are necessary.

Tips for playing!
Place tape in a circle to indicate where to stand.

Directions

Everyone stands in a circle. It may be useful to mark each person's space with a small piece of tape or some other floor marker. Introduce the activity: *We will begin by silently "switching places" with one other person in*

the circle. Explain that when two people agree to swap spaces they must both commit to completing the switch. Begin playing. After a number of switches have been made, discuss strategies that were most successful. Any questions? Next, remove one space in the circle and stand in the middle of the group. Explain that while the group is making silent switches, a person in the middle will try to get to an open spot before the people who are trying to switch make it to their new spot. The person left without a spot goes to the middle. Play the game. Each person controls the number of times they want to switch places. If someone is in the center too long the teacher can call out *All Dash!* which means that everyone finds a new space including the person in the center. The last person to a space is the new center person.

Reflection

Make the transfer!
Use this strategy as a metaphor for ways to effectively observe and/or strategize.

- *What did you notice about yourself as you participated in this game?*
- *What strategies did you use to get the attention of, or communicate with your switching partners?*
- *What strategies did you use to "out switch" the person in the middle?*
- *What does it take to make this game "work?" How might those things be useful in our classroom work?*

Possible side-coaching

- *Be sure to make eye contact with someone before you try to switch places.*
- *Please be aware of each other's bodies when switching places and moving through the circle.*
- *More than one pair can switch at a time—so make eye contact and go!*

Possible variations/applications

- Establish a rule that students cannot switch with the person next to them. This makes the switches a bit more complicated, which can help the center person get an open space.
- Establish a rule that each participant can only be in the center once. If a player gets in the center a second time, a new center person takes their place. When playing with this rule, it can be helpful to establish the "group goal" of giving everyone a turn in the middle the circle.

5.d.iii. Crumbling

Source: Unknown
Number of Players: 6+
Space: Open area
Materials: None

Image 11: Crumbling.

What is it and why use it?

Crumbling invites students to move around an open space, control their bodies, and be responsible for gently catching one another as they crumble to the ground. This strategy helps students build trust and awareness skills through a collaborative group challenge.

Directions

Define a large designated space with lots of room to move. Introduce the activity: *In this strategy everyone receives a number. Then we cover the space silently and I will call out a number and the person with that number will call out "Crumbling!" then crumble their body very slowly and safely toward the ground. At the same time, the rest of the group tries to support the crumbling student to stand upright again.* Clarify that the goal for the group is to keep the person crumbling from falling to the ground. The goal for the person crumbling is to call out loudly and to crumble slowly, so that they can be caught. It can be useful to model this action and ask the group to establish rules for safety and physical contact for both the people crumbling and the people working to catch the crumbler(s). Invite students to walk in the space, without speaking or making physical contact. When the group has reached a comfortable rhythm and pace, call out a number. Once the crumbler has been brought back up, repeat the process. Once directions are clear, 2 or 3 numbers can also be called at the same time. If the group is struggling, pause the game and strategize ways to be more successful.

Reflection

- *What did you notice about yourself as you participated in this activity? What did you notice about the group?*
- *How did it feel to crumble, to be caught, and to catch?*
- *What skills did we use in this activity to be successful and safe and solve the problem? How else can we use these skills?*

Make the transfer!
Use this strategy as a metaphor to explore how to work together as a group or class.

Possible side-coaching

- *The group is responsible for everyone's safety and there are never too many catchers.*
- *It should be silent except for the voice saying "crumbling."*

Possible variations/applications

- The group can use "the force" or imagined energy from their hands to support the people who crumble; no physical touch is required.
- Math: Have students wear a sticky note with their number attached to their shirt. Explore different sorts of math facts. *Crumble if you are an even number! A factor of 2. Divisible by 3. If you have a 2 in the hundreds place. If you are a multiple of 5.*
- Social Studies: Have students play as a US state (e.g., California, Ohio, and Virginia). *Crumble if your state is bordered by an ocean.* Or as a figure from history.
- Reading/Writing: Have students play as a character from a story. *Crumble if your character was against war in our story.* Or as a word. *Crumble if you are an adjective.*
- Science: Have students play as an animal or an element from the periodic table.

5.d.iv. Data Processing

Source: Unknown
Players: 5+
Space: Room to make one, two, or three single-file lines
Materials: Nametags, index cards, or post-it notes (optional)

What is it and why use it?

Data Processing is an activity in which a group quickly and silently puts itself into a single line continuum based on visible or invisible characteristics (e.g., height—smallest to tallest, birth/month—January 1 to December 31). This strategy engages students in an active, embodied problem-solving process and offers a concrete way to review how to sequence a collection of data points. Students can play from their own experience or physical characteristics or they can play "as if" they were a number, fact, date or event from history, etc.

Directions

Define a playing area(s) where students have enough room to create a single-file line(s). Offer a challenge to the group: *How quickly can the group line up from shortest to tallest without making a single sound?* Define each end point of the continuum: *shortest here and tallest here*. Explain that if there is a sound the game will stop and the group will have to try again. Ask the group to raise a hand when they believe they have successfully completed the task. Start the timer and begin the activity. Afterward, reflect on how it went and what strategies were used to be successful. Next, invite students to see how fast they can form an alphabetical line by first name (or surname/last name, depending on the desired difficulty level) from A to Z without making a sound. Students may need to review the rules of alphabetical order or brainstorm ways to communicate non-verbally prior to playing. When the students are finished, each person says their name (first or last) to collectively check their answers and make any adjustments. There are numerous variations for this strategy. This activity can be timed so that groups can try to beat their own "time" each round or compete to beat a set time (i.e., a minute).

Reflection

- *What did you notice about yourself as you participated in this activity?*
- *How did you find ways to communicate with each other? What were some of the different forms of non-verbal communication the group used?*
- *Which line up or continuum was easiest to create? Which was the most challenging? Why?*

Possible side-coaching

- *Remember this is a silent activity. How will you silently communicate your needs to others?*
- *Open up your awareness to your group members, who may be trying to communicate with you.*
- *Let me know that your continuum is complete by raising your hand silently in the air.*

Tips for playing!
If students are playing as someone or something else, give them a card to hold or wear so others can see the data point they represent.

Possible variations/applications

- Divide students into smaller groups so that they compete with each other to see which group can complete the continuum successfully first. Or all groups can race the clock so there is less competition between the groups.

- Math/Music/History/Science/Reading: Invite the group to step into a role as a collection of data points that need to be sequenced or placed in relationship to each other, for example, numbers on a number line, musical notes on the treble clef, events in history, steps in the scientific method, and parts of a story.

5.d.v. Fruit Bowl

Source: James Thompson
Number of Players: 5+
Space: Room for a standing circle
Materials: Chairs can be used

What is it and why use it?

Fruit Bowl invites students to listen, negotiate, move, build, and represent knowledge kinesthetically. Everyone, including the teacher, is up, moving and playing together. This strategy lends itself well to the exploration of a targeted set of vocabulary, since there is a lot of repetition and the scope is limited.

Directions

Ask the group to set up their chairs in a wide circle, or invite students to stand in a circle with a piece of tape or non-moveable floor marker to designate each standing spot. The teacher does not make a spot in the circle. Either construct with group or share a pre-determined list of 3–4 names of fruit. It can be useful to provide a visual anchor chart of fruit names as well, particularly if the vocabulary is new. Go around the circle and assign each person a fruit name from the list; it is important that at least 3 people have the same fruit names, so use fewer fruit names if the group is small. Make sure the teacher has a fruit name too! Next, stand in the middle of the circle and say the name of a fruit on the list (it does not need to be your own). All participants with the fruit name must find a new space/seat. The teacher tries to find a spot as well. This leaves a different person standing in the middle. They repeat the process. Rather than saying the name of a single fruit, the person in the middle can also say "Fruit Bowl," at which point everyone must change chairs. If the same person gets in the center multiple times, they can be asked to pick someone who has not been in the center to take their place.

Reflection

- *What did we notice about yourself and the group in this activity?*
- *What type of strategies did you discover, and use, to be successful in this game?*
- *How can we use these same strategies in our work together this year/in this unit?*

Possible side-coaching

- *Only one person should be in a chair or standing space at a time.*

Possible variations/applications

- Reading/Writing: Have students play as words that represent different kinds of chunk sounds in order to work on syllabication ("ch," "th," and "cr"). Then, the caller in the center picks a word from the list (or is told a new word) and then everyone who has a word that also uses the chunk sound must move.
- Foreign Language: Have multiple students play as "I form," "You form," etc. The center person calls out a verb from the list (or is given a verb) and students must move if the verb is in their form.
- Math: Have students play as a two-dimensional shape and call out characteristics from a list (*at least three vertices*) or they play as number and calls out characteristics like place value, divisible by, factor of, and multiple of.

5.d.vi. Group Counting

Source: Various
Number of Players: 3+
Space: Room for a standing circle
Materials: None

What is it and why use it?

Group Counting invites students to count out loud from 1 to 20 (or higher) as a group without a designated order. This strategy asks students to heighten their awareness of the group, practice patience and listening, and work together to accomplish a challenging group task.

Directions

Invite students to stand in a circle. Introduce the activity: *Our task is to count from 1 to 10 out loud, in random order, with each group member offering one number at a time. If two people say a number at the same time, the game stops and begins again with 1.* Explain that anyone can say a number whenever they wish, although they cannot say two numbers in a row. To begin, ask everyone to close their eyes or focus on the floor in the center of the circle, then say, *Go!* The teacher might set an initial goal: *Can we get to 10?* Then, push the group to count to 15 or further, if possible. It can be productive to stop the game and discuss group strategy. Part of the learning is the groups' discovery about how to solve the difficult task.

Reflection

- *On a scale of 1–10, with 10 being very successful and 1 being not so good, how did we do as group? Why?*
- *When did you choose to say a number? When did you choose to stay silent?*
- *What skills or strategies did you use to be successful in this activity?*
- *How might we use these same skills/strategies in other areas of our classroom?*

Possible side-coaching

- *Take your time. There's no need to rush. Working together takes time.*
- *Let's all take a deep breath to regroup.*
- *Try to sense when it might be your turn—listen and be aware of the whole group.*
- *Try staring at a focal point in the center of the circle to stay focused and to listen.*

Possible variations/applications

- Use the game as a closing activity for each class so students can end their work in a focused, collaborative mindset, and also track their improvement over time.
- Reading: Instead of numbers, try reciting the alphabet one letter at a time.
- Math: Repeat this activity multiple times and chart the group's progress each time. The number achieved can serve as data to teach averages, mean, median, mode, and range as well as probability, fractions, and percentages. Students can also count by 2s, 3s, etc.

5.d.vii. Group String Shapes

Source: Various
Number of Players: 5+
Space: Open Area
Materials: A large length of string
or yarn knotted together at the ends

Image 12: Group String Shapes.

What is it and why use it?

Group String Shapes invites students to use their collective group of bodies to create and represent shapes, often with string. This strategy is an exercise in non-verbal communication and group problem-solving.

Directions

Designate a playing space. Ask students to work together to silently make a shape (e.g., *Make a triangle)*, as quickly as they can, using a length of string or their bodies. A time challenge can also be given. Afterward, ask the group to explain how they know they have made the shape. Next, explore other shapes based on the investigation. For example, *explore specific types of triangles (equilateral, isosceles, and right); explore the perimeter of a square, then use this measurement to make two right triangles; explore a two-dimensional shape and turn it into a three-dimensional shape; explore perimeter and area using standard or informal units of measurement.* Students may need to talk as they work to solve the challenge, especially when tasks become more difficult. With each shape made, it is important to work collectively to "prove" how students know they have made the requested shape. Students should be encouraged to use mathematic vocabulary (angle, height, width, perpendicular lines, vertices, diameter, radius, etc.), whenever possible.

Reflection

- *What was the easiest part of this exercise? What was the most difficult? Why?*
- *If working silently, what communication strategies did you use? How did your group work together as a team?*

- *What relationships did we discover between the shapes we made? How can we use these same strategies in other areas of our curriculum or classroom?*

Possible side-coaching

- *How will you solve the problem without talking?*
- *Open up your awareness to your group members who may be trying to communicate with you.*

Possible variations/applications

- Have students work in small groups to solve the same task and compare strategies and results.
- Give students the answer and have them work backwards: *Make a rectangle with the perimeter of 12; pick your own informal unit of measurement.* Or, *make a scalene triangle with the perimeter of 13.*
- Math: Have students use string/yarn to make examples of angles (e.g., acute) or lines (e.g., perpendicular or parallel).
- Reading/Writing: Have individuals or a group use string/yarn to map a line or shape which metaphorically represents their experience of something (*what I did over the summer or our work together on the project*). Individuals or groups can also map a representation of a character's journey and use post-its or other types of labels to map significant moments or events.

5.d.viii. Heads Up

Source: Various
Number of Players: 7+
Space: Room for a standing circle
Materials: None

What is it and why use it?

Heads Up is about building ensemble through eye contact and non-verbal, personal connection. It also explores ideas of chance. This fast-paced strategy serves as an efficient, effective way to build focus as a group at the beginning or end of a lesson.

Directions

Invite students to stand in a circle. Introduce the activity: *When I say "Heads down," everyone put their heads down. When I say "Heads up," please lift your head and look directly at one other person in the circle. If two people happen to randomly choose to look at each other, then you both are out of the game. If you look at someone and they are looking at someone else, stay in the game. Next, I will say "Heads down" and people still in the game, put heads down; people out of the game, step out of the circle and the game to watch.* (Students who are out of the game can help point out when players in game make eye contact and should also be out.) As the game gets smaller, students may need to step closer in to make a smaller circle. Continue to say "Heads down. Heads up." until one or two players remain. When this happens, the others re-join the circle, and the game re-starts with every player for another round.

Reflection

- *What did you notice about yourself as you participated in the activity?*
- *What did we do in this activity? What skills does this game require?*
- *Why was there laughter?* (There is often laughter when players make eye contact.)
- *Why is eye contact important in the work we will do together?*

Make the transfer!
Use this strategy as a metaphor to explore themes of luck, chance, risk, and/or strategy.

Possible side-coaching

- *Let's adjust the circle to see who is still playing.*
- *Remember you must choose a specific person as your point of focus each time you look up.*

Possible variations/applications

- Instead of stepping back, when two students make eye contact, have them switch places and stay in the circle. In this version, there is no way to be "out."
- Math: Invite someone to take a quick count of the number of the group still in the game each round. Chart the numbers and explore proportions, percentages, ratios, or probability.

5.d.ix. Heartbeat Ball

Source: Julie Pearl
Number of Players: 5+
Space: Room for a standing circle
Materials: A large ball and other common objects that can be passed in a variety of ways (see directions)

What is it and why use it?

Heartbeat Ball invites students to work collaboratively to maintain the steady beat of a ball—the heartbeat—as it is passed around a circle in a single direction, while also passing multiple objects in different ways and different directions. This activity requires students to strategize and multitask while remaining focused on a single collective goal (maintaining the heartbeat).

Directions

Gather a number of objects including a playground ball, which is easy to catch. Additional objects can include a second ball made of soft material, a very long necklace, an empty gallon-sized can, a cane or tall stick, a hat, a bag with a stiff circular handle, glasses, etc. Invite players to stand in a circle. Hold up the playground ball and explain that this is the heartbeat ball. The group's goal is to pass the ball in a steady, consistent rhythm around the circle in a single direction. The sound of the ball being caught should resemble a heartbeat. There should be no talking. The group passes the ball in one direction until a solid rhythm is established. Next, introduce a new object into the game, which is passed from person to person in the opposite direction of the circle to the ball (see Possible Variations/Applications). Let the group explore passing the new object. Explain that although the new object is important, the MOST important aspect of the game is the heartbeat ball; other objects can stop and start. Then, start the ball and the new object together at the same time until the group can pass both with success. Proceed to add new objects into the game one at a time. It is useful to change directions for each new object (e.g., if the heartbeat ball goes clockwise than the next object to be added goes counterclockwise). The number-one priority is always the heartbeat ball. If the heartbeat ball drops to the ground, the game stops, the group strategizes how to play more effectively, and starts again from the beginning adding each additional object back one at a time.

Reflection

- *On a scale of 1–10, with 10 being very successful and 1 being we need some work, how successful were we?*
- *What was easy? What was difficult? Why?*
- *What strategies did you use to make sure the group was successful?*
- *How is the heartbeat in this game a metaphor for our work together?*

> **Make the transfer!**
> *Use this strategy as a metaphor to explore how and why we multitask, prioritize, and focus.*

Possible side-coaching

- *Remember, your number-one goal is to maintain the heartbeat.*
- *Each new item is another problem to solve. How will you still make the heartbeat your priority?*

Possible variations/applications

- Explore and vary the kinds of objects added and how they are passed. For example, a tin can might be passed with the left foot to the left by sliding it on the ground; a necklace might get put over the neck of the person to the right, and a large broom handle might be hit against the ground two times before passing it to the person on the left. If you play this game over a long period of time, encourage students to bring in new objects to add to the mix.

5.d.x. Invisible Balls

Source: Viola Spolin
Number of Players: 4+
Space: Room for a standing circle
Materials: None

Image 13: Invisible balls.

What is it and why use it?

Invisible Balls engages students' imaginations as they pass energy across the circle in the form of an invisible ball with a specific size, shape, and weight. In this activity, students practice ensemble-building skills, accepting offers, and using detail in their pantomime.

Directions

Invite students to stand in a circle. Introduce the activity: *I have an invisible ball in my hands that has a specific size, shape, and weight.* Then, use pantomime to demonstrate the characteristics of an imagined ball by throwing it back and forth in your hands, e.g., imagine holding a very large, round, heavy ball. Ask students what they saw you do. Develop vocabulary about how artists use body, shape, and attitude in pantomime. Explain that when the invisible ball— that has a particular size, shape, and weight—is passed to another player, they should keep the size, shape, and weight consistent as they catch the ball. Pick up the imaginary large, heavy ball again and toss it to another participant to model the action. Once the new participant has the ball, invite that participant to change the invisible ball to a new imagined size, shape, and weight and pass the ball to a new person, who then repeats the process. As the group passes the ball around the circle, encourage each player to use their body, shape, and attitude to establish the characteristics of the ball as it is received, transformed, and thrown to someone else. The imaginary ball can travel randomly across or from person to person in sequence around the circle.

Reflection

- *What did you notice about yourself as you participated in this activity? What did you notice about the group? What kind of balls did we imagine?*
- *What did we need to do in order to be successful at this activity?* (Useful to reference aesthetic skills here: detail, imagination, etc.)
- *Where else in our work might we also use these skills?*

Possible side-coaching

- *Really see the ball. Feel its weight in your hands. Be specific and detailed with your movements.*
- *How do you throw this type of ball? How do you catch this type of ball?*
- *Don't think or pre-plan what you're going to do ahead of time—just receive the ball as it was given to you and let the changes occur naturally.*

Possible variations/applications

- Add sound when the ball is thrown and the receiver echoes the sound when (s)he receives the imagined ball. Then, as the receiver changes the size, shape, and weight of the ball to become the thrower, they use their new sound when throwing the ball to someone else.

- Science: Have students throw and catch balls with different densities. The teacher should coach them to pantomime these details with specificity. Explore how to make solid, liquid, or gas balls.
- Reading/Writing: Using a list of adjectives/adverbs, have students demonstrate/explore their understanding of the words based on how they throw/catch balls with different physical qualities.

5.d.xi. Islands

Source: James Thompson
Number of Players: 5+
Space: Open area
Materials: Newspapers

What is it and why use it?

Islands is a strategic ensemble-building activity that invites students to negotiate fitting their bodies into a diminishing number of spaces in a limited amount of time. This activity is often used as an icebreaker to establish guidelines for appropriate physical contact and can serve as a metaphor for numerous social, science, and cultural topics.

Directions

Prior to the activity, place sheets of newspaper around the floor of a large area with one fewer sheets than the number of players. To begin, establish an outside perimeter for the activity that includes all the newspaper sheets and space to move. Introduce the activity: *In a moment I will ask you to "go for a swim," (which means that you walk or swim silently) making sure you don't tread on the paper or "islands." At some point I will call out "Sharks!" Then, each player needs to put his or her entire body on a sheet of paper to remain in the game. Once everyone is safe, I will remove an island or two and we will begin again. The goal is for the group to keep everyone safe from sharks for as long as possible.* Begin the game. The group is safe if no part of anyone's body is touching the surrounding floor; multiple people will end up sharing one sheet of paper. End the activity when the whole group has successfully negotiated staying "safe" on a few remaining pieces of newspaper or when the students have collapsed in an amicable pile trying.

Reflection

- *What did you notice about yourself in this activity? What did you notice about the group?*
- *Were we successful in this game? Why or why not?*
- *What strategies did you use to solve the challenge? Where else might we need to apply these strategies?*
- (Optional content connection) *What other situations do we see in our world in which many people have to share a small amount of land or resource?*

Possible side-coaching

- *Keep moving around the space.*
- *Watch the other bodies on your island when you join up. Take your time to play safely and strategically.*
- *No one is safe until everyone is safe.*

Possible variations/applications

- Use music to cue swimming off the "islands"; use hula hoops instead of newspaper.
- Reading/Science: Use the islands to represent dwindling and/or less diverse resources as in *Hunger Games* by Suzanne Collins or in a unit on climate change.

5.d.xii. Jump

Source: Unknown
Number of Players: 3+
Space: Room for a standing circle
Materials: None

What is it and why use it?

Jump invites students to jump in the air together without a designated leader. This strategy asks students to heighten their awareness of the group, practice patience and listening, and work together to accomplish a challenging task.

Directions

Invite the group to stand in a circle. Introduce the activity: *Our task is to jump up and land at the same time; we must do this silently and cannot cue each*

other when to start. The jump has to be done together and none of us alone can cue the group to go. If one person starts to lead (by obviously bending their knees or other physical cues), then the whole group has to start over. To begin, ask the group to focus on the center of the circle, then invite the group to jump when they feel all students are ready. If challenges arise, pause the game to discuss strategy. Once the group has successfully completed one jump together, encourage the group to synchronously jump three times in a row.

Reflection

- *On a scale of 1–10, how did we do as a group?*
- *When did you choose to jump? When did you choose to wait?*
- *What skills or strategies did you use to be successful in this activity?*
- *How might we use these same skills/strategies in other areas of our classroom or inquiry?*

Possible side-coaching

- *Take your time. There's no need to rush. Working together takes time.*
- *Try to sense when the group is ready—listen and be aware of the whole group.*

Possible variations/applications

- Use the game in a gym or on a stage floor. The echo that the jump produces energizes and excites the group to keep focused on jumping together.
- Use the game as a beginning or closing ritual for *each* class so that students can begin or end their work in a focused, collaborative mindset, and also track their improvement over time.
- Reading/History: Explore themes like communication, group mindset, and collaboration that connect with moments in history or action in a story.

5.d.xiii. People Shelter Storm

Source: Augusto Boal
(and others)
Number of Players: 12+
(multiples of three are ideal)
Space: Open Area
Materials: None

Image 14: People Shelter Storm.

What is it and why use it?

People Shelter Storm requires students to shift roles and quickly organize themselves into three-person group formations based on specific prompts. The activity gets students moving, listening, and practicing reasoning skills. It can also be used as metaphor for inquiry around habitats, basic needs, and group problem-solving.

Directions

Invite students to make groups of three. Introduce the activity: *In your group of three, two people represent a "shelter" (they face each other and raise their arms so that palms meet to form an angled roof) and one person represents "people" standing underneath/inside the two-person "shelter." When I call out "people," the person in the center of each group will leave their shelters and run to a different "shelter" pair, while all the "shelter" pairs stay in place.* Practice "people" a few times. *Next, when I call out "shelter," the students making a shelter will break apart, the people stay in place, and the shelters must find a new person to make a shelter over.* Explain that shelters can and should separate. They do not need to travel together to find a new person. Try "shelter" once or twice, making new shelters around the space. Introduce the final cue. *When I call out "storm," everyone moves and makes a new group of three. You can choose to remain in the same position or change—shelters can become people and people can become shelters as long as every shelter has a person.* Once directions are understood, the game begins. Alternate between calling out "people," "shelter," and "storm" in random order.

Reflection

- *What did you notice about yourself as you participated in this activity? What did you notice about the group?*
- *What strategies did you use to find a new trio?*
- *What connections can we make between this strategy and our current work in the classroom?*

Make the transfer!
Use this strategy as metaphor to explore resources, ecosystems, and/or problem-solving.

Possible side-coaching

- *Remember, only the shelters (or people) can move!*
- *Find a group as quickly as possible!*

Possible variations/applications

- With uneven numbers, the last person to get in a group of three becomes the next caller, or the teacher can also play.
- Allow students to add in sounds or movements during the storm transition.
- Science: Have the group make their own 3-person images to represent different habitats and an animal that might live in it. Explore different types of storms or natural disasters like earthquake, tornado, or tsunami; develop a unique movement vocabulary for each event.
- Math: Have 2/3 play as assigned numbers and 1/3 play with a card that has < on one side and > on the other. Each new group of 3 requires the trio to flip the middle card to the correct direction.
- Once the shelter/person group of 3 is complete offer a prompt for them to consider together, e.g. *Share out one goal you have for our work together today*. After all the groups dialogue, return to the game using the commands to make a new group of 3 and then ask a different reflection question.

5.d.xiv. People to People

Source: Various
Number of Players: 6+ (even numbers are ideal)
Space: Open area
Materials: None

What is it and why use it?

In People to People, partners collaboratively problem-solve to physically connect different body parts based on prompts from the teacher. This icebreaker invites students to engage in safe physical contact through non-verbal negotiation. The teacher also has the opportunity to scaffold the level of risk through intentional choices about which body parts students are asked to connect.

Directions

Invite students to begin walking around the room. Introduce the activity: *When I say "people to people," everyone must find a partner and stand next to them*. Once paired, offer a direction. For example, *Elbow to elbow! This means*

each pair must connect their elbows in any way they want. Ideally, both students must follow the direction, so both elbows from both students are touching. Then ask the group to walk the space again until they hear *people to people* to find another pair again. Play a number of rounds. Vary the body parts connections (*elbow to knee, hip to hip, shoulder to hand, etc.*) Try keeping pairs together for to connect multiple sets of body parts (*foot to foot* then add *hand to back*). Repeat this process a number of times, offering students different sorts of challenges to problem-solve with their partners.

Reflection

- *What did you notice about yourself as you participated in this activity?*
- *How did you and your partner work together to follow the instructions?*
- *What factors impacted your success with each challenge grouping?*
- *How can this activity serve as a metaphor for a larger inquiry or goal of our group?*

Possible side-coaching

- *Is there another way you might be able to accomplish this instruction?*
- *Make sure you're taking care of your partner.*
- *How can you work together to accomplish your task?*

Possible variations/applications

- After students have grouped and connected body parts, ask them to disconnect and respond together to a reflective question: *Share one success you had today. Name your favorite moment in the story we read and explain why. Discuss whether you think young people should vote at age 18 or 21.* Then, have them regroup people to people, connect body parts and give a new reflection prompt.
- Invite students to offer suggestions for instructions that require careful problem-solving.
- If the group becomes comfortable with working in pairs, try having students perform the given tasks in groups of three.
- For groups who struggle with physical contact, ask students to imagine that they are connecting with "the force," so body parts are close together but not actually touching.
- Use this strategy to regroup students into working partners for the next activity.

5.d.xv. Round of Applause

Source: Various
Number of Players: 5+
Space: Room for a seated circle
on the floor, in desks or at a large table
Materials: None

Image 15: Round of Applause.

What is it and why use it?

In Round of Applause, students pass a hand slap on the floor or tabletop, or a handclap/foot stomp, around a circle, striving to slap/clap/stomp at the exact same time or in sequence. This activity requires listening, collaboration, and focus to achieve group success. The strategy can be used as a metaphor to prompt dialogue about collaboration and problem-solving strategies.

Directions

Invite students to sit on the floor, with both hands out in front of them, flat on the ground. If students are in desks, hands should be on desks, as close to each other as possible. To begin, slap your left hand on the ground, as the student to the left, Player 1, slaps his or her right hand on the ground. The hands nearest each other should slap the ground at the same time. Player 1 then slaps his or her left hand at the same time that Player 2, next to Player 1, slaps his or her right hand against the ground. The slap continues to move around the circle. The same process can be used with students standing in a circle and clapping their hands together or stomping their feet at the same time to pass the sound around the circle. The group challenge is to clap at the same time and to keep the sound moving around the circle. Whatever version is being used, after a few rounds, add a second clap or slap, so that two slaps/claps are moving around the circle at the same time.

Reflection

- *How did you do in this activity? On a scale of 1–10 how successful were you?*
- *What do we need to do to be successful at this activity?*
- *What skills does this help us to develop that we can apply to our current inquiry?*

Possible side-coaching

- *Pay attention to which hand you are using.*
- *Really listen to the rhythm.*
- *See if we can establish a steady tempo.*
- (If clapping) *Make sure you make eye contact with your partner.*

Possible variations/applications

- Introduce a double clap, in which players have the option to hit the ground (or clap hands) twice in a row. When this happens, the clap reverses the direction in which it is traveling around the circle.
- Music: Develop a steady rhythm with the clap/slap equally different types of notes (half note, quarter note, etc.). If interested, two claps can move around the circle at different beats (such as a quarter note and a half note).
- Create a circle on the floor; students alternate hands on the floor with the person next to them. (Other people's hands will be between their two hands.) Make the slap sounds in the same way, with the added challenge of moving sound sequence while hands are intertwined.
- Science: Have students represent a circuit or a food chain (*What happens when one part is pulled out? The movement can't continue or we must find a way to adapt or evolve*).

5.d.xvi. Stop and Go and Jump

Source: Unknown
Number of Players: 3+
Space: Open area
Materials: None

What is it and why use it?

Stop and Go and Jump is a physical and mental warm-up that involves listening and body awareness. It begins with simple prompts that students respond to as they move through an open space. Later, when the teacher announces that the meanings of prompts are switched, students must remember the new meaning for each prompt and the corresponding action.

Directions

Define the playing area and invite students to walk silently around the space. Encourage students to be aware of their pathways and change walking patterns often, while remaining aware of the rest of the group. Introduce the prompt "stop": students freeze their bodies in place. Then, introduce "go": students continue walking. Rehearse the prompts until they are understood. Next, introduce "jump": students make a small jump in place, as bodies are able. The final prompt is "name": students state their name out loud once. Once all the vocabulary and responses are clear, play the game by alternating through different prompts. Next explain that prompts will begin to swap, beginning with swapping "stop" and "go" with each other, so that when students hear "stop," they start walking and when they hear "go" they freeze. Switch the actions of "jump" with "name." If desired, add a third set of actions "arms": lifting arms up and "knees": hands on knees, into the game.

Reflection

- *What different skills did you have to use to successfully participate in the activity?*
- *What was challenging about this activity? What was easy? Why?*
- *What skills did you use in this activity that you want to use in our work today?*

Make the transfer!
Use this strategy as metaphor to explore listening, collaboration, and group mindset.

Possible side-coaching

- *Try not to walk in a circle. Make sure your feet are covering the entire space.*
- *Listen carefully so you can process the command quickly before responding.*
- *Remain aware of others in the space.*

Possible variations/applications

- Invite students to be the caller who chooses the prompts for the group.
- Work together to create new prompts with academic vocabulary and gestures to add to the prompt vocabulary.
- Math: Have students create gestures for parallel lines and perpendicular lines, or acute and obtuse angles.
- Science: Have students create gestures for landforms like mountain, butte, or island. In this version, the teacher does not swap gestures and names.

5.d.xvii. Telephone

Source: Unknown
Number of Players: 4+
Space: Room for a standing or seated circle
Materials: None

What is it and why use it?

Telephone challenges students to share a single phrase, with the goal of repeating the phrase to the next person exactly as it was said to you. This activity demonstrates how verbal messages have the potential to change and evolve when shared over time through multiple people. It can also serve as a metaphorical representation of rumors and gossip, a circuit, or a catalyst.

Directions

Invite students to sit or stand in a circle. Introduce the activity: *I will begin by thinking of a word or phrase and whispering it in the ear of the participant next to me. That person whispers the phrase in the ear of the participant next to them, using the exact same words as it was passed to them, and so on around the circle.* Explain that the group challenge is to pass the message without changing anything. The catch is that no one may ask for a repeat of the whisper; students simply repeat whatever they thought they heard the first time. The idea is to see if we can get the same phrase to travel all the way around our group. Once the word or phrase has been passed around the circle, the first and last person shares the beginning and phrase. Discuss how or why the phrase might have changed. Suggest strategies for success and try again.

Make the connection!
Use this strategy as a metaphor to explore circuits, adaptation, evolution, or gossip.

Reflection

- *How did we do as a group? Were we successful? Why or why not?*
- *How did the message change as it traveled?*
- *How does this game relate to your understanding of a rumor or gossip?*
- *What does this game have to do with the way people communicate every day?*

Possible side-coaching

- *No repeats allowed—say whatever you thought you heard!*
- *Remember the goal is try and successfully share and maintain the phrase around the circle. Think about what choices you can make to help us achieve our collective success.*

Possible variations/applications

- Pass a pantomimed gesture or sound instead of words.
- If helpful for the group, allow students to say "operator" to hear the phrase a second time after it is spoken to them.
- Reading/Writing or Social Studies: Use the strategy to discuss a moment in a story, text, or historical event in which information gets passed from person to person. Invite students to consider: *What parallels do we see between the way we passed information and the way information was passed in the event discussed?* Explore connections to how history is constructed or how media shares information.

5.d.xviii. Truth about Me

Image 16: Truth about Me.

Source: Unknown
Number of Players: 6+
Space: Room for a standing circle
Materials: Chairs or masking tape
to designate space

What is it and why use it?

Truth about Me creates opportunities for students to connect with each other as they exchange information about themselves. Once the group has played this to get to know each other, Truth about Me can also be played "in-role" to activate connections to curricular content.

Directions

Invite students to stand in a circle. It may be useful to mark each person's space with a small piece of tape or some other floor marker; the teacher stands in the center of the circle. Introduce the activity: *One of our goals today is to learn more about each other. In this game the person in the center will share something about themselves by saying "The truth about me is . . ." and then*

Spotlight on Facilitation
For more details about this strategy, see the "Spotlight on" section at the beginning of this chapter (p.110).

complete the sentence with a true fact. For example, the truth about me is that I like ice cream. If this statement is also true about you, you like ice cream too, then you must find a new space to stand in the circle. Explain that the person in the middle is also trying to get a spot, so whoever does not get a spot goes to the center and the game begins again with a new truth. Play a number of rounds. Encourage students to choose truths that will get more people to move. If the same person ends up in the center multiple times, they can choose a replacement who has not been in the center yet.

Reflection

- *What did you notice about yourself as you played the game? What did you notice about the group?*
- *Which statements made a lot of people move? Why do you think that is?*
- *What did you learn about our group/your colleagues? Why is this important to know?*

Possible side-coaching

- *What guidelines can we use to be successful?* Invite the group to build safety rules for the game.
- *Remember your statement needs to be something that is true about you.*
- After some playing time, encourage students to move past simple observational statements (*The truth about me is I'm wearing red.*), to more personal opinions (*The truth about me is I like scary movies.*), and onward (*The truth about me is I have stood up for something I believe in.*).
- *Try to say a statement that will also be true for many other members of our group.*

Possible variations/applications

- Have students play as someone/thing other than themselves. To help review key information, the teacher or students can create info cards listing key information to hang around students' necks. The cards may be later removed from play.
- Math: Have students play as integers naming truths about their number.
- Science: Have students play as animals, habitats, planets, or geographic formations.

- Social Studies: Have students play as a US state or a geographical region or event in history.
- Reading/Writing: Have students play as different verbs/vocabulary words; or have students play as a character from a story.

5.d.xix. Three Ball Toss

Source: Unknown
Number of Players: 5–15
Space: Room for standing circle
Materials: Small balls or beanbags

What is it and why use it?

In Three Ball Toss, students toss multiple balls or beanbags across the circle in a particular pattern. Students work together to keep the pattern going, generating strategies to be successful as they practice. Three Ball Toss offers a way to physically rehearse a sequence and also serves as a metaphor for collaboration and working together toward a common goal.

Directions

Get three balls or beanbags to use that can easily be thrown (or rolled) and caught by the participants. Invite students to stand (if throwing) or sit (if rolling) in a circle. Introduce the activity: *Our goal is to successfully pass this ball to each person in our group. To do this, we will make eye contact with someone else, say that person's name, and throw (roll) the ball using a gentle motion so the other person can catch it. We will do this until every person has had the ball once. Then it returns to me. Any questions?* Play a round to establish the pattern. If students cannot remember who has not had the ball yet, invite those waiting a turn to raise a hand. Once the full round is done ask everyone to point to the person who threw the ball/bag to them. Then, ask everyone to point to the person they threw the ball/bag to in the circle. After this review, start with the first person and repeat the toss pattern exactly as it was done before; rehearse this pattern until students can move through the full cycle with speed. Once the group is comfortable, add the second ball, a few seconds after the first, to follow in the same pattern or a new pattern. Finally, add a third ball/bag in the same pattern or a new pattern.

Reflection

- *On a scale of 1–10, how successful were we at this activity?*
- *What skills did you have to practice to keep up with the task?*
- *If you were giving someone else hints about how to play this game well, what would you say?*
- *What does this game have to do with everyday life or upcoming tasks or the task we just completed?*

Possible side-coaching

- *Remember the goal is to be successful as a group. What choices can you make to help your partner catch the ball?*
- *Remember to make eye contact with you partner before you toss the ball.*
- *What strategies can we use to help us remember the pattern that was created?*

Possible variations/applications

- Have the second balls/bags to move backward through the throwing pattern.
- Direct the third ball/bag to go in a clockwise movement around the outside of the circle only.
- Sequential Content Review: Have a ball track a pattern sequence for content review, e.g., Math: skip counting; Foreign Language: verb conjugation.
- General Related Content Review: Have a ball track a content topic for review, e.g., Geography: name a country in the world; Science: name a mammal or an element in the periodic table; Writing: name a part of speech (e.g., verbs).

5.d.xx. Two by Three by Bradford

Source: Augusto Boal
Number of Players: 4+ (even pairs are ideal)
Space: Open area
Materials: None

What is it and why use it?

Two by Three by Bradford asks students to work in pairs to count from 1 to 3 repeatedly, then to substitute gestures and sounds for each number. This

strategy builds focus and concentration and introduces basic sound and gesture vocabulary through sequence.

Directions

Invite students to make a pair facing one other; one person will be A and one will B. Introduce the activity: *In your pair, please count from 1 to 3, with each person saying one number.* Participant A says "One," B says "Two," A says "Three," B says "One," A says "Two," B says "Three," and so on. Invite students to try this sequence. *Now, instead of saying "One," A will make up a movement and sound that both players can easily do to replace "One."* Invite students to make up their own gesture/sound and try this sequence. *Now, instead of saying "Two," B will make up a movement and sound that both players can easily do to replace "Two."* Students will have a sound/gesture for "One," "Two," and "Three." Invite students to try this sequence. *Finally, instead of saying "Three," A and B will work together to make up a movement and sound that both players can easily do to replace "Three."* Invite students to try the full sequence.

Reflection

- *How did it go? What kinds of sounds and actions did you and your partner use during this activity?*
- *How did you negotiate with and support your partner in this activity?*
- *How might the strategies we used to be successful apply to our current inquiry?*

> **Make a connection!**
> *Use this strategy to explore a moment in history, a relationship between two characters in a novel, or a shared experience that is happening in class.*

Possible side-coaching

- *Try to use different sounds and actions for each number.*
- *Continue to work at a speed that you can be successful at with your partner.*

Possible variations/applications

- Take the count up to 5 or 7. Any odd number will work.
- Base all rhythmic sounds and actions on theme. For example, *All sounds and actions must represent modes of transportation.* Or, *All sounds and actions must be verbs, e.g., run.*

5.d.xxi. Zip, Zap, Zop

Source: Michael Rohd
Number of Players: 5+
Space: Room for a standing circle
Materials: None

Image 17: Zip, Zap, Zop.

What is it and why use it?

Zip, Zap, Zop is about focus and energy. As students pass the energy across the circle (in the form of a Zip, a Zap, or a Zop), they make eye contact with the person they send the energy to, and work together to keep the rhythm going. The activity also provides an opportunity to explore pace, specificity of choice, "energy," and sequence.

Directions

Invite students to stand in a circle. Ask the group to repeat the words "Zip, Zap, Zop" three or four times, all together. Introduce the activity: *Imagine that I have a bolt of energy in my hands. To start the game, I will send the bolt out of energy out of my body with a strong forward motion straight to someone else in the circle (use hands, body, eyes, and voice to make contact across the circle) and say "Zip."* Explain that the next person takes the energy and passes it immediately to someone else saying "Zap." That person passes it on to another participant with a "Zop." The game continues and the "Zip, Zap, Zop" sequence is repeated as the energy moves around the circle. Encourage all players to use their whole body to send energy and to make eye contact. They can send the energy to whomever they want but the goal is to include all players. Practice the game. If there is a mistake, encourage students to simply resume playing without discussion. The group challenge is to go very quickly and stay consistent in rhythm; if students struggle, pause the game, discuss strategy, and try again.

Reflection

- *On a scale of 1–10, how successful were we at this strategy?*
- *What strategies did you use to be successful?*
- *What did you notice about our group dynamic? How did it change?*
- *How did you use your whole body to help with clear communication? How might we apply these ideas to our larger inquiry or work together?*

Possible side-coaching

- *Don't forget to make eye contact with the person you pass the bolt of energy to.*
- *Work to stay focused. There should be no pauses. Try to maintain a steady rhythm.*
- *The bolt of energy should never hit the ground.*

Possible variations/applications

- Try "Zip, Zap, Boing." In this variation, a player can choose to raise both hands in front of their bodies at chest height and say "Boing" when they are sent a Zip, Zap, or Zop. When this happens, the move bounces back to whomever passed it. Thus, the progression might sound like "Zip-Zap-Boing-Zap-Zop-Zip-Boing-Zip," etc.
- Math: Use this strategy to practice skip counting (3, 6, 9, 12…)
- Science: Use this strategy to explore organisms in a food chain (or stages in a life cycle); students send energy from organism to organism in the food chain to represent a mini ecosystem.
- Reading/Writing: Use this strategy to review helping verbs (am, is, are, was, were, be, been…).

E. SETTING, STORY, AND CHARACTER

What is it? *Setting, Story, and Character* strategies use a group game to explore the drama/theatre skills of pantomime, voice/sound, imagination, and storytelling.

Why use it? *Setting, Story, and Character* strategies invite students to use language, movement, and/or gesture to apply prior and new knowledge within a structured activity. These strategies provide discrete entry points to support students' abilities to create and share their meaning-making through verbal and kinesthetic approaches, specifically within the art form of theatre. Reflection within and after *Setting, Story, and Character* strategies provides a way to "name and celebrate [students'] existing and growing competence" (Wilhelm, 2002) as artists and thinkers.

When and where is it used? *Setting, Story, and Character* strategies offer ways to learn and apply foundational theatre skills from the theatre classroom. Drama-Based Pedagogy often uses these strategies as a way to make cross-curricular connections with elements of story and drama that appear in all areas of the curriculum.

In a primary school unit on fairy tales, a teacher uses Gift Giving and Everybody Do as a way to review and share prior knowledge about the characteristics of fairy tales. In each activity, students recall and represent specific objects and events that could be found in a fairy tale story. Afterward, the class dialogues about the types of objects and actions generated by the activities.

At the secondary level, a life skills class focused on interview skills might use Story of My Name to work on eye contact and vocal expression or use One-Word Storytelling to explore verbal storytelling skills like descriptive language, plot, and story structure elements. The lesson might conclude with students embodying strong interpersonal and intrapersonal behavior, like "confidently" or "friendly," through the In the Manner of the Adverb strategy.

How do you use it? *Setting, Story, and Character* strategies can be adapted for a variety of ages and a variety of subject areas. As you prepare to use a *Theatre Game as Metaphor*, consider the following:

Participant knowledge and skills

Academic: What ready knowledge about the content topic do students need to be able to connect their creative and critical thinking in this strategy? To be

able to physically represent an object or action through pantomime, or to spontaneously build a verbal story with a group, students need ready knowledge about the content topic being explored. For this reason, it may be important to initially build some "think time" into the strategy as they learn and play it. Eventually, students will enjoy and benefit from the improvisational structure of the strategies as their ability to use quick cognitive recall and imaginative thinking grows.

Affective: Can students work collectively toward a common goal, prioritizing the group's success? What is the level of emotional and physical risk associated with the activity? Some groups might need to build additional trust among members before they are ready to improvise an action or phrase in front of others, particularly in a learning setting where this type of work is not the norm.

Aesthetic: What specific drama skills—like pantomime, gesture, imagination, and storytelling—do students need to understand in order to be successful and to fully benefit from the strategy? It can be useful when initially teaching a new strategy to focus on the actors' tools of expression—the voice, imagination, body, ensemble, and story—and develop a common vocabulary for quality work (Dawson & Kelin, 2014).

Context needs

Group Size: If the group is large or has difficulty waiting their turn, teachers might select a game with a high level of structured group participation that will keep everyone engaged in the action simultaneously, like Everybody Do, In the Manner of the Adverb, or New York, New York. If students will benefit from taking the time to see work modeled by colleagues then Who am I, Give and Take, and This Is Not a might be most productive. For groups who benefit from independence and the lower risk of parallel play (pairs or groups playing simultaneously without any audience), Story of My Name or Gift Giving are strong strategies to use.

Space: Some of these strategies, such as In the Manner of the Adverb and Story of My Name, can be played in desks or at tables; even Gift Giving can be adapted to a seated environment. This Is Not a, One-Word Storytelling, and Everybody Do, however, work best in a circle where all students can easily see one another. Finally, there are few strategies that really do need space to move, play, and observe like Give and Take and New York, New York.

Time: Consider how instructional pace shapes the experience of play during these strategies. Some of these strategies require energized direction to set a tone that is quick and playful. Moving quickly keeps students engaged and focused on multiple possibilities, assuaging their need (and the pressure) to find the one "right" answer. For some groups, it will be important that all students get a turn to share their ideas. Consider that it may take time for each person to have a turn to perform his or her thinking and plan accordingly.

5.e.i. Everybody Do

Source: Unknown/Peace First Variation
Number of Players: 5+
Space: Room for a standing circle
Materials: None

What is it and why use it?

In Everybody Do, one participant names and performs a physical action, and then everyone enthusiastically agrees to do the action and repeats the action together. This strategy encourages students to engage their voice, body, and imagination. Each participant has an opportunity to generate an idea—based on a theme or topic—and see their original idea positively rendered by their peers and the teacher.

Directions

Invite the class to stand in a circle. Explain that each person will have a chance to make a suggestion about a movement and/or sound that the whole group will do together. Introduce the activity: *In this strategy, someone will make a suggestion that we will all follow. For example, I might say, "Everybody wiggle their fingers: (wiggles fingers)." Then all of you must enthusiastically say "Yes!" and then you move your body just like me* (encourage students to wiggle fingers). Once instructions are clear, model another example and then proceed around the circle. Each participant makes a suggestion, receives an affirmation ("Yes!"), and has their action performed by the group, until every participant has had a turn. The group should play the game at a tempo that is right for them, but the teacher can speed up or slow down the activity, as appropriate.

Reflection

- *What was the easiest part of this activity for you? What was the hardest part? Why?*
- *After every suggestion, the group said, "Yes!" How does receiving positive feedback feel?*
- *What situations can you think of in which people (classmates) might appreciate positive feedback? What might be the consequences of that positive input?*

Possible side-coaching

- *Be sure to suggest a single movement or an activity that everyone can do.*
- *You can pick a movement we know* (model jumping jacks) *or a movement that you make up* (model a hip wiggle)—*but just give us one thing to follow.*
- *Let's respond with an enthusiastic YES, with our whole bodies!*

Possible variations/applications

- Another variation is called "Yes, Lets!" The group covers the space. A volunteer calls out a suggestion: "Hey, let's try on hats." The group then responds with great enthusiasm, "Yes, let's!" Everyone then pretends to try on hats until someone else calls out a new request, such as, "Let's all jump up and down." The group again responds "Yes, let's!" and jumps up and down until a new suggestion is made and accepted.
- Reading/Writing: Have students explore actions that represent events from a story.
- Foreign Language: Have students practice verbs/commands by playing the game in a different language.
- Math: Have students use math vocabulary, such as "everybody make a triangle."
- Science: Have students represent different concepts like animals, ecosystem, the lifecycle of a plant, and weather formations.
- Social Studies: Have young students perform jobs from their community.

5.e.ii. Gift Giving

Source: Chris Vine
Number of Players: Any (even pairs if possible)
Space: Any
Materials: None

What is it and why use it?

Gift Giving is a strategy that uses improvisational play to practice pantomime skills and ways to positively accept "an offer" from a partner. The game asks students to be present in the room, focus on the task, use their imagination, and react to their partner. This strategy encourages reflection and dialogue about respect, spontaneity, and cooperation.

Directions

Divide students into pairs and ask one person to be Player A and the other to be Player B. Player A names and pantomimes a non-stop series of imaginary gifts that they give to player B. Player B's job is to receive each of these gifts with as much enthusiasm as possible, no matter how strange or unexpected, and explain how they will be helpful. For example, Player A might shape their arms into a large circle and pantomime lifting a large, heavy basket as she says, *I'm so thrilled to be able to give you this extra, extra large box of old banana peels.* Player B would accept the gift—using the same physical gestures as A—saying, *Thank you, thank you! This extra, extra large box of old banana peels is exactly what I need to put in my garden to make my plants grow.* After a set time, switch roles and repeat. Encourage students to use descriptive language and pantomime skills to show the size, weight, and shape of the object being given.

Reflection

- *Did you prefer giving or receiving gifts in this activity? Why?*
- *What gift do you remember best? Why?* (Can follow up with questions about verbal and physical details used in the activity as context clues.)
- *What might this activity have to do with the way we work together or how we write creative stories?*

Possible side-coaching

- *Givers, remember to use specific, rich vocabulary (adjectives and adverbs) to describe the gifts you give. Give the totally unexpected!*
- *There's no right or wrong gift to give.*
- *Receivers, respond enthusiastically to each and every gift!*

Possible variations/applications

- Try having the gifts named by the receiver rather than by the giver. The giver pantomimes holding a gift—using their body to show shape, size, and weight—and the receiver then identifies the gift based on the context clues provided by the giver's performance. *Thank you for this very stinky sock.*
- Try having player B only react non-verbally.
- Reading/Writing or Social Studies: Have students explore themes from a story or book or moment in history through the types of gifts that are given. For example, if exploring Lois Lowry's *The Giver*, students might consider what memories they might share with each other.
- Reading/Writing: Have students use as many descriptive words or adjectives as possible. For example, instead of saying *It's a ball*, a participant might be encouraged to use a variety of adjectives and instead say something like *It's a humongous, squishy, blue ball that smells like the ocean.* Or they might give the same gift multiple times but use adjectives to change the description that will impact the receiver's response.

5.e.iii. Give and Take

Source: Viola Spolin
Number of Players: 8+
Space: Open area
Materials: None

What is it and why use it?

Give and Take invites students to explore a range of repetitive sounds and movements, and to consider how they connect together as part of the give and take of energy between performers on stage. The activity focuses on improvisation, repetition, active listening/responding, and abstract/concrete embodied ideas.

Directions

Define an open space as the "stage" with space in front for the "audience." Invite a portion of the students (5–10 is best) to play first. Ask them to evenly position themselves throughout the stage space, with space to move between them. Everyone is frozen, except one player who uses a

repetitive sound and movement to travel through space and "gives" a sound/movement energy to another player, who makes a new repetitive sound and movement. Players can use literal or abstract movements. For example, player A stomps his feet and says "Boing, Boing, Boing" as he travels across the playing space to player B who is frozen; A makes a loud final "Boing" in the direction of player B. Then A freezes and B jumps up and grabs her toe saying "Ow, Ow, Ow" as she hops one foot saying "Ow" to C and then freezes. C shoots her arms out, saying "Ohwah, Ohwah," and so on. After the group has played for a while, swap groups and begin again. Introduce themes to inspire movement/sound like *School*, or *Fame*, or *The Ocean*. Once "give" is mastered, introduce "take." In "take" players repeat the same pattern, but instead of waiting for a player to "give" the energy, players "take" it. When the energy is taken, the player it was taken from freezes. After the group understands the rules for "give" and "take," players can use both; so, C may "take" from B, and then B can "give" to player A, and so on.

Reflection

- *On a scale of 1–10, how successful were we at this activity?*
- *How did our sound/movements evolve throughout the game? Did we tend to use literal or abstracted movements more? Why do you think that is?*
- *How did our sound/movements build a story or connect to our larger inquiry when we were working with a theme?*

Possible side-coaching

- *Try to use your whole body. If we are playing on a 4, on a scale of 1–10, what does a 10 look like?*
- *Remember that you must remain completely frozen when it isn't your turn.*
- *This is an ensemble game; it is your responsibility to make sure everyone has a turn.*

Possible variations/applications

- During thematic explorations students can use short word phrases; encourage students to really listen and respond to what is given them to build out a story.
- Social Studies: Have students explore events in history (Industrial Revolution) or a time period.

- Reading/Writing: Have students explore the setting or world of a story, key themes, and characters.
- Science: Have students explore ecosystems, seasons, weather, and animal characteristics.
- Math: Have students explore skip counting (give 3 to 6 to 9).

5.e.iv. In the Manner of the Adverb

Source: Bob Gregson
Number of Players: 5+
Space: Any
Materials: None

What is it and why use it?

In the Manner of the Adverb strategy invites students to non-verbally embody a single idea in multiple ways so that another participant can infer the meaning of the first participant's actions. The exercise requires students to be creative, clear, and specific in their choices (or context clues) to support inferences made by the individual trying to guess the word being shown. This strategy has clear connections to language arts, but is also used to explore inferencing, non-verbal expression, kinesthetic embodiment, and strong performance choices.

Directions

Select a volunteer to be "It" and ask them to leave the room. Invite the remaining students to select an adverb (such as merrily, nervously, warmly, etc.). Invite "It" back into the room; explain that "It" must try to guess the selected adverb by asking the entire group to perform an action in the manner of the adverb. For example, "It" might say *Shake hands in the manner of the adverb; Walk in the manner of the adverb*; etc. "It" asks for demonstrations until "It" guesses the word. (If "It" is stuck, offer recommendations of the type of actions that might help to solve the mystery.) Play multiple rounds to explore different adverbs and allow multiple students to be an "It." To make the process easier, a word bank of adverbs can be listed on the board; "It" can be two or three people working together; or a list of actions prompts can be generated that "It" can use with the group.

Reflection

- *What helped "It" figure out our chosen adverb?* (Focus on context clues and inferencing).
- *Were some adverbs harder to perform than others? Which ones, and why?*
- *Why are adverbs useful in writing?*

Possible side-coaching

- *For the players: Use your whole body to demonstrate the adverb.*
- *For the person who is "It": How would you describe the way the player is doing this action?*

Possible variations/applications

- Have players demonstrate the adverb individually, in pairs, or in small groups.
- Reading/Writing: Have students explore and review different genres of literature—fiction, fantasy, poetry, etc. For example, *describe your pencil in the manner of the genre.*
- Reading/Writing: Have students explore different character traits and actions from a story. For example, *sit down and say "Hello" like the character.*
- Foreign Language: Practice adjectives/adverbs in a different language.
- Social Studies: Have students explore and review time periods and technological advances. For example, *show us the best way to travel across town* (to explore the 1800s).
- Science: Have students explore different ecosystems, scientific theories, and animals. For example, *show us what plants and animals you might find here.*

5.e.v. New York, New York

Source: Neva Boyd and Helen White
Number of Players: 2+
Space: Open area, with space to run and move
Materials: None

What is it and why use it?

New York, New York uses voice, gesture, and movement while requiring students to work collaboratively and quickly. The strategy supports skills in ensemble, quick decision-making, and pantomime.

Directions

In a very large space, make (or use if one is already there) a distinct line on far end of each side of the room and line down the middle of the space. Split the group into two sections (A and B). Invite Group A to stand at one end of the room on their line and Group B at the other end of the room on their line. Teach the full group a cheer, with each half-group practicing their part.

Group A: *Here we come.*

Group B: *Where from?*

Group A: *New York!*

Group B: *What's your trade?*

Group A: *Lemonade!*

Group B: *Give us some!*

Group A: *Here we come!* Then, swap the cheer so Group B begins and learns the first line and Group A learns the second line, and so on.

Once both groups know the full cheer, ask each group to stand behind a marked line on their side of the end of the space. This is their home base. Group A huddles in its home base and decides, secretly, what trade or profession it will act out (barber, painter, etc.). Once the trade/profession has been decided, the chant begins. When Group A says its final "Here we come," it moves to stand at the middle line and acts out its trade silently; Group B remains at its home base line. Then Group B (at their home base line) has to guess what trade Group A is acting out by shouting out answers. Once Group B has guessed the trade, it runs to capture Group A; meanwhile, Group A runs back to its own side, attempting to cross its home base line before Group B can tag it. If members of Group B tag members of Group A in time, those tagged become members of Group B. Then the game switches and Group B begins the chant and acts out its trade with Group A trying to guess and capture Group B members. The game repeats until the time is over or all members have joined one group.

Reflection

- *What "trades" were most memorable from this activity? Why?*
- *What context clues in other groups' performance did you find most helpful?*
- *What key ideas do we want to remember from our work today to use in the rest of our work together?*

Possible side-coaching

- *Think about the different, specific actions to illustrate the trade you are acting out.*
- *Think about how you can use context clues from the other group's performance to infer your answer.*

Possible variations/applications

- Once one group guesses the other group's trade, have both groups run in slow motion as they try to get back to their base/tag the other group.
- Social Studies: Explore actions associated with important figures from history, e.g., the work of Dr. Martin Luther King or the actions associated with jobs in a community.
- Reading/Writing: Have students explore/act out important events from a story or novel.
- Science: Have students explore/act out ecosystems, animals, or states of matter.
- Math: Have students explore/act out academic vocabulary (shapes, angles, types of lines, etc.).

5.e.vi. One-Word Storytelling

Source: Unknown
Number of Players: 5+
Space: Room for a seated circle
Materials: None

What is it and why use it?

One-Word Storytelling is a verbal activity that asks students to actively listen and respond to one another to create a collaborative story. Students apply their knowledge of story structure (beginning, middle, end, problem/solution, etc.) within an ensemble-based improvisational activity.

Directions

Invite students to sit in a circle. Explain that the group is going to create a story together, one word or one phrase at a time. Discuss the elements of a good story and story structure; set goals for effective story making. Begin the story by contributing a first word (*Once* or *The* or *Corinna*) or phrase (*Deep in the ocean* or *The worst day I ever had* or *My magical hat was first discovered*).

The next participant in the circle adds another word (or phrase), and so on around the circle for one or more rounds until the story seems complete. After each story, ask what the group liked about the story and discuss ways to make a more effective story for the next round. If helpful, pause the story in the middle and review suggestions for effective story making.

Reflection

- *How did we do with this activity?*
- *What was the main conflict in our story? Why? How was it resolved?*
- *How might we improve on our story if we wanted to tell it again?*
- *What makes a good story?*

Possible side-coaching

- *What kind of word might we need next in our sentence/story? A verb? A noun? An adjective?*
- *Try and incorporate our story structure elements to make an even better story.*
- *What is the conflict in our story? How will the conflict or problem be resolved?*
- *Try to build on what has already happened.*
- *Try to wrap up the story within the next five or six words.*

Possible variations/applications

Reading/Writing: Focus just on the use of punctuation as the group tries to build a sentence that uses a specific punctuation (colon, comma, or question mark). Make sure that students vocalize the punctuation as part of their "turn"; Focus on building a single sentence together in smaller groups rather than a large collective story; Connect the story to content. For example, direct students to create a story about what the group thinks happens next in the story they are reading, or to create a story that uses the elements found in a fable.

5.e.vii. This is a/is Not a

Source: Unknown
Number of Players: Any
Space: Room for a standing
or seated circle
Materials: A roll of tape (alternate
variations: use a cloth, a 2-dimensional
figure like a triangle, or a dowel rod)

Image 18: This is a/is Not a.

This could also be . . .
(wording)

What is it and why use it?

This is a/is Not a… asks students to use their imagination and pantomime skills to transform an object into something else. This activity supports students' abilities to use specific details both in their pantomime skills and in their verbal description of the object if words are being used as a description. This activity also encourages students to explore how to infer based on context clues, and identify the main idea of an action.

Directions

Hold up a roll of tape to offer an imagination challenge for the group. The object of the game is to transform the tape roll into something it is not. For example, *This is not a roll of tape, this is my red, shiny apple* (pantomiming biting into the apple, and then making a sour face). *Yuck, with a worm inside.* Ask students to describe what you did. Reference the performance skills that actors use to transform an object including the voice, body, imagination, face, point of view, descriptive language, etc. Explain that each person in the circle will take a turn. They will say *This is not a roll of tape. This is a…,* then they will state what the object is as they use the context clues of their performance and their words to transform the object into something new. Take questions. Pass the object around the circle so that each participant can transform the object. The pace of the game is dependent on the needs of the group, but the teacher should keep the goals of spontaneity and creativity in mind. For early learners, the prompt can be adjusted to *This is a roll of tape. It is also…* to avoid confusion.

Make a connection!
Use this strategy as a metaphor for the inferencing process.

Reflection

- *What object transformations do you most remember from our exploration? Why?*
- *How did the properties/characteristics of our object (tape roll) inform your transformation choices?*
- *What skills did you use to be successful in this activity? Where else in our inquiry might we want to use these skills?*

Possible side-coaching

- *Think about how you can use your actor tools (voice, point of view, imagination, body shape, expression, etc.) to help us understand what the object has become.*

- *In your verbal description of the object, try to use adjectives and adverbs to help us understand what this object looks like.*

Possible variations/applications

- Multiple objects (e.g., a group of 3-dimensional solids) can be placed in the center of the circle and each person can choose which object to use for their turn.
- After playing multiple rounds, allow students to play a round in which the participant pantomimes the object without words so that other students must guess what the object is.
- Reading/Writing and Social Studies: Have students turn a piece of fabric or a dowel rod into something related to a story from class or from a time from history.
- Math: Use 2-dimensional shapes (a triangle or a square) or 3-dimensional solids (a prism) to make connections to the shape and the larger world. In this version, it can be useful to say *This is triangular prism AND it is also…*

5.e.viii. Story of my Name

Source: Kat Koppett
Number of Players: Any (even pairs is ideal)
Space: Any
Materials: None

What is it and why use it?

Story of my Name asks students to share the meaning or story behind their first, middle, last/surname or a nickname. This strategy requires active listening skills and verbal communication; it is often used as an icebreaker or introductory activity or to explore themes from literature.

Directions

Invite students to sit in a circle or in desks/tables. Introduce the activity: *Today we will share a brief story with a partner about some aspect of our name.* Explain that students can choose to tell the story of their first, middle, or last name, or a nickname. Depending on the context or class, students can also invent a story about their name if they prefer. (This takes the pressure off people who do not have a story to tell.) Model the process by sharing the story

of your name as an example. Next, give the students a moment to think about the story they wish to share with the larger group. Then, divide the group in pairs and ask each pair to choose one person to share their story first. All students share their stories at the same time. After two minutes, ask the pairs to switch and the second person shares their story. After each person in the pair has shared, the full group comes back together to reflect on the activity. Depending on the level of comfort and time, once back in the full group each pair member can introduce their partner and share a brief description of the story they heard, or the group can move directly to reflection on the larger activity without additional sharing.

Reflection

- *What did you notice about yourself as you participated in this activity?*
- *Where do our names come from? Did we see any common themes?*
- *If you've had the chance to name (or help someone to name) a new sibling, a pet, a doll, etc., what informed the choice you made?*
- *What do names tell us? Are they important? Why or why not?*

Possible side-coaching

- *You can share the story of any piece of your name.*
- *Try to be succinct in your story.*
- *Pay attention to the storyteller's body language. How do we look when we tell a personal story? What changes about our voice, body, and eye gaze?*

Possible variations/applications

- Reading/Writing: Use this strategy as engagement for a book where a key literary theme revolves around the importance of names (e.g., *Because of Winn-Dixie, Morning Girl*, or *Romeo and Juliet*).
- Social Studies or History: Explore why certain names are popular at different times. Who do we name children after and why? Consider how culture, race/ethnicity, and language origin impacts the names we use.

F. CONFLICT, POWER, AND PROBLEM-SOLVING

What is it? *Conflict, Power, and Problem-Solving* strategies ask students to work as a collective or in small groups to solve a problem or to navigate a specific challenge within real or imagined circumstances.

Why use it? *Conflict, Power, and Problem-Solving* strategies offer opportunities to create concrete representations of abstract ideas or concepts. These strategies build physical and social awareness of how power and conflict function within a specific setting, relationship, or story. Theatre practitioner Augusto Boal (1992; 2002) offers that games are a way to reclaim our ability to be agents of change within our individual and shared world. These strategies provide an embodied way to support students' capacity to make sense of how they think, make decisions, and act in a variety of situations (Edmiston, 2000). They create a way for us to begin to understand our social reality, so that we can make active, informed choices and decisions about how we lead/ follow, problem-solve, and navigate conflict.

When and where is it used? *Conflict, Power, and Problem-Solving* strategies offer an active way to explore, through dramatic work, power, and conflict in our own lives or in stories from history or literature. For example, a primary classroom examining the history of indigenous people might use Mirrors, Keeper of the Keys, or Columbian Hypnosis as a way to engage with complicated histories of colonialism. Later, a specific conflict within real or imagined circumstances from history might be examined through Defender or Obstacle Course. At the secondary level, a mathematics classroom might use Three Changes to think about observation and how to structure a hypothesis, or use an Obstacle Course to review and apply knowledge about the types and degrees of angles.

How do you use it? *Conflict, Power, and Problem-Solving* strategies can be adapted for a variety of ages in a variety of subject areas. As teachers prepare to use strategies for *Conflict, Power, and Problem-Solving*, they might consider the following:

Participant knowledge and skills

Academic: What structured reflection time is needed to identify how power and conflict function within the strategy? Take time to make connections between the action of the strategy and larger issues of the human condition and

society. As always, it is important to consider what prior personal or content knowledge students need to think critically and to be successful in the strategy.

Affective: What level of trust do the students need to establish with each other so they can successfully partner and feel physically and/or emotionally safe within the strategy? For example, Mirrors, Knots, and Trust Walk, all require a culture of respect and collaboration for students to be fully successful. Be sure students are ready to support their colleagues to reach the goal of the strategy. If there are challenges, do not hesitate to stop the activity and discuss how to play for success. For activities that involve large amounts of physical contact or the loss of a sense, such as sight, consider how you might adapt the rules to accommodate students with differently-abled bodies or needs around sensory-integration.

Aesthetic: What time is needed for students to engage all of their senses in the activity? Students may need extra time to listen and look; this supports better perception and observation skills, which leads to improved problem-solving. These strategies also support the development of movement as a form of expression, particularly when movements are repeated or structured into a sequence with another individual.

Context needs

Group Size: If strategies require groups to work in pairs—like in Mirrors, Columbian Hypnosis, Three Changes—consider whether the group benefits from teacher-selected, randomly assigned, or self-selected partners. When playing strategies that focus on a large group task—like Knots, Who Started the Motion, or Keeper of the Keys—the class can be split into two or three groups to play simultaneously.

Tips for playing!
One way to make groups is to ask everyone to find a partner. Then tell them to say "Hi! Wait a minute. You are not my partner." And, then ask them to find a different person to make a pair. Move through this cycle 2–4 times and stop when the group pairs look the most productive for learning.

Space: Consider the amount of space students need to play safely, as many of these strategies require a lot of room to move and play. During activities like Columbian Hypnosis, Defender, and Trust Walk, make sure the space is free of distracting or potentially dangerous objects or shifts in floor level (e.g., the end of a stage space). Students are highly focused on each other and may have their eyes closed, so they can have less awareness of the objects and space around them.

Time: If the plan is to apply a curricular content to the strategy, be sure there is time to fully teach the activity, and clarify the strategies used to successfully solve the task, before the application of content is added. Obstacle Course requires at least one, if not two, rounds of play before content can successfully be added. Strategies like Defender, Trust Walk, and Three Changes involve all students playing together or working in pairs to allow everyone to consider the role of leader or problem-solver in a shorter amount of time.

5.f.i. Columbian Hypnosis

Source: Augusto Boal
Number of Players: 4+
Space: Open area with lots of space to move
Materials: None

Image 19: Columbian Hypnosis.

What is it and why use it?

Columbian Hypnosis involves students working in pairs to lead one another through a space as one participant follows another participant's hand. This activity requires trust, awareness, and non-verbal communication as students work together to move safely through the space.

Directions

Divide the full group—or let the group divide itself—into pairs. Each pair decides who is Player A and Player B in their small group. Have partners check in with each other about any physical needs or limitations they might have today (e.g., "Getting up and down off the ground is hard for me"). Set space parameters so students know where they can move in the activity to keep their partners safe. Then, ask Player A to hold the palm of the hand about six inches from Player B's face. Ask Player B to imagine that Player A's hand has hypnotized Player B and needs to follow the hand anywhere it goes, keeping the same distance between the face and the hand at all times. As Player A moves around the room, Player B follows. After a set time, switch and let B's lead.

Reflection

- *How did it feel to participate in this activity?*
- *Which did you prefer—being the leader or being led? Why?*
- *What does this activity have to do with trust? With power?*
- *How does this relate to our larger inquiry?*

Possible side-coaching

- *Try moving in slow motion as you begin leading your partner.*
- *What new ways of moving through the space can you challenge your partner with?*
- *How are you keeping your partner safe as you move through the space?*

Possible variations/applications

- After all students get a chance to lead or follow, repeat the activity, but this time encourage the follower to try to take power from the leader (while still following the rules of the game).
- In small groups, have the leader hypnotize with two hands and/or other body parts (such as knees, feet, back of head, etc.).
- Reading/Writing or Social Studies: Use this strategy to discuss how power/leadership functions within a story or historical event.

5.f.ii. Defender

Source: Augusto Boal; Michael Rohd
Number of Players: 6+
Space: Open area
Materials: None

What is it and why use it?

Defender is a game that allows students to explore and embody conflict through non-verbal play. This activity can be related back to a real-life scenario or kept in an imaginary frame. The anonymous nature of who is chosen both as an enemy and a defender allows for emotional safety.

Directions

Begin by defining a very large, open playing area for students to move within. Ask students to walk silently around the room at their normal pace. After a minute or two, invite students to secretly pick one person in the group and imagine this individual has a force or energy that makes them stay as far away as possible. Be very careful in your choice. Do not say the person's name or give them any indication that they have been picked. Keep walking but, now, try to stay as far away from this person as possible. Next, secretly pick another person in the room to represent a force or energy that pulls you as close to them as possible. Try to move as close to this new positive force person as possible; remember to also stay as far away from your opposing force person. If possible, suggest students keep the defender (the positive force) between themselves and their enemy (negative force) at all times.

Reflection

- *What did you notice about yourself as you participated in this activity?*
- *What did you notice about the group and how it moved?*
- *What strategies did you use to keep your defender between you and your enemy?*
- *How does this activity relate to moments in our daily lives?*

> **Make the transfer!**
> *Use this strategy as a metaphor to explore the food chain, relationships between predator and prey, and themes from literature and history.*

Possible side-coaching

- *Keep your positive force or defender between you and your negative force or enemy at all times!*
- *How close or far away from your defender can you be to stay safe?*
- *Remember this is a silent activity.*

Possible variations/applications

- Reading/Writing: Explore character relationships in a story or from literature through this strategy. Play as characters from *Among the Hidden* by Margaret Peterson Haddix; reflect on the relationship between Luke and his parents. When are they enemies or defenders? Include a motivation for avoiding the enemy. How does shifting motivation in an imagined story change how the game is played?
- Science: Explore covalent bonds through this strategy.

- Math: Have students play as numbers. Explore different variations that allow them to play with the relationship between numbers. For example, students must make an effort to try and stay between two factors at all times.

5.f.iii. Keeper of the Keys

Source: New Games Foundation
Number of Players: 3+
Space: Room for a standing circle
Materials: None

What is it and why use it?

Keeper of the Keys involves strategy, collaboration, and the use of multiple senses to solve a collective challenge. This strategy creates opportunities to generate dialogue about individual and collective group strategy and to practice engaging more of the five senses.

Directions

Invite the group to create a standing circle around a stool or chair. Choose a player to be "Keeper of the Keys" and invite them to sit on the seat with a set of keys underneath. The "Keeper" wears a blindfold or keeps their eyes closed. Invite all other players to sit in a circle (real or imagined) 5–7 feet from the seat with the keys. Begin the game. Players can sneak forward and attempt to get the keys without the "Keeper" hearing them. If the "Keeper" hears someone, they raise a hand and point at where they heard the sound. If the "Keeper" points at a player trying to steal the keys, that person must go back to the outer circle and begin again. The game continues until someone steals the keys and brings them back to the outer circle without the "Keeper" knowing. Once the keys are taken, all players pretend they have the keys behind their back. The center person then takes off the blindfold and gets three guesses to figure out who has taken the keys. Repeat with a new person as the "Keeper."

Make the transfer!
Use the "keys" in this strategy as metaphor to explore resources, power, and forms of government.

Reflection

- *What tactics did you try out in order to retrieve the keys?*
- *What tactics seemed to work? What made those tactics effective?*
- *In what other spaces or in which other times do we need to think strategically?*

Possible side-coaching

- *Think about how we can work together to capture and fool the keeper of the keys.*
- *What other strategies can we use to get possession of the keys?*
- *How might we work together to get the keys?*

Possible variations/applications

- Reading/Writing or Social Studies: Have students play this game in-role as someone else from a real or imagined story. The Keeper of the Keys and the keys themselves can represent characters or ideas from a variety of content areas. The Keeper might be a character from a literary story or history that wants to hold on to power in some form or another. The keys might represent key resources or ideas that others want to get to take or share.

5.f.iv. Knots

Source: Augusto Boal
Number of Players: 8+
Space: Room for a standing circle
Materials: None

What is it and why use it?

Knots is a strategy that requires students **Image 20:** Knots.
to solve a physical dilemma. In this
activity, students need to use spatial skills to try and unravel a human knot made by the connection of the arms across a standing circle. To be successful, students must engage in physical contact, be aware of physical limitations, and work together to solve a challenging problem.

Directions

Invite students to stand shoulder-to-shoulder in a circle. Each participant puts both hands in the center and grabs any two hands that (1) do not belong to somebody right next to them, and (2) belong to two different people. Once all the hands have been grabbed across the circle, the group should be tied together in a large knot. One way to test this is to pass a hand squeeze around the knot; everyone should get the squeeze exactly once. Without letting go of the other students' hands, the group must untangle

the knot. If the group is large, divide up into two or three circles and play simultaneously.

Reflection

- *On a scale of 1–10, how did you do? What did you notice about yourself? What did you notice about the group?*
- *What did you have to do to untangle yourselves? How were decisions made within your group?*
- *What skills did you have to use in this activity? In what other situations might these skills be useful?*

Make the transfer!
Use this strategy as a metaphor to consider problem-solving, observation, collaboration, and/or cause and effect.

Possible side-coaching

- *Who can see what needs to happen next?*
- *If one idea doesn't work, try another tactic.*
- *Remember to be safe with the movement and flexibility of others' bodies.*

Possible variations/applications

- Have the group untangle the knot silently using only non-verbal cues.
- Invite one person to stay outside the knot and work to help unknot the group.
- Reading/Writing or Social Studies: Explore themes of entanglement from literature or history. Explore ally relationships or the ways complicated systems are entwined.

5.f.v. Mirrors

Source: Viola Spolin
Number of Players: 4+ (even pairs)
Space: Open area
Materials: None

Image 21: Mirrors.

What is it and why use it?

Mirrors is a paired activity that allows students to work on leading/following through collaboration and focus. Partners work silently to create mirrored kinesthetic movements. The activity involves shared trust and responsibility as partners work to keep each other safe.

Directions

Divide the group into pairs and ask each pair to decide who is Player A and who is Player B. Player A will be the mirror and B the actor. Pairs stand facing one another. Ask students to make eye contact. As Player B begins moving, A mirrors B's actions exactly. Both players should maintain eye contact, with Player A seeing B's movement through peripheral vision. Encourage slow and sustained movements to begin with and/or simple actions like brushing teeth or playing a sport in slow motion. After a set time, ask students to switch leaders. Eventually, pairs can be encouraged to switch back and forth between leaders on their own or to try and work together where neither person is leading.

Reflection

- *Which did you prefer: leading or being led? Why?*
- *How did you strategize to help your partner keep up with you?*
- *What does this activity have to do with trust and the work we are about to do together?*

> **Make the transfer!**
> *Use this strategy as a metaphor to explore observation, choice, and collaboration.*

Possible side-coaching

- *Try your best to move as one unit.*
- *Try experimenting with different levels.*
- *Take turns shifting between leaders; find a natural way to switch who is leading and who is following.*
- *Remember to maintain soft focus throughout the activity.*

Possible variations/applications

- Have students explore feeling vocabulary (sad, excited, etc.) through their movements.
- Science: Have students explore different environments (the rainforest) or times of year (summer) through their movements.
- Math: Have students explore different types of angle movement (acute, obtuse, etc.) or types of lines (parallel, perpendicular, etc.). Ask students to explore rotation, translation, and reflection and have them choreograph a dance that uses each form of movement, which they can teach to others.
- Reading/Writing or Social Studies: Have students explore literary or historical themes—like war or gossip—through their movements.

5.f.vi. Obstacle Course

Source: Various
Number of Players: 5+
Space: Open area
Materials: Collection of random objects and a blindfold

What is it and why use it?

Obstacle Course is a strategy in which an individual or group navigates a blindfolded person through a series of obstacles without touching them. This strategy is used to work on sensory perception and clarity of directions. It can be used to metaphorically explore the types of conflict or "Obstacle Courses" in an event, situation, or relationship.

Variations

For some communities, a minefield has very real implications due to past or current conflicts. In these settings, it is important to remove all language and reference in the game to "mines" and to use the phrase field and obstacles, only.

Directions

Introduce the activity: *Our goal is to navigate a blindfolded volunteer through a series of obstacles to reach a specific destination.* Brainstorm verbal directional vocabulary that could be used to navigate the volunteer (*step right/left, turn 45 degrees/90 degrees, step north/south/east/west, take a small/medium/large step*). Next, select a volunteer who is willing to be blindfolded and directed by others. Invite the volunteer to leave the room or to put on the blindfold and sit outside the playing area. Then, the rest of the students place various objects (boxes, chairs, books, crumpled paper, shoes, etc.) across the playing area. After the obstacles are placed, students sit around the border of the playing space. The volunteer, with blindfold, is placed on one end of the space. The students offer verbal directions to the volunteer—one phrase of instruction per person. If the volunteer touches one of the obstacles, the attempt is over. The entire group talks about what happened, how to improve, and tries again with a new volunteer and layout of obstacles.

Reflection

- *On a scale of 1–10, how successfully did we play this activity? Why?*
- *What strategies did you or the group use to make the journey as safe and successful as possible? What adjustments did we make throughout the activity?*
- *Why do you suppose some people say life is like an Obstacle Course?*

Possible side-coaching

- *Give precise directions—how many inches or centimeters do they need to move?*
- *If you are trying to cross the field, listen carefully and only do what your navigator tells you.*
- *How can we clarify what, exactly, our directions mean?*

Possible variations/applications

- Reading/Writing: Explore characters from fiction. An example is Auggie (a child with a facial deformity) and his journey into a new public school in *Wonder*. Students can use lines of the text to represent various forces and stand in as the various objects ("obstacles"), whispering the lines of text as Auggie navigates the space. In this variation, Auggie is navigated through his obstacles by characters from the story who support his school transition. Another participant (or students) represent his sister and/or friends who work to verbally navigate Auggie through the space.
- Social Studies: In a unit on US history, have students represent the obstacles that Native Americans faced as they were forced to leave their homes during the Trail of Tears.

5.f.vii. Three Changes

Source: Kat Koppett
Number of Players: 2+
Space: Any
Materials: None

What is it and why use it?

Three Changes is a strategy where students simultaneously make imaginative changes to their appearance while using close observation skills to figure out what changes have been made in their partner's appearance. This activity can be done with a large or small group and it encourages students to notice visual details.

Directions

Begin by counting the group off into two lines facing one another, 2–3 feet apart so that each person has partner: line A and line B. All students take a

full minute to observe the person they are facing, noting clothing, hair, accessories, and so on. Partners then turn their backs on each other and each makes three changes in personal appearance; for example, they might change the part in their hair, untie a shoelace, and switch a watch to other arm. After a minute, partners face each other and try to identify the three changes the other has made. Ask students who guessed all three changes to raise their hands. Then, line A steps sideways so that each person is facing a new partner, while the person on the end of line A moves to the front of the line. Repeat, each person makes three more changes. The game continues for three or four more rounds, or until the first person in line A has returned to his original partner. Students are encouraged to be creative as they work to discover different ways to make changes.

Reflection

Make the transfer!
Use this strategy as a metaphor to explore observation and choice.

- *What did you notice about the changes we made in the beginning compared to the end of the activity? How did you come up with new ideas for changes?*
- *What strategies did you use to be successful in this activity?*
- *How do the skills required in this game relate to everyday life or our larger inquiry?*

Possible side-coaching

- *Once a change is made it may not be altered.*
- *Think outside of the box; find new ways to make changes.*
- *Find a new use for your accessories, shoes may become hats and belts can be headbands. Have fun!*

Possible variations/applications

- Math: Ask students to determine how many changes each of them made during the game. *What is the mathematical equation needed to answer this question? How many changes did the entire class make during the game? Explore probability, percentages, fractions, graphs, etc.*
- Reading/Writing: Connect this activity to a character from a book. *Has this character made big choices; small, safe choices; or dangerous ones?* Have students write about a time when they had to make a big change.

5.f.viii. Trust Walk

Source: Traditional/Augusto Boal
Number of Players: 4+ (even pairs)
Space: Open Area
Materials: Blindfolds (optional)

What is it and why use it?

Trust Walk involves pairs working together as one participant closes their eyes and is led through the playing space by the other participant. The goal is to create a physically and emotionally safe experience for the partner who is walking without sight. This strategy involves verbal or physical direction, spatial awareness, and collaboration.

Directions

Divide the group into pairs; each group chooses who will be Player A and B. Player A will close their eyes (or put on a blindfold) and then Player B will guide A on a journey around the space. Depending on comfort levels, B can place a hand on each of A's shoulders, one arm around A's shoulders, and/or hold A's inside arm/wrist/hand in order to guide them physically as well as verbally. Player B should try and explore levels, tempo, and space, being sure to vary how and where the Players move in the room. Once directions are explained, the group begins their work. After a set number of minutes, switch roles so that Player A can lead Player B and repeat the process. When everyone has had a turn, the teacher brings the full group back together to reflect.

Reflection

- *Which did you prefer—leading or being led? Why?*
- *What responsibilities did you have as the leader? As the person being led?*
- *What does it take to trust someone to lead you? What does it take to be trustworthy leader?*
- *How might these ideas inform our larger class inquiry?*

Possible side-coaching

- *If you are leading, start slowly. You are responsible for your partner's safety.*
- *If you are being led, experience the space as fully as possible. What do you hear, what do you feel, etc.?*

Possible variations/applications

- Have B take A on a journey through an imaginary space with several invented obstacles (a forest, etc.). For a similar activity, see Obstacle Course.
- Allow Players to choose to at any point to an A or B. Player A can stop, open eyes, and find someone to lead. Player B can stop leading and find someone else to lead or stand with eyes closed to be led by a different Player.
- Have the leading partner narrate the walk by describing what is seen as they move through the space.
- Reading/Writing or Social Studies: Reflect on the strategy, connecting to themes from history (qualities of leadership) and literacy themes (trust, leadership, what is seen/not seen, etc.).

5.f.ix. Who Started the Motion?

Source: Viola Spolin
Number of Players: 8+
Space: Room for a seated circle
Materials: None

What is it and why use it?

Who Started the Motion is a problem-solving activity that requires close perception and ensemble skills. This strategy asks students to collaborate and use soft focus and physical gestures to follow an assigned leader's movements. It requires participants to use observation and problem-solving strategies.

Directions

Invite the group to sit in a circle. Introduce the activity: *In this game we will ask someone to be the "Investigator" and they will leave the room. While they are gone, I will choose someone else to be the "Leader." The "Leader" will do simple arm and body movements that everyone will follow. Then we will bring the "Investigator" back into the room, they will stand in the center of the circle and they will have three guesses to figure out whom the "Leader" is.* Choose an "Investigator" and have them leave the room. For the first round, select yourself as leader; this is a good way to model the game, especially for younger players. Start the movements and keep up a consistent stream of motion, such as tapping the head, snapping fingers, waving arms, etc., changing occasionally while the rest of the group follows along. Invite the "Investigator" back into the room. Remind students that whatever the "Leader" does, everyone in the circle

must copy exactly, so that everyone is always doing the exact same thing. The "Investigator" stands in the middle of the circle, observes the group, and makes three guesses to try to figure out who the "Leader" is. Afterward, a new "Investigator" is selected to leave the room, and the game repeats with a new "Leader." Play continues until everyone has a turn in one of the roles.

Reflection

- *What strategies did you use to keep the "Investigator" from guessing the "Leader"?*
- *What strategies did you use as "Leader" to avoid being found out?*
- *How do we use these same strategies in other parts of our curriculum or in our current inquiry?*

> **Make the transfer!**
> *Use this strategy as a metaphor to explore observation, leadership, and problem-solving.*

Possible side-coaching

- *How will you keep the "Investigator" from guessing the "Leader"?*
- *Remember we need to make sure we are all doing exactly the same thing so we can stump the "Investigator."*
- *"Investigator," give yourself time to look closely before you make a guess.*
- *Let's avoid looking directly at the "Leader." Can you use your peripheral vision (looking at someone else on the side of the "Leader") to stay on track and follow the "Leader"?*

Possible variations/applications

- Have students create motions around a central theme or idea. For example, the "Leader" might generate motions that come from a specific story or from a specific location like the ocean.
- Reading/Writing: If the class is reading a book that involves investigation/mystery, have the "Leader" and "Investigator" take on specific roles from a novel.

Chapter 6

Image Work

Teacher: *Can we make a frozen picture of the floor tiles we need to fill the space? How can our multiplication arrays help us figure out an answer to this problem?*

Image 22: Frozen Picture.

What is it? Image Work strategies invite students to use an object or their bodies to represent and dialogue about an idea, feeling, character, relationship, force, setting, or situation.

Why use it? Image Work strategies encourage students to make meaning in multiple ways, to dialogue with various perspectives, and to situate meaning-making as culturally and personally bound (Eisner, 2002; Greene, 1995). In these strategies, students do the following:

- ✓ Make meaning: These strategies allow multimodal ways of meaning-making (visual, kinesthetic, spatial, etc.) in addition to oral expression as a means of communication. Through creating, sharing, and responding to images, students are given an opportunity to develop and improve their inferencing skills to support their observations.
- ✓ Explore perspectives: These strategies invite students to explore and dialogue about multiple perspectives on any given topic.
- ✓ Situate meaning-making: These strategies enable students to consider multiple facets of a concept, event, or character and put them in

relationship with personal experiences and knowledge to create a more complex understanding.

When and where is it used? Image Work strategies can be used in all areas of the curriculum and can easily be adapted to a variety of instructional tasks and physical/emotional and cognitive levels. Image Work strategies in the category *Object as Image* engage students in a collective process of "reading" or interpreting a still object or art piece as a way to build aesthetic and academic skills that are used to enter a larger dramatic inquiry. Image Work strategies classified as *Body as Image* invite students to explore developmentally appropriate ways to build images individually, in small groups, or as an entire class. Finally, *Images in Action* strategies use the creation of multiple images or gestures/actions within a larger sequence to dialogue about the relationship between separate parts within a larger concept, text, character, or event. All of these strategies create a productive opportunity to explore the difference between observation and interpretation skills through the use of the DBP meaning-making routine described in Part I of this book: Describe/Analyze/Relate or DAR.

6. Image Work Strategies

G. Object as Image

6.g.i. 3-D Models
6.g.ii. Artifacts

6.g.iii. Object as Metaphor
6.g.iv. The Great Game of Power

H. Body as Image

6.h.i. Frozen Picture
6.h.ii. Sculptor/Clay
6.h.iii. Show Us

6.h.iv. Statues
6.h.v. This Setting Needs

I. Images in Action

6.i.i. Bippety, Bippety, Bop
6.i.ii. Complete the Image
6.i.iii. Connecting Images
6.i.iv. Machine

6.i.v. Mapping Geographies of Home
6.i.vi. Real and Ideal Images
6.i.vii. What's the Story?

G. OBJECT AS IMAGE

What is it? *Object as Image* strategies use objects (photograph, painting, character prop, map, headline from a newspaper, a collection of chairs, etc.) to visually represent an idea, character, conflict, setting, or situation.

Why use it? *Object as Image* strategies are foundational Image Work strategies that focus on a step-by-step process for dialogic meaning-making with groups. In *Object as Image* strategies, the teacher or student(s) use aesthetic vocabulary to examine an inanimate object. Then, over an extended time—looking closely at the object to make specific observations—the group collectively interprets the object's/image's meaning and relates it to a larger inquiry. As we slow down our perception to actually *see* what is before us and find visual clues that support our inferences, we gain the opportunity to experience and make meaning from each perception (Eisner, 2002/2009; Dewey, 1934).

When and where is it used? *Object as Image* strategies can be used in all areas of the curriculum and can easily be adapted for a variety of cognitive and grade levels. In social studies, an elementary unit on the Depression in the United States might use Artifacts from the time period, like the Works Progress Administration (WPA) photographs by Dorothea Lange, to engage students in thinking about the people, setting, and emotions of the time period and the event. A middle school English classroom might use Object Metaphor to explore character traits in the novel *The Absolutely True Diary of a Part-Time Indian*. A high school government teacher might use The Great Game of Power to represent how checks and balances work within the three branches of the US government.

Tips for playing!
When a student creates an object to be "read" by others, invite the student to listen to interpretations of their work first and speak last about what they created. Once the student creator says what something "is," it becomes more difficult to explore new interpretations.

How do you use it? *Object as Image* strategies can be adapted for a variety of ages in a range of subject areas. When using these strategies, teachers might consider the following:

Student knowledge and skills

Academic: How much time and practice do students need to effectively engage in the DAR reflection routine in these strategies? The first time an object is "read," participants often need to be reminded to slow down and:
D—Describe: what do they see, before making the jump to… **A—Analysis:** If they analyze first, ask students *What*

do you see that makes you say that? to further encourage the link between observation and interpretation. **R—Relate:** Then, use this meaning-making as a foundation for more complex discoveries.

Affective: How can a group with a range of background experience and understanding be encouraged to make, and equally value, multiple interpretations of an object? After an interpretation is offered, ask *Does anyone have another interpretation?* When productive, consider where different interpretations come from and why this group might have different sorts of meaning to make.

Aesthetic: Do students have a rich visual literacy vocabulary (shape, color, size, texture, foreground/background, etc.) to use in their description of an object? Consider how language about design elements and principles, composition, and style invite students to be more rigorous and detailed in their observation and interpretation of an object.

Context needs

Group: Will all members of a large group stay engaged throughout the DAR reflection process with a single object, as each individual group member takes time to speak? DAR can take time. Large groups may benefit from moments of simultaneous think/pair/share meaning making so everyone makes meaning at the same time and then a few groups offer their thinking to the full class. Another option is to split the large group into smaller groups, with multiple copies of the same object to explore or a series of different objects that relate, so each small group reflects simultaneously on their object and then shares out discoveries at the end.

Space: Can the whole group clearly see the details of the object in order to respond to it constructively? Sometimes, using a large, projected image of the object is better than using a small version of the actual object. Some students may particularly benefit from using their senses to physically interact with an object or objects—touching, smelling, and listening to the object, as well as seeing the object. This may require more than one copy of the object to pass around the room.

Time: How can Object as Image process be adapted to work within a limited time frame? When time is limited, one part of a group can be asked to **describe** what they see, another to **analyze** based on their colleague's description, and the final part to **relate** what has been said back to the larger inquiry.

Spotlight on Artifacts: Reading images with DAR

For a literacy lesson in her first grade class, Adina wanted to use Artifact *activity to introduce the book* Ghost Wings *by Barbara M. Joosse. It was late October and she knew many of her Mexican-American students would celebrate Dia de los Muertos (Day of the Dead) on November 1. Set in Mexico during the Day of the Dead holiday, the book celebrates the endurance of love and the power of memory through the story of a little girl who is struggling with the death of her grandmother. Adina decided to build a character bag as an anticipatory set to hook students into the story. She also wanted to introduce and use the Describe-Analyze-Relate (DAR) thinking routine to reflect on each object in the bag.*

D—Describe
A—Analyze
R—Relate

Select a compelling object or objects

Adina knew her 20 first grade students would be more engaged if she had a number of objects to describe, analyze, and relate to during the activity rather than just one. Adina looked through the story and picked out key thematic elements, which she could represent with easily found objects. She found an older bag made of cloth with the logo of a Mexican banana company, put some brown smudge stains on the outside, and wrote the story's protagonist's name in crooked letters on the outside of the bag in colorful marker. Inside, she put a framed picture of the grandmother from the story (which she made by copying a picture from the book), an authentic looking plastic butterfly, an orange, and a sugar skull.

Build story through your presentation

Adina began her lesson by inviting her students to sit in a circle in their meeting area rug. She invited students into the drama by saying the following:

ADINA: *Today our drama work begins with a discovery. Let's imagine that a bag, this bag, was found outside an elementary school, not so different than our own. We aren't sure to whom this bag belongs. Will you help me figure out whose bag this might be and why it was left in front of a school? Let's begin by describing the bag itself. What do you see? Can someone in our circle share one observation they have about the outside of the bag?*

♡ this

183

Relate: Making Meaning (changing)

Decide how best to use DAR thinking to support the developmental needs of the group

Adina had two different ways she could use DAR dialogue with her class. She could move between (D) description questions and (A) analysis questions, with each description offered by a student, toggling back and forth until finally she felt they were ready to relate their interpretations back to the larger inquiry. Alternatively, she could gather lots of (D) descriptive offers from students, then collectively (A) analyze based on all of the description before collectively (R) relating the analysis to the larger theme. The second option would keep each step of DAR separate. Since this was the first time her students used DAR as a thinking routine, Adina decided to keep the steps separate with her first graders. She also decided to write visual notes on the board as they move through DAR together as a class for the first time. Finally, she decided that once she goes through DAR step-by-step with one object, she will move more quickly (and toggle between D and A questions in DAR) with the later objects.

Invite deep perception through *Description*

To begin, Adina takes single observations from students about the bag.

ADINA: *Let's take a moment, can someone tell me one thing that they see?*

After each student offer (*a brown bag, rough material, red and yellow shape,* etc.), she is careful to remain neutral in her response:

ADINA: *Thank you!*

Then, she writes each student's answer under the word DESCRIBE. Next, she asks the following:

ADINA: *What else do we see?*

When students start to share multiple ideas, she pauses them and asks them to share just one thought so that others can also share their ideas. When a child repeats what someone already said, she puts a check mark by the answer on the list to show that more than one student made the observation. When they offer an interpretation (e.g., *it's a girl's bag*) rather

than an observation, she asks them to explain their thinking with an observation:

ADINA: *What do you see that makes you think this is a girl's bag?*

Invite multiple interpretations through *Analysis*

Once students offer multiple observations and descriptions, Adina invites her students to analyze what the descriptions might tell us about the bag's owner. She models her thinking routine by reading over the key observations on the paper to show how she links an observation to an interpretation. An example of this exchange might flow like this:

ADINA: *We described this bag as having brown smudges on it; we saw a big yellow and red shape on the side, which someone interpreted to be a banana because bananas have a curved shape; and, we noticed a name written in a language, which someone said was Spanish, near the top of the bag. Based on all of these context clues, whose bag might this be?*

Students make inferences about the owner. Adina asks students to point out which observation/description they analyzed to make their interpretation.

STUDENT: *It's a kid because the name has messy writing.*

STUDENT: *She's from Mexico because her name is Spanish and it's a girl name.*

STUDENT: *She likes bananas.*

Adina writes down the students' analysis and uses arrows to link their inference to the observational evidence from the description list. She works to stay receptive to all answers. She redirects students' sense-making when they get off topic or struggle to connect their interpretation to an observation.

ADINA: *If you remember for our drama work today we are imagining that this bag was found in front of a school. If we think a child, maybe a girl—who is from Mexico and speaks Spanish, who maybe likes chocolate, or plays in the mud, who might even like bananas—owns this bag, why do we think the bag is outside the school?*

As she asks this question, she picks up the bag and moves it so that students can see and hear that there are clearly things inside it. The students eagerly ask to look inside the bag.

ADINA: *Of course, how silly of me, I didn't look inside the bag. There might be more clues to tell us who owns this bag and why it was left outside the school if we look inside the bag.*

Make connections and *Relate* thinking to context clues, larger inquiry, and lived experience

After each object is considered, she relates students' sense-making back to the bag and its owner...

ADINA: *What does this object tell us about our mystery about who owns the bag and why it was left in front of the school?*

To end the activity, she invites each student to think for a moment about all the information they have gathered. Then, she asks them to turn to the person sitting next to them and have a dialogue about whom they think owns the bag and why it was left. To continue their thinking, students return to their seats and complete the sentence stem "I think the bag belongs to...it was left in front of the school because..." After they have finished writing, students share their sentence stems.

ADINA: *Thank you for making such strong, thoughtful connections between what we see and what we think; tomorrow, in our literacy time, we will we read **Ghost Wings** by Barbara M. Joosse. There is a girl in this story with a bag, just like the one we were thinking about today. When we read, we will see if we can find things in the text that support or go against our predictions about the girl in this story.*

For the objects inside the bag, Adina repeats the DAR process much more quickly. She does not write down details for each of the new objects. Instead, she flows back and forth between observations and interpretation (description and analysis) for each object.

6.g.i. 3-D Models

Source: Katie Dawson
Number of Players: 3+
Space: Any
Materials: Miscellaneous craft
supplies such as aluminum foil, pipe
cleaners, straws, paper, tape, markers,
crayons, popsicle sticks, and feathers

Image 23: 3-D Model.

What is it and why use it?

3-D Models invite students to use a range of materials to create an abstract visual representation of a key concept, theme, or personal belief. Students then use elements of visual design to verbally respond to each other's models. This strategy asks students to transfer between multimodal forms of expression (text/word to visual to verbal) and to practice deep perception and inferencing.

Directions

Gather enough craft supplies so that every student has materials to use. Invite students to respond to a prompt. For example, *A successful group always... Or A key theme in the story is...* Invite participants to brainstorm individual responses on paper and then circle the three most important words. Introduce the task: *Your challenge is to represent your response to the prompt through a 3-D model. Use your three key words as a guide; how can you represent your thinking using symbol, color, shape, and line to communicate your ideas? If you want to use words, the only words available are the three you circled on your brainstorm.* Give participants a tour of the materials they can use to build their model. Explain that the model can be literal or abstract and provide an example if necessary and establish a time frame. Generally, the more supplies available, the more time students need (10–25 min is typical).

Once completed, lead full group reflections on each model while the artist listens, or invite small groups of 3–4 students to lead their own discussion. Questions may include the following:

- *What do you see in this 3-D model? Encourage description without interpretation: I see colorful lines, which cross each other. I see a large round circle on top of a wooden stick.*

187

- *What might be an interpretation of these observations? What is another interpretation? And another? What else do you see?*
- *What do these interpretations invite us to think about the larger concept/ question/theme we are exploring?*
- *(Final question to artist) Is there anything you would like to say or clarify?*

After all the 3-D Models have been discussed, the full group reflects on the process.

✱ Reflection

- *What did we do in this activity?*
- *Were the responders' interpretations consistent with your thinking as the creator? How so or how not?*
- *Why do people make models? How did making and interpreting 3-D models impact our thinking and understanding of our prompt?*

Possible side-coaching

- *Think about how the texture, line, and shape of the materials might help you communicate the meaning of your three ideas through your 3-D model.*
- *What is another interpretation?*

Possible variations/applications

- If time is short, limit the materials (e.g. only provide aluminium foil) to create their 3-D model.
- Students create a model that represents who they are as a learner.
- Individuals can also interpret their own work for others first and then invite others to comment and reflect if desired; this situates the power more centrally with each individual and allows them to control the interpretation of their personal expression.
- Reading/Writing or Social Studies: Have students create a model of a literary or historical character.
- Math or Science: Have students create a model of concept, theory, or relationship. For example, students might make a model of a symbiotic relationship.

6.g.ii. Artifacts

For further help!
*Check out **Spotlight on Artifacts** in the introduction to this section (p. 183).*

Source: Jonothan Neelands and Tony Goode

Number of Players: 5+

Space: Limited Space

Materials: An object that can relay story (a map, photograph, letter, advertisement, quotation, headline from a newspaper, prop or costume piece, public record, phone message, song, etc.)

What is it and why use it?

Artifact is a strategy that "hooks" students into inquiry through the use of an object. This strategy encourages participants to engage in critical thinking and inferencing skills.

Directions

Gather an object or series of objects that connect to the inquiry. Objects can be real or images projected for the class. Invite students to sit in a position where they can easily view the object. Provide context or backstory—real or imagined—about where the object came from that ties it to a larger inquiry or story within the lesson content. *This newspaper article was in the New York Times last week.* Or *Let's imagine this mysterious object was found at the bottom of a trunk in an old house about to be torn down.* Next, ask the group *What do you notice about this article/object/etc.? Describe what you see.* Invite each student to make an observation about the object. Next, ask students to make interpretations or analyses about the artifact based on their observations. Demonstrate and encourage ways to make connections between observations and their potential meaning as needed. *We noticed as a group that this artifact is a book, that it is torn in a few places, and there appears to be writing faded by water and wear on the cover. What might that tell us about the history of the book?* Avoid suggesting that an answer is "right"; work to honor all interpretations as potentially valid. *So, one interpretation is that the person who owned this book lived in a place with a lot of rain. What else could "writing faded by water and wear on the cover" suggest?* Once students have made some predictions about the object's origin, meaning, and purpose, relate the sense-making back to the content to transition into the next task. *You made some excellent predictions/inferences about this book.*

Let's explore, now, what happens when a group who was very interested in its contents found this book and decided to hold a press conference about their discovery.

Reflection

- Reflection is embedded throughout the structure of the strategy. Artifact activity ends with a discussion about how the artifact(s) links to the next task.

Possible side-coaching

- *What else do you see?*
- *What about it makes you say that?*
- *What else might it mean? What is another possible interpretation of that observation?*

Possible variations/applications

- Provide multiple copies of the same object in small table groups so that a large class can reflect simultaneously on an object for greater participation.
- Have small groups explore a number of related objects and then share with the full group.
- Create a series of headlines about a specific issue or story. Before exploring that issue/story, introduce the headlines and make predictions about what the story might be about or what the issue might be.
- Reading/Writing or Social Studies: Create a character bag that contains multiple objects connected to a character or historical figure. Use articles from the newspaper, political cartoons, old maps, masterworks of art related to themes from literature or history, or make an imaginary object like an invitation to join a political action, a diary entry from a main character, or an imagined announcement of a trial.
- Math: Create a bag of objects that all have similar qualities. For example, all of the objects might have a pattern, or all of the objects might be prisms.
- Science: Create a bag of objects related to a specific animal and their habitat, or a bag of objects that relates to a specific profession. Share a measuring device like a rainwater gauge, images of weather patterns, masterworks of art that use geometric shapes, or a video of a dancework that explores themes about the natural world.

6.g.iii. Object as Metaphor

Source: Meryl Friedman
Number of Players: 3+
Space: Limited Space
Materials: An assortment of objects with diverse characteristics (kitchen utensils work well)

What is it and why use it?

Object as Metaphor is a strategy that invites students to make meaning by describing an object that represents an aspect of their identity or that of a character. This activity invites students to use deep perception and observation to examine and describe an object. It also encourages the understanding of metaphorical thinking.

Directions

Assemble a large assortment of random objects (mirror, whisk, nutcracker, funnel, candle, etc.) where all students can see them. It is helpful to have as many (or more) objects than participants. Invite students to respond to a prompt. For example, *Compare your strengths as a learner to an object.* Or *Pick an object that represents something about your historical figure.* Model how the strategy will work. *In this activity you will pick up the object you want to use* (the teacher picks up a funnel) *and first describe it. This object is round and open at the top to bring a lot of things in and then narrows to a tight small hole. I am a funnel as a learner because I am good at taking a lot of different ideas and putting them together into a single, powerful argument.* The activity can be repeated with additional prompts and objects as useful. Remind students that the same object can and should be used by different people. Review the difference between a simile (uses like or as) and a metaphor, if helpful.

Reflection

- *How did it feel to choose an object? What part of the strategy was easy/ difficult, and why?*
- *What were some common ideas represented in the metaphors we created?*
- *Where do we see or use metaphors or similes? Why? How might the information we shared and discovered about each other help us in our work?*

Possible side-coaching

- *Focus on making observations about the object first—the object is worn and it has long thin parts—and then offer a personal connection to your interpretation of that characteristic.*
- *There is no right answer. Multiple people can use the same object.*

Possible variations/applications

- Have students pick an object randomly from a bag and work from and with whatever they picked.
- For a second part of this activity, give students some aluminum foil and ask them to construct their own model based on the prompt, to build on areas that the first object metaphor did not fully support (see 3-D Models).
- Reading/Writing or Social Studies: Have students use the objects to explore character traits of literary characters, historical figures, or the tone/mood of a story.
- Math or Science: Have students use the objects to identify mathematical characteristic (geometric shape, line, etc.) or metaphorical representations of a scientific phenomenon or relationship.

6.g.iv. The Great Game of Power

Source: Augusto Boal
Number of Players: 3+
Space: Open Area
Materials: 3–5 chairs and a water bottle

What is it and why use it?

The Great Game of Power is an activity that explores representations of power through the construction of a visual image made of everyday objects. This strategy explores the relationship between observation and interpretation through the use of the Describe, Analyze, Relate (DAR) meaning-making routine.

Image 24: The Great Game of Power.

Directions

Place a set of four chairs (all the same) in a row, along with a water bottle in front of a seated group. Ask for a volunteer to silently arrange the four chairs and a water bottle in such a way that, in their opinion, one chair has more

power than all the other chairs. Explain that any of the objects can be moved in any direction or placed on top of each other within the space. Sit in the audience and wait for a volunteer to arrange the chairs. Once the chairs have been arranged, ask that volunteer to return to their seat and to not reveal their thinking behind the arrangement. Next, ask the group to interpret or "read" the image made by the chairs and water bottle:

- Describe: *What do you see? Describe the way the chairs are positioned.*
- Analyze: *What does that position represent or make you think of? Why do you say that? What is another interpretation of this position? Which chair has the most power? Why?*
- Relate: (Make connections to content) *If this image represents a moment in history/a scene from our book/an interaction at our school… what does this image represent? Why? What else could it be?*

Encourage a number of different interpretations. Have another volunteer repeat the activity.

Reflection

- *What are some of the different ways we saw power represented in this activity?*
- *What makes someone or something powerful?*
- *Who or what is powerful in our world now/was powerful then? Why?*

Possible side-coaching

- *Remember you can arrange the chairs in any position you wish.*
- *How is the water bottle positioned in the image? Consider what it represents.*

Possible variations/applications

- As a final step, invite a student to place and pose their body in the image in an effort to take power away from the chair. This leads to reading a body as image in relationship to an object.
- Invite students to make a specific image of power in response to a prompt: *Arrange the chairs to represent the author's argument from the reading.* Or *Arrange the chairs to represent a democracy.* In this version, the person or group creating the image should get to share their thinking after all the rest of the group has completed their meaning-making, in order to explain the intention behind their interpretation of the prompt.
- Reading/Writing or Social Studies: Use this strategy to discuss types or systems of government, character relationships, or representations of power within a story or history.

H. BODY AS IMAGE

What is it? *Body as Image* strategies invite students to shape their bodies or the bodies of others to represent an idea, feeling, character, relationship, conflict, setting, or situation.

Why use it? *Body as Image* strategies are foundational Image Work strategies that use drama/theatre techniques to invite students to create, perform, interpret, and revise their meaning-making through their bodies. *Body as Image* strategies support a student's ability to make meaning in multiple ways. Specifically, they invite students to make meaning though kinesthetic and visual interactions in addition to verbal exchange (Kress & Van Leeuwen, 1996, 2001; New London Group, 1996). Exploring meaning though the body gives students an opportunity to translate from one symbol system to another (written or verbal text to bodies and vice versa), which has been shown to improve retention of information over time (Kayhan, 2009).

When and where is it used? *Body as Image* strategies can be used in the curriculum when students need to visualize, perceive, and reflect their understanding of the following:

- Characters (e.g., from the *The House on Mango Street*)
- The relationship between people (e.g., bully, target, and bystander)
- Forces or ideas (e.g., colonization of an indigenous population)
- A setting or event (e.g., the Montgomery bus boycott in the US civil rights movement)
- A concept (e.g., tessellation)
- A single word (e.g., catalyst)

For example, in an early primary classroom, a teacher reads an informational text about different jobs in a community. Each time a profession is introduced, the teacher asks the students, while still seated on the rug, to shape their bodies into an action related to the profession, using a modified version of Statues. A middle school teacher explores characteristics of cloud formations through Sculptor/Clay. A high school teacher might use Frozen Picture/Stage Picture in her English class as way to assess students' understanding of the inciting incident in a short story.

How do you use it? *Body as Image* strategies can be used with every subject area. When using these strategies, teachers might consider the following:

Student knowledge and skills

Tips for playing!
An improvised body image provides an easy way to embed a simple performance-based assessment of student understanding: The author states our character feels "Exhausted"; show us with your body what "Exhausted" looks like … 4-3-2-1 GO!

Academic: What is the learning task of the *Body as Image* activity—immediate assessment or understanding and learning over time? In a spontaneous, improvisational approach to making body images, the student immediately pulls from their current knowledge to shape a response using a different symbol system—the body—as a way to express meaning. This is a fast way to assess individual student understanding. In a discussion/rehearsal approach, students take time to consider how to best use their bodies as way to express individual or collective knowledge and understanding. They negotiate and explore ideas in small or large groups, and give and receive feedback. They might even share a draft of an image with their teacher, another small group, or the full class, and then revise their body image to perform again for further feedback. Both approaches work; however, they provide different types of learning opportunities for students and the teacher.

Affective: What knowledge (about the content or the DBP strategy procedure) will help students to safely and effectively partner in Body Image for the first time? Students might need to see the steps of how to negotiate physical contact with a partner before beginning to make Sculptor/Clay body images.

Tips for playing!
When reading images, disconnect the performer's identity from the character or idea they represent. For example if a student named Jenny is making an image:

Avoid: *Jenny is angry in this image.*
Better: *The character Jenny is portraying looks angry.*
Best: *This character looks angry.*

They may feel less risk if they can build a Frozen Picture one person at a time or if one person in the group is assigned the role of director to shape the larger group within the image before it is shared with the rest of the class. To support distancing between a character and idea being represented, a student in a body image can be given the option to be replaced by another student at any time for any reason. This keeps the focus on the body representation being explored rather than the performer playing the part. This is particularly important if an individual or group is required to share their image, rather than volunteering to share.

Aesthetic: What basic theatre skills do students need to learn to successfully make and interpret body images? Teachers need to take time to build a common artistic

195

performance vocabulary about building images. For younger students, it can be useful to discuss different body levels and shape, facial expression, point of view, and feelings. Older students can explore a more expansive performance vocabulary to create and respond to body images, including tension/release, gaze, internal motivation, physical connections among students, and positive/negative space.

Context needs

Group: Will students be most successful working individually, independently in pairs or small groups, or in a single large group with teacher-led facilitation? All of the *Body as Image* strategies can be adapted to support any of these choices. If working in small groups simultaneously—with one teacher moving between multiple groups—make sure students understand a clear procedure of how to move independently from dialogic sense-making through group discussion into the creation of an image.

Tips for playing!
Remind students to be responsible for their own body weight and to keep both feet on ground when making images. The goal is to keep everyone physically safe and to focus on meaning-making rather than a balance challenge.

Space: What space is available to make images? Body images can be made seated at a desk but are much more detailed when students have space and room to explore the full aesthetic potential of the strategy. If students are making images in one space and sharing in another, they may need time to rebuild their image in the new space, as it can be disorienting to shift from one space to another.

Tips for playing!
Invite the audience to close their eyes while the students make their image in secrecy: I'm going to count backwards from five, and when I reach one you will open your eyes to see the image—5-4-3-2-1— open your eyes!

Time: How long can students hold a frozen image? It can be challenging to maintain a pose for a long period of time, even for the dedicated and focused student. Take moments to "shake out" from the image and then return to hold the pose again. Students can also ask for a replacement if they get tired or if they want a turn to make meaning of the image that has been created. Body images can also be digitally photographed and then projected to allow more time to respond to each image.

6.h.i. Frozen Picture

Source: Viola Spolin
Number of Players: 3+
Space: Open area
Materials: None

What is it and why use it?

Image 25: Frozen Picture.

Frozen Picture is an activity that invites students to work quickly in small groups to create a visual representation of an idea, theme, text, event, or character using their own bodies. Students work collaboratively to make meaning through both their bodies and their words.

Directions

Invite students to sit on the floor or at their desks facing a small empty space. Introduce the strategy: *What makes a successful Frozen Picture that involves multiple people?* Invite students to generate a list of the ways actors tell a story in a frozen image without words. For example, actors use their body and face, defined point of view, imagination, levels, physical frozen action, and the relationship between bodies. Invite a group of volunteers to stage the first group image with clear characters and/or a conflict based on an interesting, accessible prompt for the group. For example, "Summer time" or "Our School" or "First day of Kindergarten" or "The accident." Ask the volunteer group to stand in front of the rest of the class; give each student a number (for example, 1–5). Next, randomly call a number and the person assigned to that number steps forward and makes the first part of a frozen image with their body. Call another number and invite that person to look at what has begun and add to the image. Continue until all of the students have joined the image. While the Frozen Picture is still frozen, ask the audience students: *What do you see? What could be happening in this image? What about the bodies/characters that you see make you say that? What is a title for this image? What else could we title this image?* The performers return to the audience and new group of volunteers are selected and the process repeats itself. Once all students understand the procedure, build images spontaneously on a 5- or 10-count with students joining the image at any time within the count. Or, build images without a theme and make a theme based on what is built. Or make an image, title it, and then invite participants to spontaneously build

another related image either backward or forward in time. Give them a ten second transition to move to the new image.

Reflection

- *What did we do in this activity?*
- *What performance choices helped us to explore the vocabulary word/ character/concept?*
- *How do our images connect to our larger inquiry?*

Possible side-coaching

- *Find a different way to join the image that you haven't done before (a new level or viewpoint).*
- *Make sure you are building on the image that is already there!*
- *Audience, let's think like a director: Is this picture telling the story we need to tell? What suggestions might we make to strengthen or clarify the image?*

Possible variations/applications

- Reading/Writing or Social Studies: Give the students a quotation, a photograph, or an illustration from a book, or passage from an informational text and have them build an image of the picture.
- Science: Students can build group images of scientific concepts (meiosis, states of matter, etc.).

6.h.ii. Sculptor/Clay

Source: Various
Number of Players: 6+
Space: Open area
Materials: None

What is it and why use it?

Sculptor/Clay is a strategy in which students work together to visually represent a word, idea, or character, with one individual serving as the "sculptor," who moves the other individual(s) serving as the "clay" into position. This activity allows students to safely practice physical interactions and explore how to build an effective visual representation of their thinking using another person's body.

Directions

Invite students to sit on the floor or at their desks. Introduce the strategy: *How do sculptors make meaning through their art form? Today we will work like sculptors, using a partner's body to express our thinking.* Select a volunteer to help model three different sculpting techniques. Pick a word/character that is familiar to the group, and then ask the student volunteer, *May I sculpt you?* (Full touch) Once consent has been given, move the person carefully and appropriately into position, model how to use physical contact to sculpt a person; show the final sculpture of word and then invite the volunteer to relax. (Near touch) *May I sculpt you again?* Once consent has been given, use imaginary puppet strings attached to the volunteer (or clay)'s body to raise or lower different parts of the body, without actually touching, to make the exact same image; show the sculpture and then invite the volunteer to relax. (No touch) *May I sculpt you a final time?* Once consent has been given, shape your body into the sculpture and show it to the volunteer. Then, the clay shapes their own body into the same form; show the sculpture and then invite the volunteer to relax. Next, put students into pairs. This can be done randomly or students can make two concentric circles and the people who end up across from one another become partners. Give students a prompt: *Sculpt an image of the word tenacious.* Or, *Sculpt an image of how you think adults view teenagers.* Or, *Sculpt an image of Esperanza from the book, Esperanza Rising.* One person in each pair will be the sculptor and the other will be the clay. Ask groups to choose a sculpting technique that feels most comfortable. Remind them to ask permission to sculpt. Ideally, the pairs work silently and simultaneously. After they finish, the sculptures remain frozen and the sculptors walk about their newly created gallery. The sculptors are asked to describe what they see and make inferences and connections between the sculptures and the initial prompt. Afterward, the sculptor and the clay switch roles and the cycle of creation and reflection are repeated.

Reflection

- *How did it feel to be the clay? How did it feel to be the sculptor?*
- *What body shapes did we see in our statues? How did these shapes represent similar/different ideas?*
- *How did our sculptures connect to our larger inquiry or question?*

Possible side-coaching

- *Before beginning please ask your partner if you may sculpt them; discuss any physical limitations that the "clay" has today. Honor what is needed.*

- *Please be sure to sculpt your clay into a comfortable position that can be held.*
- *Try to explore different levels and body positions. Don't forget about sculpting a facial expression.*

Possible variations/applications

- Allow multiple sculptors to work on multiple pieces of clay (people) at the same time.
- Reading/Writing: Create a sculpture of a character at a specific moment in a story, or of a feeling or action in a story.
- Math: Create a statue that represents opinions about math or a mathematical vocabulary: parallel lines, triangle, acute angle, etc.
- Science: Create a statue that represents a scientific concept or term.
- Social Studies: Create a statue that represents a moment, concept, or person from history.

6.h.iii. Show Us

Source: Brian Edmiston and Rachel Gartside
Number of Players: 3+
Space: Open area with room to move
Materials: None

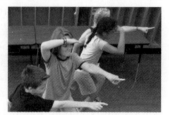

Image 26: Show Us.

What is it and why use it?

Show Us is an activity that invites students to work silently individually or in small groups to create a visual representation of an idea, theme, text, event, or character using their own bodies. Students make sense verbally and kinesthetically in this activity as they place their understanding, represented via their bodies, in dialogue with others' bodies.

Directions

Invite students to walk through a defined space without touching one another. Ask the group to create a silent, spontaneous individual or group image of a word on the count of 5 or 10. For example, *In groups of three, show us Bravery.* Once students have made their frozen images, make observations about the similarities/differences in the images: *I see bodies standing open*

and strong. I see arms up. I see eyes look out to the future. Or, ask half of the students to unfreeze and observe the other students' images, asking the group to describe what they see bodies doing in space. In this version, it is important to repeat the observation process for the other half of the student images. After observation/meaning-making is completed, either by the teacher or by the group, ask the students to resume walking through the space silently. Then, ask the group to explore another word or phrase through the same process.

Reflection

- *What kinds of images did we make? How were our bodies shaped?*
- *Why do you think we made these artistic choices? What similarities and/ or differences were there between the images we created?*
- *What do our images tell us about our larger inquiry?*

Possible side-coaching

- *Work quickly and silently to create your images.*
- *In a group, make sure you are building upon everyone's ideas to create the image.*

Possible variations/applications

- Place students in different sized groupings for different images (single, paired, or trios).
- Invite students to make a series of images to explore a concept over multiple images: family, royal family, and royal family during times of war. See Connecting Images.
- Science: Have students explore vocabulary terms or concepts like proton/neutron/atom, evaporation, or cumulous cloud.
- Math: Have students explore vocabulary terms or concepts like perpendicular lines, or a rhombus.
- Social Studies: Have students explore vocabulary terms, concepts, or events related to the study of history or society like monarchy, equality, or the immigration or the colonization of indigenous peoples.
- Reading/Writing: Have students explore vocabulary terms, concepts, or events like an inciting incident from a story, or a key argument from reading selection.

6.h.iv. Statues

Source: Augusto Boal
Number of Players: 2+
Space: Limited space
Materials: None

What is it and why use it?

Statues is a low- to medium-risk image work activity in which students quickly shape their own bodies individually and independently to create a frozen "statue" that represents a person, feeling, or idea. This activity uses limited space and it is a great way for students to practice how to shape their bodies to represent their thinking and understanding.

Directions

Invite students to find their own space in the room with a set perimeter. (This can also be done seated, though standing with space is preferable.) Introduce the activity: *In a moment I will give you a word/theme/character to explore. Your job is to create a frozen statue that represents your response.* Encourage students to use their whole bodies including their faces. Offer the prompt. For example, *Make a statue of one character you remember from our story.* Or, *Make a statue that shows how we use measurement to do something.* Give students a moment to think, then count backwards from five or ten to one while they create their images. Once statues are made, choose a way to look at the images. For young players, try quickly calling out what you see their bodies doing: *I see arms wide open. I see big smiles on faces.* And then let all students relax. For older students, ask half the group to relax and half the group to hold their statues and take time to look at and interpret the statues with the other half of the group; then switch. For all students, it can also be useful to single out a particularly effective statue or two to remain frozen while others relax, to invite and focus further interpretation and discussion. It is important, however, to give the selected statues the option to be replaced by another body—in the same body image pose—if that is their preference.

Reflection

- *What sort of statues did we make?*
- *How did we use our bodies to represent the idea we were working on today? How did it feel to take on that pose in your body?*
- *What did we discover about our inquiry through this activity?*

Possible side-coaching

- *What position best represents what you wish to express?*
- *Remember to use your face when you are in your statue. Try to use your whole body! Arms, fingers, head.*

Possible variations/applications

- Reading/Writing: Create a sculpture of a character at a specific moment in a story, or of a feeling or action in a story.
- Math: Create a statue that represents opinions about math or a mathematical vocabulary: parallel lines, triangle, acute angle, etc.
- Science: Create a statue that represents a scientific concept or term.
- Social Studies: Create a statue that represents a moment, concept, or person from history.

6.h.v. This Setting Needs

Source: Unknown
Number of Players: 5+
Space: Open area
Materials: None

What is it and why use it?

In This Setting Needs, students build an environment with their bodies based on a teacher's prompt. By embodying objects/people/animals/actions in a space, students explore the many characteristics and aspects of a location, setting, environment, or event.

Directions

Invite students to sit together on the floor or in chairs as an audience, facing a large empty space. Introduce the strategy: *Today we will create an environment or a setting using only our bodies.* If needed, help students to construct a shared definition of the word "setting" or "environment" as a place or location where an event takes place. Next, invite students to build a familiar setting. *The first setting we are going to create is a playground. Everyone take a moment and think of the different things and people that you would find on a playground. When you have an idea, please raise your hand. I will invite you to come into our stage space and shape your body into a frozen action of something you do or*

might find on playground, as you describe what you've become. Offer a few examples to the group. *This setting needs a swing.* Then become a swing set or become a person on a swing. Or, *this setting needs a game of tag,* as you become a child about to tag another person. Once instructions are clear, begin the activity. Encourage students to make specific physical choices that they can hold for a few minutes. Build each setting until 5–10 students are on stage. Once the image is built, ask questions to the audience: *What do you see in this setting? What clues do the actors give you to help you understand who they are/ what they are doing/how they feel about it? If you had to give this setting a title, what would you title it?* After the questions are completed, give students a round of applause and have them return to their seats. Repeat the activity, this time inviting the group to create an image of a location, setting, environment, or event tied to the day's inquiry.

Reflection

- *What settings did we create today? How did we use our bodies to show the setting?*
- *What actions did we see in the settings? What relationships did we see?*
- *How does creating and interpreting these settings together help us to think about (different environments, our story, the way we infer to make meaning, etc.)?*

Possible side-coaching

- *Show us the character/object with your body. Be as specific as possible.*
- *What else is missing from our setting?*

Possible variations/applications

- Have each student create the setting silently without explaining what is happening.
- Reading/Writing, Social Studies, Science: Students are invited to choose a setting, moment in history, environment, or process and begin to construct the image without sharing where it is. Others try to figure out what the image is and join in, one at a time. After 4–10 people have entered, the round ends as everyone shares what setting they imagined and compares their ideas.

I. IMAGES IN ACTION

What is it? *Images in Action* are strategies that build off participants' understanding of how to make a basic image to explore how multiple images function in relationship to one another, as a way to explore complexity, sequence, and cause and effect within concepts, arguments, feelings, characters, conflicts, or situations.

Why use it? *Images in Action* strategies use the creation of multiple images or gestures/actions in a sequence to dialogue about the relationship between separate parts or aspects within a larger idea, concept, event, or character. These strategies invite students to see how perception and reception is situated culturally, individually, and collectively (Edminston, 2014; Greene, 1995; Kress, 2003). By building images in relationship to one another, *Images in Action* offer students an opportunity to see multiple viewpoints regarding a situation, character, or idea. Through the process of sharing and interpreting, or "reading," the Image Work of others, students observe, interpret, and infer new meaning, as well as dialogue about multiple perspectives.

When and where is it used? *Images in Action* strategies can be used in the curriculum when the curricular goal focuses specifically on investigating a change. Through the creation, sequencing, and reflection of images, which are made in relationship to another image, *Images in Action* support further critical understanding of the *what*, *why*, and *when* of related concepts/events/characters in relationship to one another. For example, in a primary classroom, a teacher might take time to create/perform/respond to images that depict how energy impacts particles in solid, liquid, and gas forms in Connecting Images or Real/Ideal Images. Then the group might create a "states of matter" Machine, which moves through each of the phases of matter in sequence.

Images in Action strategies also provide an active way to explore and make meaning about how individual action is shaped by identity, context, and society. For example, in a secondary classroom, a teacher might use What's the Story to begin an exploration of the relationship between Lenny and George in *Of Mice and Men*. The group might review an evening reading assignment by working collectively or in pairs to represent key moments between Lenny and George in Complete the Image. Finally, having finished the book, the group might explore their own relationship to home and how the characters in the story might embody the theme of home in Mapping Geographies of Home.

How is it used? *Images in Action* strategies can be used with every subject area. When using these strategies, teachers might consider the following:

Student knowledge and skills

Academic: What sort of knowledge and understanding do students have of the underlying pattern or cause/effect relationship being explored? Because *Images in Action* involve students thinking through complex, abstract relationships and translating their ideas into body-based expression, it may be useful to examine an image individually before building a larger sequence, or for the teacher to facilitate a process for the full group rather than ask students to work in small groups independently.

Affective: What level of trust exists among the group? What is the group's ability to collaborate and negotiate creative decisions so that all students can be successful? If students can work effectively with a small group, then Mapping Geographies of Home or Connecting Images might be a strong fit. Some strategies like Complete the Image and Real/Ideal Images can be done with limited or larger amounts of teacher support. If the group would benefit from a highly facilitated strategy to mitigate risk, then What's the Story; Bippety, Bippety, Bop; or Machine would most support students' social-emotional needs. If the culture of the classroom feels unsafe for students to risk putting their body up in front of others, then What's the Story is often the easiest strategy to use since it requires the smallest amount of people taking the smallest amount of risk to perform.

Aesthetic: What understanding do students need about how to build and link aesthetically complex and rigorous body images to use the strategy most effectively? Introduce ways to transition between images (slow motion, audience eyes close for image change then audience eyes open cued by teacher, tambourine/chime/drum cue, music in background) as a way to add another layer of nuance and interpretation to the creation of and meaning-making process with *Images in Action*.

Tips for playing!
Consider using a critical response method to frame reflection on a presentation:

I appreciate: The audience shares specific moments they appreciate from performance.

I discovered: Performers share what they learned by making and sharing the sequence.

I wonder: Audience and performers ask questions about revision or make connections to the larger inquiry.

Context needs

Group: How will students be grouped for success? Will they work best alone, in pairs, in small groups, or with the full group? For a new or struggling group, sometimes the teacher needs to model with a small group how to successfully complete the task. For other groups, keeping all members engaged in their own creative work in pairs, without an outside audience observing, is more effective.

Space: What sort of space will students need to move, make body images, and stay engaged in the activity? Some of the strategies require room to make a circle. Many of these strategies also need space to establish a performer/audience divide. It is important that students in the audience can see the images being shared in order to successfully reflect on what they see.

Time: How long do students need to make images in a brainstormed or step-by-step *Images in Action* process? Students need time to fully explore the theme, concept, character, or event, but not so long that they lose interest. Consider ways to give an additional task (create a caption, revise images, etc.) to a group that is finished earlier than other groups. If a small or large group is sharing a sequence of images, often the larger impact of seeing the sequence of images all the way through is most important. Therefore, it is best to wait until all the images are shared to engage in dialogue with the audience about what was seen.

6.i.i. Bippety, Bippety, Bop

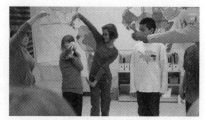

Source: Various
Number of Players: 8+
Space: Room for a Circle
Materials: None

Image 27: Bippety, Bippety, Bop.

What is it and why use it?

Bippety, Bippety, Bop is a fast-paced game that asks students to work together to recall and create specific three-person images within a given time limit. This is a playful way to work on focus and collaboration and to make and practice non-linguistic representations of vocabulary words.

Directions

Invite students to stand in a circle. Introduce the strategy: *In this activity, I will teach a series of images, then I will stand in the center of the circle as the caller and point at a group of three to make one of the images. If chosen, your job is to make the body image I ask for within the count of three.* Teach the first image: "Elephant." Point to a person in the circle and ask them to make a long trunk with one arm, ask the person on either side to each form an ear in a "C" shape, facing toward the trunk. Call out: *Elephant 1-2-3.* Practice "Elephant" with the group, pointing at lots of different people around the circle, working to build confidence and speed. Next teach "Palm Trees." Explain that in this image, all three people do the same thing. Point to a person and ask them, and the person on either side, to wave their hands in the air above their head like a palm tree blowing. Call out: *Palm Trees 1-2-3.* Once both images are taught, play the game with "Elephant" and "Palm Trees" calling on students as quickly as you can around the circle. Finally, introduce "Bippety, Bippety, Bop." Explain that if the caller says "Bippety, Bippety, Bop," the person being pointed to must say the word "Bop" before the caller completes the word "Bop" at the end of the phrase. The two people on either side of the person being pointed to, do nothing and must not move. Practice with "Bippety, Bippety, Bop." Then, play with all three calls (Elephant, Palm Trees, and Bippety, Bippety, Bop); work on speed and accuracy.

Once students understand the activity, introduce 2–3 content-related vocabulary words (e.g., a math unit might use *obtuse angle, acute angle,* and *right angle,* while a science unit might use *solid, liquid,* and *gas*). Build a three-person image for one of the words. Practice the word as an image in the game. Then, split the group in half, and invite each half to create a

three-person image of one of the remaining vocabulary words. Remind the groups that it must be an image that everybody can do, which can be created quickly on a count of 3. Each group shares and teaches their image to the rest of the group. The game resumes with the new vocabulary, plus the original terms of "Elephant," "Palm Trees," and "Bippety, Bippety, Bop."

Reflection

- *What did you have to do to play well?*
- *In our content vocabulary, how did we differentiate between our images? Why did we do this?*
- *Why might it be useful to construct a body image of vocabulary word? How can we use this technique to help us better understand the material?*

Possible side-coaching

- *How quickly can you make the image?*
- *How can you stay focused and ready to go?*

Possible variations/applications

- This can also be played so that when a student makes a mistake they move to the middle and serve as the "caller" and the teacher joins the circle. If using this choice, be sure to remind the "caller" to use speed and an element of surprise to try and get out of the center. The caller needs to be fast to keep the game moving.
- The game can be played with students getting "out" if they make a mistake. However, when this happens it is important to find a way to keep them engaged in the activity as judges or in another role.

6.i.ii. Complete the Image

Source: Augusto Boal and
Michael Rohd
Number of Players: 6 or more
Space: Open area
Materials: None

Image 28: Complete the Image.

What is it and why use it?

Complete the Image is a fast-paced activity in which students work with a partner or as a large group to quickly create a series of two-person images based on a theme, event, or situation. Complete the Image challenges students to use their whole bodies to make meaning as they explore proximity, shape, and levels in space through a series of images over time.

Directions

Teach the Strategy: Invite students to sit together and face the largest open space in the room or invite students to sit in a large circle. Ask two volunteers to come up front or to stand in the middle of the circle. Ask the volunteers to shake hands and freeze their entire bodies, including their facial expression. Process the image with the rest of the group: *What is going on in this image, in this moment, between these two people? What makes you say that? What else could it be?* Invite the group to make multiple interpretations. Then, invite a volunteer to come up and tap out one of the frozen characters while the other person stays frozen in the handshake. The volunteer then creates an entirely new frozen image by placing himself or herself in a new position in relationship to the already frozen person with his or her arm outstretched. The new person can make a physical connection to the person or they can be separate. Invite the group to make meaning, again, of what they see. *What is going on in this image, in this moment, between these two people?* After ideas are shared, explain the strategy: *In a moment, our job as a group is to make as many different images as possible. We will keep subtracting and adding a person to the two-person image to make a new image as quickly as possible. The new person coming into the image will always make the new image. We can explore realistic or abstract images. Any questions?* Students work together to create an uninterrupted flow of images. Encourage as many students as possible to play as often as they can. All image-making is silent. The group does not make verbal meaning of the images.

Reflection

- *How did it go? What did you notice about the images we created?*
- *How was it different to do this exercise in pairs as opposed to in a large group?*
- *How did the images change when a theme or idea was added?*

Possible side-coaching

- *Explore the space (physical levels as well as the floor, walls, or doorways).*
- *Remember that your face and attitude is a large part of the images you create.*
- *Go with your first (appropriate) idea. Don't think about it too much. Practice being in the moment.*

Possible variations/applications

- Reading/Writing or Social Studies: Invite students to explore themes from literature as part of reading comprehension or explore arguments on a key social issue as part of persuasive writing unit. Engage with complex moments in history at the top of a unit as a pre-assessment or at the end of a unit to share feelings and discoveries about learning.
- Invite the group to find a partner and create a frozen handshake image together. Then, all groups work simultaneously, in their own time, to create a flow of images rehearsed before. Introduce themes related to content (communication, jealousy, family, high school, fame, immigration, etc.) for students to use to inform their partnered images.

6.i.iii. Connecting Images

Source: Various
Number of Players: 4+
Space: Open area
Materials: If using text, then specific lines of text for each group to base their images

What is it and why use it?

Connecting Images invite students to create multiple images to tell a story or explore a theme or character. To be successful, students should understand the basics of Statues or Frozen Picture in order to be able to link images together. Connecting Images offers a way to explore multiple perspectives, to display specific moments that exist throughout a passage of text or over a period of time, or to illustrate contrasting ideas such as internal/external, before/after, and real/ideal.

Directions

Review how to build an effective frozen image. Invite the full group or groups to generate two to five frozen body images that explore the answer to a prompt, such as *Tell the story of the Three Little Pigs in five frozen images*. Or, *Explore the causes of the Great Depression through three different frozen images*. Or, *Show the main ideas of these four lines of Beneatha Younger's monologue from Raisin in the Sun* in a specific amount of time (7–15 minutes). If useful, facilitate the construction of each image: *We will begin with the first image in the sequence. You will have five minutes to make this image. I will check in with each group to offer support where needed.* Then facilitate the creation of each of the following images, with a short amount of time given to the making of each image in the sequence. Next, invite groups to explore how to transition between the images, and rehearse how they will move from frozen image to frozen image to create a fluid performance sequence. Invite each group to share their entire image sequence informally with another group or formally for the whole group.

Reflection

- *Describe what you saw in the first image. How did that change in the next image?*
- *What ideas, events/actions, or environments did each image explore? What clues did you see to help you draw that conclusion?*
- *What was the story? Or, how did the images relate to one another?*

Possible side-coaching

- *How will you transition between images? How is the transition telling the story?*
- *It is helpful to keep the same person/people playing the same character(s) (particularly a central character) in all the images? Consider how the character's body, emotions, and/or actions shift between the images to tell a story.*
- *Use the space and your body to creatively depict different environments in your images.*

Possible variations/applications

- Play out a paired improvisation with action and dialogue. The teacher calls out "freeze." Students freeze and readjust their bodies to capture the emotions, ideas, and forces at play in the frozen moment. Unfreeze, and the scene continues. Repeat as desired.

- Social Studies: Have students make images of a historical event or figure over time. What key images best tell the story of this event or person?
- Reading/Writing: Give students a short passage of complex text (like a poem from *Brown Girls Dreaming* by Jaqueline Woodson) and ask them to circle five key words. Then have them make five connected images to represent each of the words.
- Science: Have students create multiple images to illustrate scientific concept like metamorphosis.

6.i.iv. Machine

Source: Viola Spolin
Number of Players: 5+
Space: Room for a circle
Materials: None

What is it and why use it?

Machine is a game in which students connect multiple simple, repetitive body motions in a sequence to represent an idea, theme, or process. In Machine, students explore vocal and body theatre skills—like projection, articulation, level and shape in space, quality of motion, and tempo—as they consider how an individual action is part of a larger connected system.

Directions

Invite the group to sit facing an open space or in a large open circle. Ask *What is a machine?* Develop a definition together, naming different types of machines as examples. Based on their suggestions, pick a machine to explore. Ask the group what simple sound and gesture—or movement—might appear in this machine. Invite a volunteer to move to the front of the space or the center of a circle and make this simple, repetitive sound and movement; this is the first piece of the machine. Invite another person to find a way to add another sound and motion to the first person's action. Then, either continue to call students into the machine or encourage them to enter on their own. Ideally, each student's motions relates to what the other students are doing, as parts of a machine do. Students can be invited to link to the machine in any area or be instructed to just build onto the last player to be added. When a large portion of the group has joined in, play with tempo—turn up the speed so the machine must work quickly, or slow down the machine so it must work very slowly. After a bit, freeze the machine and asks students who are watching to name

the machine. *Thinking about the types of movements we saw, what kind of machine is this?* It may be the original machine idea or it might have become something else. *What else could it be?* Encourage another interpretation. All students return to the outside circle and the group dialogues about what worked well in the machine creation. Build another machine. This time explore a less-familiar machine, such as a spaghetti-making machine, a life cycle of a seed machine, or a happiness machine, or let them make a machine that gets named at the end. If making a themed machine, it might be helpful to brainstorm actions that relate to the given theme. Continue to explore cause and effect, levels, tempo, and quality of movements throughout the activity.

Reflection

- *How would you describe our machine?*
- *How did each student add to it?*
- *What does this machine say about our larger topic of exploration?*

Possible side-coaching

- *Keep doing your sound and motion so others can join in!*
- *Think about how your sound and action relates to our theme. What do you see missing that we need to add?*

Possible variations/applications

- Try taking out a piece of a machine and observe what happens. This becomes a strong metaphor for interdependence.
- Reading/Writing: Create a machine that relates to an event, theme, or character from the text. For example, students might create a gossip machine for *The Scarlet Letter*, or a story structure machine as a way to explore the parts of a story.
- Science: Create a machine that relates to an environment/setting or cycle. For example, students might create a rainforest machine or a water cycle machine.

6.i.v. Mapping Geographies of Home

Source: Drama For Schools (DFS), Jan Cohen-Cruz, and Omi Osun Olum
Number of Players: 6+
Space: Open area
Materials: None

What is it and why use it?

Mapping Geographies of Home invites students to map and perform their literal and figurative understanding of home on an imagined map on the floor. This activity asks students to think about how the construction of home is culturally situated and invites students to engage with and consider multiple experiences, perspectives, and definitions of home.

Directions

Define the perimeter of a large, open playing space and orient a compass rose on the space for north, south, east, and west; this is the imagined "map." Introduce the strategy: *I will give a series of prompts. You will respond by placing yourself on the map in the space that best represents your answer.* Explain that the map is very flexible and space/distance between locations will have to be flexible too. Begin the strategy. *If our current space is located at the center, here, of an imagined map, please go stand on the place where you often spend time when you are not in school.* Once placed, invite students to name where they are standing. Next, ask *If our current space is located at the center of an imagined map, please stand where you were born.* Once placed, invite students to name where they are standing; some might shift in response to what others share. Finally, ask *If our current space is located at the center of an imagined map, please stand at one of the physical spaces that you call home, recognizing that there may be more than one. This could be a place where you have spent a lot of time, or a physical space that you feel is "home," although you may have never been there.* Once placed, invite students to name where they are standing.

Next, ask students to create a gesture, which offers an abstract or concrete representation of the physical space that they call "home." Then ask all participants to perform their gesture at the same time as a rehearsal. Next, invite each student to pair up with another person near them on the virtual map, and teach them your gesture. Then, put the gestures together in a sequence. Finally, each pair is grouped with another pair. The group of four works together to create a final performance that includes all four gestures in a sequence of shared choreography. The activity closes with each group sharing its performance of "home" for the full group, while the students respond to what they see. Have each group share their choreographed sequence through two times. Then, invite the audience to "popcorn" out one word that sticks with them—those words might be an emotion, an idea, or an action that they saw represented or that they felt.

Reflection

- *What did you notice about yourself in this activity? What did you notice about the group?*
- *How did our map shift and change as we moved between imaginary map locations?*
- *What is home? What shapes our understanding of home?*

Possible side-coaching

- *Remember our map has flexible space; just place yourself where you feel like you need to be.*
- *Once you know where other folks think they are placed, you are welcome to adjust your position.*

Possible variations/applications

- Ask students to map more complex ideas, e.g., *Stand on the location where you first felt a feeling of love. Stand on the location of a place you would never want to visit.*
- Reading/Writing: Have students play the game as a character from history (Anne Frank) or from literature (Ashima Ganguli from *The Namesake*) or from a play (Walter from *A Raisin in the Sun*).
- Social Studies: Using the first part of this activity, have students review geography and/or the location of different key events in history.

6.i.vi. Real and Ideal Images

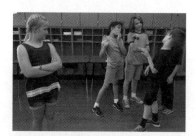

Source: Augusto Boal
Number of Players: 4 or more
(best with more)
Space: Open area
Materials: None

Image 29: Real and Ideal Images.

What is it and why use it?

Real and Ideal Images asks a group of students to build an image with bodies of a *real* challenge or problem and an image of the *ideal* solution, along with the *images of change* between. This activity supports students' abilities to understand the complexity of solving problems within real circumstances and provides a way to dialogue about multiple solutions verbally and physically.

Directions

Invite students to sit in front of an open space. Review the elements of an effective frozen image—captures a moment in action using the body and face, strong point of view, tells a story, uses levels, etc. Then, offer a prompt for the group to explore: *What does bullying look like at our school?* Once the prompt is established, the group can verbally dialogue about ideas as a full group or in small groups and then make an image based on the thinking; or, they can make an image spontaneously, using their bodies to dialogue together through an improvised response. Whatever the process, the group creates a frozen picture, which represents their expression of the "real" problem. Explore the "real" problem frozen pictures with the group using the DAR reflection. Select a representative "real" problem image that the group would like to explore further. Ask *What would it look like if we could wave a magic wand and the problem(s) presented in this image are solved?* The group works to transform the "real" problem image into new image of the "ideal" solution. Explore the new image and discuss the changes. Next, ask *So, how do we move from the real problem to the ideal solution in this image sequence?* Invite students to construct 2–3 images that could live between the "real" problem and the "ideal" solution. This final exploration can be done as a full group, or smaller groups can work independently to create their own "images of change" as a way to investigate multiple solutions. To conclude, view the full sequence of all of the images, starting with the "real," moving through the images of change, and ending with the "ideal."

Reflection

- *What were the "real" issues our work explored today?*
- *What outside forces (societal or individual) shape "real" issues? Who or what helped to make change in our exploration?*
- *What makes change in our world? How do we become agents for personal or collective change?*

Possible side-coaching

- *Is this an authentic representation of the real problem? If not how can we make it more real?*
- *How does the character get from the real problem to the ideal solution? What has to change? What actions might the character have to take? What other people might be a part of the solution?*

Possible variations/applications

- Allow some students to be the clay while others sculpt the group into images (see Sculptor/Clay).
- Science: Have students create real and ideal images linked to environmental issues, and create an image in the middle that represents how we as a society might transition from the real environmental situation to the ideal environmental situation.
- Reading/Writing or Social Studies: Have students create images from *March: Book One* by John Lewis. Create images to represent actions taken to move toward equality.

6.i.vii. What's the Story?

Source: James Thompson
Number of Players: 5+
Space: Open area
Materials: None

What is it and why use it?

What's the Story uses two students to stage a series of simple neutral images so that a group can dialogue about how body language and proximity shape an understanding of relationship and situation. This simple strategy provides a low-risk way to explore and apply aesthetic language to describe two character bodies in relationship to one another in space.

Directions

Sit group in chairs or on floor in front of an open space with a single chair close to and facing the audience. Ask for two volunteers. Invite the first volunteer to be Character A. "A" stands and faces the group, 5–6 feet behind the chair, at the far end—or upstage—from where the group is sitting. Invite the second volunteer to be Character B. "B" sits in the chair—downstage—facing the audience. Both "A" and "B" look straight ahead, freeze, and try to be as "neutral" in their feelings as possible. Invite students to "read" the relationship between "A" and "B": *Describe what you see Character A doing in this image? What is Character B doing in this image?* Ask the group to connect interpretation to what they see. *What's the physical, or spatial relationship between A and B? Based on what was just described, what's the story of this image?* Have "A" take 3 steps forward, but keep everything else about the character's position the same.

Repeat the above questions. Have "A" take three steps forward, while maintaining the character's position. Repeat the above questions. Continue until "A" is very close to "B"; this usually takes three rounds. Have the group agree on a specific story that they would like to explore further. *Who are these characters? What are they about to say to each other?* Invite the group to create a line of dialogue for each character. Have the characters repeat the lines to each other. Have entire group give volunteers a large round of applause.

Reflection

- *What did you notice about yourself as an audience member during this activity?*
- *What changed as the characters moved closer together? How did the proximity of the characters change our inferences about the relationship?*
- *Where might we see a scene like this in our everyday lives? How did this activity help us create a detailed story?*

Possible side-coaching

- *What do you see? Describe how the bodies are positioned?* Guide the audience to start with observations, and then interpret meaning from those observations.
- *What's another way to describe their relationship?*
- *Does anyone have a different interpretation of the story of this image?*

Possible variations/applications

- Take a digital picture of the images created by the two students and project it for students to respond as a group or as an individual writing prompt.
- Reading/Writing or Social Studies: Invite students to relate images to specific moments in history or specific moments in a story. Use the strategy to generate a creative writing story or to explore how we infer based on context clues.

Chapter 7

Role Work

Teacher: *Now we are going to ask Elmer some questions. I'll start and if you have a question you just raise your hand.*

Teacher faces students in the hot seat.

Teacher: *Elmer, could you please tell us what you are feeling right now?*

Student: *I feel happy because...I'm a different elephant and I have different colors.*

Image 30: Students in the Hot Seat.

What is it? Role Work strategies invite students to think, dialogue, problem-solve, and act either as themselves or as someone else in response to a set of imagined circumstances.

Why use it? Role Work strategies differ from traditional theatre performance in that students shift between roles of spectator and actor fluidly within a dramatic process: "Students in role-play are simultaneously an audience to their own acts and observers of the consequences of these acts" (O'Neill, 1995, p.80). Role Work strategies allow students to engage in, think through, and understand multiple perspectives based on their own choices and those of other students. In these strategies, students do the following:

Define it!
Dramaturgical Skills
help create and give structure to the world of a play through sounds and images.

- Engage through story: These strategies invite students to use inferential and dramaturgical skills as they actively explore elements like conflict, setting, and character, and how these elements interact and shape a story or narrative.

- Explore character choice and motivation: These strategies bring characters to life, so students can see, feel, and understand the human condition in a text, in a moment from history, or within a specific situation.
- Practice being agents of change: In Role Work, students are positioned as inquirers and investigators who are ready and able to use knowledge, experience, and skills to solve a problem.

When and where is it used? Role Work strategies can be used in all areas of the curriculum, wherever story is found or is generated related to the topic. The main consideration for using Role Work is how the teacher wants to position the students within the inquiry (Morgan & Saxton, 1987; Wilhelm, 2002). For example, if the goal is to explore and build one aspect of the imagined world (character, setting, conflict, etc.), then *Creating Context and Subtext* strategies can be useful. Or, if the focus is on a specific character's dilemma, then *Performing Character* strategies might offer a way into the imagined problem. Lastly, *Performing within a Dramatic Dilemma* strategies offer a selection of familiar dramatic situations (a secret meeting, a trial, a talk show, etc.) that can be applied to a wide range of inquiries from all subject areas. These strategies give students a chance to explore a variety of viewpoints within a specific conflict or "mess"—a term often used by Dorothy Heathcote (Bolton & Heathcote, 1995), a noted drama pedagogue and practitioner.

Part of the challenge of Role Work is finding a story/problem that lends itself to the potential of a dramatic dilemma. Sometimes, the curriculum presents an obvious story to explore, which allows the teacher to work from an informational or literary text within a curriculum unit. Then the teacher needs to decide which aspect of the story, or content inquiry, will be the focus of the learning experience.

Story → Content Inquiry: A teacher wants to explore a conflict, theme, character, or event from an established literary text. For example, during a unit on Lois Lowry's *The Giver*, the teacher might ask, *How does our memory relate to the choices we make?* Or, to explore an informational text about George Washington's crossing of the Delaware River, a teacher might choose the question *How do we restore faith in a cause?* as the starting point of a dramatic inquiry. These inquiries are directly related to the established story, have multiple answers, and open up a dialogue about the human condition.

However, sometimes a story is not initially present. The teacher has content—a set of facts, a mathematic or scientific concept or skill—but no clear story to explore. In this situation, the teacher needs to decide what story might

provide an authentic, relatable experience to explore the complexities of the content inquiry.

Content Inquiry → Story: A teacher wants to explore how problem-solving and reasoning can be used to solve a real-world problem in math. For example, during a unit on geometric measurement, the teacher might ask *How do architects use perimeter to draw a ground plan for a 2-D shapes?* Or to explore design thinking, a teacher might introduce the question *What size and kind of community garden could provide food for our neighborhood? As a starting point of a dramatic investigation to solve for area in 2-D composite shapes as part of a design to connect to our community.* These investigations invite students to take on the "mantle of the expert" (Bolton & Heathcote, 1995) to help the teacher solve a real-world mathematics problem.

Final thoughts

Role Work is a collection of DBP strategies that brings together the full potential of what drama can do across the curriculum. These strategies are based on the foundational elements of theatre performance (voice, body, character, motivation, emotional expression, improvisation, plot, setting, and conflict) and rely on an understanding of aesthetics for their successful implementation. In addition, underlying these artistic skills is the same cognitive emphasis on dialogic meaning-making and individual/ collective social-emotional skills that are explored in Activating Dialogue, Theatre Game as Metaphor, and Image Work strategies. In fact, many of these strategies are used along with the Role Work strategies when creating a fully realized role-play lesson or unit of inquiry. Detailed suggestions on how to design a role-play learning experience are offered in Part III of this book.

7. Role Work Strategies

J. Creating Context and Subtext

7.j.i. Guided Imagery	7.j.v. Travel Time Machine
7.j.ii. Objects of Character	7.j.vi. Tour of a Space
7.j.iii. Role on the Wall	7.j.vii. Visual Dramaturgy
7.j.iv. Soundscapes	

K. Performing Character

7.k.i. Conscience Alley

7.k.ii. Hot Seating

7.k.iii. Narrative Pantomime

7.k.iv. Paired/Group Improvisation

7.k.v. Voices in the Head

7.k.vi. Writing in Role

L. Performing within a Dramatic Dilemma

7.l.i. Advertising/Design Pitch

7.l.ii. Exploration/Adventure

7.l.iii. Public Service Announcement

7.l.iv. Talk Show/Press Conference

7.l.v. Town Hall Meeting

7.l.vi. Trial/Courtroom

J. CREATING CONTEXT AND SUBTEXT

What is it? *Creating Context and Subtext* strategies provide a way for students to infer, explore, and reflect upon elements of setting, conflict, and character in a real or imagined story.

Why use it? *Creating Context and Subtext* strategies offer multimodal (physical, visual, verbal, and aural) ways to initiate dialogue and "frontload" knowledge about a specific conflict, character, and/or place and time. These strategies focus on important dramaturgical and inferential skills that help students understand how the material conditions of time and place shape who people are, how they feel, and what they do within a larger social context. Specifically, these strategies enable students to enter into and explore a story world. Their purpose is "to look closely at the *significance* [emphasis added] of what has happened [or prepare for what will happen] in the drama to discover underlying meanings in human action" (Neelands, 2002, p. 29). Consequently, *Creating Context and Subtext* strategies are often used to build the imagined world before moving into *Performing Character* or *Performing within a Dramatic Dilemma* strategies.

When and where is it used? *Creating Context and Subtext* strategies can be used in the curriculum to consider the rich context of a story or event as it relates to content. For example, as part of a science unit on Weathering and Erosion, a group might use Visual Dramaturgy to create a map of a small mountain town. The people in this town have limited access to commerce and are considering the choice to remove the top of a mountain to build a new SuperMall. Next, students might select a location within that town and give each other a Tour of a Space. This builds a mental model for students of the imagined physical space. Or, through the Soundscapes strategy, a teacher might ask students to create a sound montage of a nature preserve and a SuperMall to compare and contrast how each sound location offers potential opportunities and challenges to a small, rural community.

Creating Context and Subtext strategies also engage students in dialogue about the motivation and subtext of characters within a story, event, or conflict. For example, in a literature unit on Homer's *The Odyssey*, the teacher might introduce the character of Penelope through a Guided Imagery strategy, in which students close their eyes and imagine they are waiting many, many years for a partner to return from war. The teacher might then use the Role on the Wall strategy to invite students to create and map inferences about what Penelope might feel as she waits 20 years for her husband to return.

How is it used? *Creating Context and Subtext* strategies offer a range of ways to make an imagined context and/or character in a story come to life. When using these strategies, teachers might consider the following:

Student knowledge and skills

Academic: Based on their current experience and background knowledge, what is the most productive way for students to engage in complex, rigorous meaning-making about the content? Consider whether students need a strategy that provides background knowledge within the activity, like Guided Imagery, in order for every student to be ready and able to make meaning. Or, whether students know enough about the content already to physically and verbally represent their background knowledge as they do in Soundscape, Visual Dramaturgy, or Tour of a Space.

Affective: What level of risk-taking and trust do students need to have with one another to be successful within the strategy? Consider whether the group should work as individuals at their desks or with the full group and the teacher out of their seats. Do they have the content knowledge and collaboration skills to work in small groups or pairs simultaneously through multiple procedures, or would they benefit from a highly facilitated process led by the teacher.

Aesthetic: What sort of information is needed to build a rich, complex understanding of the story, character, setting, and/or conflict? Do students need to explore a character's interior life (i.e., past experience and motivation) through exterior physical and verbal expression of feelings and actions? Or, do they need to develop a visual or aural literacy about the place, space, or inner struggle featured in the content? Consider how artistic vocabulary and skills enable students to enter the world of the investigation in more rigorous ways.

Context needs

Group: What size grouping will best support student learning? Students might benefit from working in a mediated, full group strategy like Role on the Wall, Soundscapes, or Visual Dramaturgy, or from the paired or small group tasks found in Tour of a Space and Objects of Character.

Space: What size space is available for work? Guided Imagery, Role on the Wall, Soundscapes, and Objects of Character can be done seated or in a very limited space. Other strategies, like Tour of a Space, require a larger area for students to move and explore.

Materials: What materials are necessary for the strategy? For example, if doing Role on the Wall or Visual Dramaturgy as a large group, these strategies require a place (white/chalk board, large paper, etc.) and writing tool (chalk, markers, etc.) such that students can easily see. Depending on how the Objects of Character exercise is being used, there may be any number of art supplies that students need to make their objects. Or students may choose to bring objects from home or find pictures of objects from magazines or from the Internet to complete the activity.

7.j.i. Guided Imagery

Source: Various
Number of Players: 3+
Space: Limited space
Materials: None

What is it and why use it?

Guided Imagery invites students to close their eyes to listen to a descriptive, narrative story and to imagine they are experiencing the events being described. Guided Imagery can be used to build background knowledge and experience, both factual and emotional, about an event and to build interest on a topic or story.

Directions

First, select a piece of Guided Imagery narration; this could be something written for the content/task or found and adapted. Ideally, the text is in the second person ("you" form) and includes rich sensory detail to engage students more deeply in the situation or a dilemma. Next, invite students to find a comfortable space; this can be at their seats or on the floor if appropriate. Ask students to close their eyes or look down, relax, and visualize the story as they hear it. Read the prepared narrative to the group, working to capture the tension, sensory language, and drama of the story. For example, a narration about *The Diary of Anne Frank* might read, *You wake with a start. You can feel your father's heavy hands on your shoulders, whispering urgently. "It's time," he says, "Put on as many layers as you can, but remember, it must look like an ordinary day for us." In the dark shadow of night you begin to dress. You put on three layers of socks and your heaviest boots. You put on two cotton shirts under a thick sweater. You wash your face. The cold water stings your cheeks as you look into the mirror and wonder what will happen. You leave your bed unmade. Breakfast dishes in the sink. You notice your mother has left out her knitting and the radio is on low. You walk behind your older sister and your mother and father, out your door for the last time, through the cobblestone streets of Amsterdam; you pretend to be invisible. You know that this part of your journey is the most dangerous. You can hear your mother saying a quiet, hushed prayer in Hebrew, her voice barely audible over the click of her heels on the ground. Your heart is pounding. You can feel the yellow Jewish star on your coat bending in the breeze. You see the red doorway of your father's office. A cat*

screeches. You freeze. You want to turn to look but can't. You mustn't look suspicious. Your father grabs your hand and draws you through the door: 'We made it. We're here'."

Reflection

- *What kinds of sights/sounds/smells did you imagine?*
- *Describe the central character. What is happening and why?*
- *What does this character's experience have to do with our current unit of study?*

Possible side-coaching

- *Find a place in the room (at your seat) where you can listen quietly and comfortably.*
- *Listen closely to the words and imagine the action in your mind.*
- *Pay attention to how you would feel in this situation.*

Possible variations/applications

In addition to helping students visualize a story, use this strategy to help students create a character. For example, in a lesson based on the children's book *The True Story of the Three Little Pigs*, students listen to a series of questions as a way to help them create characters for an upcoming Town Hall Meeting: *I invite you to either close your eyes or look down. I'm going to ask you a series of questions and I'd like you to silently think about the answers to these questions. Think about the character you've chosen to play. Is this character a pig? Is this character a wolf? Is this character another animal? What is your character's name? How old is your character? What does your character do for a living? How does your character know A. Wolf? Does your character know the pigs? How does your character feel about the trial? Do they want A. Wolf locked away forever? Or do they want him released? Why? Think about how your character might sit in a chair. Take a moment to transform your body to sit as your character. Leading up to the trial, there has been a lot of reporters writing articles painting A. Wolf as a villain. There is one reporter in town named Penny Penguin who wants to get the real story, or at least both sides of the story. She has called you to a meeting in town hall to interview you about your point of view. You arrive to the meeting excited to share your side of the story, to tell her what you really think about A. Wolf. I invite you to open your eyes and look up. When I put on this scarf, I am going to step into role as Penny the reporter. We will start the meeting in 5, 4, 3, 2, 1.*

7.j.ii. Objects of Character

Source: Augusto Boal
Number of Players: 3+
Space: Room for a circle
Materials: Assorted objects and images

What is it and why use it?

Objects of Character explores how objects can represent specific attitudes, feelings, or actions of a character. This strategy asks students to reflect on how objects and images communicate meaning.

Directions

Invite students to think about a character they have developed, or a character from a book, story, essay, or moment in history being studied in class. Introduce the activity: *Today, we will think from the character's perspective: **who** are you (as the character); **what** motivates you (events or feelings that shape your choices); **where** do you live (the setting, the location); and, **why** might you value a certain object or set of objects? Our task is to come up with a series of objects that represent our character. These could be things that you think they own/have or objects that are representative of who they are.* Give students time to brainstorm ideas and gather objects. Objects might be found by accessing online images, using photos from books or magazines, or selecting objects from a stockpile of objects and costume pieces the teacher provides for students. Students share their collections in small or large groups.

Reflection

- *What types of objects did we find?*
- *What do these objects tell us about this character that we didn't already know?*
- *What do you keep that is significant to you?*

Possible side-coaching

- *What kinds of objects most represent your character? Are there secret objects that are important to your character that no one else knows about?*

- *If your character always kept an old photograph in their back pocket or bag, what or who would be in this special picture?*
- *As you share your objects, consider how your character might hold the object.*

Possible variations/applications

- In addition to collecting objects, invite students to choose or design a vessel (suitcase, purse, trunk, pocket, etc.) that holds these objects, or consider how the character might store or display these objects.
- Have students create objects of character for themselves. This can be a springboard for a personal or creative writing activity. See Object Metaphor.

7.j.iii. Role on the Wall

Source: Jonothan Neelands
and Tony Goode
Number of Players: 3+
Space: Limited space
Materials: A place to write
and something to write with
(more than one color is helpful)

Image 31: Role on the Wall.

What is it and why use it?

Role on the Wall is a strategy that invites students to infer meaning about a character and to visually map the relationship between characteristics (emotions) and actions (behaviors) onto a simple outline of a human figure. By inviting students to analyze context clues, the group collectively explores and constructs a more complex understanding of the character's motivation.

Directions

Draw a large outline of a head/shoulders or human figure on paper; leave plenty of space to write inside and outside the figure. Name the character for the group and provide any necessary context. Invite the group to name out words, phrases, or messages that this specific person might receive. Write student responses on the outside of the figure. When a "message" is offered, invite participants to think about where it comes from. Connect messages to the messenger visually on the paper through color or a line and encourage

students to find multiple answers. Types of responses can also be grouped together on the paper (for example, positive on one side of figure, negative on the other) to provide further visual organization. Next, ask students how the character might feel inside, based on the outside messages, and write those feelings on the inside of the figure with another color. Finally, ask students to connect specific "outside" messages to the inner feelings, and draw lines between those connections on the figure.

Reflection

- *What events, people, or actions impact this person the most? Why?*
- *Is this a realistic portrait of the character? Why or why not?*
- *Does this character/person ever shift or change? Is there something that could make a change?*

Possible side-coaching

- *Who might have an opinion about this character's actions? Why? What would they say to express their opinion? Who else might have a different opinion?*
- *How does the character feel as a result of all of these opinions? Why?*

Possible variations/applications

- Generate feelings first, then use those to come up with the outer actions of a character.
- Invite students to use textual references to support their answers.
- Have students work in small groups or individually on their own role on the wall character map.
- Using a full body outline, map specific attributes of the character into specific areas of the body (i.e., Hands: *What does the character want to do?*; Feet: *Where does the character want to go?*; Heart: *How is the character feeling?*; Head: *What is the character thinking?*).

7.j.iv. Soundscapes

Source: Various
Number of Players: 4+
Space: Limited space
Materials: Something to write on and writing utensil

What is it and why use it?

Soundscapes ask students to think about and create the multiple sounds that may be heard in a specific location or event in time. In this strategy, students explore how to use vocal variety, rhythm, and repetition individually and collectively.

Directions

Invite students to name/describe sounds they might hear in a specific context. *What are sounds you might hear in the rainforest?* Writes students' ideas on the board for the group to see and reference. Once the group has brainstormed a number of ideas, ask for volunteers to vocally perform different sounds, ideally with similar sounds being seated together. Share and practice conducting hand signals to crescendo (get louder), decrescendo (get softer), and cut off (stop) all sound. Build a soundscape, inviting students to follow hand directions for *The Rainforest*. Reflect on what students noticed about their work. Consider how different vocal and musical choices communicate a specific tone or quality to the listener; invite the group to describe the quality of the soundscape they produced. Choose another location. Repeat the same directed procedure as before, or invite the group to spontaneously create the soundscape, without pre-listing sounds or pre-determining parts.

Reflection

- *What types of sounds did we use to establish a location?*
- *Why were these the sounds that we picked? How did they help to evoke a sense of place?*
- *Where else might you hear these same kinds of sounds? Why?*

Possible side-coaching

- *Draw on your past experiences and memories or imagine what this place might sound like.*
- *Listen to the group; add new sounds or shift your sound to explore all possible aspects of place.*

Possible variations/applications

- Have students select the location or take on the role of the conductor.
- Make a dreamscape. Explore a character's inner thoughts or fears by creating a dream montage of sound that illuminates the inner feelings or

struggle of a character or group of people dealing with a difficult decision or problem.

- Reading/Writing or Social Studies: Explore themes from a story or sounds from an event in history. With this variation, it may be useful to use a phrase of spoken text as well as a sound.
- Science: Explore ways to embody and vocally create a cycle in nature (water cycle, life cycle of a butterfly, etc.) or a specific type of ecosystem, place, or season.

7.j.v. Time Travel Machine

Source: Katie Dawson
Number of Players: 5+
Space: Room for a seated circle
Materials: None

What is it and why use it?

Travel Time Machine is a dramatic device used as a physical ritual to transition or "travel" into and out of an imagined place in a story, across time, or in another part of the world. This strategy is used to dialogue about and prepare for the imagined journey; it is often used to lead into other Role Work strategies such as Narrative Pantomime, Hot seating, or Paired Improvisation.

Directions

Invite students to make a seated circle. Introduce the larger content area to be explored. *Today, we will travel back in time 200 years to meet the original owners of the land where our school is located, the Tonkawa people.* Take time to assess prior knowledge and share information that might be useful for the trip. *To prepare for our visit, let's begin by looking at some photographs taken of the Tonkawa...what do you see?* Next, explain that the group will be building and operating a time machine together to imaginatively travel to a difference place and/or time. Lead the group through a series of pantomimed actions to prepare for travel (e.g., build the time machine, pack for their journey, put on a helmet, fasten seatbelts, and/or start the engine of the time machine). Once prepared, invite the group to count down from ten to zero. Make a traveling sound (clicking the tongue in the mouth works well) and then count down again from ten to zero for landing. Next, lead actions to leave the time machine (undo seatbelts, take off helmets, and turn off the machine) and offer any necessary final instructions about the new place. From this point, step into a

Narrative Pantomime or another type of *Dramatic Dilemma* to explore the new place. After the trip is completed, repeat the time machine pantomime process with the group to travel back to the present day or prior location.

Reflection

- *How did it feel to use the Time Machine to get to and from our destination?*
- *What do you remember most about our trip?*
- *What did we discover about…and what connections can we make to our classroom work?*

Possible side-coaching

- *What is another part of our time machine we need to make sure we build?*
- *What do we need to do to keep our bodies safe as we travel through time?*
- *What do you expect to see or hear when we arrive at our destination?*

Possible variations/applications

- Science: Have students travel to different seasons or ecosystems. Based on where they're traveling, they have to make decisions about what they will pack. Once there, students can explore the weather, surrounding environment/geography, plant/animal life, etc.
- Social Studies: Have students travel back in time to a specific time period or event. While there, students might engage in Paired Improvisation or Hot Seating with different individuals from that time period and/or involved in an important event in history.
- Reading/Writing: Have students travel into a story setting and/or conflict. The students and teacher might also create and travel to an imaginary world, then write about their experiences in that world after as a prompt for creative or persuasive writing.

7.j.vi. Tour of a Space

Source: Michael Rohd
Number of Players: 2+ (even numbers are ideal)
Space: Open area
Materials: None

Image 32: Tour of a Space.

237

What is it and why use it?

Tour of a Space asks students to offer a verbal and kinesthetic "tour" of a specific location to another student or group. This activity requires the guide to use sensory details and physical action to help other students imagine the place the guide is describing. This strategy helps all students develop further background knowledge and explore how our environment shapes our understanding of a time, place, or event.

Directions

Divide students in pairs and ask each pair to find their own space in the room. Invite pairs to sit and close their eyes. *Think of a specific place where you feel the happiest.* Imagine or recall this place in great detail, down to the color of the curtains or the texture of the grass. Next, ask each pair to decide on one person to be the guide. Each guide takes his or her partner for a 5-minute tour of the imagined place. Encourage the guide to actively describe the details of the space around them, while they physically explore each part of the imagined space. The person on the tour can ask questions, and the guide may respond briefly, though the focus must remain on the tour itself. After 5–10 minutes, have the partners switch roles and so the former partner becomes the new tour guide. Afterward, gather the group together and ask each partner in the pair to briefly describe their colleague's space to the rest of the group.

Tips for playing!
Younger students may benefit from an example "tour" before working in a pair. Give a tour of your space first to model the type of detail, physical engagement, and personal connection that is required.

Reflection

- *What do you most remember from your partner's tour? What did you see/ smell/touch/taste/hear? For those of you leading the tour, how did you help your partner see and understand the space?*
- *Now that we've heard about all the spaces, what was similar and/or different about the places we toured?*
- *How might these spaces and places invite us to think more deeply about our larger inquiry?*

Possible side-coaching

- *Be specific with your description of the space. Give as many details as you can.*
- *How can you use your words and movements to make your partner feel like they are really experiencing the space?*

- *Describe not only what you can see, but also what you smell, touch, taste, and hear in this space.*

Possible variations/applications

- Have students draw/write words (e.g., we see trolls, we hear footsteps, we smell grass, etc.) about the space on paper before giving a tour. Lay the papers on the ground to help guide the tours.
- Reading/Writing: Have students give a tour of a location from a novel, either from their own perspective or as a character from the book.
- Social Studies: Have students research locations of important historical events or cultures and then ask them to give a tour of the space to others, recalling important facts and events.
- Science: Have students give a tour of a cumulous cloud, the tundra, the ocean, or an atom.

7.j.vii. Visual Dramaturgy

Source: Various
Number of Players: 4+
Space: Limited space
Materials: Large pieces of paper and writing utensils.

What is it and why use it?

Visual Dramaturgy invites students to reflect on setting, characters, theme, and events in a story. This strategy gives students an opportunity to practice recall, and to create and "read" signs or semiotic systems of meaning-making through a collaborative, visual art process.

Directions

Set a very large piece of blank paper on table or floor, so that all students have a comfortable workspace on the border of the paper. Place a large collection of crayons or markers on the paper so that every participant will have a selection of colors to use. Read or tell a story without any accompanying images. Round One: Invite students to silently draw images of the characters, places, events, and feelings that they remember most from the story on the paper, without using any words. Play instrumental music as they silently work for 5–7 minutes. Encourage students to get as many different images on the paper as they can. When the time ends (or interest fades), stop working and

take a silent "gallery walk" around the paper to see all the images created. Round Two: Invite students to pick a colleague's image and add to it, without using any words. Explain that students should not work on their own images or make an entirely new image; also, they can add to as many pieces, made by others, as they want. Work for 3–5 minutes. Then, stop working and take another silent "gallery walk" around the paper. Round Three: Invite students to fill in the remaining empty space on the page. The goal is to connect the drawings without adding anything directly to images that have already been created. Words may be used in the final round if desired. Work for 2–3 minutes and then take a final silent "gallery walk" around the paper.

Reflection

- *How did it feel to work collectively on a drawing? What images do we see from the story?*
- *What story do these images tell together? What parts of the story appear the most? Why?*
- *What image/idea resonates with you the most? Tell us why/turn to a partner and share why.*

Possible side-coaching

- Round One: *Make big images, we are trying to fill the paper!*
- Round Two: *What important details do you remember from the story? Make sure everything you remember is here. What can you add to someone else's image to give more detail and context.*
- Round Three: *Think about how color, shape, and line communicates a feeling. What feeling sits between these images?*

Possible variations/applications

- Social Studies: Have students explore a moment in history, a time period, or a geographic region based on a reading from a textbook or primary source documents or their own prior knowledge.
- Science: Have students explore an environment, ecosystem, or a topic like energy resources.

K. PERFORMING CHARACTER

What is it? *Performing Character* strategies invite students to explore, consider, and perform character motivation and choice within a real or fictional dramatic dilemma.

Define it!
Perspective-Taking
offers a way for students to "try on" different perspectives or points-of-view that may or may not be different from their own.

Why use it? At a foundational level, *Performing Character* strategies scaffold students' learning to make intuitive and logical inferences regarding another person's feelings, thoughts, and intentions (Wagner, 1998, p. 29). Students can begin to construct their own knowledge and understanding of a character's choice and motivations based on background information shared in written, verbal, or embodied form by the teacher. Through perspective-taking, students have the opportunity to explore "why" and "what if"; they can try out and compare multiple interpretations connected to different types of textual evidence (Freire, 1970, 1985; Giroux, 1997; Kincheloe, 2008).

When and where is it used? *Performing Character* strategies can be used in the curriculum to consider the multiple dimensions of a character within an imagined story or event related to content. For example, as part of a language arts lesson described in Part I of this book, a teacher uses the book *The Paperbag Princess* with his early elementary students. The teacher uses Narrative Pantomime to engage the group in an exploration of Princess Elizabeth's emotions and actions—using rich sensory language for the young students to imagine and show through their bodies—as she goes on a search for the dragon that stole Prince Ronald. During the sequence, the teacher pauses the action at various points to ask students to speak their subtext—their inner-thoughts—through a modified Voices in the Head activity.

Performing Character strategies enable students to engage in real issues from history or current times. In an American History lesson on the US civil rights movement, a teacher activates primary source texts through Conscience Alley; she asks students to use the text to infer, create, and perform a line of dialogue about the inner thoughts of African-American student Elizabeth Eckford as she walked into a court-ordered, integrated high school for the first time. Next, the teacher links to students' background knowledge as she becomes Eckford and steps into the Hot Seat to be interviewed about by her students, also in-role, as newspaper journalists from an imagined New York paper.

How is it used? *Performing Character* strategies offer a range of ways to enter into a character's dilemma within real or imagined circumstances. When using these strategies, teachers might consider the following:

Student knowledge and skills

Academic: What prior knowledge do students need about the larger context of the story or the character to successfully participate in this strategy through their words and actions? Are students best served by a high choice (see the *Context needs* section below) activity? Do they need to push themselves to use inferential, elaborative, and analytical thinking to connect evidence (textual, visual, and/or oral) to understand how a character might engage within a situation outside of a book, history, or event? Or will students benefit from a low-choice (see below) activity? Can the teacher embed new knowledge within the activity for students to explore through a kinesthetic process of discovery and sense-making?

Affective: What do students need to be able to successfully engage with each other about complex issues of identity, society, and culture? In general, students need adequate background information about a character, time, and/or event to respectfully explore a viewpoint that is very different from their own; problematic, negative, or incorrect assumptions about a specific group of people are often a result of a lack of information and experience. A teacher should also consider the students' level of interpersonal and intrapersonal skills. Are they ready to collaborate independently, to respectfully listen and respond to ideas, and to negotiate decisions independently with limited teacher involvement?

Aesthetic: Do students have a performance vocabulary that enables them to use their voice, body, and imagination to express a character's interior thinking through exterior actions? Successful drama work gives time for dramaturgy (research on a character and their background) so that students are ready to perform as someone else before they step into role. Students also need performance vocabulary to interpret and respond to each other's work during reflection and dialogue after the Role Work has ended.

Context needs

Who is in-role? To help select which *Creating Character* strategy to use, a teacher needs to consider who will be in-role during the lesson.

The teacher in-role

Before going into role: The teacher should feel comfortable authentically portraying someone else. They need enough information about the character to avoid stereotypes and to play a character with real needs and intentions.

Going into role: The teacher needs to decide how to cue students or let them know that their teacher is now playing someone else. In general, it is helpful to make the shift into role very visible, with a simple costume piece like a hat, scarf, a tie, a jacket, glasses, or a clipboard, so that the focus is on the imagined situation. *Can we all agree that I will become Elizabeth Eckford when I put on these glasses?* It is generally recommended to avoid hiding the role transformation, e.g., the teacher makes an excuse to go out in the hall and comes back as the character who pretends that the teacher has disappeared, because this can cause students to focus on the role change instead of the role drama. Make the change to role clear and simple so no one feels tricked or confused.

Coming out of role: It is important that the teacher considers how to cue the students that they will be stepping out of role. A simple verbal cue that summarizes what just happened and makes a shift for your character is often the best choice: *Thank you for those thoughts. I'm going to pause the drama here, take off my glasses, and end our interview with Elizabeth Eckford.* (Teacher removes glasses and shifts posture and vocal tone.)

The students in-role

Before going into role: Do students have the knowledge and preparation to authentically play someone else? What research or preparation will support their capacity to speak with accurate knowledge and expertise as a character? Preparing for character work gives students a reason—and a desire—to read and re-read informational and literary texts or conduct online research as part of their preparation for performance. What DBP strategies can be used to prepare students to physically and emotionally become someone else? Teachers might also consider whether students need to rehearse what they are going to say or whether their performance will be entirely improvised. It is common to co-construct potential questions and/or responses with students before going into role.

Going into role: How will students be cued to step into role? How can students be prepared physically and emotionally to make strong artistic choices to represent their thinking? *I invite you to close your eyes. In a moment we will step into our role as someone who came to support Elizabeth Eckford's first day*

at a newly integrated school. Think about the character you have created. Why has your character come to support Elizabeth? How does your character stand as they wait to see her? How does the shape of your body let us know how you feel as you stand and wait? What are you wearing? How did your character dress for this important day? Imagine those clothes on your body. You see an angry group of people standing across from you who don't want Elizabeth and her fellow black students to racially integrate Central High School. What will you say to Elizabeth as she walks by the angry group of people? What does your character want her to know? We will begin in 3-2-1…and action!

Coming out of role: How will students be cued to step out of role? Some teachers use a word—like *Freeze!*—or a sound, like finger chimes, and, finally, verbal directions: *Let's pause our drama here and dialogue about what happened.*

Background Knowledge: Many teachers create notes for students to use during Role Work, and/or build in time for students to create notes to use during a Role Work strategy. Sometimes, part of a teacher's step into role involves picking up a clipboard (where notes may be located as part of the character transformation) as part of his/her character transformation. Other teachers ask students to prep an index card with important information to reference during the role-play. This card might include the character's name, occupation, textual evidence they might use to support the character's opinions, or a question for the teacher's character role.

Choice and Structure: The *Performing Character* strategies, in particular, can be selected based on (1) student choice, which references how much students make independent decisions that require a depth of understanding of aesthetic, academic, and affective skill and (2) teacher structure, which references the level of student choice about what to do/say and explore within the activity. In the table below, the strategies are mapped among low-medium-high student choice and low-medium-high teacher structure. Many novice teachers try a high structure/low choice to begin Role Work, as it gives them the most control over the action in the strategy.

	Low Student Choice	Medium Student Choice	High Student Choice
Low Teacher Structure			*Paired/Group Improvisation*
Medium Teacher Structure		*Hot Seating; Person in a Mess*	*Voices in the Head; Conscious Alley*
High Teacher Structure	*Narrative Pantomime*		*Writing in Role*

Table 3: Student choice and teacher structure (adapted from Edmiston, 2014).

7.k.i. Conscience Alley

Source: Various
Number of Players: 6+
Space: Room for two lines
with enough space in between
the lines for an individual
to walk
Materials: None

Image 33: Conscience Alley.

What is it why use it?

Conscience Alley invites students to explore multiple facets of a character's choice within a specific dilemma. The strategy is used to embody and analyze the range of ideas, motivations, and factors that a character may be thinking about when making a major decision within real or imagined circumstances.

Directions

Prior to beginning, be sure to introduce or review content knowledge that is to be explored in the strategy so that students are prepared to embody and express ideas, which may be different than their own. Set up the character conflict that is going to be explored. For example, *Today we are going to explore issues from last night's reading, as we consider the factors that impacted US President Woodrow Wilson's decision to go to war. First let's review the key arguments in this issue.* Next, invite the group to form two standing lines, facing each other. If there are two sides of a conflict being explored (e.g., *go to war; don't go to war)* have each row represent an opinion and invite students to stand on the side they would like to argue, working to keep roughly the same number of people on each side. Create a space or alley between the rows where a person can easily walk. Next, a student volunteer (or the teacher, if necessary) takes on the role of the character in the imagined scenario. Explain that the character will walk slowly down the row; as they pass, each standing student should try to represent arguments the character might have heard (advice, warnings, etc.) or lines that could be inside the character's head (fears, beliefs, or concerns felt by the character). Although the dialogue or lines shared by students can be spontaneous, it is important that students have the knowledge to generate realistic lines that are authentic to the situation. After walking the alley, ask the character to share how they are feeling about their decision.

Reflection

- *What was it like to hear all those voices?*
- *What was the character thinking at the end? Why?*
- *Which voices were most persuasive in exploration? Why?*
- *How do we navigate our own conscious alley when we need to make a challenging decision?*

Possible side-coaching

- *How can you deliver your line in a way that embodies a specific viewpoint (mood, tone, tempo, pitch, rhythm, etc.)? How can your body also tell us what you think?*
- *Look at the text, what line can we turn into dialogue that helps us to explore what the character is thinking?*

Possible variations/applications

- Have students in the rows speak one at a time, play with sound (whispers or loud) or overlap voices.
- Do not separate by viewpoint and encourage a range of opinions to be placed throughout each line.
- Invite the character to stand by an individual or "row" that they found most persuasive.
- Play through the conscious alley multiple times and encourage students to deepen their commitment, shift the order of voices, or develop the sequence into a performance to be shared.

7.k.ii. Hot Seating

Source: Jonothan Neelands and
Tony Goode
Number of Players: 4+
Space: Any
Materials: None

Image 34: Hot Seating.

What is it and why use it?

Hot Seating is a strategy in which a character or characters, played by the teacher or a student, are interviewed by the rest of the group. This activity invites students to recount a specific event and explore motivation and multiple perspectives/experiences related to a theme, topic, event, or idea.

Directions

Before engaging in this strategy, prepare the person or people who will be in the hot seat to successfully take on their role. The person in the hot seat [teacher or student(s)] needs to determine *who* they are in the interview; *where* they are (i.e., the setting for the interview); and, *why* they are in the hot seat (i.e., the motivation for their words and actions). Use textual evidence, other forms of research, or personal experience to prepare. Other DBP strategies like Role on the Wall can also help students to be successful in the hot seat. Next, determine whether the students/audience (outside of the hot seat role) are also in-role (e.g., as a newspaper journalist trying to find an answer) or whether they will act as themselves. If the students/audience are in-role, they may need support to prepare questions from their personal viewpoint to ask the character in the hot seat, or to research a different character perspective viewpoint to think and work from in the activity. Once the individual (teacher or student) is in the hot seat and the audience is ready, introduce and moderate the activity. Encourage the audience to ask strong questions that are relevant and within the dramatic situation and reframe any questions/add to responses if they are unclear. Work to deepen students' critical thinking, engagement, and commitment to their character(s) by modeling a strong commitment to character and the situation in your own performance.

Tips for playing!
Try to keep classroom management in the world of the drama. Students will respond better and more quickly!

Reflection

- *How did it feel to step into the character's shoes/embody the character?*
- *What new insight did you gain about the motivation of the character from our activity?*
- *What are the key issues/factors affecting this/these character(s) and their actions?*

Possible side-coaching

- *Let's take a closer look at the character's motivations in this moment. Would someone like to step into the role of…(different character name) to answer a few questions?*
- *Can you tell me more about why you feel this way?*
- *Who has a different opinion on this topic? What is it?*

Possible variations/applications

- Have a group of students prepare and play as a single character to lower the risk level (a group of students represent Charlotte from *Charlotte's Web*, not just one student).
- Reading/Writing or Social Studies: Have students take on the role of a historical figure, a literary figure, a character from literature or an informational text, or a country or geographic location.
- Science or Math: Have students become a planet, an element from the periodic table, a number, or a geometric shape. Invite them to be an expert on cloning or nuclear energy.

7.k.iii. Narrative Pantomime

Source: Ruth Henig and others
Number of Players: 2+
Space: Open Area
Materials: None

Image 35: Narrative Pantomime.

What is it and why use it?

Narrative Pantomime invites students to imagine and pantomime a character's physical and emotional journey within a story, as narrated by a teacher. Narrative Pantomime can be used to expand students' background knowledge of both factual and emotional story events through a specific character's point of view.

Directions

Prepare a narrative with rich sensory description and action that relates to the content inquiry. This can be written down to be read or improvised, depending on familiarity with the topic. Invite students to gather in a large open space, free of furniture and distractions. Next, ask students to sit in their own space, so that they can move freely without disturbing others. Introduce the activity: *In a moment, I will share a story and you will work, in your own space, to imagine and act out what you hear as if it happening to you.* Share the prepared narrative. *This is part of the story by Molly Bang called* When Sophie Gets Angry, Really, Really Angry. *To begin, imagine you are a small child sitting on the floor in your room. You have your warm, soft stuffed gorilla in your arms. It's your favorite toy; Gorilla is your best friend. You play with Gorilla and make up an adventure.* (Give them time to make an adventure and

> **Define it!**
> **Pantomime** invites students to act out an idea with their bodies without any sound.

establish a connection with the toy.) *Suddenly your little sister comes and takes Gorilla out of your hand, saying "MY TURN." You scream, "No!" Your mom says that it IS her turn, now…you reach to grab the gorilla but you trip and fall over a train track and land on the ground hard. You stand up. You are angry. Really, really angry. In your own place (without making actual noise) you kick. You scream. You want to smash the world into smithereens. You roar a red, red roar… in your place, you open your front door. Then, in your own place you run out into the woods next to your home.* During the narrative, students can be asked to freeze and respond to questions about their inner thoughts. Or they can pause so that one part of the group can watch another part of the group perform their action. Sometimes it can be productive to bring the full group together in a moment of shared interaction with each other as well. There are numerous variations and possibilities with narrative pantomime.

Reflection

- *What do you remember most from the story? What did you see/smell/touch/taste/hear?*
- *What was the character's problem in our story? How did the character feel? Why?*
- *What do you think happens next in the story?*

Possible side-coaching

- *How can you show a specific choice in your body? Even if you aren't making sound.*

Possible variations/applications

- Accompany narrative pantomimes with music.
- For younger players, have each student play on a carpet square to define their personal space.

7.k.iv. Paired/Group Improvisation

Source: Various
Number of Players: 4+
Space: Open area
Materials: None

Image 36: Paired/Group Improvisation.

What is it and why use it?

Paired/Group Improvisation is a strategy in which students step into a role to explore character motivation and problem-solving within a specific set of given circumstances. This flexible strategy can be used to fill in gaps in a text that the author does not provide, to interrogate a historical or current event, to explore cause and effect for a character, to explore a relationship between two characters, or to understand/express multiple perspectives about a character within a situation.

Define it!
"Yes, and" *refers to an improvisational rule that suggests we should ALWAYS say, "yes, and" to accept and build upon whatever idea our partner offers.*

Directions

Break students into pairs or small groups depending on the inquiry. Introduce the activity: *In this strategy we will explore a specific moment between characters. We will do this work improvisationally, meaning we will make it up as we go, and we will do it at the same time so that your pair/group can explore your thinking on your own without an audience.* Introduce a scenario to explore. Next, make sure students understand *who* they are in the scene (their character), *what* they are doing (a specific action to play is helpful), *where* they are (the setting), and *why* they are in the scene (the motivation for their words and actions—what do they want). Ask students to begin their scenes at the same time. Afterward, the full group gathers to dialogue about the meaning-making generated during the scenes.

Reflection

- *How did it go?*
- *What did you discover about the characters or conflict? Was your character successful in reaching their goal/objective? Why or why not?*
- *What external forces, ideas, or people shape this specific situation or conflict?*

Define it!
Parallel Play means that ALL students will play out the activity at the same time.

Possible side-coaching

- *Incorporate your character's objectives into the scene. If they don't get what they want how can you try a different tactic?*
- *"Yes, and" an offer from your scene partner to continue the dialogue.*
- *How will your scene end? What decision or choice has been made?*

Possible variations/applications

- Pause all the scenes and ask one group (that is highly engaged and successful) to resume their scene so that the rest can listen/watch for a minute; this can highlight strong work and help support groups that need further modeling to be successful.
- Have students stay in character after the paired improvisation ends and ask them to join a meeting or interview (led by the teacher-in-role) to talk about what happened in their scenes.
- Reading/Writing or Social Studies: When reading a text, have students act out a scene that takes place before or after a story or event. Have students explore moments of history or scientific discovery to explore key themes, ideas, or conflicts.

7.k.v. Voices in the Head

Source: Various
Number of Players: 4+
Space: Any
Materials: None

Image 37: Voices in the Head.

What is it and why use it?

During Voices in the Head, the teacher invites a student in a scene or frozen image to voice a character's inner thoughts, or invites the group observing the character to voice the character's inner thoughts. This strategy helps explore a more complicated understanding of character viewpoint and motivation through an exploration of subtext—the often unspoken motivations—of an individual.

Directions

Invite students to create a Statue, Frozen Image, Stage Picture, or tableau, to share with the group. During the sharing of the frozen image, place a hand on or near the shoulder of one person within the image and ask the student to speak their character's inner thoughts: *When I place my hand on/near your shoulder, please tell us what your character is thinking…* Or, hold a hand over the character's head (to make an imagined "thought bubble") and invite students in the audience to speak an inner thought for the character (the student playing the frozen character remains silent): *What do we think this character might be thinking?* Take answer. *What else could this character be thinking?*

Reflection

- *What did we learn when we added internal thoughts to our frozen images?*
- *For those of you in the images, how did you embody the emotions, ideas, or thoughts of your character?*
- *How does a character's inner feelings help us better understand the story we are exploring in our work?*

Possible side-coaching

- *Think about how your still image and inner thoughts connect to embody the character.*
- *What else might this character be thinking?*

Possible variations/applications

- Use this strategy during an improvised scene between two characters. In this variation, the teacher or one of the students might "freeze the scene" (by yelling *Freeze!*, playing chimes, clapping their hands, etc.). While the students in the scene are frozen, the students watching might speak the inner thoughts of the characters in the scene, adding context/subtext to the action. The teacher then unfreezes the students in the scene, and they continue their improvisation with the added context/subtext in mind.

7.k.vi. Writing in Role

Source: Various
Number of Players: Any
Space: Any
Materials: Paper and writing utensil

What is it and why use it?

Writing in Role is a drama strategy that asks students to write from a character's perspective, typically in a familiar format like a diary entry; a letter, email, or text; a newspaper headline; or a letter to an editor. This reflective tool and performance-based assessment invites the student to make inferences about a character's motivation and opinion, or to make predictions about what might happen next in a dramatic problem.

Directions

After a Town Hall Meeting, a Hot Seating interview, or another sort of Role Work activity in which students perform as individual characters reacting to a dramatic problem, ask students to return to their seats, then give them the task of reporting on what happened in the role-play from their character's perspective. Where possible, use this transition to extend the drama and deepen the commitment and critical thinking for students about the issue being explored. For example, *After the secret meeting of the Sons of Liberty concluded, the colonists each left with a major question on their mind. Would they meet at the harbor at midnight to empty the tea in the harbor? Each individual sat at their table, a candle burning beside them. Each pulled out diary, a quill, and some ink, and began to write. The colonists described what happened at the meeting, the words of Samuel Adams, and thought through their decision about whether or not to join the raid. I invite you now to take out your pen and paper and write the diary entry that your character wrote that night. Be sure to make a decision...will you join the protest? Why or why not?* At the end of Writing in Role, invite students to share their writing with a colleague or a portion of their writing with the whole group.

Reflection

- *What did you discover about your character through the writing activity? What did we discover, generally, about the characters in our story/this moment in history?*
- *How did it feel to write as your character from within the drama?*
- *What do you think will happen next to the characters in our drama? Why?*

Possible side-coaching

- *What type of language and/or writing form/structure is used in a diary/in an email/in a newspaper article/in a letter to the editor?*
- *How does your writing match your character's personality and reveal important information about who they are and what they believe or want?*

Possible variations/applications

- Consider other documents that can be written by students to explore character: letters of complaint, an invitation or card, Dear Abby (advice) letter, a resume, a campaign speech, a newspaper headline, a personal ad, a will, a dream journal, a medical report, or a psychological profile.

[handwritten marginalia, left margin: "Put themselves in a role :: Settler Jamestown :: on the ship women came over Pocahontas"]

L. PERFORMING WITHIN A DRAMATIC DILEMMA

What is it? *Performing within a Dramatic Dilemma* strategies use familiar dramatic situations (a trial, an interview, a town hall meeting, an opportunity for a journey, etc.) to ask students to apply knowledge, explore multiple viewpoints, and make choices about how to solve problem.

Why use it? *Performing within a Dramatic Dilemma* strategies invite students to explore a problem within a story—either as themselves or as someone with more expertise or different beliefs—and to test out solutions. The choice to focus on "issues that are made complex by situated contexts and multiple interactions" (Cahnmann-Taylor & Souto-Manning, 2010, p. 91) gives students practice seeing themselves as active agents of change. Through these strategies, students have the opportunity to engage with a new perspective, culture, situation, and/or historical event from inside a real or imagined story. Students can question, take action, reflect on action, and share their new understanding, while making connections to their larger world (Wilhelm, 2002; cf. Wilhelm & Edmiston, 1998; Edmiston & Wilhelm, 1998).

When and where is it used? *Performing within a Dramatic Dilemma* strategies are used when teachers want to deepen, extend, or assess student understanding of content. These strategies can be used to put students and the teacher inside an established story from the curriculum, to think through multiple perspectives that shaped a historic event or events in a fictional text, or to generate a new story that invites students to apply content to an authentic situation. In all of these strategies, both the teacher and the students step into role together.

For example, as part of a fifth grade Texas history lesson, a teacher complicates student understanding about the *Battle of the Alamo* by asking them to imagine that a journal from a Mexican solider who fought in the Alamo has just been discovered by a Texas museum. The museum's head curator plans to prominently display the book in her museum and calls a press conference to share her announcement. Out of role, students dialogue about others who might also claim ownership of the book. Then, they pick one of these roles to play at the Press Conference with the museum curator, who is played by the teacher.

Performing within a Dramatic Dilemma strategies enable students to apply a concept within an imagined authentic event. For example, in a secondary earth science lesson on the biodiversity of habitats, students learn about the threat of extinction to various species. The teacher-in-role as an Associate Director of Wildlife Foundation asks the students to put together a Design Pitch for the foundation that only has the resources to help educate about and reduce the rate of extinction of one particular habitat and its species. Students

work in small groups and share their compelling arguments for each habitat during a Design Pitch with the group and the teacher-in-role.

How is it used? *Performing within a Dramatic Dilemma* strategies offer a range of ways to enter into a narrative dilemma within real or imagined circumstances. When using these strategies, teachers might consider the following:

Student knowledge and skills ＊ play characters

Academic: Will students be most successful within the dramatic dilemma acting as themselves or are they able to play as characters with specialist knowledge relevant to the situation (e.g., scientists, detectives, or historians)? Consider if students have all the background knowledge necessary to authentically embody and portray a character with different beliefs and skills than their own.

Affective: How relevant is the topic being introduced in the dramatic dilemma to students? Also, consider whether the dramatic structure strategy or dilemma (a meeting, a presentation, or a trial) is familiar and recognizable to the young people from their own life experience or do they need an introduction to the roles and processes that are a part of context.

Aesthetic: Are students ready to use their voice, body, and imagination to express their understanding or opinion about a character's feelings? Are students ready to respond to character's situations through exterior actions within the dramatic dilemma? As in other Role Work categories, be sure to offer time for students to prepare to perform as someone else and allow appropriate time to interpret and respond to the role-play after it is completed.

Context needs

To prepare to use a *Performing within a Dramatic Dilemma* strategy across the curriculum, the teacher must make an initial choice about how the student will be positioned within the dramatic dilemma. Some leading drama and education theorists (Edmiston, 2013; Morgan & Saxton, 1986; Wilhelm, 2012) have used a spectrum to describe how far a "role" is situated from a student's own identity and lived experience. For this text's particular interest in the use of Role Work to support curricular goals, a simplified version is offered with three key entry points to consider, depicted in *Figure 8*. Note that these categories can be explored individually or blended. Sometimes, within the same group, students may enter the same proposed dramatic dilemma at different points.

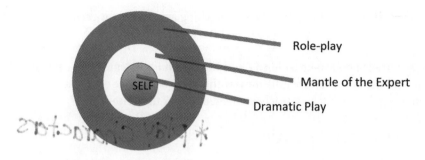

Figure 8: Adapted phases of role.

Dramatic Play: The student plays as oneself or a very accessible, familiar character within an imaginary situation.

- This approach is the most accessible for the youngest students.
- Concrete thinkers, groups that struggle with trust or collaboration, and/ or students with limited experience with how to use their voice, body, and imaginations to perform as someone else will be most successful with this approach to Role Work.

Mantle of the Expert: The student plays as oneself or someone else with the knowledge, skill, experience, and authority of an expert. Sometimes the student chooses to use a different name or identity within this approach but many times the interpretation and opinions expressed often remain close to the student's own belief system.

- This choice focuses on application of new knowledge or a new thinking process.
- It is important that students have the depth of knowledge to take on an expert role within the dramatic dilemma.

Role-play: Students often play as someone who is different from who they are, with a different history, identity, attitude, and/or belief system.

- This choice requires the students to think abstractly. They must have an ability to apply content knowledge and consider how motivation is shaped by context in a variety of ways.
- Ideally, students also have an ability to use their voice, body, and imaginations to authentically represent and perform as someone else.

Spotlight on Role Work: Planning a Dynamic Dilemma

In an Alaskan boarding school, Scott wanted to use a *Dramatic Dilemma* strategy to conclude a tenth grade earth science unit on energy resources. He wanted to engage his mostly Native Alaskan students in a narrative that made connections between their science reading and relevant economic issues where the school was located. The community is located on the bank of a major river in the middle of the Alaskan tundra and was not accessible by roads. All food, living, and shelter resources not found from the land were flown or floated into the village. There were also limited opportunities for work in the village outside of Tribal positions, a few stores, the Fish and Wildlife Department, and two schools; a former military base located in the community was recently closed. Fuel costs were very high during the extremely cold winter. The village had begun to meet monthly to discuss options about new cost-efficient energy sources.

Create a dilemma with high stakes

Scott decided that the village's energy challenges might make a perfect *Dramatic Dilemma* to explore through Role Work. He decided to create a narrative about a community that struggled with economic issues and high fuel costs. In his *Dramatic Dilemma*, a new Mayor was elected in the village based on a platform of change. The Mayor, in his constructed story, promised new jobs, new industries, and ways to address the community's growing high fuel costs. The Mayor made a secret deal with a new company, the NPC (a nuclear power company) to build a new power plant in the community. The new power plant would bring down energy costs, create many new jobs, and breathe new life into the village. The Mayor just needed the community to approve the new NPC contract. After some reflection, Scott decided a Town Hall Meeting would provide the right structure for a conversation with the mayor about his big, new idea. Plus, it would give students an opportunity to explore a potential relationship between civic engagement and environmental decisions within a community. To raise the stakes, Scott decided that the Mayor would enter the Town Hall Meeting and immediately try to get community members to sign the NPC contract, with no information about the NPC or what it does. To give the drama additional urgency, he decided the Mayor needed the contract signed that night or the NPC was going to go with a different village site on another river.

Create a dilemma with distance

After some thinking, Scott decided he needed to place the narrative conflict in an imaginary place instead of their community. He was concerned that if the role-play was set in the community's village, students would be inclined to play parodies of actual people in the village (or each other!) and lose focus on the topic. Role-play was new to his students and he wanted them to be as successful as possible. He decided to explain to students that the village had some characteristics of their village (remote, rural, on a river, and high energy costs) but that it was a different place. He added a moment at the top of the lesson for his students to create a name for the imagined village.

Create students' roles with multiple viewpoints to play

Next, Scott reflected on how he could get his students to consider a wide-range of opinions about the benefit and challenges of nuclear energy in a community. He hoped students might use textual evidence from their science textbook to make justifications for their characters' opinions about the benefits or challenges of a nuclear power plant in their village. In the end, he spent time before the Role Work Strategy brainstorming and dialoging with his class about different forms of energy used in the United States, as a way to review background knowledge. Next, he set up the dramatic dilemma of the community in need. He had the class name the community, then share the news that the newly elected Mayor had called a Town Hall Meeting about an important economic announcement. He asked his class who in this small town might care about the economy and had them brainstorm a list of possible characters (school teacher working in a run-down school, hotel owner with no guests, out of work father, Tribal Elder, etc.). Finally, he asked students to select a character that they would like to play in the drama. Throughout, he was careful to focus only on the economic challenges. He wanted students to choose their characters based on economic issues to foreground the complicated relationship between economics and environmental policy.

Create a teacher role with a mid-level amount of power

Scott also reflected on what his role should be in the *Dramatic Dilemma* before facilitating. The obvious choice was the Mayor as he would be able to direct and extend the action of the drama from this key character. After thinking further, he realized that if he played the Mayor who wanted the new plant, he would lose his ability to bring up issues on both sides of the argument for and against nuclear power, since the Mayor wanted the plant in his

imagined scenario. Thus, he decided to play the Mayor's assistant, Mr. Scott. He would announce at the top of role-play—in character as a very nervous Mr. Scott—that the Mayor, Ms. Jones, had a bad case of food poisoning, so he was here to present the plan in her place. As the neutral assistant, his character could share that the plant was Mayor Jones's idea, not his. Then, he could present more background knowledge about nuclear power, and possible pros and cons, within the drama to diversify and complicate the opinions presented. He then gathered some informational texts that discussed the pros and cons of nuclear power to be shared by his Mr. Scott character as needed.

Give time for students to create their role

Scott's students were new to role-play. Before they began, he let them know that they could choose to use their own name in the drama or they could make up a new name. He invited students to make some notes about their character and why they wanted to come to the Mayor's meeting about a big, new economic plan. He suggested that they could play a character whose personality was close to their own or they could choose to explore a personality or opinion different from their own, if they felt they could portray it authentically. Finally, he used Guided Imagery to talk them into their roles.

> *Close your eyes and imagine what your character looks like. How are you dressed? What kind of shoes are you wearing? Imagine how your character feels sitting in their seat at this meeting. Decide what you will say when you see the Mayor? What does Mayor Jones need to know about you and how you feel? I'll give us the count of ten to step fully into role. When I get to one you will be in character and I will be in character and we will begin our Town Hall meeting 10-9…3-2-1-action!*

The complete *Ethics of Nuclear Energy* lesson is located in Part III, Chapter 9 of this book.

7.l.i. Advertising/Design Pitch

Source: Drama for Schools
Number of Players: 2+
Space: Any
Materials: Arts supplies, as needed

What is it and why use it?

The Advertising/Design Pitch invites students to help a character solve a problem through the creation of an advertising campaign or the application of content to some sort of real-world design question. This strategy gives students the opportunity to apply specific design skills including aesthetic vocabulary and layout, and the communication of a message.

Content and form preparation

To prepare to explore this dramatic dilemma, engage students in background research about the advertising form(s) being explored in the inquiry through concrete examples. Students may need an introduction to key elements of persuasion used in different forms of advertisement (e.g., message, slogan, celebrity endorsement, music, and visual design) as well as common forms of advertisement (e.g., print, TV commercial, and radio).

Directions

Begin by reviewing prior knowledge about content and introduce a procedure for problem-solving that will be explored within the lesson. Next, set up the conflict: a character needs students to use their content and procedural knowledge to help solve a problem. Step into role as the character. Bring students into role as "experts" ready to help the character. Introduce the problem and answer students' questions with information about how they can help. Give students a clear process to prepare their advertising or design pitch solution to the character's problem. Invite students to work individually or in small groups and give time to prepare their ideas and/or presentation. Students share their work—individually or in small groups— and receive feedback from the teacher-in-role and their fellow students.

Reflection

- *What is the main message of this pitch? (Ask for each presentation.)*
- *What made this poster/pitch/commercial effective in persuading their audience?*
- *What similarities or differences did you see in the ways each group approached the task?*

Possible side-coaching

- *Who is your target audience?*
- *How can you synthesize your message into a single slogan*
- *What are some of the methods advertisers use to sell a project or pitch an idea?*

Possible variations/applications

- Math: Have students design a floor plan for each of the houses that the 3 little pigs build, using shapes and perimeter to note the size of the house.
- Science or Math: Have students work individually or in groups to design a new roller coaster for an amusement park that will close unless it brings in new visitors.
- Reading/Writing or Social Studies: Have students design a historically accurate advocacy campaign for the Women's Suffrage Movement or construct a leadership campaign for various characters in Shakespeare's *Macbeth*.

7.l.ii. Exploration/Adventure

Source: Drama for Schools
Number of Players: 3+
Space: Open Area
Materials: Varies

What is it and why use it?

The Exploration/Adventure dilemma invites all students to step into characters who must make a decision about whether, why, and how to embark on a journey/exploration of a new place. It focuses on the reasons that people

and societies move and expand (e.g., war, health, economics, curiosity, food, resources, and shelter) and the impact of human exploration and expansion on those who go, those who stay, and those whose lands are taken by the newly arrived explorers and colonizers.

Content and character preparation

In this dramatic dilemma, students choose a character that might choose to attend a recruitment meeting about moving to a new place. To prepare, give students time to review related academic vocabulary, to research, and to consider who might have an opinion about the topic being introduced, and/or develop the physical/vocal performance of their character. It is often helpful for students to choose a name, a profession, and a specific reason why they might choose to go on this adventure/to this new land prior to beginning the drama work. Choose a facilitator role to play in the recruitment meeting that is embedded in the world of the story. It can be useful to become a person with a medium amount of power, but limited decision-making ability, who offers information (both positive and negative) about the opportunity and works to bring out multiple viewpoints on the choice whether to go or stay.

Directions

Although there are multiple ways to begin this strategy, a particularly engaging way to start is to use an Artifact, e.g., a newspaper advertisement or a poster hung in the town square with information about the opportunity. This prop offers a simple way to introduce and establish background information about who is being recruited to move/travel to a new place and why. Once the question/story is introduced, brainstorm a list of people who might respond to the invitation to come to this meeting because they want or need to leave or perhaps they want to stop the trip from happening. Invite students to pick a character from the generated list or make up another idea; ask them to create a character profession, a name, and to generate specific reasons for coming to the meeting. Select a role that allows you to give information about the opportunity but to remain neutral to students' characters' decisions. Everyone steps into role together. Welcome students in-role and explain why you have brought them together. Share information about the benefits and challenges of the opportunity. Invite students to ask questions and to share information about who they are and why they are considering joining the Exploration/Adventure. Work to develop a multifaceted understanding of the larger issues that shape why a group might choose to move to a new place. The session typically ends with a vote being taken where each individual decides whether or not to explore/go on the adventure.

Reflection

- *What did we learn about this exploration opportunity?*
- *Why did people in our community want to go? Why did they want to stay?*
- *How does this experience relate to other times in history when a group of people has made a decision to go to a new land? Who else is impacted by decisions made by one group to explore another groups' land?*

Possible side-coaching

- For this particular strategy, side-coaching often occurs "in role"— meaning the teacher might ask questions or prompt further inquiry as they are in-role as a character. For example,
 - *What brought you to this meeting today? What are some of the reasons you decided to attend this meeting?*
 - *Why do you want to go on this adventure?*
 - *Are there any questions or concerns you have before we set out?*

Possible variations/applications

- Science or Social Studies: Use this strategy to explore famous expeditions. Students research the expeditions and step into role as characters that either were a part or might have been a part of the expedition/research team. Or, consider how an indigenous group might feel learning that an expedition of outsiders had arrived to claim their land and resources.
- Reading/Writing: To explore the children's book *The Rainbow Goblins*, have students step into role as the different rainbow color goblins who meet to decide whether or not to make the long journey to the land of the Rainbow.
- Math or History: To explore Ancient Greece and first Olympics, have students use graph paper to chart a course from their Greek city-state to Athens. They calculate the distance and estimate how long it would take each team to travel to the first Olympic Games.

7.l.iii. Public Service Announcement

Source: Drama for Schools
Number of Players: 4+
Space: Open
Materials: Props as desired, but not needed.

What is it and why use it?

The Public Service Announcements (PSAs) offer a way to check for understanding as students are tasked with embodying and representing information within this creative format. The brevity of the PSA form necessitates a clear synthesis of ideas that can be communicated in 30–60 seconds. This strategy also offers opportunities for revision after the first sharing so that students have a chance to implement the feedback they receive from their peers.

Content and form preparation

To prepare to explore a PSA, invite students to examine the characteristics of the PSA form. Show examples of actual PSAs to students to co-construct an understanding of key elements of persuasion used in the form (e.g., message, slogan, celebrity endorsement, music, and visual design) as well as common forms of advertisement (e.g., print, TV commercial, and radio).

Directions

Invite students to share what they know about public service announcements (PSAs). Then, show examples of successful PSAs found on the web or YouTube. After viewing the examples, ask students to articulate the message of each PSA and the strategies used to convey the message, then to express why they thought it was effective or not. Keeping this reflection and analysis in mind, divide the students into smaller groups. Each group creates a PSA around content; it might be the same content or each group may have a different topic. For example, if the content is how to use science lab equipment safely, each group can be assigned a different science tool. Each PSA should last one minute or less and should include elements like sound, visual imagery, text, a slogan, "real-life" examples and applications, etc. After each group creates and rehearses their PSA, the creative work is shared out with the larger group for feedback and potential revision.

Reflection

- *What was the message of this PSA? How was it communicated?*
- *What was most effective about this PSA?*
- *What similarities or differences do you see across the PSAs we created today?*

Possible side-coaching

- *Think about how you can use the elements you've seen in the example PSAs to communicate your message.*
- *Is there a slogan or tagline that would clearly communicate your main ideas?*
- *Who is the audience for your PSA?*

Possible variations/applications

- Have students create PSAs to explore good classroom behavior, work habits, and daily procedures. For example, at the beginning of the year/ of a unit, students might create a PSA about lab safety, the importance of checking your work, or why it is important to create a safe, brave learning environment in the classroom.
- Reading/Writing or Social Studies: Have students create a PSA concerning a major theme or social issue presented in a text or prevalent in history. For example, after reading the book, *Wonder*, they might create a PSA about bullying.
- Math: Have students create a PSA that helps teach others the importance of a mathematical concept/equation and its uses in everyday life. For example, students might create PSAs about the many uses of the Pythagorean Theorem or forms of measurement.
- Science: Have students create a PSA about a variety of environmental issues. For example, when exploring natural disasters, they might create a PSA about avalanche, hurricane, or tornado safety as part of an earth science investigation.

7.l.iv. Talk Show/Press Conference

Source: Drama for Schools
Number of Players: 5+
Space: Open space
Materials: An object to use as a microphone (if desired)

What is it and why use it?

The Talk Show/Press Conference invites students to examine how the media (journalists, interest in celebrities, etc.) shapes multiple perspectives on a topic, problem, or central question. The familiarity of the format encourages students to pay attention to the way the media is used to shape information for a particular audience.

Content and character preparation

In this dramatic dilemma, the students step into a more articulated "role" in the audience of the talk show or press conference than they might in a simple Hot Seating or Person in a Mess strategy. To prepare, decide who is being interviewed; will the teacher be the character or will the student(s) play the role(s)? Take time for the person or people being interviewed to research and prepare background information about their character for the interview. Next, decide who is in the audience. Participants in the audience often need to review related academic vocabulary, research, and consider who might have an opinion about the topic being introduced. In the Press Conference variation, students serving as the audience can choose a name, a publication they represent, as well as questions that might be used by the journalist.

> **Tips for playing!**
> *Younger students may need an introduction to the structure of a talk show or a press conference BEFORE the drama work begins.*

Directions

After the larger problem or content area has been introduced, explain that the "situation" being explored in class has caught the attention of the local media and an interview has been arranged. Introduce the character being interviewed and step into role as an outside moderator or as the subject of the interview. The interview begins with a few questions that establish why the character is being interviewed. Then, the students are encouraged to engage independently following a talk show or press conference format. Eventually, find a way to end the strategy from within the dramatic context of the scene (e.g., *Looks like we are out of time for today for our show.* Or *Clearly, there are a lot of disagreements about this issue; we have to stop now as my client has a very important meeting to attend. No more questions)* and invites everyone to step out of role together to reflect on what has happened.

Reflection

- *What new information did we learn?*
- *What new questions do you have now about (the problem/situation)?*
- *What do you think might happen next?*

Possible side-coaching

- For this strategy, side-coaching often occurs "in role"—meaning the teacher might ask questions or prompt further inquiry as they are in-role as a character. For example,

◆ *Can you tell me more about that?*
◆ *Thank you for sharing your opinion; does anyone else have a different opinion about this topic?*

Possible variations/applications

- Reading/Writing: Have students step into role as different characters from a novel and have them attend a talk show where the major conflict in the text is being discussed. Depending on the purpose of the lesson, the teacher might choose to lead a talk show at multiple key points in the text. For example, a talk show might happen with key characters right before the climax of the story and then another might happen after students finish reading the book. Students can also determine whom they want to interview at different points in the reading of a collective story/novel.
- Social Studies: Have students embody characters from across history who represent different viewpoints on a connecting issue. For example, *Today we've gathered key figures who've addressed human rights issues around the world and across time.*
- Science: Have students be different media reporters who have come to interview the teacher-in-role about an important advancement in the cloning of human organs as a cure for cancer.

7.l.v. Town Hall Meeting

For further help!
Check out the **Spotlight on Role Work** *in the introduction to this section (p. 257).*

Source: Drama for Schools
Number of Players: 3+
Space: Room for a circle (ideal, but can be facilitated in any space)
Materials: None

What is it and why use it?

The Town Hall Meeting invites all students to step into role and explore multiple perspectives in a community that is preparing to make a decision about a problem or a proposed change. The format encourages students to look at what shapes individual and collective perspective on an issue. It also reinforces the importance of civic dialogue as an essential part of citizenship within a society.

Content and character preparation

Select a compelling problem or proposed change that needs a solution that is shaped by a specific community or context. In this dramatic dilemma, students choose an imagined, realistic character to play that might be engaged in or have opinions about the issue being explored. To prepare, give students time to review related academic vocabulary, to research and to consider who might have an opinion about the topic being introduced, and/or develop the physical/vocal performance of their character. Sometimes it is helpful for students to choose a name, a profession, and a specific reason they came to the Town Hall meeting. Choose a facilitator role to play in the meeting that is embedded in the world of the story. It can be useful to become a person with a medium amount of power, but limited decision-making ability, who moderates the meeting and works to bring out multiple viewpoints on the proposed issue.

Directions

After exploring/establishing background information, introduce the topic of the meeting and the community where it is taking place. Invite students to brainstorm a list of people who might choose to attend the Town Hall meeting. Ask students to select a character to play; it may be useful to also decide on a profession, name, and motivation for their chosen character role. *Why has this character come to the meeting? What do they want/need?* Students step into role. Then, step into role as the leader of the town hall meeting who introduces the issue at hand. Within the drama, be sure to introduce key points that support opinions on all sides of the issue and pose central questions that the characters/students need to consider to make a decision. After presenting the issue, ask for opinions from individual townspeople. If it seems the group is leaning strongly in one direction, work to introduce new information that might complicate the issue further and keep multiple sides of the debate alive. Sometimes it can be productive to take a vote at the end of the meeting so that students make a final choice on where their character stands on the issue.

> **Tips for playing!**
> *Ask students to introduce their character name, position and reason for coming to the meeting when they choose to speak.*

Reflection

- *What new information did we learn in the town hall meeting?*
- *What are the major supporting points for each side of this conflict?*
- *What do you think will happen next in this community?*
- *What sorts of factors shape community decisions?*

Possible side-coaching

- For this strategy, side-coaching often occurs "in role"—meaning the teacher asks questions or prompts further inquiry from inside the drama. For example,
 - *Let's begin by finding out who is in the room with us today.*
 - *Can you tell me more about that?*
 - *Thank you for sharing your opinion; does anyone else have a different opinion?*

Possible variations/applications

- Math or Social Studies: Use this strategy to explore real-world financial issues. For example, to explore issues around minimum wage, students step into role as workers, managers, and owners of a popular fast food restaurant who are struggling to decide whether or not to raise minimum wage.
- Science: To explore how food waste impacts the environment and society, have students step into role as members of a community who want to figure out how to deal with high levels of ethane gas from landfills and community members who lack resources for food.
- Reading/Writing or Social Studies: To explore issues around the Second World War, have students step into role as non-Jewish families in the Netherlands during Nazi Germany's occupation of Amsterdam. In role, characters decide how and where they can help hide a Jewish family that wants to go into hiding.

7.l.vi. Trial/Courtroom

Source: Drama for Schools
Number of Players: 6+
Space: Limited

What is it and why use it?

In the Trial/Courtroom, a character is on trial and the students generate and collect evidence to decide the outcome of the case. Students can explore several different roles—from witnesses, to members of the jury, to the accused, to lawyers who prosecute or defend the accused. The dilemma focuses on how we explore right/wrong and guilt/innocence through the familiar structure of a courtroom trial.

Content and character preparation

To prepare to explore this dramatic dilemma, engage students in background research about the story/issue/character focus for the inquiry. Key characters related to the story can be generated and/or developed, along with their perspectives on the issue, before beginning the drama work. Once students generate a list of potential characters and roles within the trial, assign/or let students choose a specific character or role to explore. To prepare, students may need to review related academic vocabulary and/or explore the structure and format of a trial. Choose a role to play that supports what students need (e.g., a large role, like the judge at the trial or a small role, like the court stenographer).

Directions

After students have been assigned roles and have prepared their parts, introduce the trial. Follow an agreed-upon format for a trial with each side sharing their case, witnesses offering testimony, and cross-examination, if desired. The dramatic dilemma ends with a final vote, or a pause in the drama so that each student can reflect and offer his or her own determination of the outcome. This can be documented through a Writing in Role activity where students write a news headline and article about the trial outcome, a journal entry for their character, or complete some other writing activity that synthesizes a potential ending and their understanding of the content.

Reflection

- *What happened in our trial today?*
- *What were some of the key arguments that were presented?*
- *What types of final outcome predictions did we make at the end of our work together? Were our predictions realistic? Why or why not?*

Possible side-coaching

- For this particular strategy, side-coaching often occurs "in role"— meaning the teacher might ask questions or prompt further inquiry as they are in-role as a character. For example,
 - *Does the defense/prosecution have anything to say in response to this statement?*
 - *Are there any additional pieces of evidence you would like to present?*

Possible variations/applications

- Reading/Writing or Social Studies: Have students research an actual trial or a fictional trial (as presented in a novel or other text) to stage and explore. The teacher might choose to put someone or something on trial even if the event does not appear in the book or in history. For example, upper primary students might put the colonizing rabbits from the story *The Rabbits* on trial to explore what they did to the numbats and their land.
- Science or Social Studies: When studying scientists/inventions throughout history, have students put scientists whose accomplishments were marginalized based on their race/ethnicity and/or gender in a courtroom to sue for the recognition they deserve (e.g., Lewis Howard Latimer, Sor Juana Ines de la Cruz, Rosalind Franklin).
- Math: Have students explore and practice mathematical language, logic, and proofs by putting an equation or geometric shape on trial.

Part III

How Is DBP Used?

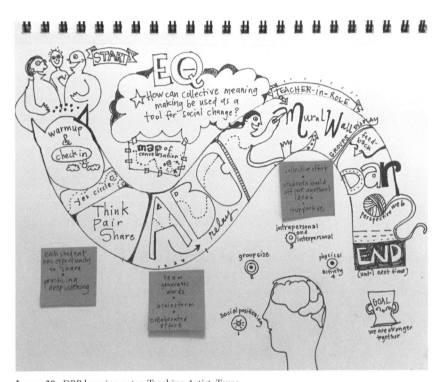

Image 38: DBP learning notes, Teaching Artist, Texas.

These notes represent the types of questions, brainstorming, and thinking that teachers and teaching artists often move through as they design a new DBP learning experience. What essential question drives this inquiry? What key aspects of thinking and working will be explored? What DBP strategy will invite students to engage in the *big idea* and demonstrate their learning? And, finally, how can students synthesize their discoveries and return to their *big idea* inquiry at the end of the learning experience through DAR? The final portion of this book will offer a detailed and comprehensive process for how teachers design new DBP learning for their classroom. We will bring together the *why* and the *what* of DBP experiences in the first two sections of this book to explore the thinking behind *how* to link multiple DBP strategies together to reach specific goals and objectives.

Part III begins with a brief review of the 5 steps of DBP learning design. Next, we offer four distinct examples of teachers applying the learning design approach to meet the needs of students in a unique educational context. We follow the development of each inquiry from beginning to end, and then consider how the same sequence might be adapted to meet different needs. Throughout, we offer detailed examples of teachers' thinking to illuminate the reflection and choice involved in each step of DBP learning design process. Part III concludes with a list of final design considerations, including the role of the facilitator, and an exploration of ways to moderate and differentiate the physical and emotional aspects of DBP practice.

Chapter 8

Review of the DBP Learning Approach

Over the past ten years, we have had the opportunity to work with teachers and artists in a range of K-12 school contexts and university settings. Throughout this time, we explored a variety of ways to support new-to-drama educators and new-to-education artists to effectively create a learning experience or unit of inquiry. As introduced in the beginning of this book, the 5-step DBP planning approach offers a process to help support teachers and teaching artists as they attempt to link multiple DBP activities together. The 5-step DBP learning design process invites teachers to do the following:

1. **Consider stakeholder intention**
 a. *Who are the students?*
 b. *What is the main curricular topic for this learning experience?*
 c. *What excites me the most about exploring this topic with DBP?*
2. **Identify what students need to know**
 a. *What are the* big idea *learning areas and/or content standards that relate to this topic?*
 b. *Where are the learners in the instructional cycle?*
3. **Define relevant connections**
 a. *What is the essential question for this plan?*
 b. *What are the key events related to the essential question that will promote dialogue?*
4. **Select key strategies and assessments**
 a. *Which strategies might productively explore and rehearse key learning areas?*
 b. *Which strategies might be used as a performance-based assessment of student knowledge, skill, or understanding?*
5. **Construct a sequence to engage, explore, and reflect**

We believe that teachers and teaching artists have the power and capacity to design effective DBP learning for their classroom if they understand why and how to make decisions that will help them reach their goals and outcomes.

Chapter 9

Examples of DBP Learning Design in Action

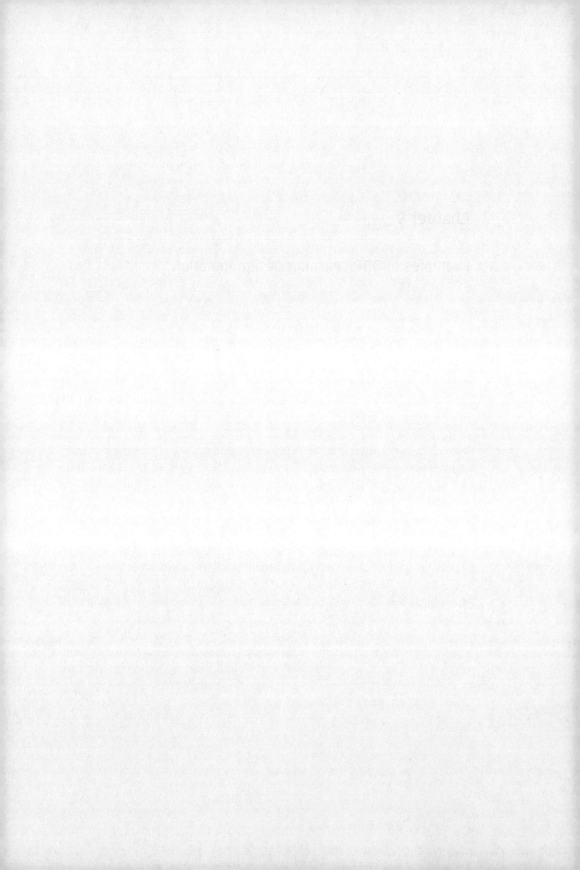

As discussed throughout this book, DBP is inherently interdisciplinary; DBP pulls from and builds upon the educational and arts standards, skills, processes, and contexts, which shape its pedagogy and practice. Many popular approaches to DBP (see the work of Belliveau, 2014; Edmiston, 2014; Grady, 2000; Heinig, 1992; Landay & Wooton, 2012; Miller and Saxton, 2004; Saldaña, 1995; Tarlington & Verriour, 1991; Willhelm, 2002, for examples) use dramatic or literary texts as the key content entry point. Far fewer texts tackle non-literary or informational content-based approaches to the integration of drama into other curriculum (see the work of Manon van de Water et al., 2015; McDonald, 2010; Prendergast & Saxton, 2013, for examples).

This next section details four different curricular entry points for DBP practice that we have found most productive as a starting point into DBP design. These include, beginning with (1) a literary text, (2) an informational text, (3) a concept or skill, or (4) a human dilemma. Each curricular entry point example is illuminated through an example of practice told from an imagined teacher's perspective, constructed to represent the actual educator's context where the DBP plan was first created and taught. We have purposefully constructed examples that show teachers working in a range of contexts and subject areas. We purposefully include the mandated teaching standards from the specific US state context where the learning experience was developed to show how teachers activate the given curriculum. After each example, we show how another teacher adapted the structure—shifting the subject area, the topic, or the target participants, or some combination of all three—for their own context. We explore how DBP teachers can (1) take a one-day facilitation plan and expand the same structure to multiple days, (2) use the same structure in the same subject area and students with a different topic, (3) use the same structure and subject area and topic but adapt for younger or older participants, or (4) use the same structure but adapt for a shift in subject area and topic and age of participants.

DBP Planning from Literary Text

DBP planning from a literary text is the most common approach to DBP teaching and learning design. We look at an example of practice from an imagined teacher, Gene, as she develops a new DBP plan based on the complex literary text *When Sophie Gets Angry—Really, Really Angry...* by Molly Bang. This inquiry invites students to embody the story from an existing text.

> **DBP Learning Design: Step One**
> **CONSIDER STAKEHOLDER INTENTION**
> **EXAMPLE OF PRACTICE: KINDERGARTEN, GENE**

Who are my students?

I teach a diverse class of 20 kindergarteners (one-third identify as minority, differing behavior/learning challenges, range of income levels, etc.) in an urban district that uses the US common core standards. Most of my students enjoy imaginative play; however, they need structure in activities (known expectations, similar schedule each day, modeling appropriate behaviors) to feel successful. Because it is a new school year, I do not have a clear understanding of my students' competencies and assets. Although I am sure many of them have experience using their imaginations and their bodies in play, I assume that they have had little experience with drama in the classroom. Developmentally, they have access to a range of emotions, but can likely use some focus on expressing and managing those emotions. The students have a wide range of literacy skills as evidenced in their vocabulary, reading, comprehension, and inferencing. Finally, I know I need to modify this specific story a bit since a key part of the storytelling is the main character's choice to run far away because she is unhappy. My understanding is that one student in my class often runs away without telling anyone. To avoid reinforcing challenging behavior, our work will focus on Sophie running to a tree *inside* her yard. We will also discuss how a parent might feel about a child leaving without saying where they are going.

What is the main topic for this inquiry?

Affective and aesthetic skills to set-up classroom culture

What excites me most?

I know that students will identify with the main character Sophie. I also really love the way the illustrations in this story capture the strong feelings of a young person. I want to use this story to help students develop other tools for managing their big emotions. I'm also excited about incorporating the new national standards for theatre in my teaching because I am required to be covering those standards in my daily teaching practice.

DBP Learning Design: Step Two
IDENTIFY WHAT STUDENTS NEED TO KNOW

What are the *big idea* learning areas and content standards that relate to this topic?

1. Academic *big idea*: I want students to rehearse listening/engaging with a story, retelling parts of the story, developing opinions about the story, and filling in possible holes in the story.
 - **Kindergarten Writing: 8** With guidance and support from adults, recall information from experiences or gather information from provided sources to answer a question.
 - **Kindergarten Writing: 3** With prompting and support, identify characters, settings, and major events in a story.
2. Aesthetic *big idea*: I want students to rehearse "reading" an image on paper (before we attempt to read an image with our bodies), enacting a character's perspective in body and language, and attempt basic improvisation with our ideas and with a partner.
 - **Generate and Conceptualize Artistic Ideas and Work** With prompting and support, invent and inhabit an imaginary elsewhere in dramatic play or a guided drama experience (e.g., process drama, story drama, and creative drama). With prompting and support, identify similarities between characters and oneself in dramatic play or a guided drama experience (e.g., process drama, story drama, and creative drama).
3. Affective *big idea*: I want students to rehearse recognizing and naming emotions they have experienced. I want students to rehearse hearing, offering, and respecting peers' perspectives; discuss the range of possible responses to anger and other emotions; and consider healthy, productive coping tools for school.

- **Goal I.A.K-2** Student demonstrates an awareness of own emotions.
- **Goal II.A.K-2** Student demonstrates ability to manage emotions constructively.

Where are the learners in the instructional cycle?

I have introduced the idea of emotions and managing emotions, but we have not explored specific ways in our classroom to do this. We have used a few theatre games to build ensemble and listening skills during our morning meeting. We have never done a full DBP plan. Our reading time often includes a brief post-story reflection on characters and story events. My goal is to "explore" and "explain" this content to my students.

> **DBP Learning Design: Step Three**
> **DEFINE RELEVANT CONNECTIONS**

What is the essential question (EQ) for this DBP plan?

EQ: How do we show and act upon our emotions?
Accessible, Open-Ended, and Applicable: I chose this EQ to reference a familiar concept and skill (emotions). I think this question invites students to engage in dialogue based upon prior experiences and knowledge; it has very broad parameters for "right" answers and can easily be used across the curriculum.

What are the key happenings related to the essential question that will promote dialogue?

- Problem: Sophie's sibling takes a toy away and her mom says it's okay.
- Obstacle: Sophie wants to keep playing with the toy, but falls, gets upset, and runs out of the house to get away from her family.
- Possible Solutions: Sophie climbs a tree and calms down.
- Resolution: Sophie returns and the reader is unsure how the family may respond to her angry outburst and her leaving the house.

DBP Learning Design: Step Four
SELECT STRATEGIES AND PERFORMANCE-BASED ASSESSMENT

Which strategies might productively explore and rehearse key learning areas?

The main DBP strategy I want to use is Paired Improvisation. This strategy will allow students a way to "try out" some of their ideas and see how another person responds to their ideas. Likewise, the partner gets an opportunity to practice responding to a classmate. In order to prepare students to participate in this strategy, I will build their understanding through Everybody Do and Narrative Pantomime. This gives students practice with expressing the emotions as well as an opportunity to explore what anger (and other emotions) feels like in our bodies.

Which DBP strategies might be used as a performance-based assessment of student knowledge, skill, or understanding?

My main strategy for individual performance-based assessment will be In-Role Writing, which I will adapt to In-Role Drawing for my kindergarten

EQ: How do we show and act upon our emotions?

students. This strategy will give students individual time to deepen their personal meaning-making of the story. I also know that students will need a brief transition with quiet, seated work after a very stimulating strategy.

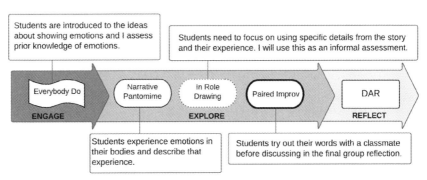

Figure 9: *When Sophie Gets Angry*: DBP design.

DBP Planning Process: Step Five
CONSTRUCT A SEQUENCE TO ENGAGE, EXPLORE, AND REFLECT

Sophie Gets Angry: Exploring Emotions

Topic: Tools for managing emotions
Grade: Kindergarten
EQ: *How do we show and act upon our emotions?*
Materials: Copy of illustration from book cover, paper, writing utensils, tape or clips to hang drawings (optional)
Space: Seated circle, open space for students to move, seated at tables
Number of players: 8–25

Engage

Students begin in a seated circle. *Today we are going to explore: how do we show and act on our emotions? Give me an example of an emotion.* Students raise their hands with responses like "sad" or "excited." Then I ask a student to show me what sad or excited looks like on their face and in their body.

After a few responses, *great ideas, now let's play a game called Everybody Do. In this game one person will say an emotion and show us what it looks like, then everyone will repeat the emotion and action back to the person. Let's try an example. If I start, it may look like this.* Then I say, "Frustrated!" and clinch my fists and scrunch my face. I invite everyone to show me what I looked like. Then we continue the game around the circle, allowing each student to get a turn. I also allow for repeat emotions—because we all show emotions differently.

Question:

What emotions did we name?

How did we use our bodies and faces to show our emotions?

Tips:
My students have carpet squares with their names on a square. This allows our class to quickly assemble in a circle that sets personal space. I can also lay them out before students arrive if I have students who need to sit in particular places.

During this discussion, I write the names of emotions or circle the faces showing emotions on an emotion sheet (available online).

Today we are going to explore a story about a young girl, the girl in this picture (show book cover). *What emotion do you see on this character's face?* I make connections to the list of emotions we generated during our engagement game. *This character is named Sophie and Sophie has a big problem and big feelings about her problem.*

Explore

Narrative pantomime: *When Sophie Gets Angry—Really, Really Angry…*

Before we start this activity, I want to remind everyone of how important it is for us to control our bodies when we are moving around in our classroom. Remember that controlling our bodies means that we make sure we have enough space that we can move without touching anyone else, that we are moving with purpose, that we are keeping our bodies still when we are not moving, and that we are following directions. In this story, our character runs, can you show me a way you can silently run without moving from your spot? (Students demonstrate their silent running.) *Now, it gets even trickier, when our character has a moment where she feels very angry, and kicks and screams. Can you show us how it looks when you are very angry while controlling your body, silent, and staying in one place?* (You can also have students make a frozen statue. It can be productive to comment on different choices made by students).

Find a place by yourself on the ground, where your body is not touching any other body. (Let them settle.) *Now, imagine you are playing with your soft gorilla. You lift her in the air and hug her tight. Maybe your gorilla can dance or jump or you can have tea with your gorilla. You play for a little bit.* (The teacher can describe strong acting choices that she sees without naming student names. *I see people hugging their gorilla. I see…*)

Suddenly, your little sister comes and takes the gorilla out of your hand, saying MY TURN. You scream, "No!" Your mom says that it IS her turn, now… You reach to grab the gorilla but you trip and fall over a train and land on the ground hard. You are angry. Really, really angry. In your own place you kick. You scream. You want to smash the world into smithereens. You roar a red, red roar… and then you run. You open the door and in your own place you run. You run away from your sister and your mom and your dad. You run through the trees in your yard. You run so hard and so long that you can't run anymore and you slow down to a walk. And you cry. A little. Then you see the trees in your yard, the rocks. You hear a bird. You come to a large birch tree, your favorite tree, and you climb all the way to the top. You sit on the thick branch and look out. When you squint, you can see the water below. You feel a breeze and you take a deep

breath and blow out slowly. The wide world comforts you. You sit for a moment looking around.

Then, slowly, you climb down the tree, walk through your yard, past the bird and rocks and trees back to your very own house. You open the door and your mom and dad and sister are there. You go to your easel and you draw a picture of what you saw or felt like in that moment in the yard.

Reflect:

What happened at the beginning of our story? How did your character feel?

What happened in the middle of our story? How did your character feel?

What happened at the end of our story? How did your character feel?

In-role writing/drawing

Let's pretend to be the character in the story again and explore the moment when our character returns home and draws a picture of how she is feeling, now, at the end of the story. Let's take some time now to make that picture. Let's draw Sophie's experience in the story. Then you will complete this statement, "Sophie feels..." Allow time for students to move to work tables and do this drawing. During this time, I walk around and ask students what they are thinking about while drawing. This opens up the opportunity to talk about anything they are drawing—rather than my guessing (sometimes incorrectly) what an object is or making them tell me exactly what they have drawn.

Tips:
I prep paper and markers for the students. I attach two sheets of paper to clipboards and one marker. Then I pass them out to where they are seated.

We are going to pause on the drawing in two minutes. I know some of you may want to draw longer. We will have an opportunity to add to our drawings later today.

Paired improvisation

When authors write stories, they can't include all of the details, but we as the readers can imagine what happens. I'm wondering if we might explore what happened when Sophie returned to the house after running away. What do you think her mom or dad might say to Sophie when she comes back into the house? (Take a few ideas; encourage students to explore how a parent might ask questions to find out what happened.) *You've got*

great ideas. Let's try some of them out. By the count of three find a partner—making sure everyone has a partner.

We will take turns pretending to be the main character in the story. One of you is the main character, Sophie, and the other is a parent who wants to know where Sophie went and what happened. For our first try, I will walk around and tap on the shoulder of the student who will play Sophie in the first round. Remember, everyone is going to get a chance to play both parts. I walk around the room and tap one student in each pair on the shoulder to designate that he/she will be the main character, Sophie, for the first round. *Sit knee to knee and I will help you talk through the scene.* We move through the next sequence together and I give time in the improvisational sections for the pairs to explore their own words.

The family member will start by saying,

PARENT: Where have you been?

And the main character will say,

SOPHIE: The backyard.

PARENT: What were you doing in the backyard??

SOPHIE: I was outside and I did _____ *Sophies please tell your parent all the details about what you saw outside. You can also describe the picture that you drew.*

PARENT: Why did you do that?

SOPHIE: Because I was feeling _____ *Sophies please tell your parent what you were feeling. You can use the words/pictures that you used to describe your picture.*

Then, I invite students to switch roles. Students move through the entire dialogue sequence again, with my help, this time playing the other character. Then we reflect as a group.

Question:

So we all got to play the parent in our scene. Let's first talk about our parent roles: What did the parents find out about Sophie's time outside?

As parents we found out [answer] and [answer] and [answer]. What is the same? What is different between these answers?

Now, let's talk about our Sophie roles. How did Sophie feel when her sibling took the gorilla from her hands? How did she feel when she walked back to the house? I write both of these emotions down on the board.

Reflect/assess

DESCRIBE: *Our work today looked at how we show and act on our emotions. We said Sophie showed (or felt) [answer] in the story. What did Sophie do (or act) as a result of this feeling?* Take answers and make links between anger and actions like running, stomping, and crying. *How else did she feel? What did Sophie do as a result of this feeling?* Take answers and make links between calm and actions like walking slowly, big breaths, stretching, and sitting quietly by yourself.

ANALYZE: *Now, let's circle the feelings and actions on our list that we think are safe to do in this classroom when we are feeling big emotions.*

RELATE: *What can we do to take care of ourselves and our emotions in our classroom? What can we do to help one another with our emotions in our classroom? Decide on one strategy that you will remember to help manage emotions and one strategy that you want to remember to help our classmates with emotions. We will keep working with these throughout the year.*

OTHER EXAMPLES FROM THE FIELD

How do we expand or contract a lesson sequence?

Gene has a colleague, Sherri, who also teaches kindergarten. Sherri wants to use Gene's 45–50 minute DBP plan. However, Sherri's students do best with 30–35 minutes for literacy, so she decides to expand and spread the *Sophie* plan over three days. Sherri keeps the main DBP sequence, but expands the structure to include new strategies each day, so that each daily "mini" drama session moves through an ENGAGE, EXPLORE, REFLECT sequence.

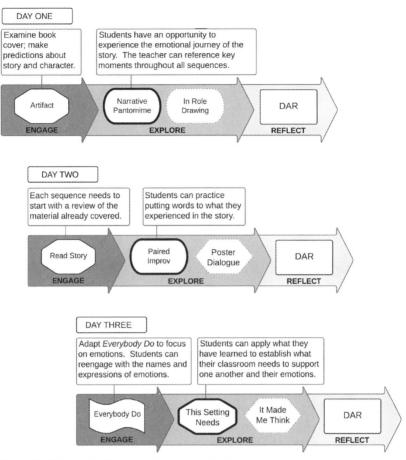

DAY ONE

Examine book cover; make predictions about story and character.

Students have an opportunity to experience the emotional journey of the story. The teacher can reference key moments throughout all sequences.

Artifact

Narrative Pantomime

In Role Drawing

DAR

ENGAGE EXPLORE REFLECT

DAY TWO

Each sequence needs to start with a review of the material already covered.

Students can practice putting words to what they experienced in the story.

Read Story

Paired Improv

Poster Dialogue

DAR

ENGAGE EXPLORE REFLECT

DAY THREE

Adapt *Everybody Do* to focus on emotions. Students can reengage with the names and expressions of emotions.

Students can apply what they have learned to establish what their classroom needs to support one another and their emotions.

Everybody Do

This Setting Needs

It Made Me Think

DAR

ENGAGE EXPLORE REFLECT

Figure 10: *When Sophie Gets Angry*: Three-day facilitation plan.

293

DBP Planning from Informational Text

In the next approach to DBP teaching and learning design, we look at an example of practice from a teacher, Judy, interested in exploring a complex informational text. This inquiry requires that a teacher build upon historical events and create a story with imagined happenings from the content.

DBP Learning Design: Step One
CONSIDER STAKEHOLDER INTENTION
EXAMPLE OF PRACTICE: TENTH GRADE, JUDY

Who are my students?

I teach in a large public school. My US history class of tenth graders (all minority, differing behavior/learning challenges, range of income levels, etc.) has 25 students in it. Because it is the middle of the school year, we have explored many DBP strategies together. We have worked hard to create a classroom culture that supports multiple perspectives, sharing our ideas, and risk-taking. Many students ask to do DBP when they walk into the classroom. Some of my students need to have a calm, highly structured environment due to learning and behavioral challenges; therefore, I only plan DBP work two-three days a week. Most of my students want to do well, but often are focused on personal needs or situations that make learning more challenging. Finally, the students have a wide range of literacy skills as evidenced in their vocabulary, reading, comprehension, and inferencing skills.

What is the main curricular goal for this inquiry?

To explore and analyze a historical primary source text (The Gettysburg Address).

What excites me most?

I want to engage students in a complex issue that continues to have relevance today. I need to teach the Gettysburg address and my challenge is how to make it relevant to the specific students in my class.

DBP Learning Design: Step Two
IDENTIFY WHAT STUDENTS NEED TO KNOW

What are the *big idea* learning areas and content standards that relate to this topic?

1. Academic *big idea*: I want students to rehearse complex problem-solving skills through a situated analysis of a historical text.
 - **History/Social Studies: Grades 9–10** Determine the meaning of words and phrases as they are used in a text, including vocabulary specific to domains related to history/social studies.
 - **History/Social Studies: Grades 9–10/1** Cite specific textual evidence to support analysis of primary and secondary sources (corestandards. org).
2. Aesthetic *big idea*: I want students to rehearse analyzing character, responding to a text from multiple perspectives, and improvising with our ideas and others' ideas in a group.
 - **Generate and Conceptualize Artistic Ideas and Work.** Use personal experiences and knowledge to develop a character that is believable and authentic in a drama/theatre work. Convey meaning through the presentation of artistic work.
3. Affective *big idea*: I want students to rehearse recognizing and naming emotions they have experienced. I want students to rehearse hearing, offering, and respecting peers' perspectives, discuss the range of possible responses to anger and other emotions, and consider healthy, productive coping tools for school.
 - **Goal III.A.9-10** Student demonstrates awareness of others' emotions and perspectives.
 - **Goal III.C.9-10** Student demonstrates an awareness of cultural issues and a respect for human dignity and differences.

Where are the learners in the instructional cycle?

We have studied the causes leading up to the Civil War, but have not read the Gettysburg Address. My goal is to "introduce" this topic to my students.

**DBP Learning Design: Step Three
DEFINE RELEVANT CONNECTIONS**

What is the essential question (EQ) for this DBP plan?

EQ: In times of disagreement, what is our moral responsibility to others?

Accessible, Open-ended, and Applicable: The EQ addresses a familiar skill to allow students to engage in dialogue based upon prior experiences and knowledge. It has broad parameters for "right" answers and yet makes space to interrogate what is moral (e.g., respect and rights for every individual) even when people have conflicting beliefs/practices in historical or contemporary contexts.

What are the key happenings related to the essential question that will promote dialogue?

- Problem: Lincoln gives his Gettysburg Address without a clear direction for the future.
- Obstacle: Citizens are unsatisfied with his speech.
- Possible Solutions: Lincoln's advisor calls a meeting with concerned citizens.
- Resolutions: The group needs to offer suggestions of how to remember those who have died in the war.

**DBP Planning Process: Step Four
SELECT STRATEGIES AND PERFORMANCE-BASED ASSESSMENT**

Which strategies might productively explore and rehearse key learning areas?

The main DBP strategy will be Hot Seating/Student-in-Role. I will start with Show Us to give the class a chance to come together and get the students moving while engaging in the broad ideas of the EQ. I will use P2P to help students get familiar with the words and serve as a close reading strategy and the foundation for meaning-making around the text.

Which strategies might be used as a performance-based assessment of student knowledge, skill, or understanding?

I will use Role on the Wall as a performance-based assessment to give students a structured way to do a deeper character analysis of a historical figure in a specific time and place. I will also use Hot seating/Student-in-Role for individual performance-based assessment.

> **DBP Planning Process: Step Five**
>
> **CONSTRUCT A SEQUENCE TO ENGAGE, EXPLORE, AND REFLECT**

Call to Action: Gettysburg Address

TOPIC: Gettysburg address

GRADE: Tenth grade

EQ: *In times of disagreement, what is our moral responsibility to others?*

Materials: Copies of Gettysburg address (may be on IPad/tablet screen), Large area on board to write, and a cape to indicate Lincoln's advisor in-role.

EQ: In times of disagreement, what is our moral responsibility to others?

Space: Seated circle, open space for students to move, seated at tables

Number of players: 8 to 30

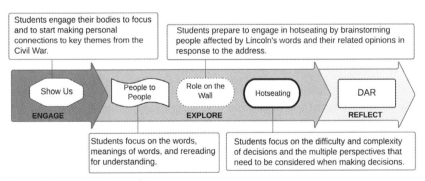

Figure 11: *Call to Action:* DBP design.

Engage

We are going to start today by reviewing what we already know about the Civil War. What have we learnt about the Civil War thus far? I respond to student answers and write facts about the Civil War on the board. Then I write

In times of disagreement, what is our moral responsibility to others?

Show Us

When I say go, I invite you to walk silently around the space. Then I will say, "Show Us" followed by some directions. You will create a frozen image. In groups of three, Show Us "brave men." I acknowledge the ways students use their bodies, facial expressions, and relational distance to express the idea of bravery.

Now, begin walking; allow a bit of time, then *in a new group of four, Show Us "brave men, living and dead."* This time I invite half of the class to remain frozen while the other half offers descriptions of the images.

Begin walking again, after a bit of time, *now in groups of four to five Show Us "brave men, living and dead, who struggled here." Go.* Students quickly form improvised images to represent these words. *Remain frozen and listen to these words: The brave men, living and dead, who struggled here, have consecrated it, far above our poor power to add or detract. The world will little note, nor long remember what we say here, but it can never forget what they did here.*

I choose two images that are very different to remain frozen. *If you need to shake out for a moment and then refreeze your position, feel free to do so. Also if you want to tap out and have someone take your place, please let me know.* To the rest of the students, *describe what you see in the shapes of these two frozen statues. Now think about what that might mean–what might the story be in these images?* When relevant, I invite students to use words that they heard from the text to describe the images.

To the students who are frozen, *if you had one line of dialogue or phrase, what might you say?* I place my hand over each student's head as if to create a thought bubble.

Then *Thinking back to our initial question, what can you add now?* I invite students to be seated in a circle and we add to our responses to the essential question.

Tips:
Early in the year, I establish different classroom arrangements with the chairs, tables, desks, etc. We name each of the arrangements (e.g., Plan Circle, Plan Open Space, etc.) and we practice moving the furniture quickly and silently. Then, I can call out a Plan and students help transform the classroom.

Tips:
When able, I take digital pictures of frozen statues and project them on the board so that everyone can have an opportunity to respond.

Punctuation to Punctuation (P2P)

Next, I hand out the entire text of the Gettysburg Address. *If you come to a comma, period, semicolon, or dash, you will stop reading and the next person will begin reading. If there are any words that you don't know, say, "Stop," and we will discuss the meaning as a group.* After this first round we read the text again, adding movements.

Now we are going to walk the text to see if movement gives us any more information about the intentions of the words. You will begin reading and walking in a straight line. Whenever you come to a period, you will turn 180° and continue reading/walking. Whenever you come to a comma, semicolon or dash, you will turn 90° and then continue reading/walking. When you get to the end of the passage, please stand still. All students read aloud and walk at their own pace the entire text. Then, all students come to the end of the text and we reflect.

Reflect:

What words or ideas did you notice while walking the text?

Why might it be so complex and difficult to remember the dead at Gettysburg?

Let's take a moment to think about the historical context for Lincoln at the moment he is delivering this speech.

Role on the Wall

I ask students to be seated at their desks. Then I draw a Role on the Wall (with a large hat for Lincoln). Throughout this strategy, I invite students to reference the text of the Gettysburg Address when relevant.

Tips:
If an individual assessment is needed I can give each student their own "role on the wall" to complete first, before we create the group "role."

What messages can you imagine that the character of Lincoln might be hearing? Write these messages on the outside of the role.

From whom? Connect these people to the messages.

How does that make him feel? Write these feelings on the inside of the role and connect to the messages.

Where does he want to go? Write these ideas on his feet.

What can he do? Write these ideas on his hands. After creating a complex depiction of Lincoln, we revisit the EQ. *What else might we want to add or revise in response to our EQ: In times of disagreement, what is our moral responsibility to others?*

Hot Seating

It seems that Lincoln might benefit from receiving some advice from the people of his country. Let's imagine Lincoln could get advice from the people in the small town of Gettysburg, PA. Remembering the dead (Union and Confederate) will be challenging. The people of Gettysburg take great pride in being the first stop north of the Mason Dixon line and an integral part of the Underground Railroad. In a moment, I'm going to invite you to take on the role of respected representatives of Gettysburg, who are asked to meet with the President's main advisor quietly and discretely in Gettysburg following the President's address. You are being asked to help Lincoln remember the dead and the sacrifice of war, while continuing the work to end slavery and bring the Union back together. Looking back at our Role on the Wall, which of these people might be interested in talking with Lincoln. Are there other people that you want to add to this list?

Take out your text again, highlight words that raise questions about how to remember the dead and the importance of equality for all. What are some questions you might like to ask Lincoln?

In a moment, I will put on this cape and become a trusted advisor to President Lincoln the moment following the Gettysburg Address. You will take on a character from Gettysburg that we have listed here or you can create another relevant character for this discussion. Your character needs to be heard and to persuade Lincoln to to remember the dead in such a way to help future generations learn from the horrific battle fought here to end slavery in our country. Any questions? I narrate the context of their meeting with Lincoln's advisor: *It is a cold morning, Friday, November 20, 1863, following the delivery of the Gettysburg Address. The President is deeply concerned, knowing that he has offered no answers. Instead, he proposes that they have "unfinished work." You have been asked to consider, how do we honor the dead (Union and Confederate) within the context of a war fought for the equality of all men and the end of slavery. When I place this cape across my shoulders, I will become a trusted advisor to Lincoln. Do you have any questions or concerns before we begin?*

I put on the cape. I become Lincoln's advisor to the group, "*I am honored by your company at this tragic time. The President needs guidance and hope. What do you have to share with me?*" Students reference their notes on the Address and begin to question what happened at Gettysburg. I do not answer questions directly, but take notes. Throughout, I offer a representation of Lincoln's emotional state and political position. When it seems that ideas have been exhausted, I say, *It seems that this is going to be a very difficult decision to create a place where our history is remembered and a place for rebirth of our*

nation conceived in liberty. I will take your advice back to Lincoln and write to you with his response. I remove the cape and begin reflecting on the experience.

Question:

- *What did we hear during the secret meeting? What was the general attitude toward Lincoln and remembering the dead?*
- *Which of the messages and people that we have on our Role on the Wall did we hear about? What additional information was revealed during the meeting? What else can we add to our Role on the Wall?*
- *How might these individuals, events, and issues have helped shape Lincoln's perspective on freedom and equality?*

Reflect/assess

DESCRIBE: *What did we learn about Lincoln's difficult position?*
ANALYZE: *Going back to our original question, in times of disagreement, what is our moral responsibility to others? What does Lincoln need to consider when making this decision about how to remember the dead?*
RELATE: *What significant disagreements do you currently see in our country? What are our current, moral responsibilities to one another? Why is it important how we remember and share our collective history?*

For additional information about the National Cemetery erected for the Gettysburg Battle, see this link: http://www.nps.gov/nr/travel/national_cemeteries/pennsylvania/gettysburg_national_cemetery.html.

OTHER EXAMPLES FROM THE FIELD
How do we apply the same essential question to other content areas?

For this DBP plan (much like many DBP plans), a teacher can adapt the essential question for multiple areas of the curriculum. Later in the month, Judy returns to her EQ: In times of disagreement, what is our moral responsibility to others? She decides to use the same DBP sequence of strategies with the text of the Rev. Dr. Martin Luther King, Jr.'s "Letter from Birmingham Jail." The familiar sequence of strategies and EQ helps students to see larger patterns of white supremacy and the ongoing struggle of inequity that people of color (and other marginalized identities) have faced throughout US history and that they still face today.

EQ: In times of disagreement, what is our moral responsibility to others?

301

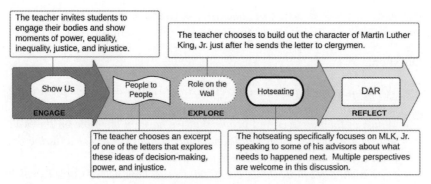

Figure 12: *Call to Action* adapted for Dr. Martin Luther King, Jr.: DBP design.

DBP Planning from a Concept or Skill

The third approach to DBP teaching and learning design explores how a teacher, Liesa, uses drama to deepen students' understanding of a concept, skill, or process. This inquiry invites students to embody their conceptual understanding of content. Next, they imagine they are experts as they apply their understanding to a real-world scenario situated in an authentic context.

> **DBP Learning Design: Step One**
> **CONSIDER STAKEHOLDER INTENTION**
> **EXAMPLE OF PRACTICE: FIFTH GRADE, LIESA**

Who are my students?

I have 22 students in my fifth grade class. I teach in a dual-language (Spanish/English) program in a central Texas school; however, we teach math only in English in the fifth grade. My students are a mix of native Spanish-speaking and native English-speaking students from a range of socioeconomic backgrounds and racial and ethnic identities. My students have a difficult time sitting for long periods of focused teaching and benefit from activities where I can get them up and moving. It is three weeks before our winter holiday break and the students are restless. There are some challenging social cliques that have formed in the classroom, so I hope to focus on positive ways to collaborate and negotiate ideas with a classmate.

What is the main curricular topic for this inquiry?

Apply mathematics to problems arising in every day life, society, and the workplace; represent and solve problems related to perimeter and/or area

What excites me most?

I am most interested in thinking about how to use Role Work in the math classroom. I reviewed how to find the area and perimeter for 2-D polygons earlier in the week but some students are still struggling with the concepts. I want our work together to feel relevant and meaningful but also have a sense of fun; we all need a way to stay excited about learning at this point in the term. I want to encourage my students to use their mathematical thinking within a real-world problem.

DBP Learning Design: Step Two
IDENTIFY WHAT STUDENTS NEED TO KNOW

What are the *big idea* learning areas and content standards that relate to this topic?

1. Academic *big idea*: I want students to demonstrate their mathematical understanding of how to determine the perimeter of a range of 2-D polygons through a problem-solving situation.
 * **(5) Geometry and measurement.** The student applies mathematical process standards to classify two-dimensional figures by attributes and properties.
 * **(4) Algebraic reasoning.** Represent and solve problems related to perimeter and/or area and volume. (www.tea.state.tx.us/teks/)
2. Aesthetic *big idea*: I want students to respond empathetically and authentically to a character in need of help. I want them to work on their perception skills, separating observation from interpretation.
 * **Theatre knowledge, skills, and perception.** The student develops concepts about self, human relationships, and the environment, using elements of drama and conventions of theatre.
 * The student is expected to imitate and synthesize life experiences in dramatic play.

3. Affective *big idea*: I want students to develop positive problem-solving skills and persistence to reach an answer even when challenged. I want them to rehearse hearing, offering, and respecting peers' perspectives on how to solve a problem when working collaboratively.
 - **Goal II.A.3-5** Student demonstrates an ability to set and reach goals.
 - **Goal IVA.3-5** Student uses positive communication and social skills to interact effectively with others.

Where are the learners in the instructional cycle?

I already taught the concept of perimeter and area for 2-D squares and triangles using direct instruction and worksheets. Now, I want students to practice using this procedure in an authentic situation. My goal for this inquiry is to "extend" students' learning on the topic.

DBP Learning Design: Step Three
DEFINE RELEVANT CONNECTIONS

What is the essential question (EQ) for this DBP plan?

EQ: How do we use math to improve our world and solve complex, everyday problems?

I want to review 2-D polygon shapes and explore how to solve for perimeter and area with different kinds of 2-D polygons. I want students to think about why it is important to know how to solve for perimeter and area in the real world and consider how to estimate using standard and non-standard units of measurement. I want them to see math as something for daily use in a job, not just an equation on a worksheet. I also want students to practice how to navigate through distracting information and to be able to find the question/s that need to be solved in a multi-step problem.

What are the key happenings that will promote dialogue in response to the essential question?

Problem: Google believes that innovative, creative spaces enable us to learn and discover more. Google has awarded our school a large chunk of money to re-design our classrooms into creative learning spaces. What do creative learning classrooms look like? Obstacle: Oh no! A junior member of the

floor design team has an opportunity to present her ideas about creative learning spaces in schools to her boss, but she doesn't know what to say. She also discovers that the site plans for the creative learning spaces are missing some of their measurements. Possible Solution: Students need to use their mathematical content knowledge of perimeter and area to (1) determine the surface area of the floor of each room and (2) to design a creative learning classroom, with flooring recommendations, for improved student learning. Resolution: Students present their room design recommendations and explain how and why they made their mathematical and design choices.

DBP Planning Process: Step Four
SELECT STRATEGIES AND PERFORMANCE-BASED ASSESSMENT

Which strategies might productively explore and rehearse key learning areas?

The main DBP strategy will be a Design Pitch dramatic dilemma. To prepare for the role-play, we can use String Shapes to review properties of polygons and how to solve for perimeter and surface area. Next, an informational text as Artifact can introduce students to key background information about Google's views on creativity and arguments about innovative work/learning environments. Teacher-in-Role can introduce the teacher as a junior floor designer in the new school re-design project, who needs help. The students Hot Seat the designer to find out what they need to know to help solve her problems. The students work in groups to fix the designer's plans and to imagine a new learning space for their school through a Design Pitch.

Which strategies might be used as a performance-based assessment of student knowledge, skill, or understanding?

I will use String Shapes as a performance-based assessment of the full group's knowledge and understanding of different polygon characteristics and procedure for solving perimeter and surface area for 2-dimensional shapes (square, rectangle, etc.). I will use the Design Pitch as a small group performance-based assessment for students to demonstrate their

mathematical problem-solving and critical thinking skills in a realistic scenario.

> **DBP Planning Process: Step Five**
> **CONSTRUCT A SEQUENCE TO ENGAGE, EXPLORE, AND REFLECT**

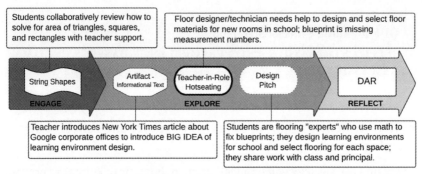

Figure 13: *Perimeter and Area of 2-D Geometric Shapes*: DBP design.

Perimeter and Area of 2-D Geometric Figures

Topic: Geometry skills and applications

Grade: 5

Essential question: How do we use math to improve our world and solve complex, everyday problems?

EQ: How do I use algebraic reasoning to design a creative learning classroom?

Materials: Yarn long enough to make a single standing circle or multiple circles with each player holding on to the yarn; copies of creative classroom plans with missing numbers, New York Times article; and, writing utensils.

Space: Enough to make a single or multiple standing circles with the full group

Number of Players: 5 or more

Engage

We've been learning a lot about 2-dimensional shapes and their properties. What are some of the shapes we have been learning about? List on the board.

(Squares, circles, triangles, polygons, etc.) *What are the properties of these shapes?* Pick one of the shapes and ask students to use their mathematical vocabulary to describe the shape. *Which of these shapes are polygons? Why? Let's take some of your mathematical knowledge, now, and put it into action as we explore how to make polygons together.*

String Shapes

I break the large group into two or more groups with 4–8 students in each group. I give each group their own long piece of yarn. *In a minute, when I say go, I'm going to invite you to make a large 2-dimensional square with this piece of yarn. Here is the challenge: we must complete this task silently. Any questions? I will time us to see if we can do this task in under 1 minute. Please raise one hand silently when you think the square is complete and I should stop the clock. Go!*

After students have successfully accomplished this task, I tell them how long it took them to complete the square. Then, I invite them to explain to me why the shape they have made is a square. I encourage them to use academic vocabulary in their descriptions. I also ask them to explain what strategies they used to complete the task successfully. *If you remember we've described perimeter as the distance around the outside of a closed shape. Please talk with you group and estimate the distance of the perimeter around your square.* I encourage students to find a creative way to estimate distance using non-standard units of measurement. They may choose to use their feet, hands, or floor tiles. Once groups are finished, I invite them to share their perimeter measurement estimates with the whole group, and explain their mathematical thinking. Each group shares out their findings. Next, I review how to find the surface area of a square (B x h = A). Then, I ask the groups to find the surface area of their square and share their results.

Tips:
I avoid giving the impression that groups are racing each other to make shapes. I'd rather have the WHOLE class race the clock. I also monitor the clock and "flex" time when necessary for morale.

> *Let's try another shape and see if we can beat our prior time. For this next shape, starting with your square let's see how quickly you can silently make a right triangle. You might look at your square first to think about anything you know about the relationship between right triangles and squares. Remember to raise one hand in the air when you have met the task; so, I can stop the clock. Questions? Okay, go!*

Once all the groups have finished, I invite them to explain to me why the shape they have made is a right triangle. I encourage them to use academic

vocabulary in their descriptions. I also ask them to explain what strategies they used to complete the task successfully and what is the relationship between a right triangle and a square. We then look at our area of our square formula and make predictions about the surface area of a right triangle. We will work together to determine the formula for the area of a triangle A = ½ (B x h). *Since you know the length of each side of your square, work with your group to determine the area of your right triangle.* Once groups are finished, I invite them to share their area measurement estimates with the whole group, and explain their mathematical thinking.

Question:

What strategies did you use to successfully collaborate in this activity?

How did you find the perimeter for each shape?

How did you find the area for each shape?

Sharing an Artifact

So recently I was reading the news online and I saw this headline: Looking for a Lesson in Google's Perks…just from the title, what do you think this article might be about? I help students identify words they know (Google, Lesson, etc.) We might make predictions about what a "perk" might be. *Let's read the first few paragraphs of the article together. As I read, please listen for information that helps you understand what this article is about.* I put the article up on my overhead projector so students can read along with me.

Tips:
I try to include informational texts in my teaching whenever possible. I want students think about how reading is essential to understanding the world.

I pause at some of the more challenging vocabulary and encourage students to use context clues in the sentence to try and determine what the words mean.

Google's various offices and campuses around the globe reflect the company's overarching philosophy, which is nothing less than "to create the happiest, most productive workplace in the world," according to a Google spokesman, Jordan Newman. During a visit to the newest Google Campus in NYC I was led on a brisk and, at times, dizzying excursion through a labyrinth of play areas; cafes, coffee bars and open kitchens; and conversation areas designed to look like vintage subway cars.

Next to the recently expanded Lego playstation, employees can scurry up a ladder that connects the fourth and fifth floors. Google lets many of its hundreds of software engineers, the core of its intellectual capital,

design their own desks or work stations out of what resemble oversize Tinker Toys. Employees express themselves by scribbling on walls. The result looks a little chaotic, like some kind of high-tech refugee camp, but Google says that's how the engineers like it. "We're trying to push the boundaries of the workplace," Mr. Newman said, in what seemed an understatement.

After reading, I ask students to make sense of what they learned. *What information stands out to you in this article? Why? What does this article tell us about what Google thinks their employees need to be creative thinkers?* I encourage students to pick out specific language from the article that they think describes what the Google offices look like. I want students to think about why a company would put adults in places that help them to play and explore new ideas.

I introduce an imaginary problem. *For our next geometry exploration, we are going to imagine Google has decided to take their millions of dollars and their ideas about play and exploration to our school. We are going to imagine that Google has offered to build a new elementary school for us to help us be better creative learners and thinkers.*

What types of activities would you like to see in a new creative learning school? (Collect ideas on the board)

Teacher in-Role/Mantle of the Expert

Today, we will explore a practical problem by going into role. When I put on my hat I'm going to step into the role of someone who has been hired to work on the new creative learning school and I'm going to invite you to help me solve a problem which you'll hear about from me when I step into character. You will be yourselves. Are you ready to help me. Any questions?

I count down from 3, 2, 1, and go into role as Liesa a worker on the new Creative Learning School by putting on this hat.

"Hi everyone, I'm Liesa from the Creative Learning School project; I'm part of the team in charge of designing the floors for the new building. I've got a big issue and I'm hoping you can help me. My boss gave me the blueprints for the new classrooms and asked me to determine the surface area, the space covering the floors, so we could order the right amount of flooring. I was eating some chocolate and I just realized that my chocolate fingers smeared the numbers on the plans. I need to fix it so I can find the surface area of the floor; but I've never seen rooms shaped like this. I don't know what to do. I show the blueprint of one room and ask for their help.

Tips:
I use a drama contract – a verbal agreement – to confirm that we are all "ready to imagine" before I begin Role Work.

309

I invite the students to help me figure out what the missing numbers are. As the character, I make mistakes and encourage students to correct me and help me figure things out. I use this process to review the procedure for solving perimeter and area. I assess whether the students are ready to work in small groups with their own set of plans. After we have finished, I say to the group *I'm so glad I asked for your help. As part of the design team I also get to make recommendations about what type of creative learning could happen in this room based on the shape of the room. Let's look at this room shape, what sort of creative learning activities do you think could happen in a room with this shape?* I will invite students to look at list of creative learning activities and to think about which activity might happen in this shaped room and make some recommendations. *These are great ideas. If we wanted to title this room, what would we call it?*

Awesome, you all really know what you are doing. This will obviously be so much faster if we share the work, so I'm going to give some of these floor plans to you in groups.

Design Pitch

I will pass out a large design plan for each table group of four. I will review the problem-solving steps and tasks with the group.

First: Think like a mathematician!
 a. *Solve for any missing lengths on your figure using your perimeter information.*
 b. *Use the area formula for a square and triangle to find the area of the floor and show your work.*

Second: Think like a designer!
 a. *Decide on the creative learning activities that you want to put in this space.*
 b. *Label each area of your floor for a different creative learning task based on the shape of your room.*
 c. *Title your room and be prepared to present it with your group.*
 ** *If time, add color and other details to your room design.*

As groups work, I support their efforts as needed. When groups are done each group presents the surface area of the flooring and how they found their answer, the learning activities for their room and the title. After each group presents the students discuss:

- What do we appreciate about this design?
- How does this room support creative learning and thinking?

After all the groups have presented, I thank them for their work and step out of role.

Reflect/assess

DESCRIBE: What did we do today?

ANALYZE: What types of thinking and skills did we have to use to be successful at our tasks? What other jobs/situations might require someone to use some of these same types of skills?

RELATE: We did some important thinking about the type of classroom activities and classroom that supports creative learning and thinking. Which of our ideas do we think we might apply to our own classroom to improve how we learn with one another?

Other Examples from the Field

How do we scale a DBP plan up or down age levels?

EQ: How do we use perimeter to solve an everyday problem?

Like Liesa's fifth grade math class, Jorge's third grade math students also need an engaging way to review and explore mathematical concepts related to geometric shapes. In third grade, students focus primarily on perimeter. He adapted the 2-D perimeter and area structure to meet the needs of his students academically, and shifted the "problem" to a topic and EQ that he felt would appeal to his students' interest in animals. Finally, he designed a "low floor/high ceiling" mathematics task that could easily be differentiated for students in his classroom.

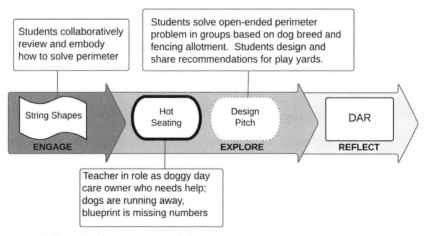

Figure 14: *Perimeter of 2-D Shapes:* DBP design.

DBP Planning from a Human Dilemma

This final approach to DBP teaching and learning design offers an example of practice from a teacher, Scott, interested in using drama to dig deeply into a larger human dilemma question related to the science curriculum. This inquiry invites students to apply content to a "real-life" scenario and to think critically from multiple perspectives situated in an authentic context.

DBP Learning Design: Step One

CONSIDER STAKEHOLDER INTENTION

EXAMPLE OF PRACTICE: TENTH AND ELEVENTH GRADE, SCOTT

Who are my students?

I teach in a boarding high school in remote, rural Alaska. I have 22 students in my tenth/eleventh grade Earth Science course. The kids represent over 60 different tribes, from across Alaska, plus young people from the local village. The teens are often difficult to engage; some spend the period with their heads down on their desks. Some have a history of trauma and do not like to be physically touched. It is spring and the temperatures have finally risen above freezing. We are adding 10 minutes of light each day and students are itchy to be outside riding snow-gos, trapping, skiing, and burning trash…anything but school.

What is the main curricular topic for this inquiry?

Energy issues in remote Alaska (focus on nuclear energy)

What excites me most?

I want to get my students engaged and thinking critically about the environmental impact of our energy resource choices in rural Alaska. I hope to use Role Work to get the students to think about the relationship between social, political, and economic issues and how they can play a part in determining Alaska's future. I want to have fun and make science learning feel relevant.

DBP Learning Design: Step Two
IDENTIFY WHAT STUDENTS NEED TO KNOW

What are the *big idea* learning areas and content standards that relate to this topic?

1. Academic *big idea*: Students will explore the economic, social, and political forces, which shape decisions around energy sources in remote, rural Alaska.
 - **Science Performance Standards** The student demonstrates an understanding of how to integrate scientific knowledge and technology to address problems by researching how social, economic, and political forces strongly influence which technology will be developed and used.
 - **Cultural, Social, Personal Perspectives, and Science** Students develop an understanding of the interrelationships among individuals, cultures, societies, science, and technology.
 - **Geography Performance Standards** Students should understand the impact of economic choices and participate effectively in the local, state, national, and global economies. Identify the costs and benefits when making choices.

2. Aesthetic *big idea*: Students will be able to create a responsible thoughtful character. They will structure an argument for a character and speak loudly and clearly to each other.
 - **Arts** A student should be able to create and perform in the arts: (4) demonstrate the creativity and imagination necessary for innovative thinking and problem-solving.

3. Affective *big idea*: Students will think about what it means to be a responsible member of the community.
 - **Skills for a Healthy Life** A student should be able to contribute to the well-being of families and communities. A student who meets the content standard should (1) make responsible decisions as a member of a family or community;
 - Identify and evaluate the roles and influences of public and private organizations that contribute to the well-being of communities.

4. Cultural *big idea*: Students will consider the connections to their cultural heritage and traditions and their role within the bioregion where they live.
 - **Cultural Standards** Culturally knowledgeable students are well grounded in the cultural heritage and traditions of their community;

313

students who meet this cultural standard are able to (1) assume responsibilities for their role in relation to the well-being of the cultural community and their lifelong obligations as a community member;

- Culturally knowledgeable students demonstrate an awareness and appreciation of the relationships and processes of interaction of all elements in the world around them: (2) understand the ecology and geography of the bioregion they inhabit.

Where are the learners in the instructional cycle?

Students were assigned reading about energy sources from their textbook last night. I want to see who has done the assignment and help students understand why knowledge on the topic of energy resources has relevance to everyone living in Alaska. My goal for this inquiry is to "assess" students' learning on the topic and support their desire to know more about the topic.

> **DBP Learning Design: Step Three**
> **DEFINE RELEVANT CONNECTIONS**

What is the essential question (EQ) for this DBP plan?

EQ: What are the ethical questions that shape decisions about energy use in rural Alaska?

Energy issues are a real concern in remote, rural Alaska. Many villages must use very expensive diesel fuel to heat their homes throughout the long, dark winter. Diesel has higher carbon content and emits more soot and carbon oxides into the environment. Making smart, informed decisions around energy use and resources in rural Alaska should be a top priority for every Alaskan citizen.

What are the key happenings that will promote dialogue in response to the essential question?

- Problem: Village has high-energy costs, unemployment, and limited access to health care.
- Obstacle: At a Town Hall meeting, it is revealed that the Mayor wants the Nuclear Energy Corporation to build a plant in town as a way to "fix" the village problems.

- Possible Solution: The villagers are encouraged to take sides on whether they think nuclear energy is a "good" idea for the village. They vote on their decision.
- Resolution: The "For" and "Against" sides meet, do research, and write a letter to the editor of the paper about why their ideas should be considered.

DBP Learning Design: Step Four

SELECT STRATEGIES AND PERFORMANCE-BASED ASSESSMENT

Which strategies might productively explore and rehearse key learning areas?

The main DBP strategy will be a Town Hall Meeting dramatic dilemma, which I will lead as the Mayor's Assistant. My job will be to encourage viewpoints on both sides of the pro/con nuclear energy debate. Students will need to choose authentic characters that might have an opinion on the energy resource issue. I will use Guided Imagery to help them step into character more fully. I will push them to offer specific details about why they are for or against nuclear power in the village. I will ask them to work collectively to structure an argument for their side as they Write in Role to the editor of the local paper.

Which strategies might be used as a performance-based assessment of student knowledge, skill, or understanding?

The initial brainstorm about energy sources will help me understand what they know and make visible any gaps in their knowledge. I will use the Town Hall Meeting as a full group performance-based assessment of their collective knowledge and understanding about the relationship of political, economic, and environmental decisions in our bioregion. The Writing in Role letters to the editor will serve as an individual performance-based assessment for students to show their opinions, as I will require each character to have at least one sentence about their argument.

EQ: What are the ethical questions that shape decisions about energy use in rural Alaska?

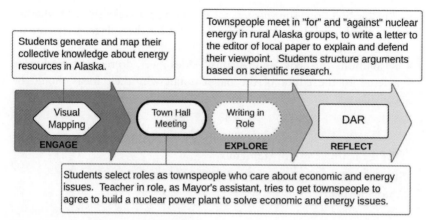

Figure 15: *Power to the People:* DBP design.

Planning Process: Step Five

CONSTRUCT A SEQUENCE TO ENGAGE, EXPLORE, AND REFLECT

Power to the People: The Ethics of Nuclear Energy in Rural Alaska

TOPIC: Energy resources in Alaska

GRADE: Tenth-Eleventh Grade

ESSENTIAL QUESTION: *What are the ethical questions that shape decisions about energy use in rural Alaska?*

Materials: A surface for writing (blackboard, whiteboard, or large paper), paper and pencils/pens

Space: Any

Number of Players: 5 or more

Engage

Today we are going to talk a bit about ways we create the power that turns on our lights and runs the heat we are enjoying right now.

Visual Mapping

Where does electricity come from? I ask students to brainstorm a list of energy sources used to generate electricity including water power, wind power, water turbine, biomass, diesel gas power, coal, and nuclear power.

Today, our discussion about energy resources in Alaska will ask us to think about the ethical questions that shape decisions about energy use in rural Alaska. In particular, we will consider how social, political, and economic issues shape choices about energy resources and what are the possible benefits and costs of our choices.

Explore

To consider these big ideas, *let's imagine we live in small Alaskan community that is in deep financial trouble.* I invite students to choose a name for our imaginary town. *This remote, rural community of [name] has to produce or purchase its own energy sources. Currently, the village relies on fossil fuels—specifically diesel—for energy to power their cars and machinery and to heat their homes.* I take time to review how diesel fuel is made from light virgin gas oil that is produced from crude oil. *This is a village that needs to bring in their diesel fuel by plane or boat. There is a high level of unemployment in the village. People who live in [name] are in need of jobs, cheaper energy, and a better economic and environmental future. Let's brainstorm a few ideas of the jobs that people might have in this community. Write their ideas on the board.*

Town Hall Meeting

We are going to imagine that we are all members of the [name] community. We are adults, who have come to a very important Town Hall Meeting. You've come because the economy is bad and many of you are out of work. Think about what your character's name will be. It could be your actual name or a new name. Choose a realistic profession for your character; something that someone might do in a small rural village in Alaska. Decide whether you are currently employed in your line of work or not. I'll know that you have an idea about what your job could be when I can see your eyes looking at me. Let's imagine that I am the assistant to the

new mayor of this town. I called the Town Meeting. When I put on my scarf, I will become the assistant to the mayor.

Teacher in-role

Ladies and Gentlemen of [name], I am so pleased that you have come to join us tonight in city hall. Mayor Jones ate some bad moose meat for dinner and had to be flown to the hospital in Fairbanks last night; so, I am here in her place. My name is Mr. Hughes, I'm the assistant to the Mayor. I'm here tonight to share some very exciting news. As you know, the Mayor made some important campaign promises to you! You said you needed jobs; our unemployment rate is at 15%. You said we need to build a new library and that we need to improve the community health center so we don't have to fly to the city for health care. You also said that the cost of energy is too high. It's costing you too much to heat your homes and run your lights and appliances. Well, the mayor is ready to deliver on her promises. I have in my hands a copy of contract from the NEC Corporation, which should bring many new jobs to our little town. Now all I need from you is a "yes" vote saying that we do want NEC's plant located in our town. This will confirm that we do want jobs and stability for our families. It will confirm that we want an end to high-energy prices. Say yes to the mayor (or me) tonight and our little town of [name] can get ready for some BIG changes.

As the Assistant Mayor, I try to get the group to quickly sign my petition without any information. I want them to be suspicious of my big claims for change and push me for more details. When they won't sign the contract, I open the floor to questions. I ask that each member of the community introduce themselves by name, profession, and current level of employment. I interact with each student/community member, and try to "sell" the character on building the NEC power plant. My goal is to make sure that there are characters that do and do not want to use nuclear power in the village. I introduce the following information as needed:

- NEC stands for Nuclear Energy Corporation. They want to build a nuclear power plant in town.
- NEC has agreed to build this power plant with no cost to the town.
- The plant is a beta project, a new type of power plant based on a battery cell. This will provide the clean power that our little village has been looking for. This approach was developed in France and is very popular there.
- NEC has agreed to build a brand new health center. They will need it to attract many workers to village to help build and maintain the power plant.

- NEC will bring new tax income to the city.
- NEC will bring at least 5000 new jobs to the village.
- NEC plans on building the power plant on the banks of the major river in town. This river supplies much of the town's water supply and is a major source for the salmon used by many families as a key source of food.
- NEC has an impeccable record regarding nuclear wastewater management. They have a very strong commitment to safety and the environment.
- There are limited places to live in the city. New industry will quadruple the number of people who live in the town. Land will need to be developed for more housing and businesses to serve all the new people. There are tribal lands, which will need to be developed. More housing needs and people will lead to many new jobs in construction and service industries.

As the assistant-mayor, my job is to instigate a lively discussion about the social, economic, and environmental issues related to decisions around energy sources in a remote, rural community and get as many student/ characters involved as possible. Once I get key the issues out in the open and there seems to be a few characters arguing for either side, I say *Well, it seems that we have opinions on both sides in the room. However, the mayor does need to give NEC an answer tonight. I will remind you all that you voted for change and change means sacrifice and faith. You wanted an answer to our economic woes and the mayor has done her best to offer it. I would like to take a vote. I will ask each person what their decision is and they may answer "yes" or "no."* I ask each student/character to make their vote, then I say *Thank you for your thoughtful dialogue.* I take off my "role" scarf and I say *I'm going to step out of role to tell you what happened next in our drama.*

Writing in Role

Tips:
I need at least two students to vote YES for the NEC and nuclear energy to make this part of the inquiry effective. I can step back into my Assistant to the Mayor role and work with the YES group as necessary.

I explain (as myself, not as a character), *So, there was indeed heated debate over whether or not the people wanted the NEC and nuclear energy in their village. Groups on either side of the issue formed and they met later that night, in different parts of the town. Each group decided to write a letter to the editorial board of the local paper, The Alaskan Gazette, arguing for their side of the issue.* I break the class into two groups—divided along the lines of the votes. I review the format for a letter to the editor and discuss

what makes a strong written argument. I ask each group to compose a letter that expresses their feelings on this subject. They can also choose a name for their group, e.g., *Citizens for Nuclear Progress.* I give them resources to use on the topic and some time to search out further information online. I ask that each group use their characters to think through arguments that their character might make about this issue. I ask them to sign the bottom of the letter as their character. After the letters are written, I bring the entire class back together and invite each group to read their letter and discuss the opinions that have been expressed.

Reflect/assess

Describe: What are the social, political, and economic issues around the use of nuclear energy that were introduced in our drama inquiry?

Analyze: Which of the arguments for or against nuclear energy as an energy resource resonated the most with you? What would you want to know as an informed member of a community that is considering building a nuclear power plant?

Relate: If a nuclear power plant was going to be built in our town…what type of people (jobs, positions, etc.) might support the decision? What type of people might be against it? How do decisions about energy resources get made in our town?

Other Examples from the Field

How do we apply the same strategy structure to different content areas?

The heart of this DBP design is an exploration of how invested community members engage in civic dialogue to make a decision about something that impacts individuals as well as the collective community. This same dramatic frame can be used in a variety of content areas. For example, below a fifth grade teacher, Maria, uses the same structure to explore issues related to the American Revolution and the Boston Tea Party. Maria changes the EQ and the subject area/topic but uses the same strategy sequence.

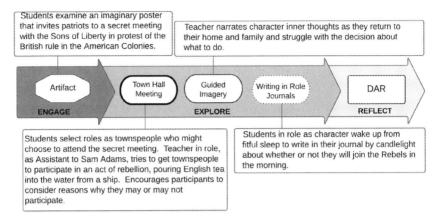

Students examine an imaginary poster that invites patriots to a secret meeting with the Sons of Liberty in protest of the British rule in the American Colonies.

Teacher narrates character inner thoughts as they return to their home and family and struggle with the decision about what to do.

Artifact

Town Hall Meeting

Guided Imagery

Writing in Role Journals

DAR

ENGAGE

EXPLORE

REFLECT

Students select roles as townspeople who might choose to attend the secret meeting. Teacher in role, as Assistant to Sam Adams, tries to get townspeople to participate in an act of rebellion, pouring English tea into the water from a ship. Encourages participants to consider reasons why they may or may not participate.

Students in role as character wake up from fitful sleep to write in their journal by candlelight about whether or not they will join the Rebels in the morning.

Figure 16: *The American Revolution:* DBP design.

Chapter 10

Further Considerations in DBP Learning Design

T eachers and teaching artists often find more ease and confidence with DBP learning design as they develop a better understanding of the larger pedagogical choices and issues that shape the practice. It takes time and effort for new teaching skills to move toward job-embedded practice, particularly when they involve a significant pedagogical shift. Pedagogical content change involves multiple shifts in teacher thinking and practice. To detail the types of transformational teaching we often observe in teachers and teaching artists who use DBP, this final section of Part III returns to the foundational learning and drama theory of DBP. First, we will consider how facilitators of DBP can achieve desired learning outcomes through specific choices about how to position their role of "teacher" in relationship to the learners' knowledge, skill, and experience. Next, we will explore how drama's use of body and emotional engagement can be moderated throughout the intentional sequencing of DBP strategies. We conclude with a list of final recommendations for DBP learning design that reference key arguments from the book.

Shared roles between teachers and students

Leader, facilitator, guide: Each of these terms suggests a specific connotation and understanding of the role of the teacher in relationship to a student in the classroom. In order to be effective facilitators, teachers must inevitably explore a more democratic and shared power structure with students during DBP. The teacher as facilitator may shift from a "guide on the side" (King, 1993) to an active co-participant in the construction of the learning. This enables the teacher to invite students to reflect "on" their actions as well invite reflection "inside" the action, as noted in Table 4. In each position articulated in the table, the teacher continues to facilitate reflection—and meaning-making—to make connections between the individual, the group, and the curriculum; this supports students' abilities to build new knowledge that can transfer to other situations. This shift in positioning can occur within a single strategy or throughout a lesson or unit of inquiry and is often supported by specific instruction, side-coaching, and meaning-making language from the teacher as described below.

Teacher and Student Relationship	Desired Student Outcomes	Instruction and Side-Coaching Language	Meaning-making Language
Guide on the Side: Teacher and Student as Co-Facilitators	Create an ensemble; encourage students to problem-solve with each other rather than look to the teacher for the answers.	*I see you working together to find a solution!*	*What choices did you make to solve the problem or task?*
	Highlight successful behaviors and attitudes.	*How can you improve on your previous work as you begin to work together again?*	*Where else in our work might we need to use this strategy or follow this process?*
Direct Guide: Teacher as Facilitator and Student as Participant	Support student capacity to create, analyze, synthesize, and infer meaning.	*As you look at this image your peers created, what do you think this character might be thinking if we could hear her inner thoughts?*	*How did the character's viewpoint about the incident change over time in our three images?*
	Highlight individual understanding as well as move to collective meaning-making.	*I'm hearing you say X, which seems to connect to the idea that LaToya had earlier about Y. Let's continue to explore this connection…*	*Where did our group align with the ideas outlined in the text? Why do you think this is?*
Full Participation: Teacher and Student as Co-Participants	Position the teacher and student as co-learners and participants, ready to learn from and play with each other.	*When I say "go" we will all step into role as our characters that have come to this secret meeting looking for answers.*	*Thank you for coming, I hope you weren't followed because what I have to say may get us all in a lot of trouble.*
	Model key drama or cognitive skills for the group.	*This is not a triangle; this is my sharp, shark dorsal fin, sitting on the back of my shark body.* Teacher puts triangle on back and makes a sharp chomping snap with his or her mouth.	*Which performance skills (body, point of view, shape, and facial expression) were most useful as you changed the triangle into something else?*

Table 4: Role of the teacher.

The type of meaning-making language used in a lesson by the teacher also depends on how the specific strategy functions within the larger learning design. As teachers and teaching artists become more familiar with DBP, they begin to understand how to use certain types of meaning-making to accomplish a goal or objective both within a single strategy as well as between strategies through the arc of the learning experience. They discover when and how to fluidly shift between a specific moment of learning to return to the broader examination of the *big idea*, when to move forward to the next question or strategy, or when to give more information or to pause and make further connections to the EQ. With practice over time, many DBP teachers develop a better capacity to respond to the DBP-related needs of students as they arise. They learn to make in the moment adjustments to their facilitation to offer a student or students better academic support (e.g., more clarity, feedback, or instruction on the cognitive task), aesthetic support (e.g., more commitment to the story or related skills of the dramatic art form), or affective support (e.g., more practice in safe ways to take emotional or physical risk), when it is needed.

Differentiating the drama in DBP

When teachers vary aspects of their teaching to support the individual learning needs of students, this is generally referenced as "differentiating instruction." By definition, differentiation is concerned with how teachers respond to the variance or difference among students in a learning environment. In general, it is understood that teachers can differentiate learning in four key ways: (1) the content is adjusted by level, (2) the process or activities used to master the content are adjusted, (3) the products that demonstrate student understanding and knowledge within a learning unit are adjusted, or (4) the learning environment that determines how the classroom feels and works is adjusted to meet specific learner needs (Tomlinson, 2000). Simply using DBP in the classroom across the curriculum is differentiating the learning for students. Much of the arguments in this book are based on the evidence that the DBP approach provides educators and teaching artists tools to "better" adapt and differentiate their teaching and learning process in multiple ways, including the four key approaches listed above. As teachers and teaching artists become more skilled, they are able to be more intentional and reflect on the ways in which they can differentiate a DBP learning experience.

When designing a DBP learning experience, it can be useful to consider how differentiation functions within the sequence of strategies being used.

For example, we see in the DBP design figure for *When Sophie Gets Angry*, the first plan shared in the *DBP Planning Approach* section of Part III. The basic sequence of strategies is as follows:

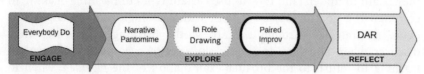

Figure 19: DBP design example.

Each of the four areas of differentiation introduced (content adjustment, process/activity, products that demonstrate learning, and learning environment structure) can be connected to specific aspects of DBP (emotion, choice, embodiment, collaboration, or group work) so that we can specifically track how

- the emotional engagement level (low, medium, or high) of each strategy differentiates the way students learn content;
- the participant choice level (low, medium, or high) differentiates the way students master content;
- the physical activity level (low, medium, or high) differentiates how students demonstrate their learning; and
- the grouping size (whole, small, or individual group) differentiates how the learning environment is structured.

When these concepts are mapped across the sequence of strategies in a learning experience—as seen in Figure 20 and analyzed using the differentiation dimensions of Emotion, Choice, Activity, and Grouping— patterns emerge that help explain why certain sequences of DBP work well together.

It is generally understood that some kind of differentiation is useful throughout a learning experience. One way to differentiate the learning environment is to choose activities that shift the kind of groupings being used at various points. Starting and ending with the whole group working together (as seen above in *Sophie* plan strategies Everybody Do, Narrative Pantomime, and DAR), and including pairs (Paired Improvisation) and individual group (In-Role Drawing) activities in between, is a common pattern for DBP learning designs. This gives time for the students to build ways of working as an ensemble, but also moments for individual and paired exploration of ideas. The physical activity levels in this learning experience are also differentiated—moving from a medium level (Everybody Do), to a high level

(Narrative Pantomime), to a low level (In-Role Drawing), to a medium level (Paired Improvisation), to a final low level (DAR)—over the course of the inquiry. The shift in physical activity levels between each and every strategy serves as a refocusing mechanism for younger students, which supports their developmental need to change the type of activity they are doing every 15–20 minutes (Wood, 2007).

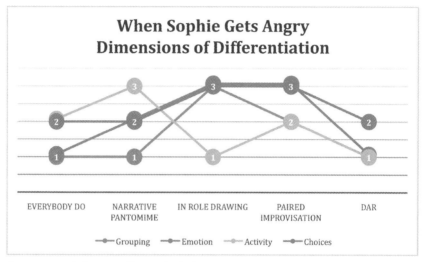

Grouping: 1 = whole, 2 = small, 3 = individual
Emotion; Activity; Choices: 1 = low, 2 = medium, 3 = high

Figure 20: Differentiating a DBP plan.

As the physical activity level is differentiated throughout the *Sophie* plan sequence, so does the form (or modality) of physical expression being used by students to express their understanding. Students use group body expression (Everybody Do), then more complicated and individualized body expression (Narrative Pantomime), then visual expression on paper (In-Role Drawing), then individualized verbal expression (Paired Improvisation), then group verbal expression (DAR) over the course of the inquiry to demonstrate their understanding.

This sequence also shows how a learning experience can be designed to slowly increase the level of a single dimension, like emotion, over time to scaffold and support increased rigor in the learning content. In the *Sophie* plan, the emotion levels begin low (Everybody Do), then step-up to a medium level (Narrative Pantomime), then to a high level (In-Role Drawing) where they remain for a second strategy (Paired Improvisation) that adds the rigor of improvised, verbal expression, until the inquiry ends, safely, with a low-level

emotional finish (DAR). The choice to slowly differentiate and raise the level of emotion in the *Sophie* plan to a heightened peak or climax, then to resolve or end the inquiry at a low level also reflects the dramatic structure of effective storytelling. In addition, this change invites students to engage in different aspects of what is being learned as it relates to the larger inquiry of *How do we show and act upon our emotions*: naming emotions, contextualizing emotions, reflecting on emotions, and taking actions in response to emotions.

Another way to explore differentiation in DBP is to compare multiple dimensions in relationship to one another within an individual strategy. For example, during the In-Role Drawing strategy in the *Sophie* plan, the emotional and the choice levels are high. Students have more ability to engage in high-level critical thinking with rich emotional content during In-Role Drawing because the group level and physical activity levels are low (individual and seated), which help them to focus on the cognitive complexities of the drawing task. In this situation, the teacher can also quickly identify a struggling student and offer additional support; this makes rigorous work more safe and inclusive to students at a variety of cognitive and gross motor skill levels.

Finally, when comparing all the strategies and their dimensions across the entire structured inquiry, it is interesting to note which strategy has the highest and lowest dimensions overall. Paired Improvisation, the teacher's chosen "key strategy" in this inquiry, is also the strategy where the teacher invites students to make the largest intellectual and emotional content stretch as all dimensions are medium to high and no dimension is ranked low. This strategy provides an intellectual stretch for a student who is capable of a higher level of independent, complex thinking. It is also useful to note that after Paired Improvisation, the next and final strategy is DAR, which has the lowest collection of dimensions of any strategy. DAR at the end of a DBP learning experience eases students back from heightened physical emotion to calm and focused reflection on the work.

Final thoughts

As we conclude PART III, we offer a final list of big picture reminders for effective DBP learning design and facilitation.

Prior knowledge: Consider what students need to know before they can participate. This may include academic learning (*Can students describe emotions with rich vocabulary?*), affective learning (*Can students feel safe to risk using their bodies to express their emotion and understanding with others in the group?*), or aesthetic learning (*Can students demonstrate their emotions*

with their bodies and voice; can they respond to others' work with rigor and detail?).

Age too

Students' interests: Consider students' interests and how learning can be situated in meaningful situations that use familiar language to describe relevant contexts.

Student grouping: Vary the type of groupings throughout a sequence, when possible. This includes individual, paired, small group, and whole group time.

Unexpected responses: Remember to remain attentive and responsive to the group needs. The teacher designs a DBP plan, but students will and should offer unexpected responses. Some teachers purposefully begin their work with DBP using strategies that are highly structured, with low choice to build up students' confidence as well as their own ability to deal with the unknown. Take time to build a comfortable learning environment where multiple viewpoints can be argued, respected, and understood.

Meaning-making: Look for ways to build meaning-making into the DBP learning sequence. Specifically, look for moments of dialogue with students as well as moments for students to dialogue with one another throughout a DBP session. Remember dialogic meaning-making can happen verbally, through written words, and through the body.

Transitions: Throughout an inquiry sequence, build in moments of reflection, synthesis, and framing as transitions between activities. Take a moment to reflect and synthesize with the group about what was just done. Then, make an artful, elegant transition into how this links into where the inquiry goes next. This might include reflection on skills, procedures, or concepts explored/ learned and how they might be useful in the next activity (*Now that we have a better idea of emotions, let's explore a story about a young girl who experienced big emotions*). Or, the transition might be situated in a larger narrative or story progression, which embeds and applies the explicit skills, procedures, and/or concepts into a larger story and inquiry into the human condition (*Later that night, their heads filled with key questions raised at the meeting, "Who has the right to make decisions for this community?" and "What do we value the most?," the concerned citizens gathered to write a letter to the editor of the town paper, expressing their concerns*).

Focus on the *big idea* and the essential question (EQ): Remember that the *big idea* and EQ should drive thinking and action forward in DBP. If a student

suggests an unanticipated possible solution and the teacher is able to keep the work focused on the larger goals, then the DBP plan may need to change—even as it is being taught.

With all of these considerations and focus on students and their process, teachers need to also consider the mental resources, time, and support that they need to incorporate DBP into their teaching. DBP often requires a teacher or teaching artist to shift their conceptions about teaching and learning while they begin to routinize and concretize specific ways of working. Early in the DBP pedagogical learning process, teachers often need additional coaching, extra mental resources, and think time to design an inquiry. Students also need time to adjust to the higher expectations of physical, emotional, and cognitive engagement that comes with DBP. They need to learn to use their bodies to demonstrate understanding and to work as an ensemble.

Later in the process of learning DBP, teachers often find that they can work quickly and independently to design a DBP learning experience, but may still want to talk through ideas with a colleague. For teachers who are motivated to further their understanding of teaching and learning in DBP, the planning process encourages teachers to engage with more learning resources, to seek out more difficult problems, and to tackle more complex representations of recurrent problems (Bereiter and Scardamalia, 1993). This can be a long process of change. We have experienced this process first hand in writing this book, during our three-year journey to document our experience with and in DBP. By taking the time to routinize and concretize what we do when we plan a drama-based learning experience, we have made our own teaching and learning in DBP much more effective and clear. We hope the same will be true for others.

Epilogue

In our work, we strive to value and make visible the "intellectual labor" of teaching (Giroux, 1988). A teacher, artist, or teaching artist may or may not have the language to describe their pedagogy in a way that speaks to specific theories; however, their practice can speak to their pedagogy. Do they offer opportunities for individual and group work? Does she facilitate ways for students to make connections between texts, between students, and between students and texts? These teaching practices have theoretical underpinnings for pedagogy that supports student learning. A key aspect of our work in schools focuses on translating the theory of drama and education into practice, so that artists and educators can be advocates for their work in their own contexts.

However, in our testing focused and assessment driven educational climate, many schools are most interested in student academic outcomes. They want to know *Will Drama-Based Pedagogy make a difference in student learning, particularly for students who have less resources or who are less engaged in the classroom for a variety of reasons*? To answer this question, one of this book's authors recently conducted a meta-analysis of 47 studies that measure the effect of DBP on student outcomes. The data shows that DBP has a significant positive effect on achievement, twenty-first century skills, attitudes to subjects in school, motivation, attitudes toward others, and drama skills (Lee, Patall, Cawthon, & Steingut, 2015). Specifically, the impact of DBP practice in schools suggests that 80 per cent of the students whose teachers used some form of DBP in their classroom had higher reading and science scores in comparison to students whose teachers do not use DBP in their classrooms. The data also show that 73 per cent of students had a more positive attitude toward classmates as compared to students who were not in classrooms using DBP. Additionally, about 72 per cent of students in classrooms using a form of DBP showed better drama skills than students who did not have DBP in the classroom. This shows that DBP can make a difference for students in academic, affective, and aesthetic outcomes. Furthermore, the meta-analysis found that DBP has a bigger impact on student achievement when teachers use it in more than five lessons (Lee et al., 2015).

In our joint research on teachers' use of DBP, we also found that DBP gives teachers tangible ways to engage students that align with and enact

their pedagogy (Dawson & Cawthon, 2011; Lee, Cawthon, & Dawson, 2013). When teachers begin to engage in an ongoing cycle of action and reflection through DBP, they begin to engage in reflective and reflexive thinking. When educators and artists apply DBP across the curriculum, they consider the *how* and *why* of *what* they want to teach.

The DBP approach is structured to invite the users to select the strategies and to construct a learning design that will effectively engage their students with a specific topic at a specific time in a specific classroom. This process invites artists and educators to assess students' experience and understandings before, during, and at the end of the inquiry process. Ideally, teachers are constantly considering how students' actions and understandings align with their initial expectations; then, teachers revise for the next teaching and learning task. This ongoing, reiterative process of pedagogical reflexivity is at the heart of DBP. It is also at the center of how our approach to DBP developed and evolved over ten years of work in diverse school contexts across the United States.

Our current individual work in DBP has moved us into new contexts. At the time of this book's publication, we are investigating how DBP functions as one aspect of a ten-year, city-wide creative learning initiative in a mid-sized US urban school district committed to the practices of arts-rich schools. We are exploring how aspects of DBP integrate into major literacy initiatives in US schools with a focus on Shakespeare and complex texts. We are engaging with international colleagues on a multi-year investigation of the use of DBP in mathematics education in South Australia. Each of these experiences has helped us to define and refine our work as we have assembled the writing of this text, often through the piloting of our ideas and these pages with our new colleagues and collaborators as well as in our university classrooms.

We hope that this articulation of DBP is only the beginning. Our work will change and should change in response to the evolutions of the educational and societal landscape as well as our own ongoing development as practitioners and scholars. Feminist educational scholar bell hooks reminds us that "the function of art is to do more than to tell it like it is—it is to imagine what is possible" (1994, p. 281). Together, we can grow toward a future educational system that supports every student and every teacher to imagine and achieve his, her and their personal potential and possibility.

Appendices

Appendix 1

Appendix A

Glossary

Below is a list of commonly used words from Drama-Based Pedagogy practice followed by a brief explanation of how they are used in this book. These are not exhaustive definitions, rather they attempt to serve as a quick reference for the reader as they navigate a potentially unfamiliar terrain.

Academic Learning References cognitive skills involved in critical thinking, including analysis, synthesis, and the transfer between symbol systems, and problem-solving.

Active Learning Participants are responsible for meaning-making and understanding rather than passively receiving knowledge.

Activating Dialogue Strategies that use verbal, written, and/or embodied dialogue to connect participants' prior knowledge and lived experiences to a larger inquiry.

Aesthetic Learning References the creative skills involved in using the senses and imagination to make and interpret meaning, in and through art.

Affective Learning References the social, cultural, and emotional skills that impact and shape learning for individuals and groups.

Arts Integration An approach to teaching and learning in which students build and show their knowledge and understanding of another subject through an art form.

Backwards Design A curriculum planning method that uses the desired outcomes or inquiry goals as a way to choose the instructional activities and assessments.

Big Idea A major concept, theme, or issue that relates to and gives structure to the learning experience.

Body as Image Strategies that invite participants to shape their bodies or the bodies of others to represent an idea, feeling, character, relationship, conflict, setting, or situation.

Co-construct Participants build ideas together.

Complex Text A text that quantitatively has a high number of complex words and qualitatively requires a higher level of meaning-making and reader background experience to understand. This is determined relative to each reader.

Conflict, Power, and Problem-Solving Strategies that ask participants to work as a collective or in small groups to solve a problem or to navigate a specific challenge within real or imagined circumstances.

Constructivism A theory of teaching and learning that emphasizes how individuals interact with their environment (the people and materials) in the learning process to make meaning. Specifically, the focus is on how an individual co-constructs ideas with others in the environment and then translates their discoveries into individual learning.

Context The who, what, and where of the location where DBP is used. This can describe the school (or arts learning space), classroom, the teacher or teaching artist, and the specific identities of students.

Creating Context and Subtext Strategies provide a way for participants to infer, explore, and reflect upon elements of setting, conflict, and character in a real or imagined story.

Creative Drama The US term for an improvisational, non-exhibitional, process-centered form of drama in which participants are guided by a leader to imagine, enact, and reflect upon human experiences.

Creative Movement Participants engage in relaxed and free movements coordinated with various rhythms, sounds, or music, which often express feelings, modes, or ideas evoked by sounds.

DAR Describe, analyze, relate. This is the meaning-making routine used in DBP throughout a learning experience. A process where participants focus on what they can see; then what they can infer based on prior knowledge or observations; and finally how to connect their ideas to a larger concept, text, and/or human condition.

Dialogic Meaning-Making An interactive exchange of ideas between people and environment—made through words, text, image, or the body—with a focus on listening, reflecting, responding, and building upon one another's ideas.

Differentiation Teachers respond to the variance or difference among students in a learning environment.

Direct Guide A teacher acts as a facilitator, with students positioned as participants in the inquiry, in order to support individual and collective meaning-making among learners.

Drama Non-performative, "process-oriented" exploration that focuses on creative expression through the key performing arts skills of ensemble, imagination, embodiment, and narrative/story.

Drama in Education (DiE) The UK term for improvisational drama or educational drama pedagogy and practice. Drama in Education strongly emphasizes imagination, inquiry, reflective practice, and role-play.

Drama-Based Pedagogy Active and dramatic approaches that engage participants in academic, affective, and aesthetic learning through dialogic meaning-making in all areas of the curriculum.

Dramaturgical Skills Skills that are used to describe and understand the structure of the world of a play, often expressed through word, text, sounds, and visual images.

Embodied Dialogue Strategies that invite participants to express their personal opinions by placing their bodies on a continuum in response to a question or statement.

Embodiment Expressing what is known or understood about a fact, feeling, concept, or idea through the body as a form of physical representation. This term also references the role the body plays in shaping the mind's ability to learn and understand.

Ensemble A community of learners who work together for a common purpose.

Ensemble, Energy, and Focus Strategies that rehearse pro-social behavior, collaboration, and focus through energized group challenges.

Essential Question A question that invites participants to link what they do to the larger human condition. It is often a question that helps individuals think about how and why they learn.

Frontloading An instructional practice that involves teaching new vocabulary or procedures, accessing students' prior knowledge about new content, and making predictions about the connections between the new vocabulary and prior knowledge.

Full Participation Teachers and students act as co-participants and as co-facilitators in the inquiry, ready to learn and play with each other.

Game as Metaphor Strategies that use group games to develop mind/body awareness, problem-solving, rehearse pro-social skills, and explore elements of story, e.g., character, setting, and conflict.

Guide on the Side Students are positioned as co-facilitators of the inquiry, with outside support from the teacher as needed, in order to encourage students to support each other and collaboratively solve problems.

Identity Markers Socialized constructs that are often used to describe an individual's identity through a classification (i.e., ethnicity, race, nationality, class, sex, gender, and sexuality). They can be fixed, fluid, and/or dynamic, and can also be a mix of inner and outer qualities or characteristics.

Images in Action Strategies that use the body to visually represent multiple images (which explore ideas, feelings, characters, conflict, setting, or situation) in relationship to one another.

Image Work Strategies that invite participants to use an object or their bodies to represent and dialogue about an idea, feeling, character, relationship, force, setting, or situation.

Imagination Two or more ideas combine to form new images or actions that do not already exist.

Informational Text A nonfictional text that focuses on factual details. This may be a primary document.

Instructional Cycle Describes the way content is presented, explored, taught and assessed by teachers based on student learning needs over time.

Literary Text A fictional text that focuses mostly on story.

Meaning-making The process by which ideas or concepts feel more finalized and steady.

Multimodal Multiple ways that participants can make and express meaning and understanding, e.g., through their spoken or written words and through gestures with their bodies.

Object as Image Strategies that use objects (photograph, painting, character prop, map, headline from a newspaper, a collection of chairs, etc.) to visually represent an idea, character, conflict, setting, or situation.

Pantomime Participants act out an idea with their bodies without any sound. They work toward clarity in manipulating imaginary objects as well as developing non-verbal characterization, setting, and/or situation cues.

Parallel Play All participants play out the activity at the same time. There is no audience.

Passive Learning The teacher is seen as the expert who "pours" knowledge into the student's mind and extracts the correct answers when they are needed.

Pedagogy The theoretical or philosophical understanding of teaching and learning.

Performing Character Strategies that invite participants to explore, consider, and perform character motivation and choice within a real or fictional dramatic dilemma.

Performing within a Dramatic Dilemma Strategies that use familiar dramatic situations (a trial, an interview, a town hall meeting, an opportunity for a journey, etc.) to ask participants to apply knowledge, explore multiple viewpoints, and make choices about how to solve problem.

Perspective-taking Participants "try on" different perspectives or points-of-view that may or may not be different from their own.

Playbuilding Participants create an original performative work together. Often, the playbuilding process begins with games, dramatic activities, improvisation, and discussion.

Playing for Observers Participants perform dramatic activities informally before a group of peers. This type of work emphasizes feedback and works best with students who have more experience and confidence in the content (art form and non-arts content) being explored.

Pre-flection The act of forming and sharing thoughts to set intention or to gather and assess prior knowledge from participants at the beginning of a learning experience.

Prior Knowledge The experiences and understanding that participants currently have based on their own life.

Reading an Image/Object Participants describe what they see using rich sensory language. Just as in traditional reading, students can also make inferences based upon what they read.

Reflection The act of forming and sharing carefully considered thoughts during and at the end of a learning experience. Many times "pre-flection" is also used to set an intention for the drama work or to gather and assess prior knowledge from participants at the beginning of a learning experience or inquiry.

Rituals to Begin and End Strategies that use a multimodal (verbal, written, and embodied) routine as a way to set intention, synthesize understanding, or provide closure for a lesson or project.

Role Work Strategies that invite participants to think, dialogue, problem-solve, and act either as themselves or as someone else in response to a set of imagined circumstances.

Scaffolding A facilitator provides a structure for participants to build upon their prior knowledge and understanding to support a more complex, rich, and nuanced understan ding of a concept, idea, or skill.

Setting, Story, and Character Strategies that use a group game to explore the drama/theatre skills of pantomime, voice/sound, imagination, and storytelling.

Side-Coaching A strategy in which the facilitator offers suggestions and/or feedback from the side of the action in order to enhance the dramatic playing or to help participants stay on task.

Socio-cultural Theory A theory of teaching and learning that suggests that the social and cultural aspects of each student need to be included in the learning process.

Sociometric A physical way to measure and compare participant opinion and response to a series of related questions based on a larger topic or inquiry.

Spotlighting A facilitator spotlights a student's or a pair of a participant's work. This usually occurs when the group is working individually or in small groups simultaneously and the facilitator asks the whole group to freeze. Then, one individual or group is asked to continue working while others observe, often just for a moment or two, after which the full group resumes their simultaneous exploration.

Story Dramatization Improvisations based on a story, folktale, or poem. The leader guides the group as they bring to life the characters, dialogue, and events suggested in the story. The stories or poems each present problems that group members can actively solve in their playing of the story.

Subtext Ideas and/or motivations that must be inferred because they are not explicitly known or stated.

Teacher-in-Role This provides a chance for students and teacher to shift between an "as is" world into an "as if" world. In the process, the teacher takes on a character or role that is relevant to dramatic story or inquiry in order to introduce information or facilitate students' meaning-making and interaction.

Text-based and Visual Dialogue Strategies that ask participants to use written and visual text to express personal opinion in response to a prompt.

Theatre Work that is oriented toward a performative product (e.g., a play) for an audience.

Theatre Games Short "improvisational" exercises that focus on developing a specific skill or skills such as concentration, cooperation, problem-solving, or self-expression.

Theatre of the Oppressed (TO) The general term referring to theatre activist Augusto Boal's strategies including Games, Image Theatre, Forum Theatre, Invisible Theatre, Rainbow of Desire, and Legislative Theatre.

"Yes, and" An improvisational rule that says a participant always says, "yes, and" to build upon whatever idea his/her partner offers.

Zone of Actual Development (ZAD) This describes what a student can already do on their own.

Zone of Proximal Development (ZPD) This describes what a student can do with the assistance of or in collaboration with a teacher or a more capable peer.

Appendix B

Related resources

Below is a list of resources that engage with the practices of DBP in schools. This not a comprehensive list. We have chosen to include current texts alongside older resources, as way to acknowledge the rich history of practice in drama and education that relates to DBP. It is useful to read older texts in the context of their larger historical context.

Books related to drama and Drama-Based Pedagogy practice

Ackroyd, J., & Boulton, J. (2001). *Drama Lessons for Five to Eleven Year-Olds*. London, UK: David Fulton.

Alrutz, M. (2015). *Digital Storytelling, Applied Theatre, & Youth: Performing Possibility*. New York: Routledge.

Anderson, M. (2012). *Masterclass in Drama Education: Transforming Teaching and Learning*. London, UK: Continuum.

Bailey, S. (1993). *Wings to Fly: Bringing Theatre Arts to Students with Special Needs*. Rockville, MD: Woodbine House.

Baldwin, P. (2008). *With Drama in Mind: Real Learning in Imagined Worlds*. London, UK: Continuum International Publishing Group.

Berry, C. (2008). *From Word to Play: A Textual Handbook for Actors and Directors*. London, UK: Oberon Books.

Boal, A. (1985). *Theatre of the Oppressed*. New York: Theatre Communications Group.

Boal, A. (1992). *Games for Actors and Non-Actors*. New York: Routledge.

Bolton G., & Heathcote, D. (1995). *Drama for Learning: Dorothy Heathcote's Mantle of the Expert Approach to Education*. Portsmouth, NH: Heinemann.

Booth, D. (1994). *Story Drama: Reading, Writing & Role-Playing Across the Curriculum*. Markham, ON: Pembroke Publishers Ltd.

Bowell, P., & Heap, B. (2001). *Planning Process Drama*. London, UK: David Fulton.

Brock, A. (ed.). (2000). *Into the Enchanted Forest: Language, Drama and Science in Primary Schools*. London, UK: Trentham Books, Ltd.

Brown, V., & Pleydell, S. (1999). *The Dramatic Difference: Drama in the Preschool and Kindergarten Classroom*. Portsmouth, NH: Heinemann.

Burke, M. (2013). *Gavin Bolton's Contextual Drama: The Road Less Travelled*. Chicago, IL: Intellect.

Cahnmann-Taylor, M., & Souto-Manning, M. (2010). *Teachers Act Up! Creating Multicultural Learning Communities Through Theatre*. New York, NY: Teachers College Press.

Dawson, K., & Kellin, D. (2014). *The Reflexive Teaching Artist: Collected Wisdom From the Drama/Theatre Field*. Bristol, UK: Intellect Books.

Edmiston, B. (2014). *Transforming Teaching and Learning with Active and Dramatic Approaches: Engaging Students Across the Curriculum*. New York: Routledge.

Fennessey, S. (2000). *History in the Spotlight: Creative Drama and Theatre Practices for the Social Studies Classroom*. Portsmouth, NH: Heinemann.

Fleming, M. (1998). *Starting Drama Teaching*. London, UK: David Fulton.

Gerke, P., & Landalf, H. (1999). *Hooves and Horns, Fins and Feathers: Drama Curriculum for Kindergarten and First Grade (Young Actors Series)*. Hanover, NH: Smith and Kraus.

Grady, S. (2000). *Drama and Diversity: A Pluralistic Perspective for Educational Drama*. Portsmouth, NH: Heinemann.

Graham, S. & Hogget, S. (2009). *The Frantic Assembly Book of Devising Theatre*. New York: Routledge.

Heathcote, D., & Bolton, G. (1995). *Drama for Learning: Dorothy Heathcote's Mantle of the Expert Approach to Education*. Portsmouth, NH: Heinemann.

Heinig, R. (1992). *Creative Drama for the Classroom Teacher*. 4th edition, Englewood Cliffs, NJ: Prentice-Hall, Inc.

Heinig, R. (1992). *Improvisation with Favorite Tales*. Portsmouth, NH: Heinemann.

Johnstone, K. (1979). *Impro: Improvisation and the Theatre*. New York: Theatre Arts Book.

Kase-Polisini, J. (1989). *The Creative Drama Book: Three Approaches*. Louisville, KY: Anchorage Press.

Kelner, Lenore Blank. (1993). *The Creative Classroom: A Guide for Using Creative Drama in the Classroom, PreK–6*. Portsmouth, NH: Heinemann.

Koppett, K. (2012). *Training to Imagine: Practical Improvisational Theatre Techniques for Trainers and Managers to Enhance Creativity, Teamwork, Leadership, and Learning* (2nd ed.). Sterling, VA: Stylus Publishing.

Lazarus, J. (2012). *Signs of Change: New Directions in Theatre Education*. Chicago, IL: Intellect.

McCaslin, N. (1995). *Creative Drama in the Classroom and Beyond*. Whiteplains, NY: Longman.

Manley, A., & O'Neill, C. (1997). *Dreamseekers: Creative Approaches to the African American Heritage*. Portsmouth, NH: Heinemann.

Miller, C., & Saxton, J. (2004). *Into the Story: Language in Action Through Drama.* Portsmouth, NH: Heinemann.

Morgan, N., & Saxton, J. (1987). *Teaching Drama: A Mind of Many Wonders.* London, UK: Hutchinson.

Neelands, J. (1984). *Making Sense of Drama: A Guide to Classroom Practice.* Portsmouth, NH: Heinemann.

Neelands, J., & Goode, T. (2000). *Structuring Drama Work: A Handbook of Available Forms in Theatre and Drama.* Cambridge, UK: Cambridge University Press.

Nicholson, H. (2011). *Theatre, Education and Performance.* New York: Palgrave Macmillan.

O'Neill, C. (1995). *Drama Worlds: A Framework for Process Drama.* Portsmouth, NH: Heinemann.

O'Neill, C., & Lambert, A. (1982). *Drama Structures.* London, UK: Hutchinson.

Prendergast, M., & Saxton, J. (2013). *Applied Drama: A Facilitator's Handbook for Working In the Community.* Chicago, IL: Intellect.

Rohd, M. (1998). *Theatre for Community, Conflict & Dialogue: The Hope is Vital Training Manual.* Portsmouth, NH: Heinemann.

Saladaña, J. (1995). *Drama of Color: Improvisation with Multicultural Folklore.* Portsmouth, NH: Heinemann.

Schutzman, M., & Cruz, J. (1993). *Playing Boal: Theatre, Therapy and Activism.* New York: Routledge.

Spolin, V. (1986). *Theater Games for the Classroom: A Teacher's Handbook.* Evanston, IL: Northwestern University Press.

Spolin, V. (1999). *Improvisation for the Theatre: A Handbook of Teaching and Directing Techniques* (3rd ed.). Evanston, IL: Northwestern University Press.

Tarlington, C., & Verriour, P. (1991). *Role Drama.* Portsmouth, NH: Heinemann.

Thompson, J. (1999). *Drama Workshops for Anger Management and Offending Behaviour.* Philadelphia, PA: Jessica Kingsley.

van de Water, M., McAvoy, M., & Hunt, K. (2015). *Drama and Education: Performance Methodologies for Teaching and Learning.* New York: Routledge.

Warren, K. (1993). *Hooked on Drama: The Theory and Practice of Drama in Early Childhood.* Waverly, IA: Macquarie University.

Wilhelm, J. (2002). *Action Strategies for Deepening Comprehension: Role Plays, Text Structure Tableaux, Talking Statues, and Other Enrichment Techniques That Engage Students With Text.* New York: Scholastic.

Winston, J., & Tandy, M. (1998). *Beginning Drama 4–11.* London, UK: David Fulton.

Studies by research design to reference regarding the impact of Drama-Based Pedagogy across the curriculum

Meta-analysis of drama-based pedagogies

Conrad, F. (1992). *The arts in education and a meta-analysis* (Doctoral dissertation). Purdue University, West Lafayette, IN.

Conrad, F., & Asher, J. W. (2000). Self-concept and self-esteem through drama: A meta-analysis. *Youth Theatre Journal, 14,* 78–84.

Kardash, C. A. M., & Wright, L. (1986). Does cretaive drama benefit elementary school students: A meta-analysis. *Youth Theatre Journal, 1,* 11–18.

Lee, B., Patall, E., Cawthon, S., & Steingut, R. (2015). Meta-analysis of the effects of drama-based pedagogy on K-16 student outcomes since 1985. *Review of Educational Research.*

Podlozny, A. (2000). Strengthening verbal skills through the use of classroom drama: A clear link. *Journal of Aesthetic Education, 34,* 239–275.

Reviews of drama-based research

Burnaford, G., Brown, S., Doherty, J., & McLaughlin, H. J. (2007). *Arts Integration Frameworks, Research Practice.* Washington, DC: Arts Education Partnership.

Deasy, J. R. (2002). *Critical Links: Learning in the Arts and Student Academic and Social Development.* Washington, DC: Arts Education Partnership.

President's Committee on the Arts and Education. (2011). *Reinvesting in Arts Education: Winning America's Future Through Creative Schools.* Washington, DC: Author.

Quasi-experimental studies

With randomization at student level

Freeman, G., Sullivan, K., & Fulton, C. R. (2003). Effects of creative drama on self-concept, social skills, and problem behavior. *The Journal of Educational Research, 96*(3), 131–138.

Warner, C. D., & Andersen, C. (2004). "Snails are science": Creating context for science inquiry and writing through process drama. *Youth Theatre Journal, 18,* 68–83.

With randomization at school and classroom level

Rose, D. S., Parks, M., Androes, K., & McMahon, S. D. (2000). Imagery-based learning: Improving elementary students' reading comprehension with drama techniques. *The Journal of Educational Research. 94*(1), 55–63.

Walker, E., Tabone, C., & Weltsek, G. (2011). When achievement data meet drama and arts integration. *Language Arts, 88,* 365–372.

Walker, E. M., McFadden, L. B., Tabone, C., & Finkelstein, M. (2011). Contribution of drama-based strategies. *Youth Theatre Journal. 25*(1), 3–15.

With no randomization

DeMichele, M. (2015). Improv and ink: Increasing individual writing fluency with collaborative improve. *International Journal of Education & the Arts, 16*(10), 1–25. http://www.ijea.org

Fleming, M., Merrell, C., & Tymms, P. (2004). The impact of drama on pupils' language, mathematics, and attitudes in two primary schools. *Research in Drama Education, 9*(2), 177–199.

Karakelle, S. (2009). Enhancing fluent and flexible thinking through the creative drama process. *Thinking Skills and Creativity, 4*, 124–129.

Wright, P. R. (2006). Drama education and development of self: Myth or reality? *Social Pscyhology of Education, 9*, 43–65.

Within group

Anderson, A., & Berry, K. (2015). The influence of classroom drama on teachers' language and students' on-task behavior. *Preventing School Failure: Alternative Education for Children and Youth, 59*(4), 197–206.

Mixed methods

Belliveau, G. (2005). An arts-based approach to teach social justice: Drama as a way to address bullying in schools. *International Journal of Arts Education, 3*(2), 136–165.

Bournot-Trites, M., Belliveau, G., Spiliotopoulos, V., & Seror, J. (2007). The role of drama on cultural sensitivity, motivation and literacy in a second language context. *Journal for Learning Through the Arts, 3*(1), 1–35.

Lee, B., Cawthon, S., & Dawson, K. (2013). Teacher self-efficacy for teaching and pedagogical conceptual change in a drama-based professional development program. *Teaching and Teacher Education,* (30), 84–98.

Websites

The DBP Network
http://www.dbp.theatredance.utexas.edu
Electronic version of some of the strategies found in this book, and lesson plans created by educators using DBP in their classrooms.

Learn NC—The North Carolina Teachers' Network
www.learnnc.org
Quality lesson plans for every subject, grades 1–12.

Arts Edge, the Education resource of the Kennedy Center
http://artsedge.kennedy-center.org/teaching_materials/
Lesson plans for K-12 in every subject, plus web links and other resources.

Drama Resource
http://dramaresource.com/
Drama games and strategies.

Appendix C

Works referenced

Alrutz, M. (2015). *Digital Storytelling, Applied Theatre, & Youth: Performing Possibility*. New York: Routledge.

Anderman, L. H. (2003). Academic and social perceptions as predictors of change in middle school students' sense of school belonging. *The Journal of Experimental Education, 72*(1), 5–22.

Anderson, M. (2012). *Master Class in Drama Education: Transforming Teaching and Learning*. New York: Continuum.

Aukerman, M. (2013). Rereading comprehension pedagogies: Toward a dialogic teaching ethic that honors student sensemaking. *Dialogic Pedagogy: An International Online Journal*, A1–A31.

Bakhtin, M. M. (1986). *Speech Genres and Other Late Essays* (V. W. McGee, Trans.). Austin, TX: University of Texas Press.

Bang, M. (1999). *When Sophie Gets Angry—Really, Really Angry....* New York: Blue Sky Press.

Beasley-Rodgers-Combs, A. (2014). *Drama-Based Strategies in the Elementary Classroom: Increasing Social Perspective-Taking and Problem Solving*. (Doctoral dissertation). University of Texas at Austin, Library Database. (895893219).

Bereiter, C., & Scardamalia, M. (1993). *Surpassing Ourselves: An Inquiry into the Nature and Implications of Expertise*. Chicago, IL: Open Court.

Berry, C. (2008). *From Word to Play: A Textual Handbook for Actors and Directors*. London, UK: Oberon Books.

Boal, A. (1979). *Theater of the Oppressed*. (C. A. Leal McBride & M. O. Leal McBride, Trans.). New York: Urizen Books. (Original work published 1974)

——— (1995). *The Rainbow of Desire: The Boal Method of Theatre and Therapy*. (A. Jackson, Trans.). New York, NY: Routledge.

——— (2002). *Games for Actors and Non-Actors* (2nd ed.). (A. Jackson, Trans.). New York: Routledge. (Original work published 1992)

Bolton, G., & Heathcote, D. (1995). *Drama for Learning: Dorothy Heathcote's Mantle of the Expert Approach to Education*. Portsmouth, UK: Heinemann.

Bruner, J. (1996). *The Culture of Education*. Cambridge, MA: Harvard University Press.

Bybee, R. W., Taylor, J. A., Gardner, A., Van Scotter, P., Powell, J. C., Westbrook, A., & Landes, N. (2006). The BSCS 5E instructional model: Origins and effectiveness. Colorado Springs, CO: BSCS, 5, 88–98.

Cahnmann-Taylor, M., & Souto-Manning, M. (2010). *Teachers Act Up! Creating Multicultural Learning Communities Through Theatre*. New York: Teachers' College Press.

Chi, M. T. H. (2009). Active-constructive-interactive: A conceptual framework for differentiating learning activities. *Topics in Cognitive Science, 1*(1), 73–105.

Dawson, K., & Kellin, D. (2014). *The Reflexive Teaching Artist: Collected Wisdom from the Drama/Theatre Field.* Bristol, UK: Intellect Books.

Dewey, J. (1916). *Democracy and Education: An Introduction to the Philosophy of Education.* New York: Macmillan.

——— (1938). *Experience and Education.* New York: Macmillan.

——— (1994). Art as Experience. In S. D. Ross (ed.), *Art and its Significance.* (3rd ed.). Albany, NY: State University of New York Press. (Original work published 1934).

Edmiston, B. (2014). *Transforming Teaching and Learning with Active and Dramatic Approaches: Engaging Students Across the Curriculum.* New York: Routledge.

Edmiston, B., & Enciso, P. (2002). Reflections and refractions of meaning: Dialogic approaches to classroom drama and reading. In J. Flood, D. Lapp, J. Squire, & Jensen, J. (eds). *The Handbook of Research on Teaching the English Language Arts.* New York: Simon & Schuster. 868–880.

Edmiston, B., & Wilhelm, J. (1998). Repositioning views/reviewing positions: Forming complex understandings in drama. In B. J. Wagner (Ed.). *Educational Drama and the Language Arts: What Research Shows.* Portsmouth, NH: Heinemann. 90–117.

Eisner, E. (2002). *The Arts and the Creation of Mind.* New Haven, CT: Yale University Press.

Freire, P. (1970). *Pedagogy of the Oppressed* (M. B. Ramos, Trans.). New York: Herder and Herder.

——— (1985). *The Politics of Education: Culture, Power, and Liberation* (D. Macedo, Trans.). South Hadley, MA: Bergin & Garvey.

——— (2007). *Pedagogy of the Oppressed.* New York: Continuum.

Giroux, H. (1988). *Teachers as Intellectuals: Toward a Critical Pedagogy of Learning.* Westport, CT: Greenwood Publishing Group.

——— (1997). *Pedagogy and the Politics of Hope: Theory, Culture and Schooling a Critical Reader.* Boulder, CO: Westview Press.

Grady, S. (2000). *Drama and Diversity: A Pluralistic Perspective for Educational Drama.* Portsmouth, NH: Heinemann.

Greene, M. (1995). *Releasing the Imagination: Essays on Education, the Arts, and Social Change.* San Francisco, CA: Jossey-Bass Publishers.

——— (2007). *Aesthetics as Research.* https://maxinegreene.org/uploads/library/aesthetics_r.pdf.

Heinig, R. B. (1993). *Creative Drama for the Classroom Teacher* (4th ed.). Englewood Cliffs, NJ: Prentice Hall.

Hinton, S. E. (1967). *The Outsiders.* New York: Viking Press.

hooks, b. (1994a). *Teaching to Transgress: Education as the Practice of Freedom.* New York: Routledge.

———— (1994b). *Outlaw Culture: Resisting Representations.* New York: Routledge.

Joosse, B. M., & Potter, G. (2001). *Ghost Wings.* San Francisco, CA: Chronicle Books.

Kayhan, H. C. (2009). Creative drama in terms of retaining information. *Procedia Social and Behavioral Sciences, 1,* 737–740.

Kincheloe, J. L. (2008). *Critical Pedagogy Primer.* New York: Peter Lang.

King, A. (1993). From sage on the stage to guide on the side. *College Teaching, 41*(1), 30–35.

Koppett, K. (2012). *Training to Imagine: Practical Improvisational Theatre Techniques for Trainers and Managers to Enhance Creativity, Teamwork, Leadership, and Learning* (2nd ed.). Sterling, VA: Stylus Publishing.

Kress, G. (2003). *Literacy in the New Media Age.* New York: Routledge.

Kress, G., & van Leeuwen, T. (1996). *Reading Images: The Grammar of Visual Design.* New York: Routledge.

———— (2001). *Multimodal Discourse: The Modes and Media of Contemporary Communication.* London, UK: Bloomsbury.

Kuhn, D. (1999). A developmental model of critical thinking. *Educational Researcher, 28*(2), 16–46.

Leander, K., & Boldt, G. (2013). Rereading "A Pedagogy of Multiliteracies": Bodies, texts, and emergence. *Journal of Literacy Research, 45*(1), 22–46.

Lee, B., & Enciso, P. (2017). The Big Glamorous Monster (or "Lady Gaga's Adventures at Sea"): Dramatic approaches to writing in high and low-resourced schools. *Journal of Literacy Research, 49*(2).

Lee, B., Patall, E., Cawthon, S., & Steingut, R. (2015) Meta-analysis of the effects of drama-based pedagogy on K-16 student outcomes since 1985. *Review of Educational Research.* doi:10.3102/0034654314540477.

Lowry, L. (1993). *The Giver.* Boston, MA: Houghton Mifflin.

Miller, C., and Saxton, J. (2004). *Into the Story: Language in Action Through Drama.* Portsmouth, NH: Heinemann.

Moll, L (ed.) (1990). *Vygotsky and Education: Instructional Implications and Applications of Sociohistorical Psychology.* Cambridge, UK: Cambridge University Press.

Morgan, N., & Saxton, J. (1987). *Teaching Drama: A Mind of Many Wonders.* Portsmouth, NH: Heinemann.

———— (2006). *Asking Better Questions* (2nd ed.). Markham, ON: Pembroke.

Munsch, R., & Martchenko, M. (1980). *The Paper Bag Princess.* Buffalo, NY: Annick Press.

Neelands, J. (2009). Acting together: Ensembles as a democratic process in art and life. *Research in Drama and Education.* 14(2), 173–189.

Neelands, J., & Goode, T. (2000). *Structuring Drama Work: A Handbook of Available Forms in Theatre and Drama.* Cambridge, UK: Cambridge University Press.

Nicholson, H. (2005). *Applied Drama: The Gift of Theatre*. Basingstoke, UK: Palgrave Macmillan.

——— (2011). *Theatre, Education and Performance*. New York: Palgrave Macmillan.

O'Neill, C. (1995). *Drama Worlds: A Framework for Process Drama*. Portsmouth, NH: Heinemann.

Osterman, K. (2010). Teacher practice and students' sense of belonging. In T. Lovat, R. Toomey, & N. Clement (eds), *International Research Handbook on Education Values and Student Wellbeing*. New York: Springer. 239–260.

Performative. (n.d.). In *Oxford Dictionaries Online*. http://www.oxforddictionaries. com/us/definition/american_english/performative.

Perry, M., & Medina, C. (2011). Embodiment and performance in pedagogy research: Investigating the possibility of the body in curriculum experience. *Journal of Curriculum Studies, 27*(3), 62–75.

Podlozny, A. (2000). Strengthening verbal skills through the use of classroom drama: A clear link. *Journal of Aesthetic Education,* 34(3–4), 239–276.

Prendergast, M., & Saxton, J. (2013). *Applied Drama: A Facilitator's Handbook for Working in Community*. Chicago, IL: Intellect Books.

Rohd, M. (1998). *Theatre for Community, Conflict & Dialogue: The Hope is Vital Training Manual*. Portsmouth, NH: Heinemann.

Ryan, R. M., & Deci, E. L. (2000). Self-determination theory and the facilitation of intrinsic motivation, social development, and well-being. *American Psychologist, 55*(1), 68–78.

Schutzman, M., & Cruz, J. (1993). *Playing Boal: Theatre, Therapy and Activism*. New York: Routledge.

Souto-Manning, M. (2010). *Freire, Teaching, and Learning: Culture Circles Across Contexts*. New York: Peter Lang.

Spolin, V. (1986). *Theater Games for the Classroom: A Teacher's Handbook*. Evanston, IL: Northwestern University Press.

——— (1999). *Improvisation for the Theatre: A Handbook of Teaching and Directing Techniques* (3rd ed.). Evanston, IL: Northwestern University Press.

Steinbeck, J. (2002 [1937]). *Of Mice and Men*. New York: Penguin.

Strike, K. & Posner, G. (1992). A revisionist theory of conceptual change. In Richard Alan Duschl, & Richard J. Hamilton (eds). *Philosophy of Science, Cognitive Psychology, and Educational Theory and Practice*.

Taylor, P. (2000). *The Drama Classroom: Action, Reflection, Transformation*. London, UK: Routledge.

The New London Group (1996). A pedagogy of multiliteracies: Designing social futures. *Harvard Educational Review, 66*(1), 60–93.

Thompson, J. (1999). *Drama Workshops for Anger Management and Offending Behaviour*. Philadelphia, PA: Jessica Kingsley.

Toth, J. (1996). *Exploring a Visual Work of Art*. http://www.innereye.net/schools/ ExploreArt.htm.

van de Water, M., McAvoy, M., & Hunt, K. (2015). *Drama and Education: Performance Methodologies for Teaching and Learning.* New York: Routledge.

Vygotsky, L. S. (1934). *Myshllenie i rech': Psikhologicheskie issledovaniya* [Thinking and speech: Psychological investigations]. Moscow and Leningrad: Gosudarstvennoe Sotsial'no-Ekonomicheskoe Izdatel'stvo.

——— (1971). *The Psychology of Art.* Cambridge, MA: MIT. Press.

——— (1978). *Mind in Society: The Development of Higher Psychological Processes.* Cambridge, UK: Harvard University Press.

——— (2004). In R. W. Reiber & D. K. Robinson (Eds), *The Essential Vygotsky.* New York: Kluwer Academic/Plenum Publishers.

Wagner, B. J. (1998). *Educational Drama and Language Arts: What Research Shows.* Portsmouth, NH: Heinemann.

Walker, E., Tabone, C., & Weltsek, G. (2011). When achievement data meet drama and arts integration. *Language Arts, 88*(5), 365–372.

Walsh, J. A., and Sattes, B. D. (2005). *Quality Questioning: Research-Based Practice to Engage Every Learner.* Thousand Oaks, CA: Corwin Press.

Ward, W. (1930). *Creative Dramatics.* New York: D. Appleton & Co.

Watkins, C., & Mortimore, P. (1999). Pedagogy: What do we know? In P. Mortimore (ed.), *Understanding Pedagogy and its Impact on Learning.* Thousand Oaks, CA: SAGE Publications.

Webb, N., & Mastergeorge, A. (2003). Promoting effective helping behavior in peer-directed groups. *International Journal of Educational Research, 9*(1–2), 73–97.

Wertsch, J.V. (1985). V*ygotsky and the Social Formation of the Mind.* Cambridge, UK: Harvard University Press.

Wiggins, G. P., McTighe, J., Kiernan, L. J., & Frost, F. (1998). *Understanding by Design.* Alexandria, VA: Association for Supervision and Curriculum Development.

Wiggins, G. P., & McTighe, J. (2006). *Understanding by Design.* Cambridge, UK: Pearson Publishing.

Wilhelm, J. (2002). *Action Strategies for Deepening Comprehension: Role Plays, Text Structure Tableaux, Talking Statues, and Other Enrichment Techniques that Engage Students with Text.* New York, NY: Scholastic.

——— (2012). *So, What's the Story? Teaching Narrative to Understand Ourselves, Others, and the World.* Portsmouth, NH: Heinemann.

Wilhelm, J., & Edmiston, B. (1998). *Imagining to Learn: Inquiry, Ethics, and Integration Through Drama.* Portsmouth, NH: Heinemann.

Winston, J. (2015). *Transforming the Teaching of Shakespeare with the Royal Shakespeare Company.* New York: Bloomsbury Arden Shakespeare.

Wood, C. (X). *Yardsticks: Children in the Classroom, Ages 4–14.* Turner Falls, MA: Northeast Foundation for Children.

Yager, R., & Akcay, H. (2008). Comparison of student learning outcomes in middle school science classes with an STS approach and a typical textbook dominated approach. *Research in Middle Level Education Online, 31*(7), 1–16.

Online Resources

Activating Dialogue

Artifact: http://dbp.theatredance.utexas.edu/content/artifact

Exploding Atom: http://dbp.theatredance.utexas.edu/content/exploding-atom

Theatre Game as Metaphor

Truth about Me: http://dbp.theatredance.utexas.edu/content/truth-about-me

This Is A/Not A: http://dbp.theatredance.utexas.edu/content/not

Image Work

Image Work Introduction: http://dbp.theatredance.utexas.edu/content/image-work

Sculptor/Clay: http://dbp.theatredance.utexas.edu/content/sculptor-clay

Bippety Bippety Bop (Donkey): http://dbp.theatredance.utexas.edu/content/donkey

Role Work

Role Play Introduction: http://dbp.theatredance.utexas.edu/content/role-play

Hot Seating: http://dbp.theatredance.utexas.edu/content/hotseating

Role on the Wall: http://dbp.theatredance.utexas.edu/content/role-wall

Foundational Skills

Classroom Management: http://dbp.theatredance.utexas.edu/content/classroom-management

Constructivism: http://dbp.theatredance.utexas.edu/content/constructivism

Questioning: http://dbp.theatredance.utexas.edu/content/questioning

What is DBI? (Drama-Based Instruction): http://dbp.theatredance.utexas.edu/content/what-dbi

Links to Curriculum Standards from Model Learning Experiences

When Sophie Gets Angry…: http://www.corestandards.org/ELA-Literacy/W/K/8/

http://www.corestandards.org/ELA-Literacy/RL/K/3/

http://www.nationalartsstandards.org/sites/default/files/Theater_resources/Theatre%20at%20a%20Glance.pdf

https://www.austinisd.org/sites/default/files/dept/sel/images/A.I.S.D._SEL_Standards_-_Elementary_and_Secondary_9-11-12.pdf

Call to Action: Gettsyburg Address: http://www.corestandards.org/ELA-Literacy/RH/9-10/

http://www.corestandards.org/ELA-Literacy/RH/9-10/

https://www.austinisd.org/sites/default/files/dept/sel/images/A.I.S.D._SEL_Standards_-_Elementary_and_Secondary_9-11-12.pdf

Area and Perimeter of 2-D Geometric Shapes: http://ritter.tea.state.tx.us/rules/tac/chapter111/ch111a.html#111.7

http://ritter.tea.state.tx.us/rules/tac/chapter117/ch117a.html#117.119

https://www.austinisd.org/sites/default/files/dept/sel/images/A.I.S.D._SEL_Standards_-_Elementary_and_Secondary_9-11-12.pdf

Power to the People: Investigating the impact of Nuclear Energy as a Resource: https://education.alaska.gov/akstandards/standards/Science_Performance&GLEs.pdf

https://aws.state.ak.us/OnlinePublicNotices/Notices/Attachment.aspx?id=101914

https://education.alaska.gov/akstandards/standards/standards.pdf

Index